Praise for *Cesar Romero*

"*The Joker Is Wild*—and the book is wonderful. Wonderful because Cesar Romero is wonderful, and 'biographer of the stars' Samuel Garza Bernstein has the perfect immersive style to share exactly why that is. Brilliantly researched and written, the book feels more like a memoir than a standard biography; it has a 'you are there' quality that makes you feel as if you're experiencing the surprising life and career of Romero at exactly the same time as he is. Not just a Latin lover, not just the iconic, beloved Joker from *Batman*, Romero—and Garza Bernstein—are originals. You'll so appreciate this in-depth look at a Golden Age actor who could have been written off, but thankfully, Garza Bernstein has brought him back to life for every Hollywood fan."

—**KIM POWERS**
author of *Rules for Being Dead*
and *Capote in Kansas*

"What Samuel Garza Bernstein has given us with his breezily written bio of the iconic Cesar Romero is no less than the history of the working actor in Hollywood from the studios' early sound era to the dominance of television. With his debonair charm and talent over six decades, Romero managed to navigate the changes better than some of the golden era's biggest stars, amassing an impressive roster of motion picture roles before segueing effortlessly into television. If you only think of Romero as the definitive Joker in the *Batman* series or as the wily Peter Stavros in *Falcon Crest*, Garza Bernstein is here to tell you otherwise."

—**RICHARD NATALE**
novelist and journalist

CESAR ROMERO

CESAR ROMERO
The Joker Is Wild

SAMUEL GARZA BERNSTEIN

FOREWORD BY MICHAEL USLAN

UNIVERSITY PRESS OF KENTUCKY

A note to the reader: This volume contains images of an actor wearing theatrical makeup and costuming to portray a character of a different race. Several of the quotations printed in this volume contain outdated or racially insensitive terminology, and the original language is retained here for historical context. Discretion is advised.

Copyright © 2025 by Samuel Garza Bernstein

Published by The University Press of Kentucky,
scholarly publisher for the Commonwealth,
serving Bellarmine University, Berea College, Centre
College of Kentucky, Eastern Kentucky University,
The Filson Historical Society, Georgetown College,
Kentucky Historical Society, Kentucky State University,
Morehead State University, Murray State University,
Northern Kentucky University, Spalding University,
Transylvania University, University of Kentucky,
University of Louisville, University of Pikeville,
and Western Kentucky University.
All rights reserved.

Editorial and Sales Offices: The University Press of Kentucky
663 South Limestone, Lexington, Kentucky 40508-4008
www.kentuckypress.com

Unless otherwise noted, photographs are from the author's collection.

Cataloging-in-Publication data is available from the Library of Congress.

ISBN 978-1-9859-0288-6 (hardcover : alk. paper)
ISBN 978-1-9859-0290-9 (epub)
ISBN 978-1-9859-0291-6 (pdf)

For Ronuel, the worst kind of boy.

They say the camera never lies. It lies every day.
Cesar Romero

CONTENTS

Foreword by Michael Uslan xi

Introduction 1
1. Dancing on Air 11
2. Most Eligible Bachelor 32
3. Sly Fox 47
4. Passport to Danger 73
5. Clown Prince of Crime 94
6. Silver Fox 107
7. Sex, Lies, and Grandfathers 119

Afterword 137
Special Thanks 139
Chronology: The Film and Television Appearances 141
Selected Bibliography 255
Index 261

Illustrations follow page 82

Foreword

Holy Jersey Shore! THREE of Batman's most legendary supervillains hailed from the Asbury Park, New Jersey, area: Danny DeVito's Penguin and TWO Jokers . . . Jack Nicholson and the first actor to play the Joker in a Batman movie, the amazing Cesar Romero!

In Samuel Garza Bernstein's new book, *Cesar Romero: The Joker Is Wild*, the author reveals not only how a Hollywood legend was born but how, through depression, wars, tech revolutions, political witch hunts, and secret identities, Romero continued to span generations by always taking on daring new challenges and successfully reinventing himself in the process.

If you're a fan of classic movies, Hollywood's star-studded golden age, comic book superheroes like Batman, and (along with Darth Vader and the Wicked Witch of the West) one of the three greatest villains in cinema history, the Joker, you'll applaud and even maniacally cackle at this in-depth revelation of the utterly true story of Cesar Romero. And that's no joke!

—Michael Uslan, Originator and Executive Producer of the *Batman* movie franchise

Introduction

Cesar Romero's laugh as the Joker is magnificent.

It is never exactly the same. Most of the time, it starts with a gleeful, falsetto "ooh" and "ah," building into a frenzied cackle, maybe a brief pause (even archenemies need to take a breath now and again), back to the cackle, then edging down, first into a baritone, then to bass territory. Play a recording or show a video of that laugh to anyone with any access to American pop culture, and my bet is that person will recognize him as the first Joker. They may not know Romero's name, but the voice and his face are immortal.

In Romero's incredible six-decade-long career, he brings a gallery of characters to life, spanning every genre imaginable, but it is that laugh and the full-bodied, hammy, joyful performance that goes with it that, in 1966, make Romero a superstar. Suddenly he is on lunch boxes, school supplies, board games, T-shirts, jigsaw puzzles, and trading cards; he is an action figure and a Halloween mask; toys inspired by him include joy buzzers, squirting flowers, and trick guns; and the character goes from being one of many *Batman* villains to rivaling the popularity of the Caped Crusaders themselves.

For the next three decades, until his death in 1994, people stop him on the street and in restaurants, airports, shopping malls, and hospitals and ask him to do the laugh. Ever gracious, Romero always happily complies. He is grateful for this legacy that binds him to multiple generations of fans.

It isn't until the 1970s when *Batman* is in reruns that I see Romero as the Joker for the first time. I fall in love immediately, and it is the camp element that attracts. This is not just my introduction to the Joker and Romero; it is my first real exposure to live-action superheroes of any kind, leaving me with a sense of the genre being great fun and, more important, a place that is queer friendly, though I do not have the vocabulary or sense of cultural identity to articulate it in that way at the time. The only

other nascent LGBTQIA+ representation in the media I remember from that era is also camp—with the usual suspects—performers like Charles Nelson Reilly, Paul Lynde, Rip Taylor, and Wayland Flowers and Madame (a phenomenally popular ventriloquist and his garrulous drag queen–like puppet). More serious fare, like *That Certain Summer* and *Boys in the Band*, is not in my childhood experience, and the idea of lesbians, bisexuals, and trans people is not yet on my radar.

I recognize these men as projections of my future self. I'm not delusional. I don't imagine myself growing up and becoming a hilarious villain in clownish, neon makeup plotting the demise of grown men who wear their underpants outside of their tights. But I recognize the humor, the mannerisms, and the undercurrents if not the physicality of the innuendos. And Cesar Romero takes no shit. By the end of the first of each two-episode story, he is always winning. I know he will lose by the end of the second part, but on some level, I recognize that as a fulfillment of the narrative demands of the form rather than as a personal loss for him. To me, he is a winner, and I like that very much. I'm an effeminate kid, thankfully not bullied or particularly singled out, but for a variety of reasons, I don't feel very powerful. The Joker's wild abandon is inspiring and empowering in a cockeyed sort of way.

Over the years that follow, a rich tapestry of Romero's other accomplishments pre- and post-*Batman* also become part of my sense of him. As a kid, a performance I remember vividly is an episode of *Charlie's Angels*, where he plays a dreamy, passionate big band leader and owner of a ballroom where everyone always wears period costumes. The Angels show up in slinky satin cut-on-the-bias gowns, and best of all, Romero is revealed as the nostalgia-driven murderer. He takes Jaclyn Smith hostage with her own gun back behind the dance hall. The episode airs in 1980, eight days before he turns seventy-three years old. A little more than fifty years earlier, he gets his start in the entertainment business as a ballroom dancer in New York City. On *Charlie's Angels*, he plays that same elegant dancer grown older if not wiser.

He makes his Broadway debut in 1927 and his first film in 1933. Soon after, he becomes the Cisco Kid, the Latino Robin Hood of westerns, taking over for star Warner Baxter, who is pushing fifty; he is Shirley Temple's "swarthy," "exotic," foreign savior in two of her most beloved classics, *Wee Willie Winkie* and *The Little Princess* (though in the former, while he does save her, he is also her kidnapper, albeit inadvertently); he is a sexy gangster

Introduction

in films like *Tall, Dark and Handsome* and *A Gentleman at Heart*; and, most memorably to me, he is the singing and dancing star of some of the most popular of the deliriously demented musicals produced by 20th Century Fox in the 1930s and 1940s, like *Week-End in Havana*, *Springtime in the Rockies*, *Coney Island*, and *Wintertime*, opposite Carmen Miranda, Betty Grable, Alice Faye, and ice-skating star Sonja Henie, among others. He rarely gets the girl in these films—usually losing out to far less interesting stars like John Payne, George Montgomery, or Jack Oakie, who are billed above him. But whatever his place in the credits, he makes the stronger impression. For *Week-End in Havana*, Alice Faye is billed above Carmen Miranda, and John Payne is billed above Cesar Romero, but Miranda as a nightclub star and Romero as her gigolo "manager" are magic, dancing away with the picture.

Western outlaw, foreign savior, hot criminal, dancing Latin lover—these are only a few of the archetypes he embodies, as 20th Century Fox plugs him into anything and everything. His career runs the gamut: drama, comedy, musicals, westerns, adventure, mystery, science fiction, horror, fantasy, noir, epic, 3D, family . . .

And *Batman*.

In watching and rewatching him create the characters that come before the Joker, you can experience them as the building blocks that make this iconic performance possible. The range of genres under his belt gives him the ability to bring size and freedom to the portrayal. The colossal diversity of his experiences gives him the fearlessness that makes the character so vividly alive. The projects that follow *Batman* benefit from the deep affection the public develops for Romero. He can play the antagonist or antihero, and we still care about him. He can be a cad, but we still want him to get the girl. He can be a criminal, and we want him to outwit law enforcement—even when he murders people, since he usually has a good reason—or at least a colorful one.

Cesar Romero is completely ahead of his time in one sense: long before the term *intersectionality* exists, he embodies the concept, as an American-born Latino, the child of (very wealthy) immigrants, who is also a gay man secure enough that even though he assiduously keeps his private life out of the public eye, he still refuses to marry a woman to provide cover—unlike many of his peers in Hollywood. Neither does he conform to binary stereotypes about ethnicity, social class, sexual orientation, or cultural identity. He is Latino but never identifies as "the other," even as he is often cast as a veritable United Nations of ethnicities; he is a child of wealth who, in

his late teens, becomes his family's breadwinner out of dire necessity and remains so for decades, often living with and supporting three generations of the Romero clan; he is gay but his sense of family, partnership, and masculinity conform to the straight dictates of twentieth-century America; he adores and respects women but never questions the male power structure or gender roles; and though he is a conservative who passionately opposes communism, he is not publicly supportive of right-wing excesses during the blacklisting era.

There are rumors that his long friendship with star Tyrone Power is romantic, particularly after they fly alone, with Power as the pilot, on a ten-week trip to Central and South America after World War II. The studio 20th Century Fox sends them on the trip in support of the US Good Neighbor policy. Although the United States is decidedly haphazard in its approach to the policy's dictates of nonintervention and noninterference in the affairs of Latin American countries, the aspects of the policy that support friendly reciprocal trade exchanges are attractive to Fox. With postwar European film markets in shambles, Hollywood looks south to broaden its export business.

Amid frenzied media coverage throughout the Americas, Romero and Power dine with Juan and Eva Perón, among others, and are met by tens of thousands of fans. In 1985, when Skip E. Lowe (a legendary Hollywood fabulist who inspires Martin Short to create the slippery character Jiminy Glick) asks Romero if he and Tyrone Power are ever more than friends, Romero replies simply, "I loved this man. Were we more than just friends? Sometimes we don't know what we are."

Romero is private about his romantic life and never spills the tea on any of his famous friends. He refuses to write an autobiography, telling people that he knows what publishers want him to write about, and he has no interest in betraying friends and loved ones. Contrary to this, however, he is known to have shopped a verbal proposal for his autobiography in the mid-1980s. He and the publishers are wildly apart in terms of price though. Romero wants $100,000. One publisher offers $10,000. It is not enough for Romero to put pen to paper, and the idea dies. If someone had met his price, however, though I cannot know for certain, I don't imagine he would have outed himself or others. He is a standard-bearer for the classic Hollywood idea of film actors as fantasy archetypes. Yet his ironic nickname is "Butch," bestowed one night at a party at the Trocadero nightclub in Los Angeles in the early 1930s by his friend actor George Murphy, who goes on to become a Republican senator from California.

Introduction

"[He] tagged that name on me years ago," Romero explains to the *Los Angeles Times* in 1962. "We were all at a party and he went around tagging names on people that didn't fit them. I was tall and skinny and had black hair and played gigolos, and he said, 'Your name is Butch.' Everyone laughed and it stuck." Romero never marries. "How could I when I had so many responsibilities? Could I tell a girl, 'Let's get married and you can come and live with my father, my mother, two sisters, a niece and a nephew'? I have no regrets."

A 1939 *Look* profile describes him as "a bachelor of many arts." The article goes on to say, "Before Hollywood drafted him Romero had been on the stage, danced professionally—even been a day laborer. His biggest worry is that people will think he's a gigolo, forget that once he drove trucks and dug ditches."

In the studio press release for *Show Them No Mercy!* in 1935, Romero says he is happy to play a tough guy. "It was inevitable I should be tagged with the 'Latin Lover' label, but it gets pretty sickening to read about yourself as a glorified gigolo. The worst thing about it, American men dislike this type of prettified personality—and I want the good opinion of the men in the movie audiences as well as the women."

For the record, there is no evidence of any ditchdigging in Romero's life to that point. And when it comes to his sexuality, it's not always easy to figure out if entertainment writers and publicists are in the know. In 1943, during the publicity for the Sonja Henie ice-skating fantasy *Wintertime*, Romero's final film before leaving for his World War II service in the US Coast Guard, the studio publicity writer heavily pushes the red-blooded American he-man idea: "Butch Romero is as American as the proverbial apple pie with cheese. At school he was a crack center on the basketball team. Butch is an ardent baseball fan and goes into mourning every year the Giants fail to win a pennant. He likes football, pink lemonade, ice skating, riding western style, and Boston baked beans."

Throughout Romero's press coverage, the constant drumbeat is marriage—when, why, why not, who, where, how—with a breathless account of one or another exploit, a photo of Cesar doing something adorable with a beautiful woman, and a quote from him about not yet finding the right girl. From an unidentified fan magazine clipping in one of his many scrapbooks: "He can out rumba any South American living and out maneuver any matrimonial-minded lass in the village . . . he always seems to miss matrimony by a hair—a blonde hair most of the time." And a different unidentified fan

magazine clip picks up on the blonde theme: "Most of the girls with whom he has gone around with have been blondes. 'Real blondes or platinum,' I asked. 'Real,' he answered, with that usual male assurance that no blonde could fool him about her blondeness."

But I think there is actually a lot of sincerity and naivete mixed with the wink-wink-nudge-nudge and the puffery, and, on Romero's part, perhaps even some hope. Maybe he *will* fall in love with a woman. Stranger things have happened. All his friends have wives. He goes on double dates with them, hitting the swanky nightclubs with beautiful women on his arm. In 1941, a *Boston Sunday Post* article spreads details about his avid nightlife and headlines him as the "Smoothest Male in Hollywood." I don't know about "smooth" exactly, but he is obviously having a wonderful time dancing with women he adores, something he loves almost as much as he loves making movies. Other closeted gay actors who enter the public eye later than Romero, like Van Johnson, Rock Hudson, and Tab Hunter, go on arranged dates and in published photographs seem like they are just hitting their marks. Not so with Romero. He and Joan Crawford laugh uproariously in each other's arms; he shares a cigarette with Ann Sheridan with a gleeful, conspiratorial gleam in his eye; he winks at Betty Furness with a true sense of intimacy. He is clearly having a blast. Romero is lucky that something he is so obviously passionate about, something inherently authentic, makes him appear as something of a hetero wolf to movie fans.

He is also very lucky in his misfortunes and failures.

In the midst of catastrophic events beyond his control—like the financial ruin of his father in the mid-1920s, the legendary failure of the 1935 film that is supposed to make him a star, a 1948 Supreme Court decree that destroys the market for an entire class of films that is his specialty, even the surprise cancellation of *Batman* in 1968—he is able to find ways of making these disasters boomerang in his favor, opening doors that otherwise might stay closed. Romero's father is strict and conservative and has very specific expectations for his son. "If my father's [sugar] business hadn't gone broke, I'd be exporting nuts, bolts and sugar machinery right now," he tells the *New York Times* in 1965. "What an awful thought!" That's being lucky in one's misfortune. And were it not for a series of crises in the Cuban sugar markets in the early and mid-1920s—events completely outside of thirteen-year-old Romero's control that make it absolutely vital that he find some way of supporting his formerly wealthy family once he turns eighteen—the world would have been denied the pleasure of Cesar Romero as the Joker.

Introduction

Among *Batman* aficionados, there is actually something of a divergence in feelings about Cesar Romero's depiction of Batman's archnemesis, with intense reactions pro and con. In researching the character's origins, it is easy to see why. The Joker begins life in comic books in the 1940s as a true psychopath and sadist. His humor is evil, almost entirely devoid of actual joy or childlike glee. In the late 1950s, though, in response to a new mission from the Comics Code Authority, seeking to keep children safe from subversive ideas, the Joker morphs into more of a merry prankster. The campiness of the television series is creator and executive producer William Dozier's idea and undoubtedly owes more to the prankster than to the psychopath. The character's late twentieth-century and twenty-first-century evolution takes the character further into genuine madness. In 1989, the menace of Jack Nicholson is startlingly different from Cesar Romero. By the time of the Oscar-winning performances of Heath Ledger in 2008 and Joaquin Phoenix in 2019, Nicholson comes to seem relatively lighthearted, closer to Romero than to Ledger or Phoenix. Yet Cesar Romero's performance endures.

"The truth is that the very best Joker was not introspective and wounded and soulful. He was a cheerful, extroverted goofball, who tripped from crime to crime with purple tails flapping behind him in insouciant glee," says film critic and comic book specialist Noah Berlatsky writing for syfy.com. "I speak of course of that arch-criminal, Gotham's grinning Clown Prince of Crime, Cesar Romero."

"Romero's Joker is a far cry from the sinister, slightly more psychotic version that we're used to seeing now, to be sure," writes Sean T. Collins in a 2019 article in *Rolling Stone*. "But his flamboyant theatricality has definitely influenced all subsequent portrayals of the Dark Knight's archenemy."

Cesar Romero is born in 1907, dies in 1994, and plays the Joker from 1966 to 1968. That *Rolling Stone* thinks he is relevant enough to write about in 2019 speaks volumes about the lasting impact of his performance on popular culture. They are not writing about the other Anglo, macho leading men billed above Romero in the 1930s and 1940s, arguably bigger stars in their day than him.

Depending on what qualifies as a film appearance, whether you count cameos playing yourself, voice-overs added after the fact, and the like, Romero appears in some 110 movies. He makes over 250 appearances on scripted television. He makes another 137 or so appearances as himself on talk shows and game shows and in documentaries. He is credited over 30 times posthumously on projects using archival footage. That's over 500 professional credits. A few of Romero's films are difficult to find, but nothing is considered lost.

I don't write in detail about every single one of those five hundred–plus credits, but I do include all the films, most of the scripted television work, and his early theater work. In writing about his projects, my synopses tend to be short on plot machinations with a greater emphasis on public and critical reactions, Romero's impact on each project, how the projects relate to modern cultural moods, and my own sense of where each title fits in the body of his work. Spoilers abound, and plot summaries can be a tricky business. Many online film and television sites repeat the same mistakes about plots and about casts and crews. And some listings of his early television shows contain many factual errors. In some cases, the mistakes matter a great deal.

For instance, *Deep Water* is a 1948 feature starring Dana Andrews, Jean Peters, and Cesar Romero. Twelve-year-old Dean Stockwell is a troubled orphan who finds camaraderie with Andrews and Romero as they set off every day in their fishing boat to catch lobsters. Peters is Andrews's fiancée, and she is also Stockwell's social worker. Worried about safety on the open sea, she breaks up with Andrews and subsequently forbids Stockwell from accompanying Andrews and Romero, leading Stockwell to act out, steal a watch, and get sent to reform school—but things end happily when the boy is adopted. Almost every single available reference source says that Andrews and Peters get married and adopt Stockwell—a movieworthy happy ending. Except that it is not what happens. This is how *Deep Waters* ends: Dana Andrews, a single man living with another single man, Cesar Romero, adopts Dean Stockwell with the understanding that Romero will also take a parental role.

Two single men who live together adopt a child.

There is certainly no suggestion that Andrews and Romero are anything other than good friends and business partners, so it's not some sort of *Dean Stockwell Has Two Daddies* breakthrough in gay representation. Yet, it is an example of the very modern construct of a chosen family. That a Hollywood studio film in 1948 would depict a judge approving such an unconventional arrangement is extraordinary. The fluidity of what is possible in a supposedly rigid era defies our presumptions.

In one of Romero's final films, *Simple Justice*, as online sources describe the story, "an ordinary man seeks justice for the brutal killing of his pregnant wife." Only the wife isn't dead—she's in a coma and wakes up at the end. And the "ordinary man," her young husband, is not a killer. In fact, there are two killers: the unlikely, kindly Italian grandparents, Cesar Romero and Doris Roberts—a much more interesting story. And Romero's delicately shaded performance is a fine cap on his long career.

Introduction

So, I take a lot of care with the credits.

There are a ton of choices to make in writing about someone from a long-ago era when it comes to modern sensibilities. In the first chapter, I quote Romero referring affectionately in 1960 to the woman who teaches him to dance when he is a little boy as his family's "Puerto Rican negress maid." I confess to feeling uncomfortable about including the word "negress." It's such an anachronism at this point, offensive certainly, yet so specifically evocative of another time and other sensibility that I think it would be a mistake to cleanse it from the record. I fear it may brand Romero harshly early in his story—which strikes me as potentially a terrible shame—but I choose not to exclude it. Such are the choices made throughout this book.

In researching Romero's life and enduring career, I'm indebted to the Romero family for donating his papers and scrapbooks to the University of Southern California Cinematic Arts Library after his death, and to the staff there, especially the inestimable Billy T. Smith and Sandra M. Garcia-Myers. The scrapbooks are particularly vital to tracking Romero's professional life before his arrival in Hollywood, when his press coverage largely comes from local newspapers while touring with *Strictly Dishonorable* and *Dinner at Eight*, among other shows. Unfortunately, many of the clippings are neatly cut out and pasted without the names of their publications visible, so sometimes full attribution is impossible. With vivid, colorful language in the vernacular of show business from almost a century ago, these articles reveal so much about Romero's New York life as a dancer and stage actor.

As I began this project, I found all kinds of things posted online. My favorite clip is from the 1986 Golden Globes. Cesar Romero and June Allyson are presenting the award for Best Actress in a Motion Picture Drama and announce the winner: Whoopi Goldberg for *The Color Purple*. A shocked Goldberg can't get over it. She looks at Romero and looks around the room, doing a double take and then a triple take. "You have dreams, you have visions, and all of a sudden you get an invitation to go to one of these things," she says. "You sit and you gawk. I've never seen all these people before, I mean . . . *Cesar Romero! You know?!*" The audience bursts into hearty applause, and the camera pans over to Romero, blushing and grinning, then to a delighted Oprah Winfrey, among others, affectionately applauding Romero. His presence resonates fully among multiple generations of Hollywood stars gathered at the Beverly Hilton.

He is loving every minute of it. As well he should.

Romero is a representation of the larger story of the entertainment industry itself, spanning the early years of the talkies through the golden era of film, and the emergence and later dominance of television. His is also a story that reflects a very different era, before cultural and sexual identity becomes part of our national conversation rather than remaining hidden or assimilated. And it is a veritable primer in the benefits of relentlessly looking for the silver lining when everything around you seems like it is turning to crap—a state of mind that keeps Romero going through any number of setbacks and tragedies.

In this book, I hope to bring wider attention to Cesar Romero's many accomplishments that predate and postdate his rendezvous with Bat-destiny. For his part, Romero never regrets that the Joker proves his most enduring contribution to show business—an industry he loved with all his heart. Let Burgess Meredith grumble about how depressing he finds the fact that his own esteemed stage and film career is overshadowed by the Penguin, and how awful it is being accosted everywhere by fans asking him to do his wheezy laugh. Romero is always happy when asked to do the Joker's laugh. He loves bringing joy to the public—and he never looks a gift horse in the mouth.

"As far as I am concerned, I've been fortunate in my life, really," he says in an interview with author Louis Mucciolo in 1992.

> I had no training for this profession. What I did I just did naturally, and one thing led to another. . . .
>
> After my father lost everything, he kept me going to private school until I finished prep school, and I don't know how he did it, but he did. So, it's been constantly on my mind to take care of my family, and I brought them all out here, my parents, my two sisters and my younger brother. I had my parents under my roof until they passed away. They weren't going to any nursing home if I could help it. They did so much for me and the other children that I was only too glad to take care of them. Life has been good to me, and I did what I wanted to do, which was take care of my family. And I was able to do it because I was an actor, and I had the good luck of being successful in it. So, I have always been grateful and, believe me, I count my blessings.

"How delicious!" he often says as the Joker.

Delicious indeed.

1

Dancing on Air

Hollywood fan magazines give colorful, if often conflicting, accounts of Cesar Romero's family history. Romero is called the direct descendant of Cuba's greatest hero. The Romeros are called the fourth-wealthiest Cuban family in the United States. But sometimes they are the third or second wealthiest. And sometimes they are Italian, or Spanish, or Portuguese. His father is almost always described as having lost his fortune in the stock market crash of 1929. And Romero's date of birth is often reported as February 14, 1907, Valentine's Day.

And that's showbiz. Take a story with tons of verifiable drama and embellish it anyway.

A few correctives: Cesar Romero is indeed the grandson of a Cuban hero. The family lives near Central Park on West Ninety-Seventh Street in Manhattan and is certainly wealthy, though whether they are specifically the fourth or fortieth most wealthy Cubans in America is as unknowable today as it likely was then. Romero's father loses most of his money in a series of crises that have nothing to do with the American stock market crash. And the Valentine's Day birth is a figment of the imagination of a press agent with a Latin lover agenda.

Cesar Julio Romero Jr. is actually born on February 15, 1907, to Spanish-born Cesar Julio Romero Acosta and American-born Maria Mantilla Miyares Romero. He is the second of five children, the first boy. Their eldest child, Maria, is born in 1905. Following Cesar is Graciela in 1911, Manuel in 1918 who dies the day after he is born, and Eduardo in 1920. The cause of Manuel's death is lost to history. Romero's parents are not the sort of people who talk about painful details to their children or, it seems, to anyone, and no cause of death is listed on any available records.

The Cuban part of the equation comes from Cesar's mother, Maria Mantilla, a former concert singer, who is almost certainly the illegitimate

daughter of José Martí, considered a Cuban national hero for his central role in the war for independence from Spain. The story of José Martí is as exciting as any film Romero will make, dovetailing with the sweep of history and the intrigues of soap opera. He is a romantic figure, a Renaissance man, known also as a poet, philosopher, essayist, journalist, translator, professor, and publisher.

On the plaza at the Avenue of the Americas entrance to Central Park in New York, there is a statue of Martí (frequently cited as the George Washington of Cuba) being fatally wounded while atop his horse during the 1895 battle at Dos Ríos. It is erected in 1965, with Cesar Romero attending the dedication, and it stands between statues of Simón Bolívar (the George Washington of Bolivia, Colombia, Venezuela, Ecuador, Panama, and Peru) and José de San Martín (the George Washington of Argentina, Chile, and also Peru—perhaps he and Bolívar are coparents).

The unpredictable thing about how publicity information morphs over time is that Maria Mantilla's parentage is one thing the press coverage gets right. Eventually. At the start of Cesar Romero's career, articles about him refer to Martí as his mother's godparent. At some point in the 1930s, he morphs into her father, and it seems that during Maria's lifetime no one in the press uses the word "illegitimate." The first reference I can find is in a 1968 *TV Guide* profile of Romero, published six years after her death, that focuses on his longing and love for the old days of the Hollywood studio system.

Martí's mission to liberate Cuba from Spanish rule leads to periods of exile, and in early 1880, he arrives in New York and lives in a sort of boardinghouse operated by a married woman, Carmita Miyares de Mantilla, that functions less as a moneymaking proposition and more as a safe house for friends and Cuban exiles who support the revolution. Eleven months after Martí's arrival, still in 1880, Carmita gives birth to Maria Mantilla. At her baptism, her mother is listed as Carmen Miyares de Mantilla and her father as Maria's husband Manuel Mantilla, an invalid who passes away three years later. Martí is listed as her godfather, and for the remaining fifteen years of his life, he is actively involved in Maria's education and welfare and refers to her as his daughter.

He is also a father figure to Carmita's other three children from Manuel, pays for their education, and encourages the daughters to become teachers and to learn multiple languages. Maria donates the extensive correspondence between father and daughter to the Florida University archives

after it is a central exhibit in the festivities surrounding the Centenario de Martí of 1953, when she is a key player in celebrations commemorating the one-hundredth anniversary of his birth.

In 1895, Martí writes to Maria from Cabo Haitiano on his way to Cuba to join the war for independence, "When someone is nice to me, or nice to Cuba, I show them your picture. My wish is that we all live together, with your mother, and that you have a good life." Only weeks before his death in battle at Dos Ríos, he writes, "Love your mother. I've never known a better woman in this world. I can't, nor will I ever, think of her without seeing how clear and beautiful life is. Take great care of this treasure."

It isn't hard to imagine Cesar Romero saying that to Marlene Dietrich in *The Devil Is a Woman*. Or if you add some alliterative pep and criminal intent, to Catwoman.

When Martí dies, Maria and her mother are devastated by the loss, but Maria continues her studies, including extensive musical training, and, in her late teens and early twenties, carves out a career for herself as a moderately successful concert singer. She is booked for things like society charity events as part of an entertainment program rather than Carnegie Hall. (It's the same sort of gig that will become commonplace for her son one day as well when he starts ballroom dancing.) In movie magazines and studio-written bios of Cesar Romero, she will always be a "former opera star," though it would appear she never performs in actual operas.

She gives up professional singing in 1905 when she meets and marries Spanish émigré Cesar Julio Romero Acosta (who has a brother among his eight siblings named Bolivar Simón—who is presumably not the "Washington George" of the Romero family). Although Romero was born in Spain, his family also has Cuban roots—his father, born in Venezuela, meets and marries his mother in Havana in 1862.

Cesar Romero's father is a conservative man with traditional views on a man's role in the household, who, upon Cesar's birth, immediately sees a clear path for his son as the heir apparent of his successful sugar machinery export business. Romero Sr. rules the roost, lovingly according to most accounts, though in a 1985 appearance on a Hollywood Walk of Fame celebrity *Family Feud* special, when asked to name a childhood fear that carries on into adulthood, Romero's response is, "Fear of your father."

Romero's childhood is idyllic until his teens. He attends Riverdale Country Day School (still going strong today in the Bronx, with sweeping views of Van Cortlandt Park) and the Collegiate School. "It was very

snooty," he remembers in the aforementioned 1968 *TV Guide* profile. "The boys there were invited to Miss Spencer (the elite, all-girls Spence School) as a matter of course. I went to my first debutante dance at the Colony Club."

An average student, popular, and good at sports, young Cesar also loves dancing—but he never goes to a dancing school. "I didn't need to," he tells the *Los Angeles Times* in 1960. "I learned in our kitchen when I was five, with Victoria for a teacher. She was a Puerto Rican negress maid who was with our family for years. She was mad about dancing. She went to all the Harlem affairs and kept a little phonograph going all the time while she was cooking and cleaning. She taught me to bow and all the one, two, three stuff, and when I knew those, Victoria made me practice with my sister for a partner."

Singing is also a passion. When Romero is eight, his mother takes him for an audition, and he is offered a spot in the Metropolitan Opera boys chorus, but his father adamantly refuses to allow it. The opera may be a fairly cultured branch of the arts, but it is still show business, a disreputable industry. His wife's career from ten years before does not apparently figure into the equation. Other than that, Cesar remembers his early childhood as a time of abundance and luxury. He and his siblings want for nothing, the family is close and affectionate, and he is growing into a decidedly handsome young man.

He is unaware of an impending economic catastrophe lurching toward Cuba like a tropical storm at the end of 1920.

Since 1915, Cuba has been booming, with dizzying economic growth presaging the roaring twenties in America. The war in Europe dramatically increases the demand for sugar as Europe's beet sugar fields and factories shut down. Cuba's share of the world sugar market doubles, then triples from the already doubled figure, to six times larger than where it starts at the beginning of the century. Sugar hits a record high of 22.5¢ per pound in May, but then the price begins a steady decline over a seven-month period—by the end of November, it plummets to 4.75¢ per pound and, by the end of December, to just under 3¢ per pound. The market for Cesar Romero Sr.'s sugar machinery evaporates as Cuban banks take over the plantations, there is a run on the banks, and twenty of them collapse. Sugar speculators and bankers flee the island as fast as boats can carry them.

There is a Cuban expression, "Sin azúcar no hay país."

"No sugar, no country."

But Cesar Romero Sr. has somewhat diversified his family's wealth. His business may be teetering on the edge of oblivion, but there is enough to keep living well—though they do eventually move to their summer home in Bradley Beach, New Jersey, and give up their more expensive Manhattan residence. Cesar's life doesn't change drastically at first. There is still household help, though not as much as before, and he stays at Collegiate School on the Upper West Side in New York for the rest of seventh grade. With its upper-crust claim of being the oldest school in the United States, founded in 1628, Collegiate is a bastion of old money and high society. As someone of Latino heritage, Romero Jr. doesn't really fit in completely when the family is rich. Now he fits in even less.

He still dances with Victoria in the kitchen. But a growing awareness of the family's precarious financial future manifests. In the summertime, he starts augmenting the family coffers with odd jobs—delivering packages for Steinbach's, a department store chain based in nearby Asbury Park, and, when he is old enough, driving the delivery truck.

For eighth grade, he leaves Collegiate and attends the Bradley Beach Grammar School. In some ways, it is a freer existence than the earlier years in New York. Bradley Beach is an affluent area but without the strict social mores of Manhattan society. There are opportunities to break out from the watchful eyes of his parents. At Halloween that year, he wants to go out with his friends, but Romero Sr. vetoes the idea. He knows what boys get up to on Halloween. After dinner, Romero Jr. feigns a sudden attack of queasiness and the chills to excuse himself and disappears upstairs. He climbs out his bedroom window, down a ladder to his waiting friends. Together they head for Asbury Park, but some boys stay behind and begin "causing trouble" at the Romero home. What that means for these particular boys in 1921 is unclear. Popular Halloween tricks of the era for houses where treats aren't given include stealing gates, putting people's wagons on their roofs, and whacking unsuspecting victims with sacks of flour.

It is unlikely that his friends whack his father with a sack of flour. But evidently, they make enough noise to arouse suspicion, and Romero Sr. comes outside to chase them away. Perhaps hoping to redirect Romero Sr.'s anger, Romero Jr.'s friends tattle and tell him that his son is on the loose. He and daughter Maria go off in search of the errant heir apparent. At some point, Romero Jr. spots them before they spot him, and he hurries home and hides in the back of the family car. When his father and sister return, he jumps out of the car to surprise them. He gets grounded indefinitely.

With the lower overhead afforded by their new life in New Jersey, Romero Sr. slowly starts climbing his way back to financial health through investments, and he manages to pay for private school again for ninth grade. It's a confusing time for the fourteen-year-old. Just as he is getting used to being a "regular" kid with "regular" friends, he is back with the offspring of the Four Hundred. Assimilating back into the swing of things appears deceptively easy from the outside as Romero Jr. develops code-switching (before that's a thing) that takes him to adulthood. He is able to glide his way into a society party as easily as he gets along with his working-class coworkers in the summer.

Part of it is his listening skills. He is someone who seems to be genuinely interested in others—a quality that can go a long way to keeping others from branding you as different. It also helps that he is good at sports, already taller and more muscular than many of his classmates, and that he is rarely lost for words. He takes on four roles in the school's production of *The Merchant of Venice*. It's an all-boys school, so it's likely that boys play all the roles, male and female, but there is no record of the parts he plays, and as one of the tall boys, he probably isn't shaking a lace-covered fist and judging the quality of mercy. He likes being in the play, but it isn't some big "aha" moment; he still has no clear idea of what he wants to become, just that he will have to work. Whether he is growing aware of his attraction to his own gender is unknowable, unless there is a 115-year-old former classmate out there with a tender secret. But there is some sense that he is aware of his otherness.

"I've always liked to be one of the boys," he says in one of the interview clippings in his scrapbooks, when asked about his bachelor state and whether being thought of as a Latin lover somehow implies a lack of masculinity. "I had rather a handicap in my name, Cesar, which some of the other boys thought sounded like 'Sissy,' so I went in for athletics and tough nicknames to live down the taint."

And he dances.

In the wealthy society homes of New York, male dancers are always at a premium, and he is asked to all the Saturday socials given by Mrs. George Harris, a doyenne of the charity ball circuit and a racehorse owner to boot. His skills as a dancer notwithstanding, there is some mystery to how easily he is included in this group of silver spooners. In no sense does the Romero family think of themselves as "people of color," though the phrase doesn't yet exist, but in the early twentieth century, barriers to anyone with

a darker-than-lily-white complexion are very real at every level of the social ladder, regardless of one's wealth. Just as they can still be in the early twenty-first century.

In the photo of handsome twelve-year-old Cesar Romero that opens the image section of this book, he is clearly a young Latino boy, who looks very much like he is going to be a young Latino man. And as repugnant as it is to contemplate the hierarchies of skin shade and the odious concept of "passing," there is no possibility that his heritage goes unnoticed. Nor would his family ever want to deny their illustrious heritage. And yet for Romero, the available evidence points to an easy acceptance of him in the largely white, largely Protestant circles of debutantes and tea dances. Either the elites aren't as exclusionary as we are given to believe or the kid is such a charmer that his perceived exoticism is no hindrance.

Meanwhile, money gets even tighter when some of Romero Sr.'s investments go belly-up. Romero Jr. is pulled from private school for the second time, attending his sophomore through senior years in Bradley Beach. He still goes into Manhattan on Saturdays for dances during the "season" but tries to juggle that with doing odd jobs to help out at home. The financial panic and worry take a toll on Romero Sr. His vigor starts to flag, and he slides into a deep depression. After a lifetime of incredible success, he doesn't know how to be a have-not, and he just can't seem to find a way back into the game. In 1925, there is another sugar panic that further weakens his financial position.

The family downsizes again, moving to the more affordable Asbury Park—a city that will happily refer to Cesar Romero as a hometown hero, though he never actually lives there. After graduating from high school in Bradley Beach, Cesar moves to New York to look for work. He lives in a top-floor rear room of a tenement building in the Yorkville area, a German immigrant enclave on the outer region of the Upper East Side, though far removed from the tony milieu of Fifth Avenue and Central Park. He gets a job through a friend of his father as a runner at the National City Bank. Now going out at night to dance isn't just a way to have fun; it's a way to eat. Where there is a party and dancing, there is also food and drink. He absolutely hates working at the bank and finds it deathly dull. At least at night, he can get lost in the music, lost in how good it feels to dance, and how fun it is when everyone watches with such admiration. He's really good, but it doesn't yet occur to him that he might make it into more than a hobby.

He drags in most mornings at four or five o'clock, sleeps all the way downtown on the subway, and goes to sleep again in the runners' room until someone pokes him awake with a package to deliver. His nights are another matter. All he wants to do is dance, and he gets plenty of invitations. The only expenses are subway fare and dress shirts. He tries to make the shirts last at least for two evenings, hopefully more.

"If I ever had to take off my coat, my social career would have ended," he tells Louella Parsons in 1941 for her column. "The shirts were in shreds, all pinned together in the sleeves and down the back. I had to dance very carefully, or I'd have been a human pin cushion."

Enter debutante Lisbeth Higgins in early 1927—a most unusual society girl. In some ways, she is not unlike the debutantes that Romero's soon-to-be BFF Joan Crawford will play throughout the 1930s in a string of wildly profitable MGM comedies. Higgins is headstrong, determined to have what she wants, and willing to work as hard as she has to in order to get it. But she is often portrayed over the years in press accounts of Romero's early years as some sort of dilettante who gets the madcap idea of going professional on a lark, and, against her stodgy rich parents' wishes, convinces Romero to turn pro right along with her. That's a story that fits with preconceived notions of everyone involved, but it gets just about everything important wrong.

Higgins is a rich society girl, but she is already a professional, having gotten her start in 1924 as a Broadway entr'acte dancer. She has already been appearing professionally with a different dance partner at Ritz-Carlton tea dances for some time—all with the delighted approval of her parents, who have decidedly progressive and unconventional ideas about all kinds of things. Her mother, Alexandrina Fransioli Higgins, is a singer who keeps performing professionally for several years after she marries, until kids start popping out, and her father, Charles Michael Higgins, a wealthy ink inventor and manufacturer, is unusually broad-minded and involved in many civic activities devoted to improving relations between diverse groups. He is a Christian who accuses other Christians of being too narrow-minded and judgmental about other faiths, a white American who finds racial and nationalistic prejudices obscene. He also works tirelessly against government-mandated vaccinations.

They are an extremely unconventional family, and their willingness to flout conventions makes a real impression on Romero. Of course, most important from Romero's current situation and point of view, Lisbeth Higgins's parents provide her with the economic independence to follow her passions.

She wants him as her new dance partner and has the means and willingness to pay him a regular wage in the beginning until she can get them in shape as a team with regular bookings. She is very much in charge and has a lot to teach Romero. He quits his job at the bank and never looks back, always remembering the immense satisfaction to be had from quitting a job you hate.

And though Romero Sr. may not like the way it looks—his son taking money from a rich young woman, Higgins pays more than Romero Jr.'s bank salary. There really is no choice. Yet Romero Jr. is gentle and unusually mindful for someone so young—he is sensitive enough to understand that this is not what his father has in mind for him, and he doesn't want his father to feel usurped or disrespected. So, he treads carefully in discussing the future—though his intention to make a life in show business quickly becomes resolute.

In his lifetime, Cesar Romero will never utter a negative word about his father in public, and it seems unlikely that he ever does in private either. He only says he loves him and is grateful to him for pulling enough money together to let him finish school. But the power shift that begins now is very real. Romero Sr. is at a very low mental state and is not really functioning. There are three other children at home that need to be clothed and fed. Maria is studying to be a teacher, so that will help, but Graciela and Eduardo are still very young. Romero Jr. is becoming the major support of his family at age twenty, and he is going to do it in whatever way he sees fit. He doesn't want to be questioned or held back.

This is how the boy born to riches and a future in business becomes a ballroom dancer taking money from women—like the gigolos he will play on-screen. In reality, it isn't like that at all. He works as hard as Lisbeth Higgins does, and why shouldn't he make a living doing it? But there is a perception, a stigma around a young man living on a rich socialite's money—and though Cesar Romero Jr. cares very much how his family feels, when it comes to the judgments of others about how he makes a living, he just doesn't care that much. Paradoxically, that's the freedom he feels from not having money. Life is exciting, and anything can happen. Photos of the period reveal a dashingly handsome Romero, elegantly dressed, and almost always smoking—holding a cigarette insouciantly between his long, finely shaped fingers. He will remain a heavy smoker for the next fifty years.

Romero and Higgins put together their routines in the early months of 1927 with great care, incorporating the waltz, tango, and rumba—and even throwing in some of the new jazz dances, like the Charleston and

the black bottom. This is an era of "musical entertainments," programs of afternoon and evening recitals and charity events that always have a few spots for specialty numbers, singers, dramatic readings, and good-looking, well-connected dance teams—and nightlife is thriving in clubs and hotels all over the city. They bill themselves as "Lisbeth and Romero, Aristocrats of the Dance." In their first month, they appear at the *Bal des Fileuses* (literally, and tongue in cheek, a dance for spinsters)—an annual tea dance for singles that she has initiated the year before at the Ritz-Carlton.

"Miss Lisbeth Higgins and her dancing partner, Cesar Romero, executed three very charming dances," writes the *Brooklyn Daily Eagle*, "displaying a great deal of grace and professional agility."

Not a bad start. One of their next engagements is as part of a new nightclub show at the Park Central Hotel roof. In a 1927 "Song and Dance" column, Charles Weller highly approves:

> On the sidelines, we hear the uncouth utterance that Miss Lisbeth Higgins is worth a million and a half and her people make the famous Higgins Ink. Let's watch her dance. She's a redhead, and we inquire in confidence, is she not adept? Her partner looks consumingly Spanish. They have the rapt attention of all the three hundred people present. They not only do a ballroom number, as you detect, but include in their repertoire a black bottom—is she not an *ink* debutante? Would *you* get a kick playing leapfrog with an heiress—as is Cesar Romero's lot? Here's the hit of the evening.

Later that year, director and choreographer Busby Berkeley hires the duo for a specialty dance number in *Lady Do* on Broadway. In the middle of their two-month run, they perform a tango for twelve thousand people at Madison Square Garden, including Mayor Jimmy Walker, in *The Thousand and One Knights and Ladies*, a Florenz Ziegfeld Jr.–influenced extravaganza that involves camels, oxen, donkeys, horses, troubadours, black bottom dancers, and Persian royalty. By August 1927, they are appearing nightly at the Park Central Hotel and are headliners of the Keith-Albee vaudeville for a week.

A life in banking or business seems very far away. He and Higgins dance together for a year and then for unknown reasons part ways. There is no evidence to suggest any falling out or animosity, and she happily shows up in the 1950s as a mystery guest from Romero's past on *This Is Your Life*.

Dancing on Air

Romero begins two years as an itinerant dancer with a number of different partners, and a full schedule of charity balls: the Black, White and Red Dance at the Ritz-Carlton under the auspices of the Washington Square Auxiliary, No. 7, of the Stony Wold Sanitorium, for "self-supporting young women afflicted with tuberculosis," where "during the supper hour there will be an entertainment by Cesar Romero and Margot Zolnay"; the Annual Rainbow Ball, where "Variegated Lights And Colors Will Mark Function In Aid Of Crippled Children with Cesar Romero and Margot Zolnay in specialty dances"; the New Year's Eve Ball, for rebuilding a Japanese school for women, Tsuda College, and "Cesar Romero burlesquing an old-fashioned waltz with Francesca Carey"; the February 2, 1928, Benefit for Alumnae Society of the Spence School at the Plaza Hotel, playing opposite Mrs. Frederick Hawkins in the leading role of *Irene*; Tea Dance to Aid Bide-a-Wee Pet Home, where "Florence and Cesar Romero danced."

"Florence" of "Florence and Cesar Romero" is just a misprint. He doesn't suddenly get married to a girl named Florence. Rather, it is Florence Koelker, another society girl turned pro, and a partnership that warrants six mentions in the *New York Times*. They dance a lot for tuberculosis and also appear together nightly at the Club St. Regis, opening the entertainment with "specialty dances."

The trouble is none of these jobs pays a lot. Romero dances again in Broadway revues where the money is much better, but none of the shows are hits, though *The Street Singer*, a 1929 Busby Berkeley production where he does adagio dances with Peggy Cornell, has a six-month run, which isn't bad. Then "Wall Street Lays an Egg" (in *Variety*-speak), and Romero Sr. loses what little is left of his savings and investments. Romero Jr. must make more money. *The Street Singer* has a short engagement in Atlantic City but does not go on a national tour.

He begins a new partnership with Nitza Vernille, "one of the most beautiful girls on the American stage whose eccentric dances are always bewildering," according to the *Atlantic City Gazette-Review*. She is from a family steeped in vaudeville shows and cabaret acts, and she becomes a fixture of New York's jazz entertainment scene. She and Romero appear together at various venues into 1930, including a trip to glamorous Miami at the Floridian as "Parisian Ballroom Dancers," with singer Marion Harris top billed in the revue *Jungle Night*, which promises "Bizarre Settings, Exotic Decorations, Favors, Fun, Souvenirs, and a Show of International Stars, featuring Food by Anthony Giacofci, Chef for United States Presidents and European

Potentates." Back in New York, they get a gig at Jimmy Kelly's The Montmartre, a popular Greenwich Village club, doing nightly appearances with an adagio-inspired tango. One night just after they go on, Romero lifts his partner horizontally atop his shoulders, her arms outstretched, toes pointing like arrows, and a biting pain stabs his side like a knife tearing into his tissue. He can't stand the agony and almost faints, but if she falls, he fears she might never walk again. He holds out for one more dip and then slides her off his shoulders. They finish their bows with him clutching his hand to his side. Backstage, he falls to the floor and passes out.

A doctor diagnoses a "strained appendix" (in Romero's words) and advises that although the danger of rupture isn't imminent, Romero does need to have the organ removed. But he can't afford to take time off, so for two weeks, the remainder of their contract, he ices up, grits his teeth, and performs through the pain. He has the operation, and his recovery is painful and difficult. He fears it spells the end of his professional dancing career. Certainly, his upper body seems incapable of sustaining full adagio numbers. He still dances a bit socially, to make connections—and to eat—but he is determined to break into legitimate theater. He could look at the injury as a tragedy—it certainly gives him pause—but he doesn't stay still thinking about it long enough for it to get him down. His bad luck becomes good luck as his efforts pay off, and he starts finding work on the legitimate stage, veering away from dance. He later turns the shift into part of his manly-man shtick, "Dancing is no good as a permanent career," he tells *Modern Screen*. "It's excellent training in carriage and poise, but too much of it effemizes a man. Not *actually*, but in the eyes of others it stamps him as a lightweight, just a dancing lady's partner. Dancing is a woman's game."

He looks for work and lives in cheap single-room-occupancy hotels and rooming houses. Often, he owes back rent and comes home after a pointless day of unprofitable waiting in agents' offices, tiptoes past the desk clerk or landlady or landlord, and puts his key in the door, and it won't work. He tries it again, examining the lock, looking around the hall to make sure he is on the right floor, and then it dawns on him. They've changed the lock on the door, and they are holding on to all of his clothes and possessions until he pays up. So, he takes to the street to hunt up somebody who might be able to let him sleep on the floor next to the radiator for a few days while he rustles up enough dough to get his clothes out of hock.

He works quite a lot in 1931, but often for little money in productions that do little to further his career. He appears in a short-lived revival of *Cobra* opposite Judith Anderson, playing a promiscuous Italian count, beleaguered by women in his native land, who escapes to New York but is soon embroiled in a new series of romantic entanglements with secretaries, husband hunters, and extortionists. He costars in the Broadway-bound production of *Stella Brady* that closes out of town, playing the Cuban love interest of a girl on the lam with a bag of hot loot. He joins the cast of the Broadway-bound production of *All Points West* that also closes out of town, playing a minor role in a story about a society boy who elopes with a showgirl. And in the short-lived Broadway revival of *Ladies of Creation*, he plays a minor character in a story about a fashionable interior decorator's attempt to mix love with business.

Every so often, he is approached by movie scouts who offer screen tests. It is a regular occurrence, no different than any other audition, and a movie career isn't really on his radar. Besides, nothing ever comes of them.

During the Broadway run of *Ladies of Creation*, when it is clear that the play will soon close, he lands the third lead opposite Lenore Ulric in *The Social Register* by Anita Loos and John Emerson. He rehearses the new show by day while appearing in *Ladies of Creation* at night and being excused from rehearsals for matinees.

The Social Register is an adaptation of the story *Gentlemen Marry Brunettes* (the follow-up to *Gentlemen Prefer Blondes*), about a warmhearted (brunette) gold digger trapped between a wealthy young man she loves whose parents disapprove and a sexy saxophonist (Romero) bribed by the rich boy's mother to lure her away from her son. It opens on Broadway in late 1931 to tepid reviews (the *New York Times* doesn't even mention Romero by name) and middling business in a theater season hit hard by the increasingly disastrous financial climate. Calling it "The Depression" doesn't happen until 1934. The play goes on tour for a couple of months into 1932 and plays in Washington, DC, to decent houses, but it is not considered a success.

Once back in New York, Romero lives in a Hell's Kitchen rooming house with George Murphy, the fellow ballroom dancer who will follow Romero to Hollywood and dub him "Butch," and with the struggling writer John O'Hara, later of *Butterfield 8* and *Appointment in Samarra* fame. A decade later, in a Letter from Hollywood piece in the *New York Evening*

Journal, O'Hara tells a cheeky story that Romero confirms is essentially factual about how he gets his "big break" later in that year.

"Cesar Romero and the Three Dollar Bills." I'm sitting in the Trocadero the other night . . . and over to our table come two personable young persons. One was Miss Betty Furness, and the other Cesar Romero. . . . Well, right off the bat, Cesar said, "I'll never forget, John, the first time I ever wore a top hat was that time I borrowed yours." "Yes," I said, "and I still owe you three bucks from those days." Whereupon, with the flourish which I trust was not lost upon the young ladies present, I handed over three crisp new one-dollar bills.

There is not much plot in the story of how I happen to owe Cesar three bucks for, oh, seven years, but there is a background. Long ago, but not so long ago that I can forget it, I lived in a rooming house on West 43rd Third Street, New York. It was supposed to be for men only. A room with running water costs $9. As I cannot sleep in a room where there is running water, I lived in a $6 room. Cesar paid $9 at that time. I was living hand and sometimes to mouth by writing little pieces for magazines. Cesar was Connected With the Theatre. That is, he was doing break-in time in vaudeville. Occasionally he got a job in a nightclub, but not often enough to suit me. I liked it when Cesar had jobs, because then he and a friend of his named Campbell and your reporter would be sure of eating—if Cesar got paid.

So, we were all skipping the gutter, but Cesar and Campbell were doing it right. The moment they left our rooming house you never would suspect that they lived there. Their clothes always looked as though they were on their way to have lunch with the admissions committee of the Racquet Club. And at night there was always openings to be seen at, and balls and deb parties. The way they got to the openings and dances—that was Campbell's genius. He read the papers like a taxi driver, paying careful attention to What's Going On Tonight. There was not a hotel ballroom that he did not know his way into.

It was along about this time that Cesar one night borrowed my fold-opera hat. The hat was a Christmas gift from an attractive young woman from Babylon [Long Island] and I valued it highly.

Then right after that, instead of putting the arm on Mr. Romero for a deuce, I swung a loan of three flags.

I [forget], what ball they crashed that night, but it was at the Plaza, and they entered just behind the orchestra and ran into Maurey H. B. Paul who in public life is Cholly Knickerbocker [noted society columnist with the *New York American*]. "You're just the man I'm looking for," said Mr. Paul.

"Caught!" thought Cesar.

"I know where there's a job for you," continued Mr. Paul. He then told Cesar of a job that could be had by seeing A. J. Drexel Biddle. So Cesar went to see Mr. Biddle and got his first big break. Cesar took up new quarters before I could pay him back, and it wasn't until the other night at the Troc that I had a chance to square the debt.

Now, the payoff, or funny twist, to this prolonged anecdote, is that one of the other alumni of that West 43rd Street rooming house was also in the Trocadero that night, and by an odd coincidence, he owes me $3 from those days. I am sure W-ld-n H-yb-rn [actor Weldon Heyburn] would not like me to mention his name in print in this connection, so I will not mention it, but Jane Eichelberger, the socialite who married him, will know who I mean. And there was a fourth alumnus present, Cary Grant, but he doesn't owe me any money.

As I read this piece over, I find that it is remarkable if only for one reason: I did not once say anything about rendering to Cesar . . .

Anthony Joseph Drexel Biddle Jr., of the Philadelphia Biddles and future ambassador to many nations, is the sort of society swell connection that Romero is always hoping will lead to bigger and better things. And it does—just like in the movies. Romero's life doesn't exactly change overnight, but it is the start of everything, because Biddle is a pal of producer Brock Pemberton (a name that sounds straight out of *42nd Street*), whose production of the Preston Sturges comedy *Strictly Dishonorable*, an honest-to-God hit on Broadway with a run of 557 performances, is about to go on tour—*but the actor playing one of the three lead roles has just quit!*

The character is Count di Ruvo, a devastatingly handsome opera star and lothario.

The show and the character are instructive. They embody the dramatic and comedic elements that will be key to Romero's career—even in terms of the antihero pleasure he will embody as the Joker. (Romero plays the show for a couple of years off and on and revives it thirty years later in stock and dinner theater, playing the same role.) The conventional expectation of the story is that Romero is ostensibly the bad guy, but all along he is actually the one the audience roots for. That bad-guy-as-good-guy gestalt becomes Romero's bread and butter.

The plot outline of *Strictly Dishonorable* is the stuff of romantic melodrama: A southern girl from the sticks with an all-American hero fiancé is forced by incongruous circumstances into a potentially compromising situation (gasp, the dreaded, avoided-at-all-costs act of *sex*) with a dashing but dastardly (foreign) villain. The hero rescues her in the nick of time, and her virtue intact, the heroine collapses tearfully in the hero's arms.

Except that isn't how it goes down.

Preston Sturges is a gleefully subversive writer who goes on to have a phenomenally successful run in Hollywood—that coincidentally ends with a box office bomb in 1949 called *The Beautiful Blonde from Bashful Bend*, starring Cesar Romero, among others—and his take on virtue and its rewards is decidedly nontraditional.

He upends expectations immediately.

Set in a New York speakeasy and the apartment above it, it features a young hero who describes the Italian who runs the place and the opera singer (Romero) who lives above it as "wops," "dagos," and "greasers." Even in 1931, this is not endearing to a New York audience and serves to brand the hero as suspect. The heroine, a seemingly naive belle, also proves herself initially insensitive and narrow-minded, musing about her Mississippi upbringing, "I love to hear darkies sing 'em at night. Funny People! Don't have a thing . . . never did have anything . . . never will have anything. And just as happy."

Count di Ruvo is supposedly the bad guy who conspires to lure the heroine to spend the night upstairs when, for a variety of complicated plot reasons, she is left alone at the speakeasy. There's a lot of dancing around the will-they-or-won't-they "shocking" narrative (even reviewers at the time find it not as shocking as billed), and in the end, Count di Ruvo acts like a gentleman and falls sincerely in love with the girl—who loves him right back—and although she comes perilously close to staying with the simp,

she changes her mind in the final scene, and the happy couple contemplate a future where she and a bunch of their babies follow di Ruvo all over the world on his opera gigs. The end.

The tour travels to Pennsylvania, Michigan, Virginia, North Carolina, Tennessee, and Louisiana, among other places. It is Romero's first tour of any size and his first time seeing this much of the country outside the tri-state area of New York, New Jersey, and Connecticut. He has a blast. He can wire funds home regularly and still have pocket money to spare. He gets on well with his castmates, and his notices are terrific. In a Tulane, Louisiana, review: "Cesar Romero is handsome enough to win any girl's attention, if not her heart, but despite his movie type of beauty, he is a most persuading actor in a part that called for all the fireworks of the Latin in love and the temperament of the opera star. We doubt if you will ever see a more handsome leading man or one more wholesomely sure of himself."

A longer think piece about Romero appears in a clipping from an unidentified "Philadelphia Pictorial" in a column called "Gossip by Jeff."

> Since Caesar Romero provided a host of life hungry women a new, tangible haven for the cravings of their tired hearts by his anatomical attractiveness and histrionic accomplishments as the flashing eyed, romantic, and dashing libidinous Italian singer in *Strictly Dishonorable* at the Broad Street Theatre, the old credo, which reached its peak during the meteoric career of Rudolph Valentino—that all Italians are passionate lovers, improvements on Adonis, and generally sizzling papas—is being revived with a vengeance. And if anyone dares to doubt in the least the authenticity of this notion, its proponents look at the poor simpleton with an ill-concealed glint of pity in their eyes and point to Romero as positive proof of all contentions in this direction. . . . And the funniest part of it all is that Caesar Romero, for whom all of the shouting is set up, is not an Italian at all, although he plays the role of one, but is a Cuban instead.

When future film and stage star Margaret Sullavan joins the tour opposite Romero, Dolly Dalrymple in the *Birmingham News* is even more baroque: "A high brow, remarkable eyes, a tiny little close clipped moustache which is so tender and so young that one almost feels sorry for it. A

most attractive mouth, which is expressive and very fickle. A lean, clean-cut face with fine olive skin and ruddy cheeks, a typical Spaniard with a very close resemblance to the late Rudolph Valentino, with all the grace and suavity with which the Spaniard is endowed, a real matinee idol if you please."

A lot of the press coverage is like that—admiring but also bizarre, unpleasant even, in its objectivization of Romero as beautiful yet exotically "other." In many interviews, Romero makes a point of how "normal," how "All-American" he is, with an "aw, shucks" sense of his own boy-next-door realness. But most if not all of his press coverage in this era focuses on his physical beauty and how magnetically attractive he is to the opposite sex.

There are a lot of comings and goings to parties and openings with beautiful women. Sometimes, as will be the case with showing up for film premieres, the point is to arrive and be photographed. Often, he doesn't stay long—there's always another side hustle—a dance job, another event, another beautiful woman. It makes him feel alive—and it encourages him to believe he can make a real go of this career and keep making enough to keep his family comfortable. His self-confidence is further boosted when he lands the pre-Broadway tour and Broadway premiere production of *Dinner at Eight* at the end of 1932.

The ribald comedy of manners by George S. Kaufman and Edna Ferber, about a couple in financial trouble who invite a disreputable pack of prominent snobs, reprobates, and wannabes to a dinner party, is a giant hit. The movie adaptation made the next year starring Wallace Beery, Marie Dressler, Jean Harlow, Billie Burke, and the two Barrymores, John and Lionel, is also a huge success.

Romero has a showy role as the family's roguish chauffeur—"a tall, saturnine Italian; slim, graceful and a little sinister"—who gets into a knockdown-drag-out with the butler over a comely maid. The character is a complete cad. He doesn't just punch out the butler; he assaults the maid as well. But the audience loves him, regularly cheering Romero on in his misbehavior.

While he is still in *Dinner at Eight*, another one of those movie scouts approaches, this time with the offer of a job rather than just a screen test. It's the part of a mostly silent mobster's henchman in a low-budget independent comedy-mystery called *The Shadow Laughs* starring vaudeville, burlesque, and medicine show veteran Hal Skelly. (The medicine shows were early in his career. In between vaudeville acts, he would peddle miracle cures.) It is not an auspicious beginning. Uncredited, this is the only time in his long

screen career when his performance is awkward and unmemorable. He never talks publicly about the experience, and the film is dropped from his credits for decades. It does not appear to be a lightning-bolt moment of recognizing his future.

Dinner at Eight runs for 232 performances; then Romero heads into the 1933 spring run in Philadelphia and summer run in Chicago. Returning to New York, he lands the tour of *Ten Minute Alibi*, a turgid story of a hero who saves a young woman's honor by murdering the man who wants to whisk her away to Paris and destroy her life and reputation. The villain who deserves to die is the sin-stained Philip Sevilla, a suave seducer and consummate rascal, played by Romero, who still has gushing admirers—even as a character who toys with a young girl's pure affection and, when he is done with her, might send her to rot in the lurid brothels of South America.

Marion A. Green writes in the *Louisville Times*, "Cesar Romero, an actor new to Kansas City, but one who has a very real reputation in New York, plays the cad perfectly, and we'll have any number of matinee girls looking him over with a calculating eye this week, and deciding that life in Paris with a man such as that wouldn't be so bad."

He also gets raves in the *Kansas City Times, Indianapolis Times, Indianapolis Sunday Star, Indianapolis News, Louisville Courier-Journal, Louisville Herald-Post, St. Louis Daily Globe-Democrat, Cincinnati Post, Queens Island News*, and *New York Herald-Tribune*.

When the tour is over, he returns to New York and plays the closing weeks of the short Broadway run of *Spring in Autumn*, to replace the very Anglo Kent Smith playing the very Spanish character of Juan Manuel Lorenzana in a cast that includes the young James Stewart and legendary stage star Blanche Yurka—in a role where she gets to sing a Puccini aria while standing on her head.

It doesn't seem life changing when a casting director from MGM named Ben Piazza approaches with an offer of a screen test. He is one of many studio employees regularly scouting Broadway for new talent. He remembers Romero from one of his flops the year before, and something is coming up that he thinks Romero might be right for: a supporting part as a gigolo (what else?) who is also a murder suspect. Romero tests. No records survive of who sees the test, but he gets the job.

It is *The Thin Man*. Romero is tenth billed, behind William Powell, Myrna Loy, Maureen O'Sullivan, Nat Pendleton, Minna Gombell, Porter Hall, Henry Wadsworth, William Henry, and Harold Huber. Though it is

only Cesar Romero's second film appearance, his performance as a potential suspect, the gold-digging husband to the gold-digging former wife of the murder victim, is worlds away from his awkward debut in *The Shadow Laughs*.

During shooting, he watches his new costars and learns. Minna Gombell, the frenetic money-grubbing ex-wife of the dead Thin Man himself, plays her scenes with Romero at full tilt, using the fluttery, hyped-up mid-Atlantic speech pattern that Billie Burke employs so memorably (in the film version of *Dinner at Eight*, among many others). Gombell is showy, larger than life. Given little character advice by his brusque, efficient director, W. S. Van Dyke, whose nickname is "One-Take Woody," Romero punts—underplaying, thereby providing balance. This has the effect of leaving open the (dashed) possibility that his character might have actual affection for Gombell, rather than just seeing her as a meal ticket, which in turn brings interesting shading to seeing his character as a murder suspect. This is not to imply his role is at the center of the action or that his impact is in any way extraordinary. Even the dog Asta gets more attention than he does. Actually, *especially* Asta, who becomes a film favorite in his own right.

The Thin Man is released in theaters just twenty-eight days after shooting wraps. When Romero sees the film at the premiere, his heart sinks. He does not admire his own performance, telling his mother, "If my career depends on this picture, I'm through now." But his mother encourages him to believe in himself, and he gets a shout-out from Blanc Johnson in the *Los Angeles Daily Mirror*: "Miss Loy wears an interesting wardrobe with her usual dash and reveals herself to be a spirited light comedienne. Powell plays the detective with relish and exuberance. Their fine support includes Maureen O'Sullivan, Nat Pendleton, Minna Gombell, and Cesar Romero." Coming in at the end of a list of actors providing "fine support" to William Powell and Myrna Loy may not be showy praise, but it is praise all the same.

Categorized as a relatively inexpensive "B" picture (though Louis B. Mayer insists that no MGM picture is a "B" picture) and shot over a nineteen-day period, with a couple of days of retakes, *The Thin Man* becomes one of the biggest hits of 1934. Harrison Carroll, in the *Los Angeles Herald Express*, calls it "one of the cleverest adaptations of a popular novel that Hollywood has ever turned out," and Louella Parsons in the *Los Angeles Examiner* is equally complimentary. "The greatest entertainment, the most fun and the best mystery-drama of the year."

The Thin Man begets five film sequels from 1936 to 1947, a radio series from 1941 to 1950, a television series from 1957 to 1959, and a television movie adaptation in 1975. An expensive stage musical adaptation bombs and closes after only nine performances on Broadway in 1991, and other regional nonmusical adaptations are staged in 2009 and 2018. A feature film remake is announced in 2011, set to star Johnny Depp and to be directed by Rob Marshall, but it is never made. Currently, Brad Pitt's and Margot Robbie's production companies are in talks. Whether the film is made and whether Pitt and Robbie star as the sleuthing duo are anybody's guess.

That Cesar Romero is part of a project with this much staying power feels entirely correct.

2

Most Eligible Bachelor

The boiling frog theory holds that if a frog is put suddenly into scalding water, it will jump out, but if the frog is put into room-temperature water that is then brought slowly to a boil, it will not understand that it is in danger and will be cooked to death. The story is often used as a metaphor to warn of sinister threats that may arise slowly rather than abruptly. It also applies to two situations facing Cesar Romero in 1934: the Great Depression and, more personally, his decision to head west to try his luck in Hollywood.

The true perils of both situations are not necessarily evident to him immediately, making it possible for him to proceed without completely understanding how much he is putting himself and his family at risk. Years later, he marvels at his own naivete, arriving and taking a room at the Hollywood Athletic Club with just the clothes on his back, and, as he often says in interviews, "just $140 in borrowed cash." What if the MGM contract in his pocket had not led to other things? What if he had failed his family?

Jump back a few years in the Romero story to another jumping-out-of-already-boiling-water moment—the stock market crash itself. Hundreds of wealthy men made paupers overnight jump out of buildings, escaping the boiling water of poverty. That the number of jumpers is actually somewhere between two and eleven and that the death part of the equation switches from jumping to safety to jumping to oblivion need not necessarily spoil the comparison.

But no one in the Romero family jumps anywhere when panic hits the stock market like a tsunami. They have already been in boiling financial circumstances for nine years. By 1934, they are old hands at it. His parents are excited rather than worried about his career shift. His sister Maria Romero is working as a teacher now. So, he is not the sole support of the family, though his steady contributions continue, and bunking at the Athletic Club is relatively cheap.

Turn the metaphor back around again, and it even applies to the Joker. In his origin story, he jumps out of poisonous chemicals in time to save his life—though not before the chemicals turn his hair green and his skin a ghoulish white.

All this talk of jumping in and out of danger illustrates the fact that the Hollywood Cesar Romero encounters in 1934 is very different than it was a few years before and very different from what it will soon become. The merger that creates 20th Century Fox (a fascinating tale of its own) hasn't even happened yet. Romero arrives at a town and an industry in transition, and his Broadway prototype—the suavely handsome foreign gigolo who sweeps women off their feet—is on a wane that began soon after the crash and is now in a steep decline. Ramon Novarro is on his way out, and true leading-man stardom eludes Gilbert Roland and Ricardo Cortez (né Jacob Krantz—he is considered rather swarthy, but in the peculiar idiosyncrasies of the era's often racist compartmentalization of "the other," Jewishness is not considered a sexy foreign quality). Cortez's purported origins run in an interesting parallel to Romero's eclectic ethnicity. When the fact that he is not Latin becomes public, studio publicists try to pass him off as French before a final Viennese origin story becomes canon.

Part of the reason for the decline in popularity of the Latin lover is the Great Depression. It is still about five months before the term *Great Depression* catches on with capitalization due to the publication of *The Great Depression* by Lionel Robbins. This is mentioned not as a pedantic flourish but to underscore how fluid history is when you are living it. And with more able-bodied men on breadlines, the general mood in motion pictures favors the promotion of healthy, strong, empowered red-blooded American manly men over exotic beauties like good-for-nothing Latin lovers. There is also a backlash against dramatizing even vaguely positive portrayals of male effeminacy or of homosexuality at all. This is partly out of a sense of the need to cater to newly fragile male egos facing very real difficulties and partly because of the Production Code coming into effect in fits and starts.

Romero is forthright about talking to friends and the press about wanting to escape the stereotype, seeing it as a career trap, and in terms of masculinity, he cannot help being aware of the suspicion and hostility directed toward gay men in the early 1930s after a time of loosening constraints, especially in New York in the 1920s, when he is coming into adulthood. It doesn't require any big shift in his public behavior—he has always been private about his private life—but it seems possible that the change in the wind

increases his own desire to butch it up and eschew exoticism and high-society airs.

Or so he hopes. While *The Thin Man* is wrapping up, Romero is already on loan-out from MGM, shooting *British Agent* at First National (the studio that is later folded into Warner Bros.). The *Los Angeles Examiner* hails his arrival: "Caesar [sic] Romero, Eastern Actor, Cast in 'Thin Man'—Caesar Romero, a recent arrival in pictures from the New York stage, has been given the important role of Jorgensen in the Cosmopolitan production, *The Thin Man*, which begins production next week at Metro-Goldwyn-Mayer studios. [Note: The film has already wrapped.] Romero is a juvenile player with a colorful stage background and has just been signed for a long-term M-G-M contract." It is a four-month agreement with a one-sided option for the studio to drop him at any time.

In *British Agent*, Leslie Howard plays the titular envoy to the newly forming Bolshevik government in Russia. He gets an impossible secret assignment that proves sticky when he falls in love with Bolshevik spy Kay Francis. Cesar Romero is an Italian diplomat who sits around in evening clothes, looking devilishly handsome while playing cards with other foreign diplomats. In other words, a variation on the Latin lover. When things turn serious and Howard is in danger, Romero is called upon to be believably courageous and stalwart, and his selflessness comes across as understated and genuine.

The filming experience is the polar opposite of *The Thin Man*. *British Agent* has a relatively large budget and is a pet project of Jack Warner's. Forty-one sets are constructed. If you count extras, there are fifteen hundred in the cast. While filming the riot scenes, three thousand rounds of ammunition are shot. Warner even tries to send a film crew to Russia for location shots, but Stalin's government denies the request. It is a chaotic atmosphere, complicated by Kay Francis attempting suicide during production. She wears gloves in certain scenes to hide the deep scars on her wrists. The reason for her attempt remains a mystery, and it is unclear whether Romero is aware of the situation. What is clear is that he gets a taste of a very different kind of film shoot than on his first Hollywood movie.

The character calls upon Romero's well-seasoned skill at playing foreign charmers, and while he gets relatively little screen time, his transition from fop to a man of courage is actually key to the transition the film makes, from spy-tinged romance to something with more epic aspirations, and it fits the tougher image Romero hopes to project. He handles the transition

well, and while some reviews ding the other actors playing foreign diplomats for their wobbly accents, they single out Romero's for its perceived authenticity—though to modern ears his Italian accent is just as inconsistent and nonspecific as most attempts at foreign accents are in the period.

A few of Romero's friends from New York are also in Hollywood, including former *Strictly Dishonorable* costar Margaret Sullavan, who proves very helpful, introducing him around and recommending him to producers. And George Murphy is also there, shooting *Kid Millions* at United Artists along with Broadway transplants (and other Romero acquaintances) Eddie Cantor and Ethel Merman. Romero dons his trusty evening jacket for nights at the Cocoanut Grove and the newly opened Café Trocadero, a nightspot owned by Billy Wilkerson, the publisher of *Variety*'s competitor, the *Hollywood Reporter*. Romero quickly becomes a favorite dance partner to the glamorous stars and starlets in attendance, and his popularity at the Trocadero pays dividends with at least six mentions in Wilkerson's "Rambling Reporter" column in his first few months.

Early on he meets Joan Crawford. They become fast friends and frequent nightclub dance partners. Crawford is drawn to Romero by their shared love of dancing and her affinity for gay male companions where the sexual component is generally off the table, leaving her free to arrive with Romero and leave on the down-low with someone else, like the married Clark Gable. This also leaves Romero free for other companionship after the dance. He fits in easily, having arrived in Hollywood more fully formed than many new contract players who, like Crawford did herself, show up as somewhat blank slates that the studios mold into personalities. Romero already has great style, good friends, and the well-practiced ability to charm social and business elites.

He makes a friend who will prove vastly important, Darryl F. Zanuck, often dancing with his wife, former actress Virginia Fox, at various functions and becoming a reliable fourth for card games. (That her professional last name was once Fox is coincidental to the formation of the Fox Studios and its part in the merger that gives birth to 20th Century Fox in 1935.)

Meanwhile, after the heady rush of shooting two films at the same time, Romero is suddenly idle when *British Agent* wraps in May, and he doesn't start a new picture until early September. Accounts differ on whether MGM drops him even before his option comes up or whether they allow him to test for *Cheating Cheaters* at Universal thinking of it as a loan-out possibility. Universal negotiates with MGM to take him off their hands. So, it's

either a potential tragedy saved by a successful screen test or an encouraging but nerve-racking bump in the road when he switches studios, wiring his mother:

> WESTERN UNION 1934 JUN 16 PM 6 45
> MRS CESAR J ROMERO=
> 1119 SUNSET AVE, ASBURY PARK NJ=
> HAVE SIGNED LONG TERM CONTRACT WITH
> UNIVERSAL FIRST OPTION SIX MONTHS WRITING LOVE =
> CESAR.

It is a long, anxious summer before he is in front of the cameras again. Being on salary the whole time certainly balms the wound of things not going as hoped at MGM, but his new contract doesn't feel secure because Universal doesn't really know what to do with him either. He shoots *Cheating Cheaters*, playing an affable jewel thief who goes legit for love, and *Strange Wives* as a first-generation charmer of a Russian émigré, and has a tiny role as a stage-door johnny in *The Good Fairy* with Margaret Sullavan in the lead.

Then it seems the main chance arrives.

Director Josef von Sternberg sends for him to try out for the role of one of Marlene Dietrich's two leading men in *The Devil Is a Woman*, as the young Latin lover almost destroyed by the sheer evil of her love (as opposed to the other lead role, the old Latin lover almost similarly destroyed). At Romero's test, eccentric, exacting director Josef von Sternberg tells him on the spot, without even screening the footage, that he has the part. This is a huge deal. Dietrich is a full-fledged movie star, and her pictures are glossy extravaganzas that get extremely wide press attention. From the start of production in October 1934 to its release in March 1935, a feeding frenzy builds.

Here he is, resolutely trying to avoid a waning stereotype, once again being compared to Valentino, who has been dead for eight years. Romero is acutely aware of the power that his own exuberant press coverage had in his rise in the theater from unemployed hoofer to—if not the "star" sometimes referred to in fan magazines—certainly the miraculous level of a working actor supporting himself and a family on his earnings. Never mind the facts: "New Latin Lover Stirs Hollywood," but "He's big enough to look like a real he-man," "Romero Headed for Stardom," and "Hail, Cesar!" The last headline is from *Photoplay*, the rest from other unidentified fan magazines.

Most Eligible Bachelor

Paramount fans the flames with sensual photos of a bare-chested Romero, all moody cheekbones and soft lips. A regular update in the "Fan Mag Drop" of the *Hollywood Reporter* cites these circulation numbers: *Modern Screen*, 556,421; *Photoplay*, 461,842; *Motion Picture*, 456,002; *Picture Play*, 341,218; and *Screen Play*, 211,132. Romero is featured in all of them. Variously, he is Spanish, Italian, Cuban-born, Latin, and Cuban American. There is often a punny use of "Romeo" substituting for "Romero" in headlines and stories. And his resemblance to Rudolph Valentino is commented upon endlessly, to which Romero endlessly responds with humble assurances that he can never compare to the great man and does not, in fact, wish to be.

But it's not just the fan magazines trumpeting his foreign he-man appeal. Untroubled by her own inaccuracies, Louella Parsons in the *Los Angeles Examiner* writes: "Cesar Romero is one of the finest Italian leading men in Hollywood. Remember, Romero first came into prominence when he played the part of the speakeasy owner in *Strictly Dishonorable* on the stage." (Note: Romero is not Italian, and he played the opera singer, not the speakeasy owner.)

Lloyd Pantages in his "I Cover Hollywood" column in the *Washington Times* claims: "It will probably intrigue you to know that after Cesar Romero washes his hair, he cannot tip his hat for at least four hours on account of it is SO long, silky and unruly, it would frighten even the little children if he did."

Henry Carr's commentary in his "The Lancer" column in the *Los Angeles Times* today seems culturally insensitive at best, if not breathtakingly racist: "This Cuban boy Cesar Romero—Hollywood's newest sensation. He is a very interesting fellow. He laughs when he sees Hollywood's version of the Rhumba. He says the real dance of the jungle Negroes is indecent beyond description. The Rhumba is a mixture of old folk music brought from Europe by the first adventurers, pirate sea chanteys and songs from the jungles of Africa."

Romero's scrapbooks contain Luce's Press Clipping Bureau articles from the *Toledo Press, New York Sun, Film Daily, Rochester American, Portland News, New York Post, Atlanta Georgian, Detroit Free Press, New York Telegraph, Hollywood Citizen-News, Philadelphia Evening Public Ledger, New York Sunday Mirror,* and *Chicago Herald Examiner.*

After he has assiduously avoided the Latin lover tag in his first months in town, now it defines Romero again, just as it did in his stage years. And what does a Latin lover need to complete the image? A beautiful woman.

The following is only a partial list of the candidates said to be in the running by various publications, in alphabetical order:

Muriel Angelus, Lynn Bari, Binnie Barnes, Ina Bauer, Constance Bennett, Tala Birell, Sally Blane, Virginia Bruce, Iris Bynum, Jean Chatburn, Joan Crawford, Laraine Day, Emily Denne, Marlene Dietrich, Frances Drake, Steffi Duna, Sally Eilers, Patricia Ellis, Lucile Fairbanks, Betty Furness, Lynn Gilbert, Marian Harris Jr., Sonja Henie, Nancy Kelly, Carole Landis, Barbara Lawrence, Carole Lombard, Ethel Merman, Ann Miller, Eleanor Powell, Ann Rutherford, Ann Sheridan, Dinah Shore, Barbara Stanwyck, Gene Tierney, June Travis, Claire Trevor, Lana Turner, Venita Varden, Arleen Whelan, Cobina Wright Jr., Jane Wyman, and Loretta Young.

To be fair, all these women are not specifically named in his 1934–1935 buildup for *The Devil Is a Woman*. But grouping them together in one lump is irresistible.

As all-consuming as the press attention is for Romero on *The Devil Is a Woman*, the film is not his only focus nor the only subject of his press attention. While he shoots his scenes with Dietrich, he hustles back to Universal for *Strange Wives* and *The Good Fairy*, which are shooting simultaneously, and as *The Devil Is a Woman* wraps at the beginning of 1935, he starts shooting *Hold 'Em Yale* at Paramount, and *Clive of India* and *Cardinal Richelieu*, which will be released by the newly christened 20th Century Fox once the corporate dust settles.

He likes working with Dietrich, and they will remain friendly throughout their lives. It's not just press puffery when he talks about being surprised by her down-to-earth nature off-screen.

"Naturally I had expected that Marlene might be a little grand, and I was rather nervous about playing with her," he tells Katherine T. Von Blon in the *Los Angeles Times* in 1935. "After all, she is a great star. But I was completely disarmed. She was as naïve and sweet as an ingenue, and simply marvelous to work with. I remember one day we were coming through the commissary, and three older women, bit players, were coming out. They stood aside to allow Marlene to pass, while she waited. They said, 'But we wish to stand aside for the great star.' Marlene had her way, and they went out first, while she waited. Then she turned to me, saying, 'What is it to be a star? I do not know.'"

He does not speak of Josef von Sternberg with the same affection, calling him "a mean little man, a little Napoleon" who treats Dietrich like an object and yells often. The attention to detail both von Sternberg and

Dietrich bring to the party is razor-focused on how she looks: the lighting, the makeup, her wigs, her costumes. On a prior film, *The Scarlet Empress*, as Catherine the Great, she has a scene where she seductively contemplates tight-trousered soldiers standing in rows. She is wearing an impressive pair of gloves and swans around like a dominatrix. The gloves take twenty minutes to put on because they have been sewn on plaster casts of Dietrich's hands, leaving no room for puckering or wrinkling. They are perfect.

That same level of detail is evident every day on set, as minor adjustments of lights go on seemingly for hours. Romero is grateful to have the chance and loves Dietrich. But the work is also boring, with little in the way of new acting challenges—apart from well-publicized tales of von Sternberg cuing him to kiss for precisely forty feet of film (doubtful, since that is over ninety seconds, an eternity in screen time).

Hold 'Em Yale is more of a romp. He plays Georgie the Chaser, a suave gigolo and all-around no-goodnik in league with a bunch of small-time crooks. In an extremely complicated plot (that's also very funny) involving criminal intent at the Harvard-Yale game and Romero chasing a dizzy heiress, the crooks get most of the laughs, and Romero's character takes a mysterious powder in the third act, never to return.

Cardinal Richelieu is a more delicate affair. He is condemned to death, falls in love, switches political and religious allegiances at the drop of a hat, and helps fool everyone into thinking George Arliss is dead—all for the glory of a united France and the love of Arliss's ward, Maureen O'Sullivan. Somehow, Romero makes all this seem believable and touching rather than ridiculous, but press attention veers to the latter. "Cesar Romero will tell anyone who asks him that heavy epaulets on a uniform are a burden," writes Louella Parsons in her column. "Young Romero, who has a part in *Cardinal Richelieu* opposite George Arliss, had to have a minor operation on his shoulder as a result of wearing heavy epaulets. P.S. In case any of his many female admirers want to send flowers, he is convalescing at the home of Mr. and Mrs. George Murphy."

Epaulets aside, Romero loves working with George Arliss on *Cardinal Richelieu* and finds the legendary star of stage and film to be an inspiring mentor, admiring his calm certainty and careful preparation. The long wig and florid dialogue are a bit of a challenge, but he acquits himself well. The other Fox film, *Clive of India*, provides his first chance to play a stereotype that will pop up again and again: the foreign chieftain, usually wearing some variation of a turban or headscarf—and it is the first role in the string

of "exotics" Romero will play throughout his career. His Cuban heritage apparently qualifies him as Indian, Arab, French, Mexican, German, Spanish, Brazilian, Portuguese, Greek, British, and Italian, as well as Cuban. His accents may not always be entirely convincing, but his humanity is never in doubt, giving these portrayals a sense of nuance that frequently elevates his depictions of non-Anglo cultures.

He brings a welcome bit of emotional legitimacy to the cultural tropes of *Clive of India*. As a fierce rival to the king of Northern India, Romero is "shifty" enough for us to believe he would sell out the king and make a deal with Ronald Colman (as Clive of India), yet Romero remains likable enough for us to believe he is doing it for the greater good of both India and Great Britain—though the historical accuracy of the story does not bear close examination. *Variety* notes that "performances are consistently fine, notably Mischa Auer as the tyrannical native ruler, and Cesar Romero as the ambitious but friendly-to-Britain rival maharajah who double-crosses Auer."

He continues making friends and dancing at the Trocadero and the Grove. One night, George Murphy points in a circle around a table of drunken friends and bestows their nicknames. The exact night is lost to history, and all anyone remembers about most of the names is that as Romero is often quoted as saying, they are generally ironic. Someone heavy is Slim. Someone skinny is Fats. Murphy dubs the debonair Romero with his forever nickname: Butch. How deep the irony goes is unknowable, whether it's a joke on Romero's urbanity alone or whether it extends further. There is a fan magazine photo that tends to make me think it is not a reference to Romero's sexuality.

It is a picture set on a crowded dance floor of George Murphy with a woman's fur draped over his shoulders and Cesar Romero holding him tightly in an embrace from behind. The headline is: "There's so many willing to be his wife!" The caption reads: "George Murphy and Cesar Romero put on a burlesque of interpretive dance. What they're interpreting is hard to say, maybe how to catch a fox!" Two things seem clear: their affection for one another is sweet and genuine, and they are joyfully exhibiting themselves for all to see. If "Butch" is meant as some coded reference to homosexuality, neither man might feel comfortable mugging for the camera like this.

Most Eligible Bachelor

In March 1935, almost a year after his arrival in Hollywood, *The Devil Is a Woman* opens to great fanfare. The ads and posters are marvelous—images of Dietrich embracing Romero with ad copy like "Share My Lips and I'll Break Your Heart," "I Know Twenty Ways to Say, 'I Love You!' . . . and They're All Alluring Lies," and "For Every Kiss I Gave You . . . I Had a Laugh with Another Man!" And the reviews are largely very positive. Romero knows it's a lot of hokum, but he has every reason to believe he has definitely arrived.

Beatrice Mathieu, *New Yorker*: "[Dietrich's] finest American picture . . . a theme as moving as *Of Human Bondage*."

Andre Sennwald, *New York Times*: "Having composed one of the most sophisticated films ever produced in America, [Josef von Sternberg] makes it inevitable that it will be misunderstood and disliked by nine-tenths of the normal motion picture public. The uninformed will be bored by *The Devil Is a Woman*. The cultivated filmgoer will be delighted by the sly urbanity which is implicit in Mr. von Sternberg's direction, as well as excited by the striking beauty of his settings and photography."

Cecelia Ager, *Daily Variety*: "Not even Garbo in the Orient has approached, for spectacular effects, Dietrich in Spain. . . . Her costumes are completely incredible, but completely fascinating and suitable to *The Devil is a Woman*. They reek with glamour. . . . Miss Dietrich emerges as a glorious achievement, a supreme consolidation of the sartorial, make-up and photographic arts."

It goes on. Alice Hughes, *New York American*: "Fascinations no woman can resist! Never a more lavish fiesta of beautiful clothes!"

Motion Picture: "Never more beautiful . . . she remains the most glamorous woman to invade the sense of men."

Dwight Evans, *Screenland*: "Dietrich at her most devastating! Gorgeous costumes! Stunningly spectacular! Excitingly exotic!"

A dissenting voice emerges, as anonymous as any internet troll, from an unnamed newspaper, in a clipping that Cesar Romero pastes in his scrapbook, describing the movie thus: "A Spanish nymphomaniac falls for Cesar Romero, among others."

It is a film that attracts opinions for years. Susan Sontag, in *Notes on Camp* in 1964, declares, "Camp is the outrageous estheticism of von Sternberg's six American movies with Dietrich, all six but especially the last, *The Devil Is a Woman*." In 1982, Pauline Kael calls it "a story of obsessive love,

and von Sternberg's version is certainly obsessive. There's a slightly crazy daringness about his approach to the mythic. (You're never invited into the heroine's state of mind.) The film's near-abstract decorative quality has the fascination of a folly." David Denby, in the *New Yorker* in 2011, muses that "in this tale of a femme fatale during carnival, von Sternberg and Dietrich, who swivels her head maddeningly until she holds still for a closeup, are intentionally camping, while Dietrich's two lovers, the middle-aged Lionel Atwill and the young Cesar Romero, play it straight. The contrast strengthens the idea that passion is a mode of self-delusion."

The film remains a favorite point of discussion for film writers and historians. The only trouble is that when it is released, no one goes to see it. New York and Los Angeles box office returns are okay, but the rest of America wants no part of it. Huge movie palaces all over the country sit largely empty as Dietrich and Romero, with dueling cheekbones, smolder away in von Sternberg's exquisite lighting. An entirely unforeseen and somewhat ridiculous controversy hits when Spain's Foreign Ministry issues a warning to Paramount Pictures Corporation that if *The Devil Is a Woman* is not withdrawn from exhibition throughout the world, all Paramount films will be barred from Spain. For some reason, they object strenuously to the film's rather tangential portrayal of a corrupt Spanish bureaucracy in the late 1890s, taking it as an insult to all Spaniards.

They needn't have bothered. The film opens badly in March, is playing on double bills with "B" movies like the seven-reel cheapie *Cowboy Millionaire* and the equally down-market baseball comedy *Swellhead* starring Wally Ford by May, and by the time of Spain's protestations in October, it is no longer in release anywhere.

Film buffs know it as the fiasco that ends the career of Josef von Sternberg, ends his creative partnership with Marlene Dietrich, and sets her on a path to being labeled "box office poison." The footnote, lesser well known, is that it stops Romero's rise to Latin lover superstardom in its tracks. The miracle is that he doesn't go down with the ship. It doesn't kill his career, just redirects it back to the same path it was already on before *Devil*, toward roles that in the long run will offer far more variety and security than being an above-the-title Latin heartthrob might.

But it is a terrible blow. The saving grace is that Romero is too busy to lick his wounds for very long. He shoots seven films in 1935, possibly eight if rumors are true about the *Devil* shoot extending into the next year after a start date of October 15, 1934. Its actual wrap date is unknown.

Most Eligible Bachelor

This is Cesar Romero's filming schedule in 1935:

Hold 'Em Yale (Paramount). Start date January 18, with an unknown wrap date.
Cardinal Richelieu (20th Century Fox). Production dates: January 28–February 25.
Diamond Jim (Universal). Production dates: April 3–20.
Rendezvous (MGM). Production dates: June 24–July 29.
Metropolitan (20th Century Fox). Production dates: July 29–September 7.
Show Them No Mercy! (20th Century Fox). Production dates: August 28–late September.
Rendezvous—reshoots (MGM). Production dates: September 6–September 26.
Love before Breakfast (Universal). Production dates: December 16–January 27, 1936.

Only two of these projects are at his home studio, Universal; the rest are loan-outs. And while Romero is earning his regular salary, Universal charges other studios a premium; they pay more for Romero's services than Universal pays him. This is one of the studio advantages in the system they have created—keeping money out of actors' hands and in their own pockets. The rest of the films are mostly routine programmers that have little impact individually on Romero's career. The benefit to him is the cumulative effect. He is growing into someone audiences see all the time. You look around, and there he is again, in a comedy, then a drama, a costume picture; he's a hero, a villain; he's "swarthy" and sexy . . .

In this group of films, the one he is proudest of is *Show Them No Mercy!* at 20th Century Fox. He gets the chance to play a character with no redeeming features whatsoever, save his icy-calm ability to operate efficiently in violent circumstances. The inspiration for the movie is the real-life kidnapping of a little boy named George Weyerhauser, which is considered the first case in which kidnappers are identified by the use of marked bills given to them as ransom money. Romero gets second billing as the ruthless leader of the kidnappers who is surprised by the unexpected arrival of a young couple with a baby and a dog, who are stranded when their car breaks down, innocently looking for shelter. It's a hit and his reviews are good. *Hollywood Reporter* comments: "Cesar Romero as the kingpin kidnapper and Bruce

Cabot as his sullen henchman carry the burden of the acting and acquit themselves as ace troupers."

A fan magazine writer approves: "Cesar Romero likes being the bad man in motion pictures, especially if the character is intriguing and sufficiently villainous to stir his imagination."

A studio publicity press release assures the public of Romero's he-man credentials: "Cesar's best friends are a boxer and an Ex-All-American half back," the press release insists.

> They call him "Butch," and he beats the daylights out of them at tennis. He's as good on a swift upper cut as he is on the dance floor—which is saying a good deal. He can do a hundred yards in no seconds flat, play eighteen holes of golf, box ten rounds with his buddy, then beau some Hollywood charmer to a nightclub until the wee sma' hours and still look as fresh as the dawn.... True, he spent quite a little of his life in Manhattan. But that doesn't prevent Cesar from being as Cuban as a planter's punch or the rhumba. In his own home, "The Latin is lord and master," says the much-mooted article. "He almost never takes his wife out and seldom stays home with her."

More gangster parts follow through the next year, in *Nobody's Fool* (Universal), *Public Enemy's Wife* (Warner Bros.), and *Armored Car* (Universal). He is an undercover detective in *15 Maiden Lane* (20th Century Fox) and a double agent in *She's Dangerous* (Universal).

Hedda Hopper raises a special concern about Romero's suitability for the role of a murderous gangster who falsely implicates his own wife in *Public Enemy's Wife*.

"Moustaches can cause a lot of trouble in this business," she writes in her column, referring first to one of Romero's films from the past year. "Ronald Colman and Darryl Zanuck had many arguments because *Clive of India* was smooth shaven. They finally settled it with Ronnie cutting off his mustache, and thousands of fans wrote in and objected. Now Cesar Romero is in practically the same situation. He was signed to play the Public Enemy in *Public Enemy's Wife* at Warner Brothers and Nick Grinde the director asked him to shave off his mustache, thinking he would look more sinister. Romero has refused, and so now he and Grinde are in a deadlock." It is a debate that again takes place thirty years later when Romero is filming *Batman*.

Both times Romero keeps the mustache.

A round of who-will-he-be-next stories hit the papers and fan magazines. In some, Romero talks about wanting to do a musical so he can dance again. In others, he says he hates dancing and wants to keep playing killers. Still other articles quote him as saying he wants most to be in light comedies. None of them serves as specifically revealing anything about his artistic hopes or his thoughts about his place in the business.

Although Universal doesn't seem to know what to do with him, and most of his jobs are still loan-outs, he is secure enough to rent a three-bedroom, three-bath house on Havenhurst Avenue in West Hollywood. Soon much of the family heads west and moves in. His sisters have one bedroom, his mother has one, and his father and his live-in carer have the third. Romero Sr. is now considered an invalid by the family, with heart issues added to his untreated and largely undiscussed depression. (Later in life, Romero is more open with friends and colleagues about his father's mental health issues.)

With family taking up the bedrooms, Romero sleeps on the couch. Later, when his brother Eduardo arrives, Romero finds his own apartment and pays for Eduardo to earn an engineering degree from USC.

A Harrison Carroll King Features Syndicate article in 1937 makes a story out of the fact that it's raining when the family arrives, with ankle-deep puddles greeting them when they disembark from the long train journey. Maria Romero has given up her teaching job and will "act as hostess for her actor brother." Later Graciela (now Grace) Romero is announced for a small role in a feature at Columbia called *Carlotta and Maximilian*. "The fact that Miss Romero speaks Spanish fluently adds greatly to her success in this new production." The film isn't made for another year, but sure enough, she has a small, uncredited role with a couple of lines as a member of Empress Carlotta's ladies-in-waiting. It is her only foray into film acting. The film, cofinanced by Columbia and a Mexican film company, is completed and retitled *The Mad Empress*, but it sinks into oblivion for a variety of reasons involving studio intrigue, star power, and forces beyond the control of its cast and crew.

The same forces drive Romero to distraction as he ping-pongs from studio to studio, endlessly on loan-out.

He wants security and a home studio that is invested enough in his future to develop his career rather than scatter his efforts all over Hollywood. This is also a time when Universal is sinking into increasingly dire financial

circumstances brought about by a complicated series of events that could fill their own book. The upshot is that studio heads Carl Laemmle and his son and second-in-command Carl Laemmle Jr. are forced out. Major cost cutting begins. No one is talking about sacking Romero. He consistently delivers and his comparatively moderate salary is mitigated by the extra money he brings in on loan-outs.

But it feels like shaky ground.

Then his friend Darryl F. Zanuck asks to borrow him again from Universal—for a very tricky role opposite America's Sweetheart, box office champion and studio rainmaker Shirley Temple. It will be a match made in heaven all around.

3

Sly Fox

The drumbeat continues for Cesar Romero to find the right girl, but his newest leading lady is not a romantic possibility, even by the scattershot standards of the fan magazines: Shirley Temple in *Wee Willie Winkie*.

Wee Willie Winkie is based on the Rudyard Kipling story that first appeared in serialized form in the *Week's News*, a publication in India for British occupiers, most of whom do not see themselves as occupiers. The plot is basically how Shirley Temple's pluckiness and goodwill foster peace between Her Majesty's Empire and Indian rebels. The politics and cultural awareness of the construct don't really bear close scrutiny, but for Latino Cesar Romero, getting loaned out again to Fox and being cast as Khoda Khan, described in a studio press release as the "savage," "swarthy" leader of the rebel Indian faction, is a lucky turn of events.

His former *Dinner at Eight* costar on Broadway, Constance Collier, is in the cast, but they don't have any scenes together. Veteran pros C. Aubrey Smith and Victor McLaglen are also on hand—Smith as Temple's grandfather, a British army colonel in command of a unit in Northern India; and McLaglen as a blustery sergeant who takes Temple under his wing, turning her into Private Willie Winkie. Smith, McLaglen, and Romero give a master class in how to shine in scenes with a child star without trying in vain to upstage her. The three adult performers interact with Temple in startlingly intimate, vital ways.

A half hour into the film, Temple and Romero are called on to forge an unusual bond almost instantly when Romero is taken prisoner by her grandfather's forces. A necklace drops from his neck as soldiers hustle him to the prison block, and Temple runs to pick it up so she can return it to him. The necklace is precious. He is deeply touched by the gesture, grateful for her kindness and humanity, while she sees in him a gentle wisdom and a loving, peaceful soul. That's what we read into it anyway. It's just twenty-five

seconds of screen time—two lines of dialogue in a master shot, two medium shots, and two close-ups.

The fact that the scene registers so strongly is certainly a testament to director John Ford. This is Romero's first experience being directed by someone who takes painstaking care with every aspect of a movie. Another director, working faster and staying on schedule, might have done it more efficiently, certainly without the close-ups. Romero's is so beautifully lit, with his cheekbones so perfectly shadowed, he might as well be Marlene Dietrich but with human feeling. Ford chooses to go for the close-up because it's the right thing for the character development needed to make the narrative function—but it makes Romero look like a bona fide movie star.

This is not to undervalue what Romero brings to the table on his own. He has twenty films under his belt at this point and a clear sense of what works and how to connect with the camera and with his fellow actors. He stays fully present in his scenes, often drawing attention with a commanding stillness, moving only his eyes—which is one of Dietrich's tricks as well.

The plot calls for Romero to escape prison. One of his underlings is an undercover servant who, of his own volition, essentially kidnaps Temple by persuading her to travel with him to the rebel stronghold. Romero is angry that the man has put a child in danger. He and Temple have several scenes together where she appeals to his sense of decency to end his conflict with her grandfather. In a tense standoff with C. Aubrey Smith, Romero facilitates Temple's safe return. Temple appeals passionately to Romero and Smith's shared humanity. The antagonism between the two men evaporates, and peace prevails.

The denouement may seem mawkish and reductive, but under Ford's sensitive direction, the human relationships emerge as simple and quite moving. Shirley Temple is fantastic. If your only sense of her is as a cute munchkin tap-dancing around and singing "On the Good Ship Lollipop," her screen impact here is almost shocking. When Victor McLaglen is wounded in battle, her sense of loss is totally believable, devastating even.

That you can find yourself crying at a Shirley Temple movie is both embarrassing and kind of fantastic. Almost a century after her phenomenal reign as a box office champ, in a vastly changed world, her light can still burn brightly, and the work of her costars, all with acting styles formed in other eras, can still come across as vibrantly alive. The connection Romero makes with her and the sincerity of her total acceptance and

generosity of spirit toward him, even though he is a "foreign chieftain," is not just effective; it is extraordinarily unusual for an era when xenophobia and racism are casually accepted in most entertainment as natural, even desirable.

The world premiere of *Wee Willie Winkie* in Los Angeles draws a crowd of more than fifteen thousand people. No less than First Lady Eleanor Roosevelt gives her approval. "It is charming," she writes in her syndicated column, "and no one could help but like it." The film opens in the number two spot at the box office and stays in the top ten through the summer.

A week after the premiere, Cesar Romero is released from his contract with Universal and signs on with Fox. This is widely accepted as the beginning of his fourteen years as a contract player at the studio, but it is not. When he leaves Universal, it is unclear whether he (or Zanuck) asks for his release, which is what is reported in the press, or if Universal drops him—which is entirely possible given the studio's regime change and financial turmoil. *Wee Willie Winkie* is a smash, but even with a prestigious hit in theaters, the sixth-billed Romero is in riskier territory professionally than any of his press coverage suggests, and the Fox offer is not a long-term contract but a one-picture deal as the leading man in the film *The Great Diamond Robbery* (renamed *Dangerously Yours*) at $2,000 per week. That's a fortune in 1937, but after the shoot he could be without a contract.

As he heads into production on *Dangerously Yours*, fan magazines are still on the case. From an unidentified article he collected in his scrapbook:

ARE LATINS LOUSY LOVERS? Who is the most popular escort in Hollywood today? Nine starlets out of ten would tell you—Cesar Romero. And why? Because he's always doing the gracious thing, sending flowers to your sick aunt, seeing that you get that book you referred to. The corsage he sends you is *special*, not the ordinary run of the mill kind. For Carole Lombard yellow orchids. (Can you imagine anything better suited to Carole's luscious, exotic beauty?) For Betty Furness, gold pom-poms for her hair and a blending bouquet for her gown. For Virginia Bruce, gardenias, fragile and white. And that A.D. (Anonymous Deb) accused these boys of never sending gifts! She also implied they were emasculated, pretty much on the la-di-da side. Ladies, we leave it to you!

CESAR ROMERO

And another:

Cesar Romero Tells Why He Prefers Blondes—It was too bad I didn't take along some romantic young maid with me the other day when I interviewed Cesar Romero, the handsome newcomer to the screen. ... Almost 6 feet 3, shoulders that would take care of at least three weeping damsels all at one time, if Cesar would stand for weeping damsels, for whom, I gather, he doesn't care much. He's of Cuban extraction, with coal black hair and eyes. He doesn't set himself up as much of an authority on anything, least of all on girls, which was about what I was questioning him as to what we should aim to be. Whether he likes blondes best or not, he says he doesn't know.

He is still in the columns constantly, ice-skating with Ann Sheridan, pulling Joan Crawford onto his lap, and going to a wienie bake at the beach with Betty Furness *and* Margaret Sullavan. He also pops up in the papers in other ways:

There he is wearing a natty suit and tie and a gold pinky ring, eating an enormous slab of meat. "SAFEWAY STEAKS! SAYS SCREEN IDOL CESAR ROMERO: '*Flavor?* Wait till you bite into one of these new Safeway steaks! Under the new Safeway system, a man can be sure of *always* getting a tender steak.'"

From another ad: "WHERE-EVER ALUMINUM SQUEEZER! When mixing cocktail [*sic*] Cesar Romero uses the Wherever Aluminum Squeezer. Cesar Romero, Hollywood's new heart interest, takes credit for being one of the town's best hosts. Why is he a good host? Because he never keeps anyone waiting for a drink while he fumbles about with an old-fashioned lemon squeezer. With the new type Wherever Aluminum Squeezer it is most simple to turn drinks out in a jiffy and serve everyone no matter how large the crab [*sic*]!"

Looking at *Dangerously Yours* today, it doesn't really seem like much. It's a caper film set on the high seas involving a big diamond that everyone seems to want to steal, and Romero falls in love with a sexy jewel thief. But Romero's potential value to 20th Century Fox is clear. He has the good looks of a leading man yet can also play character roles, and he is comfortable sliding in and out of seemingly any genre—romantic comedy, crime drama, mysteries, costume pictures, and, soon, musicals. He also has the amply demonstrated ability to generate press coverage. He gets his long-term contract, and a period of constant activity begins. He will make five

movies in 1938, six in 1939, five in 1940, and six in 1941. Unlike his busy schedule in 1935, when many of the roles he played were minor, every character he plays now is integral to the plot—whether he is the leading man or one of the second leads.

He can even skate. Enter Sonja Henie.

In *Happy Landing*, Romero makes the first of three appearances with the former Olympic ice-skating champion, ranked as the eighth-biggest moneymaking star of 1937 and moving up to third place in 1938. Today her appeal is hard to fathom. She seems rigid and humorless. Even her skating seems kind of clunky. Romero remembers her fondly in one of his very last screen appearances, the documentary *Sonja Henie: Queen of the Ice*, released posthumously in 1995.

"She was charming," he says. "Not an actress perhaps, but charming. Nobody needed her to act. All they wanted was to see her skate."

In *Happy Landing*, Romero is a bandleader, nightclub star, songwriter, playboy, and amateur aviator. He sets off with Don Ameche from New York, bound for Paris, but they crash-land in Norway, where perky Sonja Henie's village is staging a musical ice-skating spectacular—as Norwegian villagers are apparently wont to do. Romantic triangles intersect: Ameche and Romero with Henie; Romero with Henie and a surprisingly young and sexy Ethel Merman. Romero demonstrates new physical comedy skills, doing elegant pratfalls and making puppy-dog eyes at Merman before and after making a play for Henie. He seems years younger than the thugs he was playing at Universal.

"I practice up on eccentricities befitting a dramatic character actor, when, boom, I'm a comic!" Romero tells an interviewer at the time. It suits him, and it suits Fox. It even suits *Modern Screen*: "When Cesar undertakes the role of a comedian in *Happy Landing* with Sonja Henie, he starts something. 'He's a very funny man,' said the reviewers. 'You're a very funny man,' echoed the producers. So Cesar is becoming a very funny man again in *Always Goodbye* with Barbara Stanwyck and Herbert Marshall, in *My Lucky Star*, again with Miss Henie, and in *Wife, Husband and Friend*, with Warner Baxter and Loretta Young."

My Lucky Star has Cesar playing the wealthy son of a department store titan. For complicated plot reasons and to impress his father, Romero sends Sonja Henie to college as an undercover model pushing the store's fashion line. Joan Davis does her comedic dance moves, Romero slides across the ice on his derriere, and Gypsy Rose Lee (credited as Louise Hovick) shows

up to stir the pot. Harriet Parsons in the *Los Angeles Evening Herald* loves Romero's work: "Best performances in current pictures: Cesar Romero in *My Lucky Star*. Star credit for best acting belongs to this clever player who makes a man about town portrayal more than colorful. Of course, Sonja Henie skates divinely and Joan Davis and Billy Gilbert are comedy champions."

Edwin Schallert in the *Los Angeles Times* also approves: "Skating Empress Shines in Box-Office Triumph. . . . It's the comedians who are evidently relied on to give the picture color and pungency. Joan Davis proves herself reliably the life of the party. I would also say that both Cesar Romero and George Barbier contribute very valiantly to the amusement."

He returns to his trusty pot of Egyptian #2 pancake makeup to play Ram Dass, the swarthy mysterious benefactor of Shirley Temple in her big-budget color film debut, *The Little Princess*. In most of his scenes, there is a parrot on his shoulder. The original idea is to have a monkey, but while shooting a scene where the small monkey hired for the job leaps from Romero's shoulder over to Temple, the monkey won't stop trying to bite her, so the parrot is a hurriedly arranged last-minute replacement. "If you liked Cesar Romero in *Wee Willie Winkie*, get a load of him in color!" reads a scrapbook clipping.

Comedies follow. In *Five of a Kind*, he and Claire Trevor are rival journalists trying to boost their careers using human-interest stories about the momentarily world-famous Dionne Quintuplets (carefully singled out in the credits, perhaps so they will not be jealous of one another, as Cecile, Yvonne, Marie, Annette, and Emelie); and in *Wife, Husband and Friend* he takes a secondary role as the musical coach to aspiring but failing concert singer and socialite Loretta Young, who fights with husband Warner Baxter when he becomes an accidental concert singing star.

Then there is a complete departure that involves the biggest sacrifice of his career thus far when Fox decides to resurrect the Cisco Kid and casts Romero as the Kid's decidedly hirsute sidekick, Lopez. His sacrifice? "Hollywood's most eligible bachelor is a familiar figure in the movie town's most brilliant night spots, but club proprietors are worried that he has permanently retired from night life. Rest assured, it's temporary and for a very good reason. He is preparing for *The Return of the Cisco Kid*, and the suave, sophisticated Mr. Romero has grown a mangy beard, his hair covers his collar, and he has become a grand example of how to avoid parties and dine alone." There is a photo of Romero in public at the time, appearing on

a radio show. He is certainly shaggy, with long hair and a beard, but as well dressed and elegant as ever. His association with the Cisco Kid, a charming, happy-go-lucky Arizona bandit, first portrayed on film in 1914, is just beginning.

The character first appeared in a 1907 short story by O. Henry called "The Caballero's Way." He is a ruthless killer, not unlike the kidnapper Romero plays in *Show Them No Mercy!* For the movies, he is reimagined as a kindhearted, mischievous rascal who tends to give his ill-gotten gains to a needy and shapely lady in distress. Warner Baxter, Romero's costar in *Wife, Husband and Friend*, already has a history as the Cisco Kid: he won a 1928 Best Actor Oscar for *In Old Arizona* and made three more Kid films before hanging up his spurs in 1931 at age forty. Now, still dapper but pushing fifty, Baxter returns to the role for just one picture. Romero's appearance is a kind of audition to see how he does on horseback and whether he and the Western milieu are a good match. They are. Cesar Romero becomes the new Cisco Kid—and he doesn't just get to ride horses; he sings and tangos as well.

Modern Screen approves:

Love, NO! Leers, NO! Laughs—WE'LL SEE! When Hollywood found Cesar Romero, it hoped it had another Rudolph Valentino. He looked like a good prospect as a Latin Lover. Tall, dark, and somber-eyed, here was a Cuban smoothie who could tango without getting all tangled up in his tails. It didn't work. Romero tried looking soulful and mouthing impassioned dialogue, but all the while he wanted to laugh. . . . So the studio took him out of evening clothes and popped him into a disreputable looking Mexican outfit. Suddenly the truth dawned that Romero is really a light comedian. This suits Romero all right, because through his clowning he has inherited a better wrap than Valentino's mantle: Warner Baxter's serape for a series of *Cisco Kid* pictures in which he will star as the Gay Caballero.

So does *Photoplay*:

Tall, dark and handsome, the Cisco Kid is a Latin from Manhattan. Meet Cesar Romero, who sings soprano but answers to the name of Butch. He's a momma's boy, but he'll pin your ears back if you laugh at him about it, then regret his loss of poise

and display of temper, and be your friend for life if you'll let him. Mr. Romero is almost too genuine, too human to work in Sue Town—a good name for Hollywood, where friendships often are assessed at their publicity value, and a knife in the back is so common that the expression is not even hyphenated. There is nothing phony about him. He uses his real name and is really a Latin from Manhattan. His fan mail proves he is one of the most popular bachelors in the business, and 20th Century-Fox pays him thousands a week to break hearts, yet he seldom gets his gal. . . . A magazine once said it means as much to an actress to be seen with Romero as it means to a piano to be seen with Paderewski.

The romantic articles flood magazines over the next two years as he plays the Cisco Kid in five films. Romero has a blast. The series of movies is part of Sol M. Wurtzel's unit at Fox. He is sometimes credited as an executive producer but often uncredited on the projects he oversees, largely for the extremely profitable B pictures division. Romero is a great fit for the unit. He can work fast, attracts more press than most other B stars, appeals to both male and female audiences, and even does some of his own stunts—though how many truly dangerous stunts he is allowed to do versus how many publicists say he does is an open question.

The plots reassuringly follow similar narrative lines. The Kid plans a big score with his trusty sidekick, Gordito; after a couple of reversals, he cashes in but gives it all to a new lady love who finds herself or her family in dire straits. Often someone else is pretending to be the Cisco Kid, committing heinous crimes the Kid would never commit, and the plot allows him to avenge his good name. Chris-Pin Martin is Gordito in all of the films. A character actor of Native American and Mexican heritage, he has a long career using variations of his name—Chrispin Martin, Chris King Martin, Chris Martin, Cris-Pin Martin, and Ethier Crispin Martin—and appears with Romero in eleven films, including the five Cisco Kid pictures. There is no getting around the fact that Gordito embodies a lot of stereotypes that justifiably make modern viewers squirm. But the Cisco Kid films give the actor more screen time and a wider range of possibility than he ever gets elsewhere. Martin takes advantage of the opportunity and scores some memorable moments.

In 1941, a sixth film is planned, *The Cisco Kid Rides Again*, but Fox decides to drop the series entirely fearing pushback from Mexican nationals,

according to *The Hollywood Reporter*. Some authors writing about LGBTQIA+ history in Hollywood believe that studio concerns over Romero's sexuality and the character's evolution into something of a fop are part of the reason for pulling the plug, but that doesn't logically align with the bigger budgets and higher profiles of Romero's next projects, including *Tall Dark and Handsome*, *Dance Hall*, and *Week-End in Havana*. (*The Cisco Kid* does live on. Four years later, budget studio Monogram Pictures resurrects the series and releases five films with Duncan Renaldo in the lead, then Ziv Television, a prolific producer for syndication, picks it up with Renaldo continuing as the lead for 156 episodes from 1950 to 1956.)

In 1940, Romero pulls permits to begin construction on a new house on Saltair Avenue in the tony Brentwood hills, north of Sunset Boulevard—a place big enough to accommodate his family and himself. Magazine spreads show off its masculine interior with a huge fireplace in the den and rifles on the wall above the mantel. It's described variously in magazines as French colonial and Cape Cod. Mostly it's early Beverly Hills—a style borrowing from whatever is handy, mixing clean lines and spaciousness with a few fancy embellishments. It's quite lovely, and his pal Joan Crawford is just a mile and a half away.

Romero is a recognized part of the Hollywood community now—represented by William Morris, *natch*. Warner Bros. Merrie Melodies releases an animated short, *Hollywood Steps Out*, playfully lampooning movie personalities of the day. Stars from Bette Davis to Humphrey Bogart are hanging around a nightclub; Romero dances with Rita Hayworth, but his feet are so big they tear off the bottom of her dress. The size of Romero's (quite graceful) feet is often commented upon in fan magazines, though not as often as marriage.

Lucille Neville at the *New Haven Register* is on the case:

I asked the handsome star, "Why such a long wait for a trip to the altar?" He told me, "I haven't been able to afford marriage yet. I've had a great many responsibilities and I want to see my mother and sister comfortably provided for. I'll need an income that will take care of them and a wife equally well. Then I had a disappointment this year too. I had met a charming girl who seemed to be everything I wanted. I didn't want to rush her or speak soon, though, and she married someone else. That's the first time that's happened to me."

This deflection, mentioning a recently lost love who leaves him wary of forming another close attachment, becomes a frequent fallback in interviews.

Hollywood social life of the era is elegant and star studded. Formal dress dinners on Saturday nights at the homes of various stars are followed by Sunday afternoons of cards, swimming, and croquet. Romero is almost always hanging out with three couples who live nearby, referred to as the George Murphys, Fred MacMurrays, and Basil Rathbones—a common custom of the time, but one can't help wondering how Julie Murphy, Lillian MacMurray, and Ouida Rathbone feel about it. Another couple joins the mix: new neighbors Tyrone Power and his glamorous French movie star wife, Annabella.

In 1941, Fox announces a remake of an old Rudolph Valentino hit, *Blood and Sand*, with Tyrone Power and Cesar Romero as rival matadors with sublimated sexual undertones. No explanation is offered when Anthony Quinn is assigned the costarring role instead of Romero. It is likely just a scheduling issue. At the same time Power is shooting *Blood and Sand* with Anthony Quinn, getting into bullfights and showing off for Rita Hayworth and Linda Darnell, Romero is shooting *The Great American Broadcast* with Alice Faye and Jack Oakie, inventing America's first radio network. These are busy people.

Tall, Dark and Handsome puts Romero back in a tux as a gangster who reforms for the love of a beautiful woman—it's a film that starts life as a B, but during shooting the rushes are good enough to warrant an elevation to A status, with a longer shooting schedule and bigger advertising budget. The same thing happens on *Dance Hall* with Carole Landis, the story of a dashingly handsome chiseler running a dance hall and a tough, belligerent singer. Their will-they-or-won't-they plotline is hard edged, bordering on nasty at times.

"The worse you treat them, the better they like it," Romero says about women in general, and when he admits to liking Landis a little after manhandling her, he says, "You know, you're different from the other girls, but I can't put my finger on it. It can't be your looks because I can think of fifty other dames better looking than you." Her comebacks are funnier: "You're nothing but a double-crossing dime store Casanova diamond-studded heel," she spits out at him. "All you are to me is a cheap oversized pair of pants!"

The character's sharp edges in *Dance Hall* don't seem to make Romero any less enticing to audiences or to the press. The *St. Louis Democrat*

declares, "Marriage proposals, six hundred a day, are literally swamping Caesar [sic] Romero as a result of a rumor that he is seeking a bride. From coast to coast, fan letters pour in from feminine admirers offering the tall, handsome, thirty-four-year-old actor everything from the old proverbial drug store and $500 to a quiet little home in the country if he'll only marry them. Many sent photographs, and they're pretty good looking, too. For every proposal, however, there's going to be a shattered hope."

Yet the *Hollywood Reporter*'s Rambling Reporter insists an ordinary girl won't do and links Romero with other stars:

> The Cary Grant-Virginia Bruce twosome is passé, for Virginia has switched her affections to Cesar Romero, the Latin from far off Manhattan. Having been seen out together three nights in a row, they are, according to the rumor makers, all set for a march to the altar. When you take a girl out three nights in a row in Hollywood, your fourth day finds you flooded with wires from the airlines offering attractive round-trip rates to Yuma with a quiet wedding thrown in for a small additional charge, and on the fifth day you start getting information on the rates to Reno.

A 1941 King Features Syndicate caricature tabulates a "Box Score on Cesar Romero, Number of pictures: 21; Years in pictures: 7; Hero: 10; Heavy: 6; Comedian: 5; Wins girl: 1; Loses girl: 18; No decision: 2; Killed: 3; Jailed: 24; Fights: 11; Won: 9; Lost: 2; Men killed: 9; Wounded: 12; Dialect roles: 8; Outdoor roles: 10; Drawing room comedy: 6; Gangster: 5." The math doesn't actually add up very well, but what it lacks in technical accuracy it makes up for in initiative.

Meanwhile, a cruise ship on the way to Havana runs aground near Florida.

Not a real ship, not the real Florida, and not the real Havana.

Carmen Miranda, the Brazilian Bombshell, is already a worldwide sensation when cameras start rolling in June 1941 on *Week-End in Havana*. Her first two American pictures, *Down Argentine Way* with Betty Grable and Don Ameche and *That Night in Rio* with Alice Faye and Don Ameche, are big hits—more than fulfilling the studio's supposed commitment to the Good Neighbor policy's emphasis on cooperation and trade with Central

and South America. Fox's deepening affection for the policy just so happens to coincide with the disappearance of most European markets because of World War II, creating exponential increases in the desirability of Central and South American markets. Cesar Romero and Carmen Miranda complement one another perfectly—they even become salt and pepper shakers as part of the marketing onslaught for the film. The salt and pepper shakers are quite rare now. When they surface, they can go for hundreds of dollars online. There is also a brisk trade on various websites of a particular shot of Romero and Miranda dancing—he is tossing her in the air, revealing her complete lack of underwear.

Other publicity from the real Havana boosts the film's profile. President Fulgencio Batista's press department issues a release trumpeting the fact that "Romero [is] to be Honored by his Cuba Native Land. A photograph of the 20th Century-Fox star and of his mother, the opera singer Maria Mantilla, will be among articles sealed in the cornerstone of a statue to be erected in memory of José Martí, Cuban patriot."

The plot of *Week-End in Havana* starts with the aforementioned cruise ship running aground on its way to Havana from New York. It ruins the vacation that salesclerk Alice Faye has spent years saving for. Fearing she will go public with having seen the captain's apparent dereliction of duty, the cruise line flies her to Havana accompanied by trusty cruise line executive John Payne. Faye finds Payne dull and prefers Cesar Romero, a Cuban gigolo with gambling debts. Romero mistakes Faye for an heiress and tries to romance her—they dance and sing "Romance and Rhumba," angering his actual girlfriend, singer Carmen Miranda. Meanwhile, Payne's fiancée, Cobina Wright Jr., shows up and gets mad that he is paying so much attention to Alice Faye. Everyone ends up with the right partner by the end, and Miranda cements her hold on the public's imagination. She and Romero blaze across the screen, beautiful, charming, funny, and full of life. Alice Faye and John Payne may be the top-line stars, but it is Carmen Miranda and Cesar Romero who make the bigger impression—which they repeat in real life at Hollywood nightspot Ciro's, where they cause a "Rhumba Riot," delighting customers with a South American routine that "fairly melts the floor," according to Louella Parsons.

Springtime in the Rockies reunites much of the same cast, though Betty Grable replaces the pregnant Alice Faye. The setup is that Grable and John Payne are a Broadway team heading for marriage, but they quarrel over his

womanizing and break off their romantic and professional partnerships. Grable takes up with old flame and former partner Cesar Romero while Payne's career fizzles. Hoping to get Grable back, he follows her to a swanky resort in the Rockies where she and Romero are opening their new act. Payne arrives after a drunken bender with two strangers in tow: his new secretary, Carmen Miranda, and new valet, Edward Everett Horton—a man with a fantastic secret (that has nothing to do with his sexuality). Everyone is in top form, but the funniest subplot is Miranda falling hard not for Payne or Romero but for Everett Horton.

As the United States enters World War II at the end of 1941 and enlistment rises in 1942, Hollywood's leading men register for conscription like everyone else but initially are not called into service. In a copy of the government's War Department registry, Romero is categorized as "deferred" and listed as "Single, Family Dependents." His government-approved war activities are "Personal appearances, government radio programs, Lieutenant in the State Guard, Member of the Evacuation Corps., Air-Raid Warden." He also volunteers regularly at the Hollywood Canteen, a club cofounded by John Garfield and Bette Davis to offer food, dancing, and entertainment for enlisted men and women, most of whom are usually on their way overseas. But he and Tyrone Power both want to join up for active service. Darryl F. Zanuck, with the full support of the US government and the military, argues that the morale-building value of their films is important war work in and of itself. A year into American involvement, with most male film stars still present on American theater screens instead of in European or Pacific theaters of war, the public begins to ask why.

Photoplay addresses the issue:

> Wives, sisters, parents, and sweethearts of drafted men who have little worldly goods to fight for, wonder why their loved ones should face danger and death while the men to whom America has given so very much remain behind. The stars have sensed this growing resentment, rubbed to a rawer edge by the actions of those few who pulled strings to get commissions in behind the lines jobs as Army, Navy and Marine press agents, intelligence officers and "specialists." Yet, when a star wants to respond to this spur of public opinion and join the fighting forces, he runs head-on into an unyielding wall of pressure.

For that is the paradox of Hollywood deferments. The stars are, in the main, deferred—not by request, but because of circumstances. No more than in Milwaukee or Spokane have Hollywood's draft boards put into 1-A men who are married, who have children, or who live under other special circumstances allowed for by the Selective Service Act. There is, of course, no law against a man with a family volunteering. But there has been, in a surprising number of cases, the ceaseless, urgent plea of the studios, of fellow workers, of friends and well-meaning advisers to "stay on the job."

Romero makes two more films before going to war—*Coney Island* with Betty Grable and George Montgomery and *Wintertime* with Sonja Henie, Jack Oakie, and Carole Landis.

The most notable element in *Coney Island* is frankly its casual violence between men and women. Like Romero's film *Dance Hall*, it normalizes unusual behavior. There's a lighthearted, romantic scene of George Montgomery putting Betty Grable's wrists and ankles in cuffs and then forcibly kissing and groping her as if it's just a boys-will-be-boys lark. Times have indeed changed, but even for the time it feels ugly and unforgivable—as do a lot of the sexual politics of the story. One wonders if this consciously or subconsciously reflects Zanuck's own worldview since it is hard to imagine Judy Garland in a similar situation at MGM or Deanna Durbin at Universal. Zanuck is a notorious womanizer with what the *New York Times* describes in 2020 as a "well-documented habit of flashing his penis at women." Perhaps his rumored predatory attitude toward women influences how the films made under his leadership depict male-female power dynamics. Whatever the cause, *Coney Island* leaves a sour taste. *Wintertime* gives Romero some very funny scenes, but Sonja Henie's brief reign as a box office draw is waning, and everyone involved seems to have their mind on other things.

After all, there's a war going on.

After *Wintertime* wraps in July 1942, Romero enlists in the US Coast Guard as an apprentice seaman, rejecting the path of accepting an officer's commission and staying stateside—an option often open to the rich and famous. He asks for no special treatment and spends ten weeks at the Coast Guard's West Coast boot camp in Alameda, California, learning all the procedures for operating the deck cranes on the huge transport ships that take equipment and frontline combatants into battle zones. The cranes swing

eighteen-thousand-pound barges and other landing craft from the deck over the sides of their vessels and bring craft and cargo back on board, along with the injured and dead. That's how the job is described to him. He rolls the details around in his head as he prepares for whatever lies ahead—rising every morning between three thirty and five thirty, sweeping down his quarters, emptying trash, obeying orders. He boards the USS *Cavalier* and sets sail for Saipan and Tinian, where major battles are about to take place.

He serves in extreme battle conditions for nine months and is promoted first to boatswain's mate, then later to chief boatswain's mate, before the military decides his value to the war effort really is larger than remaining on board. Now he doesn't have a choice; he just follows orders as the Coast Guard gives him a new job—touring stateside war plants to boost the morale of workers who supply weaponry, planes, ships, and tanks. He has a set speech that he gives. It sounds a little like movie dialogue, and it's easy to imagine how well he puts it over, with sincerity and force of feeling. Then you remember he is talking about things that have actually happened. Experiences he has actually had. Imagine working in a war plant, doing factory tasks that may indeed be vital for the war effort but are often repetitive and boring. Handsome, charming Cesar Romero arrives looking like a million dollars in his perfectly tailored uniform, buttons as shiny as his dazzling smile. He gets up to speak and seemingly looks right into your eyes, talking directly to you. He makes his hello and then begins describing his own experiences upon being deployed for the first time.

> Most of us had never seen action before we sailed for Saipan, so you can understand how we felt one night when we picked up Tokyo Rose on the radio and heard her say, "Hello sailors and soldiers, you're heading for Saipan, aren't you? Better turn back now while you still can. We are ready for you. You'll never take Saipan and those who try will never get home."
> Tokyo Rose was only partly wrong. We *did* take Saipan, but they were laying for us, and a lot of fine boys did not get home.... Our ship was carrying troops that were supposed to be reserves, possibly they would be landed towards the end of the Saipan invasion, or perhaps be held off for Tinian and Guam. Well, we arrived at Saipan on D-Day plus one, the second day of the invasion, and we hadn't been there more than an hour, when the word came through to send in those troops.

After we landed them, we had to pull out to sea without even unloading our supplies to avoid a Jap air raid. We stayed out for seven days while our fleet gave the Jap fleet a real beating. Then we went back in again, unloaded our supplies and took wounded back to another base. . . . The smoke of the barrage covering the landings was so thick that we couldn't even see the shore.

I want to tell you a little about the wounded we took back. More than anything else, they symbolize the wonderful spirit of the American fighting man. Only most of them weren't men— only boys grown up overnight. . . . One of those boys had been badly shot in both legs, most of the bone was gone, he was in a cast from the tip of his toes to his armpits. He'd never walk again without crutches, but he wasn't beefing. I still remember his words. "Hell. I'm one of the lucky ones. I've still got my legs."

Then there was a Marine captain horribly shot up from front and back by machine gunfire. He was wounded so badly and bleeding so much that we couldn't keep a bandage on his wounds. When he was conscious, which wasn't very often, he'd laugh and kid with us, but he wasn't kidding about wanting to go back for another crack at the Japs. There was one thing he wanted first, though, and that was to go home and have a look at his baby, his two-year-old son whom he'd never seen. That Marine captain needed blood badly. A lot of it. I'm sure you'd give it to him, any of you hearing this story, but let me tell you something, we had so many wounded and we were so short of blood plasma that it ran out. Everyone on board ship offered his blood, but think of it, folks, here were men right out of battle having to give their blood because there wasn't enough of it on hand.

I want to tell you about one more of those wounded, a young Marine. His leg had been shot up badly and gangrene had set in. He was in constant pain. Finally, one morning they had to amputate the leg. I went down to see him that evening. He looked up at me and said, "Well, they took it off today." I said, "Yes, I know, but it's better that way. It was either your leg or your life."

"Sure," he replied, "I'm not kicking. I'm even glad now I don't have that terrible pain anymore." Then he asked me to write down a few lines to his wife for him. It was a simple message—he still

loved her a lot. He'd been wounded. He was better now. He was all right. Everything was all right. He was coming home.

I never got to mail that letter. I couldn't. You see, he died that night.

Romero ends with an impassioned pitch encouraging them to donate blood and keep up the hard work, making the workers in war plants feel like their efforts are needed: "How many of us do come back depends a lot on how well you do your job."

Military publicists certainly have a hand in crafting the message, but the persuasive way the speech is written doesn't obscure the fact that Romero does see battle. People do die right in front of his eyes. He does put his life on the line for his country.

Many war plant workers write emotional letters of thanks to Romero after his visits. One stands out for its quiet dignity and how much it reveals about stateside life during wartime: "My girlfriend's fiancé was one of your shipmates for nine months during the invasions of Saipan and Tinian," writes the sender.

He is one of the boys in the Philippines now, and in one of his letters he mentioned you as a shipmate, honored, respected, and admired by all the crew for your sincerity, straightforwardness, spirit, and courage. His praise was the highest one man can give another, and that, in my estimation, is tops. Your simple stirring message re-emphasized his every word in my mind—therefore this letter to you.

Mr. Romero—you give a splendid performance at sea and are now giving an even greater one every time you appear in public, and in your simple, sincere, direct manner tell Americans a little of what our boys are going through in this present great world conflict. Yours was a great mission on that Coast Guard ship out in the Pacific. Yours is an even greater mission now— to make the American public more keenly aware of what's happening out there. Too often, safe and snug, far removed from the battle fields, people forget. Let me say simply as just another American—thank you. Most sincerely, Lorraine Rakow, Chicago, Illinois.

That letter is one of hundreds. At each stop on his tours, photos of his visits show him surrounded by crowds of workers—often women—clearly excited by his presence. He is treated as someone who is very special. Yet photos of him on board the USS *Cavalier*, including the ones reprinted in this book, show him doing regular duty with no special treatment. Some of the pictures are a bit playful—and yes, the one in the showers is undeniably hot—but they underlie the truth of the speeches Romero gives for a year and a half all over the country, with blank spaces to write in the names and functions of the war plants he visits, so he can address the workers with specifics. A curious mixture of fact and a little bit of fiction comes together with a truth that feels larger than fact or fiction alone. That cuts to the power of movies themselves—as an art form and as a cultural force. It cuts to the heart of everything Cesar Romero has done with his life so far. He is not the only one.

Tyrone Power is a marine pilot—part of a USMC squadron carrying supplies into the embattled Iwo Jima and carrying the wounded out. Later, he serves in Saipan. In the air, he essentially has the same function Romero does on the sea. He is in the line of fire often, but his is a supporting role for the frontline combatants.

John Payne is a flight instructor and pilot in the US Army Air Corps. He receives a Silver Star when his actions during a mission where Americans bomb the Italian fleet are key to allowing British forces to proceed.

Clark Gable flies combat missions as an observer-gunner in B-17 Flying Fortresses.

Jimmy Stewart pilots B-24 Liberator bombers over Nazi-occupied Europe.

Henry Fonda is a quartermaster 3rd class on a destroyer, rising to lieutenant junior grade in air combat intelligence in the Central Pacific.

And another man: Romero's younger brother Eduardo is a marine and sees combat action in the Battle of Okinawa.

Like many veterans, upon his release from active service after the war is won, Romero closes the door on this chapter and never speaks of it in depth again—not in public and apparently not in private. "None of them did," says actress Ruta Lee, who becomes Romero's close friend in the 1970s and 1980s, when both are active on the Beverly Hills charity circuit and Romero and his sister Maria begin spending Christmases with Lee and her husband. "That was how it was with men in those days. No opening up about negative feelings. Actually, Cesar never wanted to say anything

negative about anything or anyone. He was one of the most positive people I've ever known."

A curious situation greets Romero upon homecoming. An army private named Don Tabasco, jailed at one point for going AWOL, is now a budding actor in Miami appearing as Don Romero, with advertising posters identifying him as "Cesar Romero's Brother." Tabasco has also run up debts for expensive jewelry among other luxury items. Romero gets requests for payment. Private investigators put the pieces together and eventually, after Tabasco is arrested, Romero receives a heartfelt letter of apology from him, claiming an unscrupulous talent manager has insisted he make the false claim. The unpaid debts in Romero's name go unremarked on.

The experience is only one part of the surreal atmosphere that greets Romero on his return to Hollywood. Darryl F. Zanuck immediately puts him back on contract and stars him in *Carnival in Costa Rica* opposite Vera-Ellen. It is virtually a carbon copy of the movies he made with Carmen Miranda, Betty Grable, and Alice Faye three years earlier—a lifetime ago. The atmosphere of enforced gaiety and innocence has no sense of sparkle or joy. Romero plays a young man so afraid of his papa that he can't tell him he wants to marry glamorous gringa Celeste Holm instead of going through with an arranged marriage to Costa Rican local Vera-Ellen. That the Nordic Vera-Ellen is not at all believable as a Latina is the least of the movie's flaws. You wonder why this self-assured adult man, seasoned by the war and pushing forty, doesn't just marry Holm in the first reel and be done with it. It's like Zanuck is trying to pretend the war hasn't happened.

In some ways, Romero tries to move on as if the war hasn't happened as well.

He returns to his social life with the same friends, resuming their Sunday afternoons of cards, croquet, and parlor games. He and Fred MacMurray ride motorcycles together. His house is full of family—more since his sister Graciela, now married with children, has been staying with the kids at the house during the war, along with the already existing residents: his elder sister Maria, his parents, and his father's live-in nurse. Eduardo returns as well. With no room left to call his own, Romero builds a large addition over the garage, essentially a small house of over one thousand square feet, and lives there—with one room devoted entirely to his wardrobe of suits, sports jackets, and tuxedos, a collection that press reports often cite as numbering over five hundred. Though that figure is likely hyperbole, it is not entirely out of the range of possibility.

But an evening in May 1946 is a grim if indirect reminder that it is impossible to return to the carefree prewar days.

Romero is with Tyrone Power and Annabella at one of their typical afternoon croquet gatherings. David Niven and his wife, Primula, known as Primmie, and Rex Harrison are part of the group. Everyone stays for dinner, and afterward they play a variation of hide-and-seek they call Sardines where, with the lights off, everyone packs in together somewhere and hides while someone looks for them. Primmie is "It." She searches through the unfamiliar house. She has recently arrived with Niven and their two young boys from England, and this is her first time playing Sardines. She opens a dark door she assumes is a closet and rushes in, believing she has found the Sardines. It isn't a closet. She plunges down a steep flight of concrete steps that lead to the basement, gashes her head, and is knocked unconscious. Instead of immediately taking her to the hospital, Power suggests everyone keep playing the game, so when she wakes up she isn't frightened. Though the logic of this isn't clear, the guests go on playing for a half hour or so before Niven carries his still-unconscious wife to the car and drives her to the hospital. She is diagnosed with a slight concussion. The next morning, a brain clot develops. Surgery to relieve the swelling in her brain is unsuccessful, and she dies on the operating table.

The idyllic Sunday afternoons are never the same for Romero. The accident is no one's fault really—just a horrible, random tragedy—but it underscores the changes of postwar life. Power is also drinking heavily, and his marriage to Annabella is growing strained as rumors of both of them seeking romantic encounters with other partners swirl about, making the gossip columns. Power's possible exploits with other men, of course, do not come up in the press.

Restless and out of sorts, Tyrone Power is happy when Fox decides to send him on a South American publicity tour—but he talks them into making it a very different kind of trip than they originally imagine. Power gained extensive experience piloting large transport planes during the war and wants to fly to South America himself with his pal Cesar Romero as his companion. Fox sees the publicity value of two war-veteran movie stars at the rough and ready, barnstorming all over South America, meeting presidents, ambassadors, film stars, and Zanuck's Latin American employees. Power and Romero set off in a DC-3 along with a professional copilot who is happy to let Power do most of the piloting.

Sly Fox

They start in Mexico, then head for Guatemala, continuing through the Canal Zone to Bogotá and Quito, then to Lima, Santiago, and Valparaíso, over the Andes to Buenos Aires, then to Rio de Janeiro and through the islands over to Cuba before heading back to Los Angeles. It is the happiest ten weeks of Cesar Romero's entire life. He tells stories about the adventure to every new cast and crew he meets on film and television sets for the rest of his life. "Eva Perón was beautiful, but she never shut up!" he is fond of saying. "She just yacked on and on and never gave Juan a chance to get more than a single word in." But mostly he talks about his deep pride in representing his studio and his country with a man as important and special as Tyrone Power.

Tens of thousands of fans show up at every stop. Fox gets the goodwill from foreign governments it hopes for and an avalanche of publicity, not just in South American publications like *Sintonia*, *Ahora*, *Clarín*, *La Prensa*, *El Mundo*, *La Razon*, *The Standard*, *El Pueblo*, and *Critica* but in American newspapers and magazines too. No media outlet seems able to resist printing photos of the hunky twosome posing in their flight outfits outside the plane, both of them lean and well muscled from their war service, looking virile and ready to take flight. There are also dozens of shots from a poolside session with studio photographers that are distributed worldwide. By today's standards they are decidedly homoerotic, with the handsome men posing together shirtless, gorgeous and intimate.

The attention from fans and the press is not what Romero remembers with so much affection. It's the time with his friend Ty Power. They are together for ten weeks without Annabella or any of their witty, cultured friends, and without Romero's family. They have endless hours alone. Power opens up about his childhood and family and about his private thoughts and desires, and Romero treasures these long talks that go deep into most nights, referring to them often but never revealing any of the details of Power's memories, hopes, and dreams.

They return to the studio two and a half months later only to pack their bags again and set off for Mexico. In 1945, with the war still raging, Zanuck purchases the rights to Samuel Shellabarger's bestselling novel *Captain from Castile* for $100,000—not specifically for Power, but the star's name comes up in casting conversations almost immediately. The script is now ready—an epic account of a young nobleman's thrilling but harrowing adventures as he escapes the Spanish Inquisition and joins the Cortéz invasion of Mexico in the sixteenth century. Power is the nobleman. Romero is Cortéz.

The film shoots in Technicolor from November 1946 through April 1947, first in three Mexican locations—Morelia for the Spanish sequences; Uruapan for its proximity to the recently active volcano Paricutin, which doubles for Popocatapetl, the volcano active at the time of Cortéz's invasion; and Acapulco for the voyage arrival scenes in Mexico. Almost twenty thousand Mexican and Indigenous extras are used in the crowd scenes and as many as forty-five hundred in the sequence set at the edge of Paricutin's lava beds. The volcano is especially active during shooting, blowing huge clouds of smoke in the air, frequently blotting out the sun's rays and causing filming delays.

The plot is fairly complicated. Tyrone Power is unfairly accused of heresy and imprisoned after an act of kindness to a Mexican who is fleeing the sadistic John Sutton, who is from a rival landowning family. Sutton has Power and his whole family imprisoned, and his inquisitors kill Power's twelve-year-old sister. With the help of newfound friend Lee J. Cobb and Jean Peters (in the kind of sexy Latina role often termed as "fiery" at the time), Power and his family escape; his parents flee to Italy, and Power, Cobb, and Peters go to Cuba to join Cesar Romero as Hernando Cortéz in his conquest of Mexico. The adventure takes a turn when Sutton arrives as an officer in Mexico and is murdered, with Power as the most likely suspect. Romero is the only Latino actor among these five principals, which is par for the course at this point in Hollywood history. That he is the vibrant heart of the film is Romero's triumph. As the famed conquistador, he gives the film a joyful swagger and a shot in the arm. Power is a much bigger star, and Jean Peters has second billing, but Romero steals the movie right out from under them with what *Variety* lauds as his "stirringly virile portrait of Cortéz."

For Romero, it is the best film experience of his career, both because he continues to enjoy spending time away from Hollywood with Power and because the part is so good. Cortéz is larger than life but completely earthy, corporeal, and vivid. Power looks a little silly occasionally in his Spanish helmet and pantaloons, but Romero swaggers about like pantaloons are the sexiest, manliest pants in the world. The strained Romero of *Carnival in Costa Rica* is nowhere to be seen. *Captain from Castile* is a huge hit, Fox's fourth-highest grossing film of 1947 after another big-budget epic, *Forever Amber*; a Betty Grable show business musical, *Mother Wore Tights*; and that year's Oscar winner for best picture, the antisemitism-themed drama *Gentleman's Agreement*.

Sly Fox

Directly after *Captain from Castile*, Romero is sent on location to Maine for a very different kind of film: *Deep Waters*, which casts Dana Andrews as an architect who prefers life as a lobster fisherman and Romero as his down-to-earth Portuguese first mate, best friend, and housemate. In a highly unusual story development, they end up coparenting twelve-year-old orphan Dean Stockwell after getting him released from reform school. It's real, gritty, and as far away from *Costa Rica* as *Castile*. Romero thrives in the atmosphere of male companionship on the open sea—a milieu certainly familiar from the coast guard. The film gets an Oscar nomination for its special water effects but does not fare especially well at the box office.

Next, Romero is loaned to MGM for *Julia Misbehaves*—his first time back at the studio since *Rendezvous* in 1934. It's a breezy romantic comedy starring Greer Garson, Walter Pidgeon, and Elizabeth Taylor, with pratfalls, squabbles, and misunderstandings. It works well enough, but everyone seems a bit too worldly-wise, if not long in the tooth, to engage in all this foolishness—particularly Romero as a lovesick acrobat mooning after Garson, unaccountably misunderstanding her, and always somehow missing the point. Bosley Crowther calls it "a bright and beguiling swatch of nonsense" in the *New York Times*. He is not wrong.

During the *Julia Misbehaves* shoot, however, an event far from the MGM soundstage takes place that is probably not on Romero's radar in the slightest. In Washington, DC, the Supreme Court issues something called the Paramount Decree—a legal decision that will have a major impact on his professional future and that of everyone else he knows in Hollywood. The complicated case is a decade-long attempt to use government antitrust rules to force the major film studios to divest themselves of their theater chains. For complicated procedural reasons Paramount is the named party, but it affects all the studios. They have long owned and operated their own theaters all over the country, monopolizing the marketplace to such an extent that they can force independent theaters into a corner, often imposing blind or block booking of their films. In other words, if you want a big hit like *Captain from Castile* for your independent theater, you have to take *Carnival in Costa Rica* along with it, often without having the chance to screen either film ahead of time.

That unfairness and the studios' overwhelming market advantage over competing theaters are the issues at the heart of the ruling. The Supreme Court's solution in the Paramount Decree is to force all the major studios to divest themselves of their theater chains entirely. What that means is that

20th Century Fox (like all the studios) no longer has a guaranteed marketplace for their films. Their prolific output has been based on a business model that assures them that every single film they make is exhibited. The entire structure of their B unit (which includes most of the movies that have featured Romero as the main star rather than as a secondary lead) is built around Fox knowing that whatever double-bill they offer will automatically be in theaters nationwide. Overnight, this certainty evaporates. Maybe Zanuck and his executives see it coming. Romero certainly does not. And while Fox's gross profits are impressive in the immediate post–World War II period, they begin a precipitous decline in 1947 that is only temporarily halted in the early 1950s by its expensive foray into widescreen CinemaScope.

After *Julia Misbehaves*, Romero returns to Fox as a romantic fool who should know better in another piece of fluff, *That Lady in Ermine*—an unfunny (and uncredited) adaptation of the operetta *Die Frau im Hermelin*, with a convoluted plot about nineteenth-century countess Betty Grable (and the ghost of her lookalike sixteenth-century ancestor) falling for Hungarian conqueror Douglas Fairbanks Jr. and eschewing weakling husband Romero. It becomes legendary director Ernst Lubitsch's last film. He dies early in the shoot, well before he has a chance to give the proceedings the famous Lubitsch Touch. The dour, exacting Otto Preminger takes over—a director not known for his deftness with light comedy. Preminger insists Lubitsch get sole credit, though it's debatable whether Lubitsch would thank him for crediting him with the tepid film that emerges. The most interesting thing studio publicists can think of to highlight for the press is that the ermine coat worn by Betty Grable in the film costs $28,000 and is made of nine hundred golden-white Russian ermines. One of her big musical numbers is *Ooo, What I'll Do to That Wild Hungarian*. It is not a box office or critical success.

Fox casts Romero again as the also-ran for Betty Grable's favors when she is billed as the "hard tootin', freebootin', high falutin', rootin' tootin', six-shootin'" *Beautiful Blonde from Bashful Bend*. While singing her opening number, saloon singer Grable comes upon her good-for-nothing boyfriend Romero doing the dirty with another woman. In the mayhem that follows, Grable accidentally shoots a judge. On the lam with Olga San Juan, she masquerades as a Swedish schoolteacher in a town called Snake City. Romero follows her, and slapstick mayhem ensues. In 2016, film historian Hal C. F. Astell makes a sharp observation in *Apocalypse Later*:

It's notable today that this white woman who passes for a Swede (Betty Grable) has a Spanish-speaking boyfriend (Cesar Romero) and a Hispanic companion (Olga San Juan) who passes for Native American. No wonder the Hays Office had problems with this script as, after all, miscegenation was against the Production Code! Certainly Joseph Breen, the head of the Code, had as much trouble with Judge Alfalfa J. O'Toole indulging in an illicit relationship with someone named Conchita (San Juan) as with him having extra-marital relations in an old west saloon's hotel room. Irony abounds here. While Olga San Juan, who plays Conchita, seemed as Hispanic as her nickname of the "Puerto Rican Pepperpot" suggests, she was born in Brooklyn and grew up in Puerto Rico, a US territory. However, Cesar Romero, as the Latin lover who so upsets our heroine, had Cuban parents, even if he was born in New York and raised in New Jersey. How Puerto Rican (i.e. American) blood falls foul of the Production Code's miscegenation rule but Cuban blood doesn't, I have no idea.

If only the film were as interesting as Astell's cultural commentary. Writer and director Preston Sturges is clearly striving for the kind of inspired, breathless mania of his 1944 hit, *The Miracle of Morgan's Creek*, but the film plays as frantic farce devoid of human feeling. It is a box office disaster. Fox cancels Sturges's contract and effectively ends his career with the stroke of a pen.

The failure of *Beautiful Blonde from Bashful Bend* does not occur in a vacuum. It is part of a restructuring going on in the movie business as a whole—financially, technologically, and creatively. The forces at play in Fox's case are well documented and explored in other books, most notably Scott Eyman's *20th Century-Fox: Darryl F. Zanuck and the Creation of the Modern Film Studio*. In terms of how these changes affect Romero, the situation is simple: The kinds of musicals where Romero is a second lead, particularly those with South and Central American appeal, become a thing of the past, and the number of B films—a category where he is a top-line star—is severely reduced. The studio-controlled B unit itself is shuttered in 1946 in favor of making output deals with independent B producers. Fox releases twenty-one of these in the 1947–1948 season, but that number decreases to five in 1949 and just three in 1950.

Romero faces an uncertain future, but he wants to project an image of himself as a man on top of the world. He throws a huge, expensive cocktail party at his house. *Photoplay* breathlessly calls it a "cocktail-through-dinner-through-dawn-soiree" to honor Samuel Shellabarger, author of the novel *Captain from Castile*. Shellabarger's latest novel, *The King's Cavalier*, is the story of a Frenchman and an Englishwoman caught in the wild plots and counterplots surrounding the Bourbon conspiracy against Francis I in Renaissance France, and he has reportedly written one of the main characters with Romero in mind. Joan Crawford, Mark Stevens, Anne Baxter, John Hodiak, Gary Cooper, Lex Barker, and Hoagy Carmichael show up, and Judy Garland happily entertains everyone with an impromptu performance, singing into the wee hours. Everyone has a wonderful time. No one is persuaded that Romero is about to star in a movie version of *The King's Cavalier*—a project that is never made.

And his next assignment at Fox is something of a comedown: *Love That Brute*, a remake of Romero's 1941 hit *Tall, Dark and Handsome*, but he plays the rival gangster rather than the lead. Burly Paul Douglas is the mobster who gets Jean Peters, and all Romero gets is his comeuppance. Why Paul Douglas is considered a bigger star than Romero in 1950 is perplexing. Douglas is tired and bloated. Romero is in his prime. Yet after fourteen years at the studio, this is the last film Romero makes under long-term contract.

Trade papers as well as the *Los Angeles Times* print stories that Romero is asking to be let out of his contract so he can pursue bigger and better projects elsewhere. It's the equivalent of out-of-favor politicians giving up their seats to "spend more time with their families." By the time *Love That Brute* is released in May 1950, Cesar Romero's contract at 20th Century Fox is canceled. It is not his choice.

4

Passport to Danger

In the early 1950s, according to Broadway and Hollywood columnists, Cesar Romero is everywhere at once, working constantly. He is a globe-trotting adventurer, returning to Hollywood to shoot *Prisoners of the Casbah* after making *Shadow Man* in England, *The Naked Sword* in Mexico City, and *The Americano* in Brazil. He will head back to Mexico City to costar with Burt Lancaster and Gary Cooper in *Vera Cruz*. He has his own television show coming up, *Passport to Danger*, and guest stars on *The Martha Ray Show*, *Show of Shows*, *What's My Line?* and *The Edgar Bergen Show*. He even launches a nightclub act. Details of each appearance, each adventure, appear in print and on radio. Publicity is like oxygen to a show business career. The cumulative power of tossing off the names of all those cities and titles gives the definite impression that things are going fantastically well for globe-trotting movie star Cesar Romero.

Things are not going that well.

In the first couple of years after 20th Century Fox cancels his contract, he remains a William Morris client, though not necessarily one who is a top priority. He is unsure where to turn or how to best concentrate his energies, but no one is going to know about the struggle—not his family, not his friends, and certainly not the studio and network executives who hire, fire, and sign contracts. It isn't only a matter of pride; his survival depends on keeping his problems to himself. The minute anyone smells blood, it's all over.

Years later, he is more open about how hard the early 1950s are for him, telling friends how at one point he is literally down to his last few thousand dollars, with no job, no income, and a house full of people depending on him. He feels poor—certainly, from the outside it's a privileged, First World version of poverty for a celebrity with a whole room just for his clothes—but to Romero it is a wholly unexpected and unwelcome return to the

uncertainty of his early years back in New York in his late teens and early twenties. A lifetime ago. Everyone assumes he has a lot more in savings than he does, and members of his family are the last people in the world he wants to be honest with about his battered finances. He is a Hollywood success story, happily taking care of everyone out of a deep sense of love and responsibility, making it look easy. That is his identity.

Romero's finances haven't been particularly healthy since the war. He was off studio salary for almost three years, with nothing but his military pay coming in: seventy-six dollars per month. He uses that money mainly when he's on shore leave. He takes care of his family from his savings, which seem ample enough at the time. At age thirty-six, on a steady career path, he hasn't contemplated the possibility of going three whole years without a decent salary. He comes back home after the war and figures things will be fine—he even does the addition to the house, so he has a place to live. It doesn't seem extravagant. He's on contract. There's money coming in.

He just hasn't really had a chance to replenish his savings, a situation that doesn't feel like a necessity, never mind an emergency—until it is. Beginning in the late 1940s, every major studio is cutting costs and canceling contracts. The belt-tightening in Hollywood isn't just an effect of the Paramount Decree and movie theater divestiture. Rebuilding the European marketplace is proving complicated with allies and former enemies alike; Britain, France, Italy, and Germany all explore protectionist policies that limit American film imports. Domestic moviegoing is in a serious slump that will never actually reverse completely. Between 1946 and 1950, attendance falls from ninety million tickets sold per year to sixty million, a decline of one-third. And then there's television—the ugly little box in the living rooms of increasingly large numbers of Americans, many of whom are moving to the postwar paradises of suburban subdivisions, far away from downtown movie theaters.

Romero's first film away from Fox is a one-picture deal for *Once a Thief . . .* , distributed by United Artists. It seems like a promising new beginning in some ways. The gritty crime drama opens with down-on-her-luck June Havoc in San Francisco making a new friend who helps her replenish her bankbook by becoming a jewel thief. The two women tag team jewelry stores—the friend using a ruse to lure counter staff away from showing Havoc a tray of jewelry, left on the counter long enough for her to palm something and get out. They get away with it until they don't. Havoc skips town when the law closes in and heads for Los Angeles to build a new

life. She finds work, opens a savings account, and builds up a small nest egg. She meets thieving, small-time hustler and womanizer Cesar Romero and everything rapidly goes to hell in a handbag. The film's use of practical locations in and around the Bunker Hill section of Los Angeles as well as in the Los Angeles County jail gives added texture and realism. It takes no prisoners. Romero finds the one piece of jewelry Havoc kept from her exploits in San Francisco and tries to sell it . . . and gets arrested. Devastated by Romero's betrayal, Havoc decides she will take responsibility for her crimes in San Francisco—after robbing a liquor store at gunpoint for the $200 it takes to bail Romero out of jail. She drives him out of town and shoots him to death, then turns herself in. Now she's a murderer and a jewel thief. She dully faces the consequences.

It is an engrossing, unexpectedly emotional film—certainly as interesting as *Deep Waters*. The trouble is, everything engrossing and emotional about it involves June Havoc and other supporting characters like Lon Chaney Jr. and Marie McDonald, a starlet known in the tabloids as "The Body," who is way more interesting as an actress than her torrid press coverage suggests.

Romero is just a sketchily written, two-dimensional bad guy, more or less a plot device that gives Havoc a chance to shine. Interestingly, it's the opposite of most films of this era that tend toward exploring the male experience and adding a girlfriend or wife so there's someone to plead with the hero to be careful when he gets himself in danger. But as refreshing as the focus on the female protagonist may be in the larger picture of the industry as a whole, it does nothing for Romero's career. Nor does the film make even a ripple at the box office, and it is largely ignored by reviewers.

The light at the end of the tunnel for Romero's career in the early 1950s is television. His romantic comedy chops and dancing skills, burnished over years of Fox musicals, are just the ticket for appearances on *The Milton Berle Show*, *The Ed Wynn Show*, and *The Saturday Night Revue with Jack Carter*. But guest appearance fees are nominal. His only job is to charm his way through sketches and undemanding musical numbers. These jobs don't seem to point toward a solid future.

His press coverage is as adoring as ever, though the one positive development that comes with aging a bit and finding himself with a lower public profile is that columnists seem to give up on finding him a wife. Now he is a confirmed bachelor rather than an eligible one, and it seems relatively clear that he is not going to find the right girl.

An unexpected opportunity arises: a return to the theater. Romero dusts off Count di Ruvo's opera cape and stars above the title in an Atlanta production of *Strictly Dishonorable*—in the same role he played in his early twenties, though he is now in his early forties. It actually doesn't require as much willing suspension of disbelief from the audience as it sounds like it might. Though written with someone younger in mind, the role just requires someone sexy and desirable who poses a credible threat to the ingenue's virtue. Romero has that down. The financial arrangements are very favorable—he has a four-figure guarantee per week with a percentage of the gross once the show breaks even. But the salary ends with the end of the limited engagement. No one is offering an open-ended run in a Broadway show. He will continue to do stock and dinner theater in the summers to come if he isn't otherwise engaged, but it isn't a major income source—more a way keeping his juices flowing and keeping himself busy.

Being busy suits him. He is never happier than when he plays a balancing act, going from one job to the next without coming up for air and sometimes working simultaneously on more than one project. Like his first years in Hollywood, his early years at Fox—his happiest times.

A brief return to colorful film musicals materializes with *Happy Go Lovely*, starring Vera-Ellen, David Niven, and Romero in a chorus-girl-makes-good backstage story that revolves around the meet-cute of Vera-Ellen and Niven amid musical theater impresario Romero's frantic struggles to find the money to save his show's Scottish premiere. Just before leaving to film in the UK, Romero has an appendectomy, after which he quips to *Photoplay*, "I wanted a scar that's made in America." The script is formulaic at best, but Vera-Ellen and Romero are already friends, so the shoot is pleasant. Vera-Ellen has recently lost her father and has brought her grief-stricken mother along. She has matching mother-daughter outfits made, and Romero escorts the two on the town to various events. Romero and Niven are cordial, but they do not socialize extensively. Perhaps the memory of Primmie Niven's death at that 1946 party with Tyrone Power makes spending time together an uneasy prospect. Ultimately, the film does no one's career any good and dies at the box office. Next Romero gets an offer from Lippert Pictures and shoots four low-budget independent films—no prestige, but with a back-end percentage that becomes an ongoing, if lower than hoped for, steady income stream for a few years.

Robert L. Lippert is a former San Francisco movie theater owner (credited with starting free dish nights during the Depression to lure in cash-strapped audiences) who turns out a string of films in the 1950s that may be short on frills but often have a bit of ambition. The first to shoot (though not the first to be released) is *The Jungle*, where Romero is the fly in the ointment to a modern-day princess trying to save her people from a herd of rampaging woolly mammoths who are not, it seems, as extinct as people think. It's a short, uncomfortable location shoot in Bombay made with live elephants—some in their natural state, others wearing cute fur coats.

Coming home from India, Romero stops off in Turkey. "I wouldn't think of flying over Istanbul without stopping off to see Virginia Bruce," he tells the Rambling Reporter, who highly approves of Romero keeping up ties with his former costar and once-rumored girlfriend, now married to a "fantastically" wealthy Turk, calling it an example of Romero "cherishing his Filmland friends" wherever they may be. "Friends," says Romero, "are, after all, perhaps our most valuable possessions."

Once back in Los Angeles, he plays the leader of a rescue mission to recover a downed atomic rocket in the South Pacific who come upon a colony of dinosaurs in *Lost Continent*. Next, he is a supervising G-man far from the action in *F.B.I. Girl*, and finally he is on a location shoot back in the UK as a stranded American who pisses off the real authorities by solving a murder in *Scotland Yard*.

In between shooting *F.B.I. Girl* and leaving for England, something he and his family have feared for so long finally happens: his father dies. As grief-stricken as they are, it also comes as something of a relief after Romero Sr.'s decades of illness. His young grandchildren never know him as a successful and vital wealthy businessman. His wife and children barely remember him that way. Romero wishes his dad lived long enough to see him back on top—if that ever happens. His public and private faces remain optimistic and vigorously ambitious. His inner life is one of uncertainty and no small amount of dread.

While shooting the Lippert films, when he is not on location, he continues making television appearances, mostly in New York—on *All Star Revue* with Eddie Cantor, two appearances on *The Colgate Comedy Hour*, and a return visit to *The Milton Berle Show*. The problem with variety shows, apart from the low pay, is that he is rarely asked to do more than show up in a tuxedo and make the ladies swoon—sometimes to genuine comic effect—but

he doesn't seem to be fully present. It's not that he is giving less than his best or walking through the performances; it's that he hasn't found a heightened version of himself that fully pops over the airwaves yet.

He will, though. He shoots a couple of scripted dramas for the anthology series *Stars over Hollywood*, *Schlitz Playhouse*, and *The Ford Television Theatre*, which is more like making movies, just faster and cheaper. He also makes his first game show appearances on *What's My Line?* and *The Name's the Same* (a *What's My Line?* knockoff about nonfamous people with the same names as celebrities). In 1951, he appears on all four television networks: NBC, CBS, ABC, and the now largely forgotten smaller operation Dumont. He takes every opportunity that comes his way, yet he is still straining to find a sweet spot when he appears as himself. He attends countless Hollywood social events, appearing often in *Modern Screen* and *Photoplay* dancing with the likes of June Allyson, Betty Furness, Anne Baxter, and Greer Garson at various functions, many headily labeled "The Party of the Year." The gatherings are lavish. When Sonja Henie throws a circus party at Ciro's, she turns the bar and main dining room into a big top, stopping traffic on Sunset Boulevard as she arrives on an elephant. Inside, a calliope plays, snake charmers dance with live reptiles, caged hippos roar and spit, and trapeze acts perform around the rooms with alarming abandon. Romero comes as a gaucho, and Vera-Ellen is a fortune teller. But their smiles seem strained.

The strain is there in other ways as well. Romero has never been a big drinker; heavy smoking is his main vice. But in August 1951, he is arrested for drunk driving and pays a small fine. In the 1950s, your first or sometimes even your second or third arrest for drunk driving can still result in little more than a slap on the wrist. Another night he falls asleep with a lit cigarette burning. It falls on the floor and catches the rug on fire. The smoke wakes him. Romero moves on. Keeps busy. Keeps working.

He shoots a pilot for a syndicated half-hour drama he doesn't think much of, playing a dashing diplomatic courier named Steve McQuinn. At the top of the show, a voice-over sonorously intones, "One of the vital functions of the United States government is to establish and maintain diplomatic relations with other countries. In every friendly and civilized nation in the world there is an American Embassy or Legation. Whether it is Paris or Cairo, Shanghai or any other remote outpost, the most reliable and confidential means of communication is the Courier service. Armed only with his passport, the Courier, like a global postman, delivers the top-secret dispatches of our government. It is a *Passport to Danger*."

The pilot is set in Budapest. An imprisoned Hungarian priest passes vital information to Romero, who must act quickly to avert disaster. A few simple sets, a small cast, stock footage of Budapest for the opening and closing. It doesn't even take a whole week. Nothing comes of it at first.

He goes on location to Mexico for *The Sword of Granada*, aka *El corazón y la espada*, which offers two firsts for Romero: his first Spanish-language film and his first picture in 3D. It's actually the first 3D feature in Mexican history. It's a loopy plot, but it gives him plenty to do. In Moorish-occupied Granada, Cesar Romero is the rightful owner of a castle now occupied by the Moorish caliph who murdered his parents. He and a newly formed band of sword-wielding compatriots, including badass Katy Jurado, who wields a sword "as well as any man," try to take back the castle. There's a priest alchemist involved and a scheme to steal a rare gem that promises eternal youth. The 3D element calls for lots of sword fights with blades aimed at the audience. It takes a while to reach American audiences and is not particularly successful, but it performs well, if not spectacularly, in Mexico. It is one of a handful of Spanish-language films Romero makes over the years. To Spanish speakers, his facility with the language is passable but not good enough to keep him from being dubbed by a Mexican actor in *El corazón y la espada*.

Then comes a modern Western of sorts on location in Brazil with Glenn Ford, called *The Americano*. The film is originally planned for 3D, but somewhere in the preproduction process the idea is dropped. In addition to São Paulo, several weeks of filming take place on the Matto Grosso in Brazil. Because of unseasonably bad weather as well as problems relating to the film's Brazilian financing, the company is forced to return to Los Angeles in late September 1953, after shooting only one-third of the script; they wait a couple of months and then finish the film in Argentina. Back in the States, he suffers through a Columbia Pictures sand-and-sword epic shot on the cheap opposite Gloria Graham, *Prisoners of the Casbah*, which he later counts as one of the three worst films of his career. (The others are *She's Dangerous* and *Armored Car*.)

His constant work schedule keeps him from traveling with his mother to Cuba when Maria Mantilla Romero helps with national celebrations commemorating the one-hundredth birth anniversary of her father, José Martí. She is a sought-after guest, and all of her correspondence with Martí goes on exhibit. There is no more mention of him as her godfather—he is officially her father, at least according to President Batista, now a military dictator instead of an elected president—nor is there any mention of her illegitimate birth.

And happily, Cesar Romero finally finds his feet on variety television, perfecting a meta approach to being a heightened version of himself. In a 1952 episode of *The Colgate Comedy Hour*, a show he has appeared on several times before, he plays a sketch with host Eddie Cantor. The setup is that temperamental Romero won't come to set. He is locked in his penthouse: "Mr. Romero won't open up for anyone but a dame!" Up in the penthouse, Romero is on a divan with a beautiful woman who asks if he is seeing any other women. "I haven't even *seen* a woman in weeks," he says as a parade of women drift in and out, coming in from doors, out of closets, and from behind the curtains and furniture. One woman wonders why she is so drawn to him. "Because I'm devastatingly handsome," he replies. "But it's also my clothes." Eddie Cantor pretends to be a blonde Southern woman named Alabama Magnolia Blossom and makes his way in. Ten or twenty comic bits later, Cantor leaps up into Romero's arms, cooing, "Kiss me, honey chile!" Later, they do a matador sketch. Romero says, "I think of everyone who loves me, I love me best," then dances coyly to "A Pretty Girl Is Like a Melody."

The way Romero and Cantor play with gender, with Romero cradling him like a bride going over the threshold, doesn't cross over into anything remotely homoerotic—which is part of what makes it effective. It seems for all the world like two straight guys kidding around, secure enough in their heterosexuality that they aren't afraid of embracing the joke. It is a breakthrough in terms of Romero's variety show performances in the early 1950s. He seems completely and authentically himself, having the best time in the world. And that is the secret of being a good guest playing yourself: finding the heightened, somewhat fictionalized version of yourself that makes it seem like you just showed up to have a giggle with your friends—while playing an entertaining role of your own invention that clicks with audiences.

He does another hilarious turn on *I've Got a Secret*, a popular game show where four celebrity panelists (Bill Cullen, Jayne Meadows, Henry Morgan, and Dorothy Hart in this episode) take turns questioning someone with a secret. Each episode, a celebrity guest hides a secret as well. Romero is the guest in a January 1954 episode with the innocuous secret that every time anyone on the panel says some variation of "uh," he steps (rather hard it appears) on host Garry Moore's foot under the table. One of the panelists asks if his secret is perhaps "a great feat" of some kind. Romero replies, "It's not a great feat, but it's with my feet." There are lots of good-natured "bro"

moments about just what is going on underneath that table between Moore and Romero. When asked if he is prematurely gray, he quips, "I'm prematurely old."

The *I've Got a Secret* episode also has an incredibly funny callback joke. They replay footage of the prior week's guest, Zippy the Chimp, whose secret is he can shine shoes. Doing so reveals that panelist Henry Morgan has a rather large hole in the sole of his shoe. Garry Moore says hundreds of viewers have written in since the broadcast, offering to buy him new shoes. Moore has a different solution: he presents three brand-new pairs of shoes with holes in their soles to the other three panelists as well. They completely crack up. It's the kind of insider gag that still works. After the monkey and shoe bit, Moore welcomes Romero to the show by saying he was "just tremendous" on *The Martha Raye Show* the week before.

Moore is right. Romero has a whale of a time spoofing Liberace at a grand piano on *The Martha Raye Show*, complete with candelabra. He puts on this wide, demented smile—only slightly wider and more demented than Liberace's actual smile—and he plays the piano grandly, wafting his arms and bringing his graceful fingers to the keys, then going for a big finish by playing the piano with his forehead and feet. The audience screams with laughter. It's a small comic triumph—inventive, surprising, very funny, and, crucially, sweet and good-hearted. There is no easier target in the world than Liberace, an over-the-top, closeted but incredibly effeminate, bejeweled show business phenomenon—who is still looking for the right girl. Romero does not choose to try to make himself appear manlier by denigrating the much more femme Liberace. He doesn't need to—a testament to both his innate kindness and his performance awareness. Going for the throat will never be part of the Romero appeal on variety, game, and talk shows. Leave that to the insult comics.

Looking back from the vantage point of our own cultural sensibilities, Romero's sexual playfulness feels like it could fit in our time as well. He also gets a great opportunity to hone his skills as the host of twenty-one episodes of *Your Chevrolet Showroom*, a live variety show he shoots in New York. The producers have to fly him in for Friday night shows then back to Los Angeles, where *Vera Cruz* with Burt Lancaster and Gary Cooper is in preproduction; it will start shooting in Mexico right after Romero's final show hosting *Your Chevrolet Showroom*. In *Vera Cruz*, Romero's role is small, but he has a few good scenes as a trusted officer to Emperor Maximillian trying to smuggle $3 million in gold out of the country.

Your Chevrolet Showroom doesn't get a pickup order from ABC or Chevrolet. The most popular guest stars who can attract large audiences are usually booked to appear on bigger shows with Ed Sullivan, Milton Berle, Jackie Gleason, or Sid Caesar. Its ratings are far lower than its competitors, particularly boxing on NBC, a top-twenty show for most of the season. Without marquee guests, Romero isn't enough of a draw. Yet he is still a draw in the eyes of some columnists. His bachelor status hasn't *entirely* become a topic of the past. For his part, Romero seems to be done playing along. When asked about his lack of a wedding ring by the *Sunday Independent*, he gets straight to the point: "I've been answering questions for the past seventeen years, since I first arrived in Hollywood, on how it feels to be the screen's number one bachelor. The novelty is beginning to wear a bit thin."

He gets a happy surprise when he returns from the *Vera Cruz* shoot in Mexico: *Passport to Danger* finds financing, and the series is a go. They shoot at least thirty-eight episodes in just several months. The exact number shifts depending on the source, and the records are sketchy for shows in syndication, where programs are sold individually to stations and station groups all over the country separately, rather than to a single network. It is a lucrative deal for him, relatively speaking, and the work is easy. Most of the scenes are two-handers without a ton of physical action, and a whole episode can be knocked out in a couple of days. It doesn't make Romero rich—but it makes him sleep a lot better at night. *Billboard* approves, proclaiming, "The show's pilot has high production values and packs a suspense wallop!" The show is enough of a success that it is often the lead title in ABC Film Syndication's trade advertising, which also includes the anthology series *Douglas Fairbanks Jr. Presents* and *The Playhouse* as well as the crime drama *Racket Squad*.

By the mid-1950s, Romero's finances are stabilized, and offers for supporting roles in A pictures start coming in. He works for Fox again on *The Racers* with Kirk Douglas and Gilbert Roland, as a competitive car racer who convinces team manager Lee J. Cobb to hire hotheaded, risk-taking Douglas as a reserve driver. Darrell F. Zanuck's mistress Bella Darvi, an actress he tries without success to turn into a star, plays an internationally famous ballet dancer who inadvertently causes Douglas to crash and uses money from her wealthy lover to help him. When she and Douglas fall in love, she takes a break from her career to join the collection of wives and girlfriends that accompany the team of racers. She is terrified for Douglas's

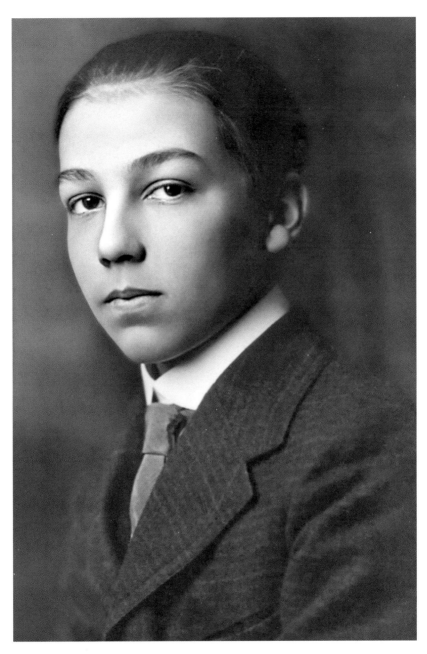
Cesar Julio Romero Jr., age twelve (1919). Courtesy USC Cinematic Arts Library

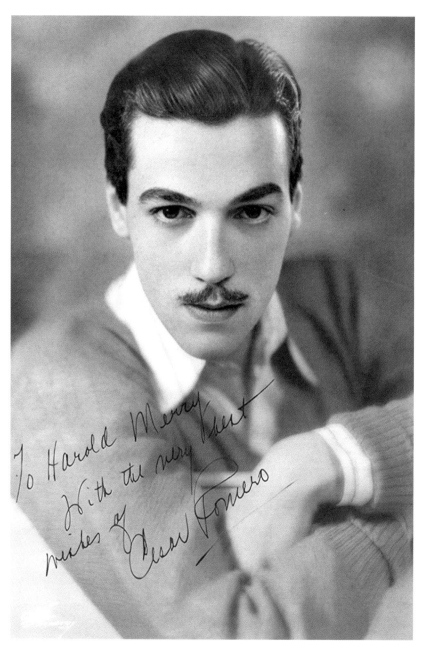

Cesar Romero, studio portrait (1931). Courtesy USC Cinematic Arts Library

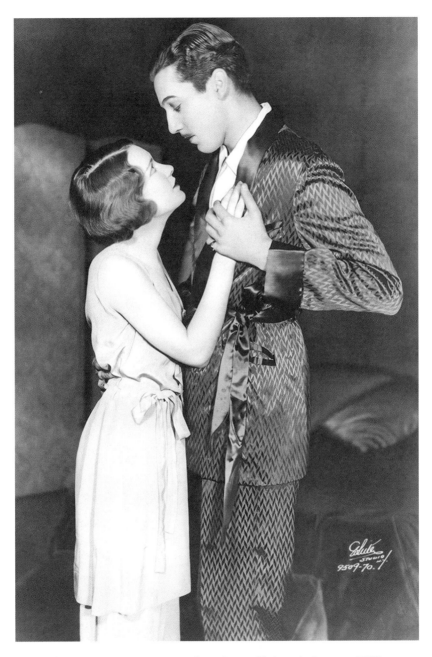

Elizabeth Love, Cesar Romero, *Strictly Dishonorable* (1931). Courtesy USC Cinematic Arts Library

Cesar Romero, *The Thin Man* (MGM, 1934)

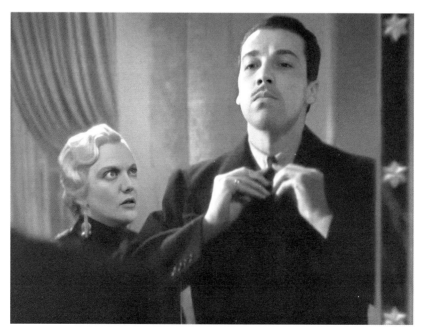

Minna Gombell, Cesar Romero, *The Thin Man* (MGM, 1934)

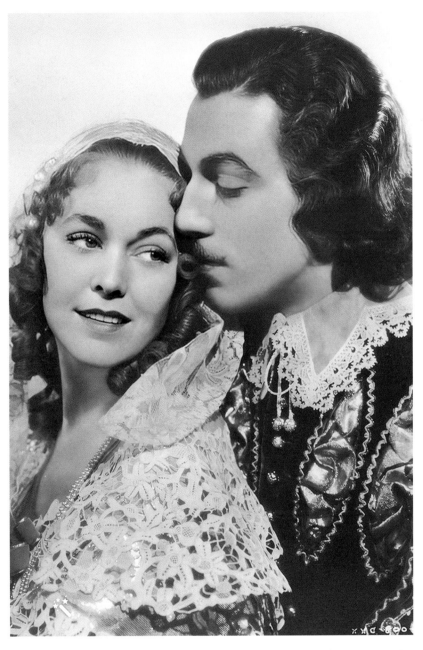

Maureen O'Sullivan, Cesar Romero, *Cardinal Richelieu* (20th Century Fox, 1935)

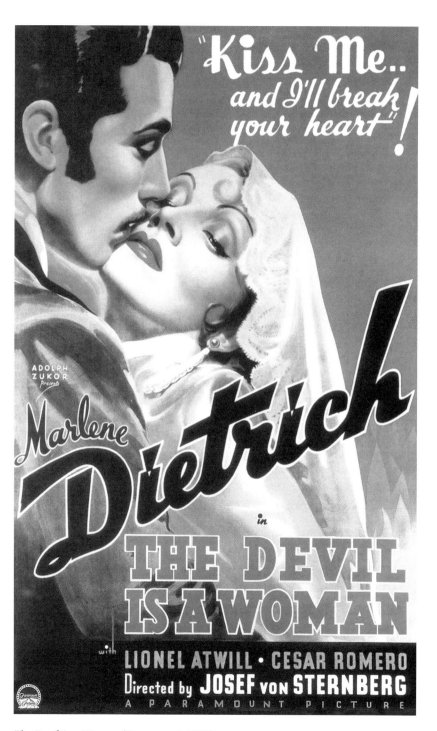

The Devil Is a Woman (Paramount, 1935)

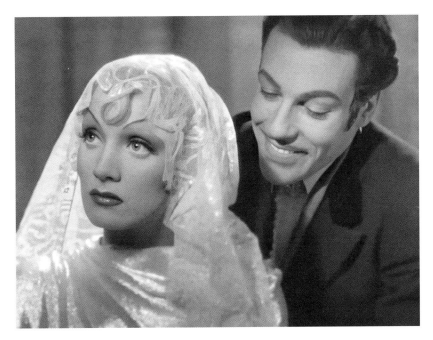

Marlene Dietrich, Cesar Romero, *The Devil Is a Woman* (Paramount, 1935)

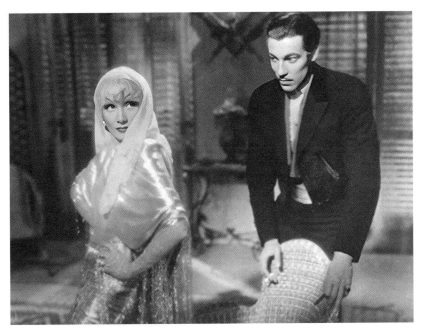

Marlene Dietrich, Cesar Romero, *The Devil Is a Woman* (Paramount, 1935)

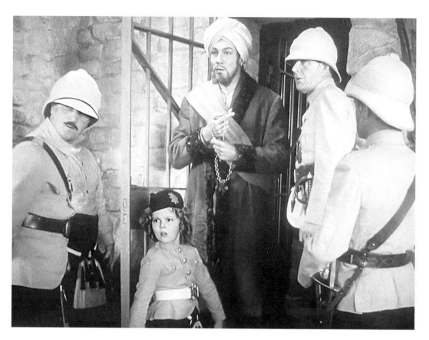

Shirley Temple, Cesar Romero, *Wee Willie Winkie* (20th Century Fox, 1937)

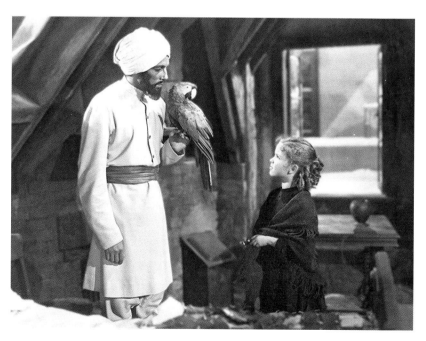

Cesar Romero, Shirley Temple, *The Little Princess* (20th Century Fox, 1939)

Cesar Romero, *The Return of the Cisco Kid* (20th Century Fox, 1939). Courtesy USC Cinematic Arts Library

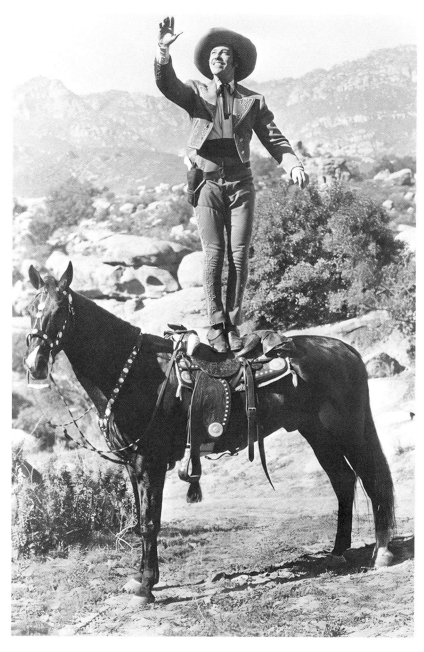

Cesar Romero, *Viva Cisco Kid* (20th Century Fox, 1940). Courtesy USC Cinematic Arts Library

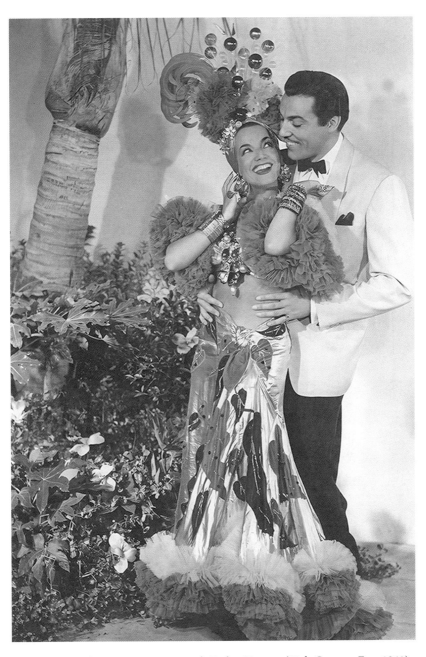

Carmen Miranda, Cesar Romero, *Week-End in Havana* (20th Century Fox, 1941)

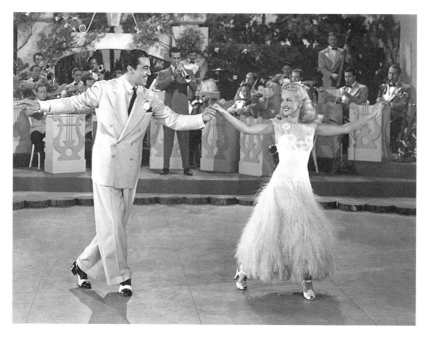

Cesar Romero, Betty Grable, *Springtime in the Rockies* (20th Century Fox, 1942)

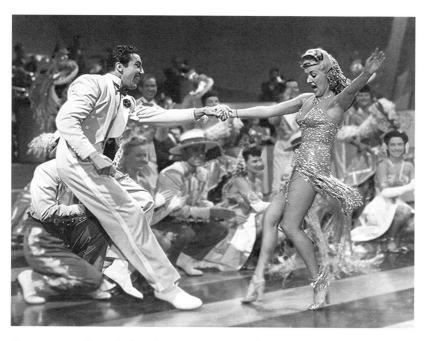

Cesar Romero, Betty Grable, *Springtime in the Rockies* (20th Century Fox, 1942)

Cesar Romero, *Wintertime* (20th Century Fox, 1943). Courtesy USC Cinematic Arts Library

Cesar Romero, servicemen, US Coast Guard active duty (1943–1945). Courtesy Alamy

Cesar Romero, serviceman, US Coast Guard active duty (1943–1945)

Cesar Romero, US Coast Guard active duty (1943–1945)

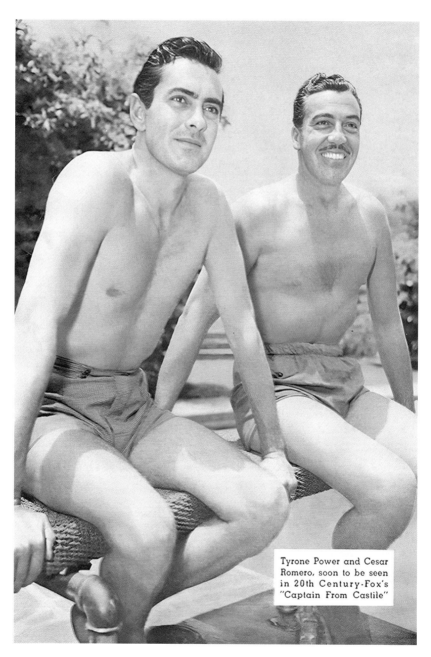

20th Century Fox publicity shot: Tyrone Power, Cesar Romero on their South American Tour (1946). Courtesy USC Cinematic Arts Library

Cesar Romero, *Captain from Castile* (20th Century Fox, 1947)

Cesar Romero, Betty Grable, Douglas Fairbanks Jr., *That Lady in Ermine* (20th Century Fox, 1948)

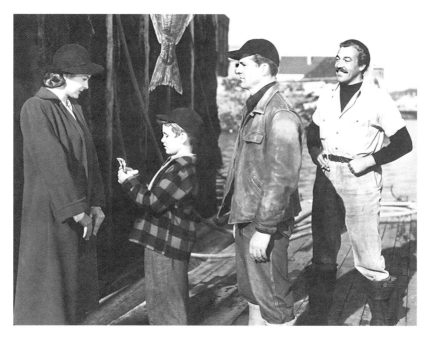

Jean Peters, Dean Stockwell, Dana Andrews, Cesar Romero, *Deep Waters* (20th Century Fox, 1948)

Sid Melton, Whit Bissell, John Hoyt, Hugh Beaumont, Cesar Romero, Chick Chandler, *Lost Continent* (Lippert Pictures, 1951)

Burt Lancaster, Cesar Romero, Gary Cooper, *Vera Cruz* (United Artists, 1954)

Gary Cooper, Burt Lancaster, Cesar Romero, *Vera Cruz* (United Artists, 1954)

Kirk Douglas, Cesar Romero, Bella Darvi, Katy Jurado, *The Racers* (20th Century Fox, 1955)

David Niven, Cesar Romero, Gilbert Roland, *Around the World in Eighty Days* (United Artists, 1956)

Cesar Romero, Ilka Chase, *Ocean's Eleven* (Warner Bros., 1960)

Frank Sinatra, Cesar Romero, Deborah Kerr, *Marriage on the Rocks* (Warner Bros., 1965)

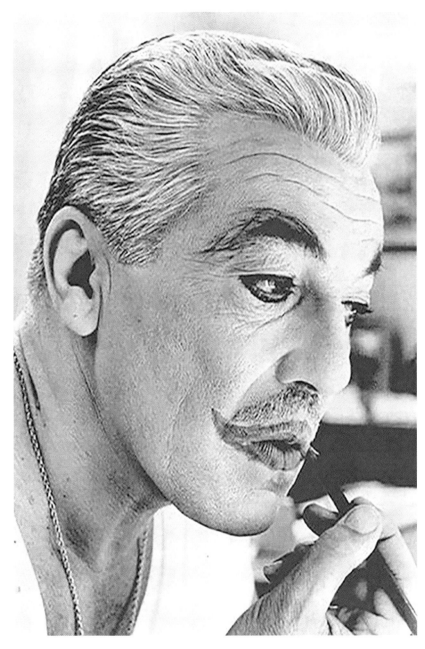

Cesar Romero, *Batman: The Movie* (20th Century Fox, 1966)

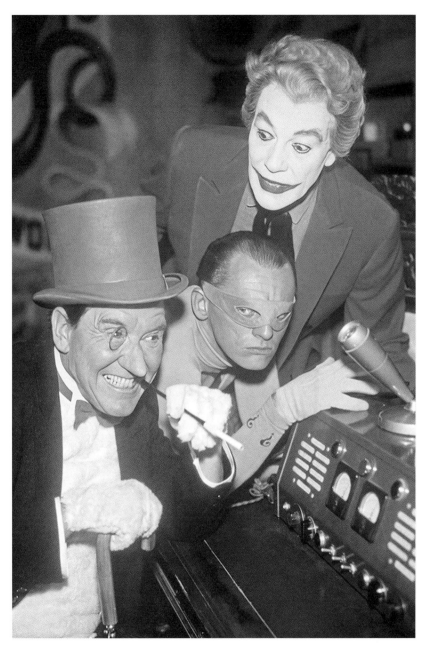

Burgess Meredith, Frank Gorshin, Cesar Romero, *Batman: The Movie* (20th Century Fox, 1966). Courtesy MPTV Images

Cesar Romero, *Batman: The Movie* (20th Century Fox, 1966)

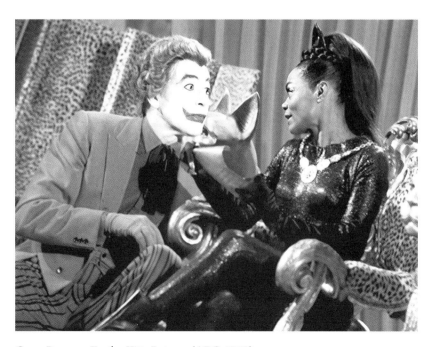

Cesar Romero, Eartha Kitt, *Batman* (ABC, 1968)

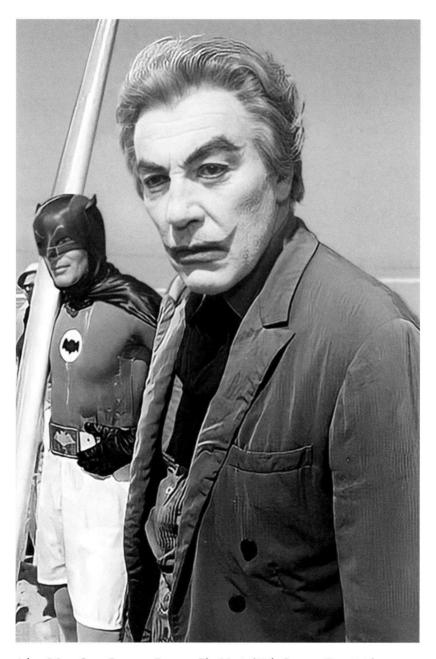

Adam West, Cesar Romero, *Batman: The Movie* (20th Century Fox, 1966)

Joan Crawford, Cesar Romero (1962). Courtesy USC Cinematic Arts Library

Lucille Ball, Cesar Romero, *Here's Lucy* (Desilu/CBS, 1969)

Arthur Mullard, Warren Oates, Telly Savalas, Cesar Romero, Nicky Henson, *Sophie's Place,* aka *Crooks and Coronets* (Warner Bros., 1969)

Richard Bakalyan, Cesar Romero, *Now You See Him, Now You Don't* (Walt Disney, 1972)

Cesar Romero (1973). Courtesy USC Cinematic Arts Library

Cesar Romero, Jane Wyman, *Falcon Crest* (CBS, 1987)

Kim Novak, Cesar Romero (1987). Courtesy Alamy

Cesar Romero, Estelle Getty, *The Golden Girls* (NBC, 1990)

safety. He is terrified that his love for her will keep him from taking the risks he believes will take him to the top. Thrills and spills ensue, with a "you'll never walk again" accident threatening to finish Douglas's career if not for Darvi's unshakable love and confidence. Gilbert Roland, a Latin lover in his own right, shows up as Douglas's main rival-turned-teammate. Roland and Romero take turns out-smoldering one another. Darvi's performance is inert, and she sucks a lot of the energy out of the scenes she is in, but even she can't slow the film's adrenaline-pumped momentum.

Next comes a memorable cameo in Mike Todd's all-star extravaganza *Around the World in Eighty Days*. The behind-the-scenes story of Mike Todd's herculean efforts to bring the Jules Verne classic to the screen is every bit as fantastic as the plot. He goes into hock to raise the money; he somehow convinces over forty major celebrities to do cameos; he fires the original director; he pulls the wool over the eyes of local authorities in France, Spain, Thailand, India, and the United States in order to get his round-the-world location shots; he goes to court over the writing credits; he gets in a major fight over allegedly hiring Communist musicians . . . and he has the last laugh. It becomes a box office blockbuster and wins the Best Picture Oscar.

In between film and television appearances, Romero usually spends a couple of months over each summer starring in additional productions of *Strictly Dishonorable* at the Northland Playhouse in Detroit, the Sombrero Playhouse in Phoenix, Mill Run Playhouse in Chicago, the Cincinnati Summer Playhouse, Grist Mill Playhouse in New Jersey, Pleasure Island Show Bowl in Massachusetts, and Ivoryton Playhouse in Connecticut. He does commercials, print ads, and personal appearances for Oldsmobile and print ads and personal appearances nationally for Petrocelli Suits. He also breaks in a Vegas act at the Dune Hotel's Havana Mardi Gras, to the enthusiastic approval of *Daily Variety*, which gushes, "Cesar Romero hit the Arabian Room with a splash. In his first Vegas appearance, he displays maximum savoire-faire with his terping [a *Variety*-speak reference relating to the singing figure of mythology Terpsichore] and joking. He proves a likable comedian."

The Vegas act leads to a very brief recording career—two albums, but only one is music. On *Songs by a Latin Lover*, a few songs are in English, like "Brazil," and some are Spanish classics like "Cielito Lindo" and "Maria Elena." Some of the tracks have a second life a few years later on a compilation album with Romero, Mel Tormé, and Robert Alda. The other album is a collection of spoken monologues for "CO STAR, The Record Acting Game," a popular series of records in the late 1950s and early 1960s featuring

famous actors performing scenes from plays, novels, and movies "costarring YOU! YOU act scenes opposite your favorite star!" The albums leave blank spaces between the recorded lines so the listener can recite the lines themselves, reading along from accompanying printed scripts. An eclectic mix of stars record individual albums, including Vincent Price, Pearl Bailey, Don Ameche, and Sir Cedric Hardwicke. Some do famous scenes; others read from projects created especially for the records. Romero's scenes are from the latter group. It is irresistible from a novelty aspect though rather ordinary and disjointed in reality.

Romero enjoys a nice reunion with friends Desi Arnaz and Lucille Ball while filming their origin story as the first episode of their last *I Love Lucy* incarnation, *The Lucy-Desi Comedy Hour*. Ann Sothern does a crossover appearance, playing her character from *Private Secretary*. The action is a flashback to 1940, when Ball and Sothern are single gals on the loose in Havana and meet two dishy tour guides, Arnaz and Romero. William Frawley and Vivian Vance are also written in—they are on their second honeymoon, and this is how they meet the Ricardos.

Romero meets Ruta Lee while visiting Tyrone Power and Romero's former costar from *The Devil Is a Woman*, Marlene Dietrich, during the filming of Billy Wilder's *Witness for the Prosecution*. Lee, who plays a small but pivotal role, is subsequently named a 1957 Deb Star (a 1953–1968 starlet award ceremony that echoes the old WAMPAS Baby Stars of the 1920s and 1930s). She isn't sure if Power arranges it or how it comes about, but Romero escorts her to the awards dinner.

"And that was my first outing with that elegant, fabulous, wonderful man who became a very good, true friend over the years," she says in a 2023 interview with the author. "I was thoroughly enchanted. In later years he came to our house for parties and at Christmas. He was so gracious and warm. And kind. If he joked it was always gentle—often with himself as the joke—or if it was teasing it was teasing someone for their good qualities. You tease a beautiful woman about her beauty, not a homely person, say, about being homely. He was always making kind gestures."

Soon after *Witness for the Prosecution*, in November 1958, Romero, as well as the rest of the world, is shocked when Tyrone Power dies at the age of forty-four while in Spain shooting *Solomon and Sheba* with Gina Lollobrigida and George Sanders. While filming a dueling scene with Sanders, Power collapses from a massive heart attack. On the way to the hospital he dies; later he is diagnosed as having undiscovered angina.

His young, seven-months-pregnant widow, third wife Debbie Ann Power, faces a feeding frenzy of reporters and photographers at the airport when she returns from Spain with the body. During the funeral, she sits beside the open casket holding the corpse's hand while an organ plays Irving Berlin's "I'll Be Loving You Always." Romero eulogizes Power: "He was a beautiful man. He was beautiful outside, and he was beautiful inside. Rest well, my friend." He remains dignified even as the event descends into a circuslike atmosphere. Crowds of fans are on hand. Loretta Young causes a stir by arriving in Asian makeup from a television role. The fans cheer Yul Brynner, Ty's replacement as Solomon. "Look at him," a woman shouts. "He's growing a beard. And him with his bald head." Babies cry while their parents eat boxed lunches, treating the funeral as a show. A little boy falls into an artificial lake and sputters up, screaming. A girl gets a Hula-Hoop lesson from her dad.

Romero does what he always does: he throws himself into his work. Back to back, he shoots an episode of *Wagon Train*, guest stars on *The Arthur Murray Party*, and then shoots a four-episode arc on *Zorro* as Don Diego de la Vega's shyster uncle.

The death of his beloved friend doesn't mark the end of just one era for Romero; it marks the end of several. The closeness he shared with Power—a time of young men growing into themselves, finding success and fulfillment, being tested and triumphing in the midst of war—is in the past. The golden Hollywood of Romero's twenties and thirties is a different society now, and it's a different business entirely. Romero adapts. He creates his own path, determined to grow and evolve with the ways the industry is changing rather than becoming an old gasbag who bemoans the present while longing for the past.

He even discovers the Twist.

"That Dance Goes Blueblood—Everybody's Doing It!" boasts the *Los Angeles Herald-Examiner* society editor. "The Twist is moving up fast in Los Angeles society, from formal balls to small private parties and the social set has gleefully taken to the torrid beat of the dancing madness—with all heck breaking loose all over town. Last night, Mayor Sam Yorty was out Twisting with columnist Louella Parsons. Cesar Romero, probably the best Twister in town, soon joined the contortionist spectacle with socialite Mrs. Lee Anderson!"

It's not just the fancy of a newspaper columnist with a deadline. Surprising even himself, Cesar Romero does like the Twist. He is not the biggest rock and roll fan by any means, but the Twist isn't really a rock and

roll dance. It's smooth, and he looks fierce swiveling in his fashionably narrow-legged suit pants, his jacket firmly buttoned up his thin but muscular torso.

His other extracurricular activity involves sorting out the future of a $100,000 statue of his grandfather, José Martí, the George Washington of Cuba, getting stabbed to death on his horse. The unveiling at Central Park is in limbo, and his mother asks him to get to the bottom of the situation. The pedestal is ready—just sitting there between the statues of Simón Bolívar and José de San Martín—but the statue itself, originally slated for installation on Martí's birthday a few months earlier, is still not on display. The New York Parks Department says it's not ready. The sculptor says she finished it two years ago. An East Bay storage facility says the order to deliver it to Central Park was rescinded. A Havana-born NYU professor says left-wing political bias is screwing things up. A little digging reveals politics *are* getting in the way.

Sculptor Anna Hyatt Huntington creates the monument to Martí in 1959 at age eighty-one, driven by personal interest in Cuba and blessed with the financial independence to sculpt a $100,000 statue for free and gift it to the people of New York from the people of Cuba. Though not Cuban herself, Huntington feels inspired by the story of José Martí. (Ostensibly, the tax regulations involved in making such a gift is what prompts the $100,000 valuation on the statue.)

The problem is, which people of Cuba are donating the statue? Not that it actually involves the official Cuban government. But Castro is in power now. Anti-Castro forces vastly outnumber pro-Castro forces in America, especially in Florida. Anti-Castro forces *completely* outnumber pro-Castro forces among Martí's descendants in the Romero household. But pro-Castro forces are surprisingly prevalent in New York City.

When Park Commissioner Robert Moses first approves the statue going up, he does not anticipate that anti-Castro forces and pro-Castro forces will stage violent demonstrations. Both sides agree that José Martí is a hero—that's not the issue. The problem is far more picayune. Each faction believes fervently, adamantly, *violently*, that their side is rightfully entitled to the honor of laying the commemorative wreath at the foot of the statue at the unveiling ceremony.

That's it.

A statue everyone thinks is terrific, of a hero everyone thinks is terrific (save for a few random Spanish royalists who cling to a belief that Cuba should still belong to Spain), is sitting in mothballs in the Bronx because of

bickering over a wreath. Martí is central to the inheritance and the legacy of the Romero family. It should be said that for his part, Cesar Romero is not angry about what now seems like the trivial nature of the disagreement. He is furious with the pro-Castro Communists he views as anti-American traitors. And no matter whom he calls, sorting out the controversy seems impossible. The statue isn't put on public display until 1965, sadly, three years after Maria Romero's death.

Cesar Romero definitely blames the Communists. His sense of himself as politically conservative is generally about being opposed to communism, not social or economic policies. Though he does not get involved in the uglier aspects of the blacklisting era, he is protective of what he considers American values in the battle against the Soviets. His longtime friend George Murphy and somewhat newer friend Ronald Reagan are also conservatives, and both are getting into politics. He supports them out of loyalty, certainly, but he agrees wholeheartedly with their anti-Communist views and is happy to help them here and there on the campaign trail when his shooting schedule allows.

During the 1960 Republican National Convention, Romero is on Kaua'i shooting *7 Women from Hell*, playing a supposedly neutral German citizen living on a Pacific island who falls in love with an escapee from a Japanese internment camp. (He turns out to be a Nazi sympathizer, though, and when his lady love discovers his secret plan to turn over her fellow escapees to the Japanese, she kills him.) It is a pleasant shoot in Hawai'i, where he and his costars are feted by local dignitaries. He also signs on for a film destined to become iconic: *Ocean's Eleven*.

Shooting the all-star caper film to end all all-star caper films is a gas. Romero is a generation or maybe a half generation removed from most of the Rat Pack—like a cool uncle or older brother; he is totally accepted and celebrated by the group but not really of its world. He also isn't enough of a drinker or gambler to be part of the Rat Pack's legendary nighttime antics.

Romero plays Peter Lawford's brand-new stepfather-to-be, a former mobster gone straight who can't resist getting his hands dirty again when he realizes that Lawford and his pals, including Frank Sinatra, Dean Martin, and Sammy Davis Jr., are behind an ingenious scheme to rob every single major casino in one night. With a big, generous smile, Romero demands a cut. He is a good twenty years older than most of the Pack, but his dynamism and physical prowess make him seem more alive, more vibrant. Let them coast, blithely going through the motions—Romero is playing for keeps. "Cesar

Romero, the big shot racketeer, steals acting honors with his smooth, elegant style," raves Jerry Pam in the *Los Angeles Valley Times*; "the most professional of all the performances." Bosley Crowther in the *New York Times* agrees: "Cesar Romero does a smooth job as the hijacker who messes up the job." "Cesar Romero contributes a priceless bit," writes Wanda Hale in the *New York Daily News*. "He's the lone operator who tries to outsmart the gang."

On February 8, 1960, in conjunction with *Ocean's Eleven* publicity, Romero receives a huge honor: not one but *two* stars on the Hollywood Walk of Fame, one at 6615 Hollywood Boulevard for his film work, the other at 1719 Vine Street for his television work. It is an encouraging way to start off a new decade, and a string of high-profile projects are on the horizon—another picture with Frank Sinatra; one with Sandra Dee and Bobby Darin, who are in the middle of having a huge moment; one with John Wayne—still a huge force at the box office; and, for the younger set, two with *Beach Blanket Bingo* alum Frankie Avalon. And Romero has more television appearances than he can count.

Romero and Ruta Lee get to act together for the first time in a *Zane Grey Theatre* anthology episode called "Man from Everywhere." The plot has a few surprises up its sleeve. In the Old West (it's *Zane Grey Theatre*—*everything* is in the Old West), local townspeople are trying to lynch suspected murderer Cesar Romero. The sheriff doesn't cotton to lynching. He hires the absurdly handsome young Burt Reynolds to escort Romero to the nearest courthouse so he can legally stand trial before getting strung up and hanged. Ruta Lee objects. Romero killed her brother. He should die *now*. The sheriff says no. Reynolds and Romero take off, and Ruta Lee follows, ostensibly so she can absolutely make sure Romero doesn't get away. Except she is really following to absolutely make sure Romero *does* get away. They're lovers. She's his Old West moll. The two of them seem like they are having a wonderful time. Romero is lean and still handles a horse with grace and ease. Ruta Lee makes her transition from outraged good girl to bawdy bad girl deftly, and she looks amazing in the period dress, flouncing around with her waist looking all of twenty inches around.

Enter Ross Hunter.

The glossy world of *Pillow Talk* and *Imitation of Life* producer Ross Hunter is a place where aging stars feel safe. He often presents his directors with demands that their cinematographers shoot stars through gauze to hide lines and imperfections. Doris Day and Lana Turner seem to have no pores in their close-ups—just dewy, perfect skin. When he starts shooting a

new sex comedy, *If a Man Answers*, not only are leading ladies Sandra Dee and Micheline Presle shot with a heavy filter, but so is Bobby Darin, because Hunter thinks he looks puffy and rough on-screen.

When Romero shows up for the shoot, he doesn't know what to expect, but he escapes the gauze effect because Hunter thinks he already looks fantastic and doesn't need it. Hunter and Romero do not socialize in the same circles particularly. Hunter is gay and somewhat open about it within a small group of friends. Romero is not open at all. The two men are friendly but have no special kinship. It's not a difficult production schedule for Romero, who appears only in the final twenty minutes of the film as a surprise character who upends the lives of both leading ladies. The convoluted plot has Sandra Dee feeling neglected by new husband Bobby Darin. Her mother, Micheline Presle, advises following the instructions in a book on how to train dogs. Presle has a second trick: an imaginary boyfriend who calls and hangs up "if a man answers." But Darin susses out the ruse and responds with a trick of his own: bringing home Cesar Romero, who claims to be Presle's imaginary boyfriend—no longer imaginary—and the charade brings chaos to Presle's marriage and confuses the hell out of Sandra Dee. Romero is actually Darin's father, the new in-law Dee hasn't yet met.

The sexual politics of two women inventing imaginary lovers and a man shaming one of them by pretending to be one of those lovers is not Romero's concern (nor, it seems, anyone's at the time). What is of concern to Romero is that his character is essentially doing something unforgiveable, something that, if taken seriously, would poison his relationship immeasurably with his new daughter-in-law. How much of an asshole is the guy if that doesn't occur to him? Romero undercuts the cringe factor by making the character seem buoyantly happy to help his son rather than sadistically intent on ruining the women's lives. In the balance, he feels like he comes out ahead, but he isn't sure how audiences will respond. He's played out-and-out heels before, but this one seems different, and it makes Romero nervous. There is no need to be. He is nominated for a Golden Globe in early 1963 for *If a Man Answers*, and it is a very big deal. Romero's career isn't the kind that attracts a lot of award consideration. Over the years he has arrived on countless red carpets at countless awards events but never as a nominee. The ceremony is its usual star-studded, spectacular self. Frank Sinatra opens the show, and most of the Rat Pack is there, along with friends Martha Raye, Ronald Reagan, Barbara Stanwyck, and Jane Wyman. *If a Man Answers* is also up for Best Picture (Comedy).

CESAR ROMERO

Unlike most of the other major Golden Globe awards, the Supporting Actor in a Film category isn't divided into separate categories for comedy and drama, and traditionally comedy doesn't triumph over drama in the world of film awards. Romero is happy to be there. Happy to be seen. Happy to see his friends. But he isn't expecting a dark-horse win in a competitive field of heavyweight challengers, including Ed Begley in *Sweet Bird of Youth*; Victor Buono in *What Ever Happened to Baby Jane?*; Harry Guardino in *The Pigeon That Took Rome*; Ross Martin in *Experiment in Terror*; Paul Newman in *Hemingway's Adventures of a Young Man*; Telly Savalas in *Birdman of Alcatraz*; Peter Sellers in *Lolita*; Omar Sharif in *Lawrence of Arabia*; and Harold J. Stone in *The Chapman Report*.

Omar Sharif takes home the Globe. And *If a Man Answers* loses to the Cary Grant–Doris Day sex comedy *That Touch of Mink*.

Soon after, Romero heads to Madrid for *The Castilian* (after taking a "rest" between movie shoots to appear in six television shows and judge the Miss Universe pageant) and finds the chaotic Spanish/US coproduction beset by delays and reshoots. It's the story of a tenth-century Castilian nobleman on a mission to get the various warring kingdoms of Spain to join forces against the invading Moors—a task the plucky nobleman cannot possibly accomplish without the help of his loyal companion, Cesar Romero, who gets star billing over him. Viewed from a safe distance of some sixty years, the best thing about this bonkers US/Spain coproduction isn't on-screen. It's the backstory of executive producer Espartaco Santoni, who plays the lead under the alias Spartaco Santony. He has a notorious history that makes Warren Beatty's string of media-reported conquests in the 1960s seem like kid stuff. Santoni has been married nine times (Zsa Zsa Gabor territory), with an endless list of premarital, postmarital, and extramarital romantic partners including Ursula Andress and Princess Caroline of Monaco. He is a one-man subsidy for Spanish tabloids. One of his more enduring quotes is "I was always a strong believer in the institution of marriage."

On-screen, you get Frankie Avalon and Broderick Crawford as Spaniards. Romero rolls with it. There is a poignant side to spending time in Spain. One of his costars is Julio Peña, who worked with Tyrone Power on his final film, *Solomon and Sheba*. It's nice that Romero can share tales of his 1946 South American tour with Power—something he likes doing when he meets a new cast and crew. But on the other hand, maybe Spain is cursed. It's not just where Power dies—it's Romero's home away from home for months during the time his mother dies.

Maria Mantilla Romero dying at age eighty-one doesn't carry the horrified shock of Tyrone Power dying at age forty-four, but the loss is every bit as significant. Throughout Romero's life, mother and son love one another unreservedly. She is his biggest source of emotional support and encouragement. They may never explore the nitty-gritty details of difficult subjects, and it is entirely possible that they never discuss the full measure of her feelings about things like her birth status, her husband's emotional collapse, and her son never getting married—let alone his sexuality. But their bond isn't about sharing the details of their lives; it's about sharing the daily moments over decades. They are so comfortable together because they don't need to say much of anything to draw peace and emotional sustenance from one another.

His mother's death is an obvious reminder of mortality, but her passing is also deeply connected to Romero's feelings about his financial security. The need to support his family is a constant throughout his adult life. He still contributes to other family members when they are in need, but his last direct responsibility is his sister Maria, who still lives with him. Through the years his relationship with his sister grows as close and interdependent as his relationship with his mother. Financially, he is determined to never again put her or himself in the position he found himself in after the war, when money was scarce and for a time he was living paycheck to paycheck. His affection for clothes notwithstanding, he is more careful with money now, investing his earnings diversely, including in real estate—in things not dependent on the caprice of producers or studio and network execs.

John Ford's *Donovan's Reef* starring John Wayne starts shooting in Hawai'i soon after Maria's death. Romero considers it a happy experience. Director Ford is a pro, and the two men have known each other since *Wee Willie Winkie*. Romero and costar John Wayne are also good friends. As with *If a Man Answers*, *Donovan's Reef* is rooted in politics that resonate differently today. Not just sexual politics but racial politics as well, though it is arguably on the progressive side of the latter issue, at least for its time. The setup is John Wayne happily carousing with frenemy Lee Marvin and pal Jack Warden on an island in the South Seas where people of different races and backgrounds live in harmony. Dorothy Lamour hangs around sans sarong. When Warden's estranged high-society daughter Elizabeth Allen shows up, she initially believes Wayne is father to a group of mixed-race children she meets. She is shocked to learn they are actually her half siblings. Romero has a side plot that echoes some of his 1940s films, as a

silly social-climbing stuffed shirt who goes after Allen for her money. But no matter how snappy Romero looks in his gold-braided uniform and trim white beard and mustache, she isn't having any of it. And though she and Wayne are frequently at odds, she falls for him instead, despite the fact, or regrettably perhaps *because* of the fact, that he spanks her, and she stays to live with him in their island paradise. The best thing for Romero is that he and Elizabeth Allen become great friends during the shoot and stay in touch for the rest of his life. *Variety* is droll about the results: "Cesar Romero and Dorothy Lamour are the victims of acute scriptitis."

Romero's concerns about Fidel Castro persuade him to sign up for a shoestring independent called *We Shall Return* as a wealthy Cuban landowner who flees to Miami when Castro takes power. His eldest son is already in Florida—secretly a Castro ally, planning deadly interference with the CIA's plans for the Bay of Pigs invasion. Romero tries to persuade his son to see the error of his ways, with violent effect.

The shoot is in Daytona. Some local press visiting the set report on a good-natured rift between Romero and his director, Philip Goodman, about some of the dialogue. "'Rip infants from their mother's breasts!?'" he asks Goodman, who is also one of four credited writers on the project, as technicians light for a scene. "I can't stand that line, and I've got news for you, I can't say it."

Romero is not the kind of actor who routinely challenges a director—certainly not in front of the company, and certainly not in front of the *press*. Though, come to think of it, maybe he makes a bit of a scene *because* reporters are present. He playfully booms out several ridiculous versions of the melodramatic dialogue to illustrate his argument. The discussion goes on until the lighting crew is ready, with Romero periodically reciting the line, giving it more and more serio-comic embellishments. When the camera rolls, he simply says the Communists intend to "take children from their parents" among a litany of other evil actions he warns his son that Castro will take. The son refuses to budge. Knowing his son's action will cost any number of noble anti-Castro Cuban patriots their lives, Romero does what he has to do: he shoots his son dead.

He moves on from the bare-bones production playing a decidedly good-guy version of Lucky Luciano opposite Shelley Winters as fabled madam Polly Adler in *A House Is Not a Home*. The classic song "A House Is Not a Home" is written specifically for the film. It's about a house of prostitution. Listening to Dionne Warwick, you would never guess. . . . Robert

Taylor is another costar. When Winters falls for a noncriminal, he grimly warns her that no decent man will ever accept her. "You're a madam. You've sold flesh," he sneers. "They haven't invented anything to wash that away and they never will." Romero's Luciano is an upright criminal who doesn't traffic in anything as immoral as prostitution. Just murder and extortion.

Romero reunites with Frank Sinatra for *Marriage on the Rocks*, a high-profile comedy, costarring as a Mexican attorney who divorces the feuding Sinatra and Deborah Kerr. Romero's character has two mottoes: "Divorce your loved one with dignity" and "Marry in five minutes with honor." His Blue-Plate Special is "mariachis, the bridal suite, and a shoeshine" and he offers "twenty-four-hour service for marriage or divorce. We never sleep." *Marriage on the Rocks* is another of Romero's 1960s sex comedies that haven't aged particularly well, but even in 1965 this supposedly swinging sex comedy has more of the 1919 vibe of Gloria Swanson in *Don't Change Your Husband*—something that flirts with modernity but barrels along promoting traditional roles and traditional values. Men are men and girls are girls. But at least Romero is funny. And big. He gives the performance an expansive, brash sense of freedom, completely fearless, tearing into the scenery with wild abandon.

His willingness to flirt with the possibility of coming across as completely ridiculous soon comes in very handy indeed.

5
Clown Prince of Crime

Thirty years after his death, Cesar Romero's performance as a villain on *Batman*, a zippy television show initially aimed at attracting children and selling a few toys is the subject of heated debate.

Romero's supporters rank him as the Number One Joker of All Time. Period.

His detractors hate every campy, goofy inch of him—along with the 1960s show itself—preferring the more serious, frightening approach of the Jokers that follow Romero, rooted in the original darkness of the comic books.

Writer and showrunner Greg Weisman, responsible for casting a few Jokers for various animated projects that feature Batman in the twenty-first century, appreciates both approaches to the character. "When I was a kid I loved the show, it was so exciting and colorful, with so much action," he says. "I didn't know it was campy and making fun of comic book culture. I didn't even notice Cesar Romero didn't shave his mustache. The Joker was just this iconic character. He will always be iconic."

The Joker is iconic in another sense as well. He is one of just three seminal characters who share the distinction of winning two Oscars for two different actors: Anita in *West Side Story* (Rita Moreno and Ariana DeBose), Vito Corleone in *The Godfather I* and *The Godfather II* (Marlon Brando and Robert De Niro), and the Joker (Heath Ledger and Joaquin Phoenix).

In one sense, Cesar Romero's casting as the Joker is merely a happy accident. When William Dozier is casting *Batman*, he isn't aware that he and Lorenzo Semple Jr. are giving birth to a cultural phenomenon. It's just a television show. Lists of actors are made, availabilities cross-referenced, pros and cons spitballed, and offers made. In a published memo to Semple, Dozier refers to three actors: "We couldn't clear scheduling problems with Jose Ferrer (1st choice) or Gig Young (2nd choice) for Joker and are going

with Cesar Romero (3rd choice). I think he'll be fine," Dozier writes. "He's a dancer, you know, moves well, and has both style and menace. With bright green hair and alabaster face, he'll look hugely bizarre. Week after next we re-Riddle Gorshin, then Catwoman, hopefully with Suzanne Pleshette."

Ferrer, Young, and Romero are not the only three actors considered. For a hot minute, even Frank Sinatra is allegedly in the running—an idea both preposterous and fascinating on any number of levels. In an interview published in *The Official Batman Batbook*, Romero says, "Why Dozier wanted me I'll never know because I asked his wife, Ann Rutherford, 'Why did Bill think of me for this part?' She said, 'I don't know. He said he saw you in something, and he said, "He's the one I want to play The Joker."' I haven't the slightest idea what it was that he saw me in, because I had never done anything like it before."

Cesar Romero and Ann Rutherford (Scarlett O'Hara's youngest sister in *Gone with the Wind*) were frequent dancing companions back in the day. They almost tied the knot. Ask Louella Parsons. It's the Hollywood's Golden Age version of playing Six Degrees of Kevin Bacon. Everyone in town is connected by someone who almost marries Cesar Romero. For his part, Romero is glad of the job and happy for the chance to chew the scenery. "It's a part where you can do everything you're always told not to do as an actor," he says. "You can get as hammy as you like."

"Jose Ferrer was my first choice for The Joker," says William Dozier. "He either didn't want to do it or couldn't. He has kicked himself ever since. Butch Romero, whom I had known forever was the second choice for the Joker, and I am not sure he did not turn out better than Jose. I am not sure that Jose would have captured the frivolity and the ludicrousness of the character. I think he may have taken himself a little too seriously as an actor to do that." Somewhere in the time between the earlier memo and this interview, Dozier forgets Gig Young.

"The genius of Romero's Joker is that he is exactly what he appears to be—a prima donna who is determined to eat every loose hunk of scenery in sight," says film critic and comic book specialist Noah Berlatsky. "If his Joker offers a message, it's not that the comedy of life conceals a secret tragedy. It's that comedies are comedies, and if we look too deeply into a blank canvas painted by a clown, the laugh's on us. . . . While life is sometimes sad and cruel, art doesn't have to be."

Or, as the Joker says, "A joke a day keeps the gloom away!"

Dozier is actually not that enthusiastic about the project when ABC executives approach him and writer Lorenzo Semple Jr. to adapt the *Batman* comic books into a television series. After Dozier reads the actual *Batman* comics, he is even less enthusiastic—a well-publicized response to the source material that over the years adds grist to the mill for the Batman fans who wish his television show would somehow just disappear. Dozier just doesn't respond to the comics at all.

Semple is living with his family in Spain at the time and also doesn't respond with much enthusiasm, believing ABC wants a drama. The part he does like, though, is the inherent absurdity in the idea of a wealthy, powerful bachelor who gets his kicks dressing up as a bat and fighting crime. Who does that? "The TV show concept virtually exploded in my sangria-enhanced brain, full-blown," Semple writes in *Variety* in 2008.

Semple sets the tone. Dozier sets the visual style.

The one thing Dozier likes is the actual look of the comic books. The punch of the colors. The jarring angles. The comics remind him of the work of pop artists like Roy Lichtenstein. A vision of what the show might look like starts coming into his head—something he refers to as the "pop art technique of the exaggerated cliché."

He sees wider commercial possibilities for the show—imagining kids can respond to the action and bright colors, the big "Zap! Krunch! Blurp!" graphic intercuts, while adults can respond to the incongruity of grown men in tights swaggering around straight-faced with an occasional tongue-in-cheek dash of homoeroticism. But just regular guys kidding around, like Eddie Cantor and Cesar Romero.

The *Los Angeles Times* calls his vision an "insane, mad fantasy world." The word *camp* starts coming up in newspaper articles once the show premieres. "The essence of Camp is its love of the unnatural: of artifice and exaggeration," writes Susan Sontag in her seminal *Notes on Camp* in 1964. It isn't clear whether Dozier and Semple are the ones who start applying the term to the show or if entertainment journalists get there first.

This is a show where a man in a mask and bat ears, wearing a cape and skintight underpants over his tights, can walk into a nightclub, ask for a booth near the wall, and add, completely deadpan, in a lower voice, "I shouldn't wish to attract attention."

Camp is baked in.

The cast is set with Adam West as Batman (and his alter ego Bruce Wayne), Burt Ward as Robin (and his alter ego Dick Grayson), Alan Napier

as Alfred the Butler, Neil Hamilton as Commissioner Gordon, Stafford Repp as Chief O'Hara, Madge Blake as Aunt Harriet, and William Dozier as the narrator. They're all veterans with tons of experience—except Burt Ward. This is his first job.

From the beginning, a broad range of stars is planned as Special Guest Villains. But the Big Four are set: Julie Newmar as Catwoman, Cesar Romero as the Joker, Frank Gorshin as the Riddler, and Burgess Meredith as the Penguin.

All of the villains have signature looks, but of the four, the Joker is the one with the most larger-than-life appearance. Romero's basic look as the Joker is based on how he appears in the comic books created by Bob Kane and Bill Finger—the chalk-white face, the green hair, and the exaggerated red lips in a permanent creepy laugh. The character is originally visualized by Kane's young ghost artist Jerry Robinson based on a Joker in his playing card deck, and that original drawing still exists. Finger, a fan of German expressionist and other foreign films, then shows Robinson and Kane stills of actor Conrad Veidt in a silent German film called *The Man Who Laughs*, about a man whose face is surgically disfigured into a grotesque grin as a macabre punishment by order of King James II. The film is an adaptation of the 1869 novel by Victor Hugo, of *The Hunchback of Notre-Dame* and *Les Misérables* fame. Pictures of Conrad Veidt are terrifying. His face isn't so much in a permanent laugh as a permanent scream, with more in common with the future Jokers of Heath Ledger and Joaquin Phoenix.

That image of Veidt is what supplies the true sense of the Joker, elevating the whimsy of a playing card and giving it the impact of a comic nightmare. Bob Kane insists to his dying day that the Veidt image is the true origin and that Robinson's drawing of the playing card comes afterward. Writer and *Batman* producer Michael Uslan believes he can supply the last word on the subject: "Being in the unique position of having known and talked to Bill Finger, Bob Kane, *and* Jerry Robinson," he says, "it is clear to me that it began with Jerry Robinson and his drawing of the Joker playing card based on the deck of cards he had in his house. It was then Bill Finger who showed him the stills/lobby cards from *The Man Who Laughs* with that portrayal by Conrad Veidt, which solidified the visualization of the image. Bob Kane approved it. Bill Finger then wrote the first Joker story and Jerry Robinson drew it with Bob Kane."

The creators of *Batman* forever argue over who created what and who should get the most credit for the more enduring elements. There is a virtual internet war currently over who dreamed up Catwoman.

CESAR ROMERO

Veteran makeup designer Ben Nye Sr. creates Romero's look as the Joker with the needs of shooting for color television in mind, rather than German expressionism, but he is aware of the whole *Man Who Laughs* gestalt. The first big issue, though, as everyone now knows, is that Cesar Romero refuses to shave his mustache. Romero may not be the biggest star in Hollywood, but he is recognizable all over the world for his signature style and look—the mane of silver hair and the jaunty mustache. Before he sits down in the makeup chair for the first time, he is already scheduled to shoot six episodes back to back, from just before Christmas 1965 through March 1966. But during January, February, and March 1966, he is also booked for weekend personal appearances for Petrocelli Suits. He is their style ambassador. And his style includes his mustache—already featured in magazine ads running nationally.

Keeping to Nye's original makeup design as closely as possible, makeup artist Bruce Hutchinson covers Romero's mustache with as much white makeup as he can. "The makeup took about an hour to put on," Cesar says, "but the wig was a thing that bothered me more than anything else. The wig was green of course, but it sometimes photographed red, yellow—everything but green. They would glue the wig to the front of my forehead, and after a while it would give me a headache."

In the comic books, the Joker's whole body is bleached chalk white, but the *Batman* production and design teams decide Romero will have only a white face. His face makeup takes long enough. Apply it everywhere else and that adds another half hour to an hour every day, with constant touch-ups if his hands are covered with makeup. He will wear white gloves. If anyone gets peeks of normal skin tone elsewhere occasionally, so be it.

"Cesar's Joker was so different from the way he really was that people were often amazed when they met him. He was poised, distinguished, a real old-time gentleman," writes Adam West (Batman) in his biography. "Though you could tell by the gleam in his eye and smile that beneath the surface he had a real flair for mischief. That really came out in his performance."

Costumer Jan Kemp's designs are based on the comics, but Romero still hasn't actually seen any comic books, so when Kemp shows his rendering of the Joker to Dozier and Romero, it's the first time Romero gets a load of the whole look—the outlandish purplish-red suit with the cutaway revealing big black stripes on his pants, a neon green shirt, string tie in an elaborate bow, white face, green hair, giant red mouth—and Romero starts giggling and howling.

Clown Prince of Crime

"Don't lose it!" barks Dozier.

Cesar doesn't know what he is talking about. "I'm sorry?"

"That laugh," Dozier gushes. "That's The Joker's laugh!"

On December 22, 1965, Cesar Romero steps onto the soundstage at 20th Century Fox to start shooting "The Joker Is Wild"—season 1, episode 5 of *Batman*. He has worked on the lot many times since his contract player days, so it's not like some teary homecoming or anything. But despite the changes at the studio over the years, it still feels like home. He arrives ready to work, knows his lines, and to a person, the cast and crew members find him extremely gracious and kind, if a little odd at times. He has a routine: He comes to set in full costume, hair, and makeup, with paper towels tucked in his collar to protect his costume from the white makeup. While the crew sets up, he sits in a chair and dozes off. He isn't just sitting there, eyes shut, resting—he is actually asleep. If anyone asks if he is okay or what he is doing, he just softly responds, eyes still closed, "I'm collecting my thoughts and marshalling my energy." He snaps to attention as soon as he hears "Places!"

"The moment he was called to step in front of the camera, he was instantly vital and in character," says West. "He never missed a cue or fumbled a line; he was *there*."

The plot of his first episode is suitably convoluted and provides plenty of opportunities for Romero to shine. The imprisoned Clown Prince of Crime finds out that the Gotham City Museum of Modern Art's Comedians Hall of Fame has neglected to include him, so he escapes from the yard while playing in a prison baseball game and seeks revenge. He brings busts of famous dead comedians to life, thus turning them into henchmen, and loots the museum of its priceless jewel collection. He caps it off by engineering a way of unmasking Batman and Robin during an opera broadcast where he appears (rather impressively) singing "Vesti la giubba" from *Pagliacci*. "Holy ravioli!" When Batman and Robin manage to elude him, the Joker ups the ante, maneuvering to execute them live on television.

Spoiler alert: he is not successful in carrying out the execution.

Among his continued antics, the Joker employs snakelike trick streamers, taunts Batman and Robin while appearing on a comical criminal game show called *What's My Crime*, plots to steal a steamship, and kidnaps Batman and Robin—before being vanquished, vowing to slay another day.

Though first planned as hour-long episodes, the shows are reconfigured as two half-hour episodes. The first episode ends in a cliff-hanger as the Special Guest Villain gains an advantage over the imperiled Batman

and Robin; the next night, the second episode picks up at the moment of peril, then Batman and Robin get free so they can go off to deal with whatever mischief the villain is cooking up, and the episode ends with good triumphing over evil and the Dynamic Duo saving the day. The format goes through some changes in the second and third seasons, but the cliff-hanger and Dozier's uncredited, hyperbolic voice-over urging viewers to "tune in tomorrow, same Bat time, same Bat channel" are the elements of the first season formula that become permanent parts of pop culture vernacular. (That and Robin's endless "Holy" expressions—"Holy red herring!" "Holy guacamole!" "Holy Taj Mahal!")

Batman premieres on January 12, 1966, and it crushes the competition with a staggering 27.3/49 rating/share, meaning 27.3 million people are tuned in to *Batman*; that number is 49 percent of households that have their televisions on during the airing. The rating/share ratio improves for the second episode to 29.6/59. Almost 60 percent of all human beings in America with their television turned on is watching *Batman*. This impact is impossible today, when the marketplace is fractured between broadcast, cable, and streaming. We don't have three choices; we have three thousand. But even considering the far higher viewing percentages available in 1966, *Batman*'s numbers are extraordinary.

Romero knows the show is a hit, but he isn't immediately aware of how much it will affect his life. His own first four episodes have aired when Queen Elizabeth II's consort, Prince Philip, Duke of Edinburgh, visits the 20th Century Fox lot. Cesar Romero is done shooting but is asked to be on hand at the studio to welcome His Royal Highness along with next week's Special Guest Villain, Roddy McDowall as the Bookworm.

The show is also a huge hit in the United Kingdom on ITV, the main commercial competitor of the BBC, and a rash of reports come in that kids are jumping out of upper-story windows wearing capes, thinking the capes are wings that will let them fly like Batman. Thankfully, no one is dead—yet. It is unclear whether this is truly a widespread phenomenon or a one-off. Newspaper accounts at the time are full of dire warnings but short on actual details.

Dozier doesn't wait to find out. He hastily assembles a special promo for emergency airing.

Batman: "Robin and I want all you youngsters to understand, we have no wings, and no superhuman powers. We cannot fly."

Robin: "Listen, kids, if either of us tried to fly, or jump off a high place, we would be badly hurt. So would you. So, for gosh sakes, don't ever try it. Holy broken bones!"

ITV runs the announcement three or four times a day for ten days, and newspapers dutifully report an end to the epidemic of kids jumping from buildings. "We are extremely appreciative of the efforts made by you in the interests of safety," write ITV executives to William Dozier. "The film has well served its purpose."

Romero is incredulous. Children jumping from buildings because of a television show? Unfathomable. He has been working professionally for forty years. He has had hits before, but nothing like this. A *Batman* feature film is hastily scheduled. Romero will have just six weeks off after shooting his last episode of the first season before starting the feature. During those six weeks, he shoots a *Hollywood Palace* variety show episode and fulfills all the Petrocelli commitments he can before getting back into his headache-inducing green wig.

The possibility of making a feature film has always been on the table. In fact, the film is initially budgeted and scheduled to shoot before the television series. In that scenario, the film is a tool to launch the show and a way to finance building expensive props and set pieces, charging them to the larger film budget and then using them for the show. The original plan is for the show to premiere in September for the 1966–1967 television season. But the September 1965 launch of ABC's schedule gets terrible ratings, and hoping for a shot in the arm, ABC moves *Batman* forward as a midseason replacement in the 1965–1966 season. (They get the shot in the arm they are hoping for. Their overall ratings increase 10 percent across the board.)

They still proceed with the feature film in between shooting the first and second seasons of the show for a number of reasons. With its action-oriented pop-art style, *Batman* seems a good bet for foreign sales, but a feature film with international distribution can sweeten the pot and close deals. It will also help drive sales of the $75 million worth of *Batman* merchandise that is hitting shelves. And the original rationale about props and set pieces still holds true. The film's larger budget will cover building the Batcopter, Batcycle, and Batboat. And footage of all three can be cut into subsequent episodes. The film plans a few other bells and whistles, including a submarine and a large shark.

The plot is relatively simple: the Joker, the Penguin, the Riddler, and Catwoman—archvillains of the United Underworld—combine forces to destroy the Dynamic Duo and take control of the entire world. Among their exploits early in the film, they hijack a yacht carrying a dehydrator with the power to extract all moisture from humans and reduce them to dust particles. To demonstrate their awesome new powers to a terrified world, the villains turn nine members of the Security Council at the United World Building into nine vials of multicolored crystals. In the course of events, they utilize a submarine, a cadre of favorite henchmen and henchwomen, an arsenal of missiles, an octopus, and a shark.

The shark attacks Batman ("Holy sardine!" exclaims Robin), but it is clearly made of rubber or plastic—a prop from the film *Voyage to the Bottom of the Sea*, where it also doesn't look particularly real. The backstory is fun, though. The shark is Peter Lorre's pet in *Voyage*, and it kills Oscar-winning actress Joan Fontaine, sister of Oscar-winning actress Olivia de Havilland and ex-wife of *Batman* executive producer William Dozier. When Batman utilizes bat shark repellent, the shark explodes—so in a twisted kind of way, it's like Dozier gets to kill his ex-wife twice.

Everyone in the television cast is on hand except Julie Newmar. She is scheduled for another movie and can't get out of the contract. Lee Meriwether replaces her, which turns out to be a happy development for Romero. He takes Meriwether—the only cast member new to the franchise—under his wing, and they become good friends. The plug is pulled on Newmar's film, and it is never made. She misses out on the *Batman* movie for nothing.

They start shooting in April and wrap in June. There is a lot more exterior filming and physical action than the series usually has. And with the exception of Meriwether, the Special Guest Villains are not exactly spring chickens. There is one on-set accident with a stunt performer on the submarine that necessitates a visit to the hospital but causes no lasting damage. Postproduction races to the finish to make the gala premiere set for Austin, Texas, at the end of July. (A company based in Austin called Glastron agrees to build the Batboat free of charge in exchange for holding the premiere in their hometown for the publicity value.)

The Saturday night premiere event coincides with a local Austin event called Aqua Fest, centered around a small river that runs through town, dividing the city into southern and northern districts. Thirty thousand people welcome Adam West, Cesar Romero, Lee Meriwether, and Burgess

Meredith. The stars ride in an open convertible past the University of Texas Tower, waving to fans. They pose with the Batboat. They are made honorary Texans. Miss Aqua Fest shows up in a Batkini—black bikini bottoms and a bikini top shaped like bat wings.

The day after the actors fly back to Los Angeles, an ex-marine climbs to the top of the UT Tower and opens fire on that same parade route, murdering fifteen people and injuring thirty-one others, most of them students. It has nothing to do with *Batman*. But it feels weirdly like a close call.

The film opens with a tongue-in-cheek dedication: "We wish to express our gratitude to the enemies of crime and crusaders against crime throughout the world for their inspirational example. To them, and to lovers of adventure, lovers of pure escapism, lovers of unadulterated entertainment, lovers of the ridiculous and the bizarre . . . To funlovers everywhere . . . This picture is respectfully dedicated. If we have overlooked any sizable groups of lovers, we apologize."

The film performs solidly and makes a profit. *Variety* is decidedly positive: "*Batman* is packed with action, clever sight gags, interesting complications and goes all out on Bat with Batmania: Batplane, Batboat, Batcycle, etc. etc. Humor is stretched to the limit, color is comic-strip sharp, and script retrieves every trick from the highly popular teleseries's oatbag, adding a few more sophisticated touches. . . . The acting is uniformly impressively improbable. The intense innocent enthusiasm of Cesar Romero, Burgess Meredith and Frank Gorshin as the three criminals is balanced against the innocent calm of Adam West and Burt Ward, Batman and Robin respectively."

Even reviews that reject the film entirely tend to praise Romero, Meredith, and Gorshin and sometimes Lee Meriwether, though she is not always singled out. As the television show goes back into production, playing a villain becomes cool, and the list of actors who show up to play is impressive, including main villain replacements: John Astin as the Riddler in the second season and Eartha Kitt as Catwoman in the third season. Other villains include Tallulah Bankhead as the Black Widow; Anne Baxter as Olga, Queen of Cossacks, and Zelda (Baxter is the only actor to portray two entirely nonrelated villains on the series); Jacques Bergerac as Freddy Touché/Freddie the Fence; Milton Berle as Louie the Lilac; Victor Buono as King Tut; Roger C. Carmel as Colonel Gumm; Art Carney as the Archer; Joan Collins as Siren/Lorelei Circle; John Crawford as Printer's Devil; Howard Duff as Cabala; Maurice Evans as the Puzzler; Zsa Zsa Gabor as Minerva; Lesley

Gore as Pussycat; Glynis Johns as Lady Penelope Peasoup; Van Johnson as the Minstrel; Carolyn Jones as Marsha, Queen of Diamonds; Liberace as Fingers Chandell/Harry; Ida Lupino as Dr. Cassandra Spellcraft; Roddy McDowall as the Bookworm; Ethel Merman as Lola Lasagne; Terry Moore as Venus; Otto Preminger as Mr. Freeze (season 2); Vincent Price as Egghead; Michael Rennie as the Sandman; Cliff Robertson as Shame; Barbara Rush as Nora Clavicle; George Sanders as Mr. Freeze (season 1); Walter Slezak as the Clock King; Malachi Throne as False Face; Rudy Vallee as Lord Marmaduke Ffogg; Eli Wallach as Mr. Freeze (season 2); David Wayne as Jervis Tetch, the Mad Hatter; and Shelley Winters as Ma Parker.

Though it cannot be said that the Joker has anything resembling a character arc over the course of the show's three seasons, he certainly gets the opportunity to contemplate a wide variety of methods of doing away with Batman and Robin, including executing them in electric chairs, killing them with poison gas, spray-waxing Robin to death, cutting Batman in half on a giant key duplicator, freezing them, crushing them to death with a giant asteroid, feeding them to a giant clam, crushing Robin to death in a printing press, shredding Robin with rotating palette knives, machine gunning them to death, and blasting them to smithereens with a bomb, plus the many times he simply orders various henchmen to kick, punch, and karate chop the Dynamic Duo into submission. When Robin is the sole target, Batman is usually tied up, forced to watch his pending demise.

And all the while, the Joker laughs. Romero sustains the intensity of his mania, never letting the machinations seem stale or repetitive. But with the show running twice a week, the film in theaters, and countless toys and promotional items flooding stores across the country, the danger of oversaturation is very real. Dozier and the studio understand that—they just see no reason to proceed cautiously, adopting a grab-it-while-we-can approach to milking the property for every last bit of revenue. The show's popularity continues into the start of its second season, but then over the next few months ratings start falling. Another problem is that viewers are starting to skip the first episodes altogether and just tune in for the second episodes—meaning the ratings slide for the first episodes is especially precipitous.

The producers try to halt the ratings decline by adding new bells and whistles. They incorporate the snazzy new movie-built Bat equipment. They add more villains. Then they experiment with a three-part adventure format. They team up villains and contemplate adding more superheroes—toying with the idea of Superman, the Green Lantern, the Green Arrow,

Aquaman, and various other Justice League of America members to give Batman and Robin a boost. The Green Hornet and Kato do show up—but mainly to help themselves. Their show's ratings are falling too.

"Holy heart failure!"

Romero isn't really all that aware of the behind-the-scenes drama. It makes no difference to him how they format shows or move episodes around. His schedule stays relatively the same. He and the other Big Four villains tend to shoot their episodes in chunks, so their schedules are free for other work. To the public, it seems like they are shooting all season since their episodes are spread out, but that's not how the scheduling works. It's like how the audience sees the same celebrities five days in a row on *Hollywood Squares* and imagines them hanging out all week together. They shoot all five in one day. Everyone has other commitments.

The decline in the ratings almost gets the show canceled at the end of the second season, but Dozier films a short presentation video—basically a mini-pilot for a third season that introduces Batgirl. He outlines plans for still more format changes: airing just one episode per week (sometimes a half hour, sometimes two half hours stitched together into a single hour) so they can consolidate, hold the audience, and counter the growing problem of viewers skipping the first episodes altogether and just tuning in for the second episodes.

While all of these decisions are being made, Romero is on a mini-tour that starts at the rather grandiloquently named Summer "Catch a Star" Cherry County Playhouse in Traverse City, Michigan, and continues on to a number of other summer theaters, starring in *The Seven Deadly Arts*, a gentle sex comedy, as a "latent swinger" who doesn't wear a wig or laugh maniacally. He still loves doing the Joker, but it's also nice to play a grown-up once in a while—even if said grown-up latently swings.

He returns to the set for season three and finds a vastly different atmosphere. Money is tight. Tempers are shorter. A feeling of the axe waiting to fall permeates. Budget cuts mean some of the villains are stuck in criminal lairs that look like black box theater sets with a couple of backdrops and painted floors. The one bright spot for Romero is that he has worked with Batgirl Yvonne Craig before, on *7 Women from Hell* and an episode of *Follow the Sun*. They happily renew their acquaintance. In between setups, he regales her with tales of old Hollywood and his South American tour with Tyrone Power. "He was so charming," she recounts in an interview years afterward. "It never seemed like he was an old man lost in the good old days. He just wanted to share stories and have a laugh."

Romero also enjoys shooting with Eartha Kitt, a new Catwoman. Her work on the show is something fantastic to check out through a modern lens. Here is this fierce African American temptress decked out in fetish wear threatening all manner of mischief to a couple of Anglo patsies. Romero and Kitt are polar opposites politically and don't hang out in the same circles, but the scenes they have together crackle with new energy.

But that jolt of electricity has no positive effect on the show's future.

In its first season, the show regularly takes two spots in the top ten every week. In the second season, it struggles to stay in the top twenty or thirty. In the third season, it bottoms out in the lower forties and fifties. ABC pulls the plug. A few weeks later, NBC makes a surprise offer for a fourth season there. They rescind the offer when they learn the sets have already been bulldozed. They're not about to spend the $800,000 it would cost to build new sets.

After shooting his final episode in February 1968, Cesar takes off for South America to shoot a picture with Chuck Connors called *The Proud and Damned*. It has something to do with Confederate mercenaries and a Mexican dictator. Is it Maximilian? He hasn't finished reading the script yet. He can't believe *Batman* is over and has no idea how to process the experience. In one sense it changes everything for him. The public reaction—even when viewers start jumping ship—is extraordinary. People *love* him now in a way that can sometimes seem a little nuts. He has no idea that it will go on relatively unabated seemingly forever or that the exact way he happened to laugh at some costume sketches a few years before is a sound people will ask him to make for the rest of his life in airports, in restaurants, on the street—anywhere and everywhere.

But someday he is going to watch that German expressionist silent movie with Conrad Veidt and see what it's all about.

6

Silver Fox

A *New York Daily News* headline on June 7, 1969, crackles with snark and condescension: "Homo Nest Raided—Queen Bees Are Stinging Mad." The article gleefully describes the surprisingly violent events happening at the Stonewall Inn on Christopher Street. "Queen power reared its bleached-blonde head in revolt. New York City experienced its first homosexual riot. 'We may have lost the battle sweets, but the war is far from over,' lisps an unofficial lady-in-waiting from the court of the queens. 'We've had all we can take from the Gestapo,' the spokesman, or spokeswoman, continued. 'We are putting our foot down once and for all.' The foot wore a spiked heel."

As Robin says in a second-season episode of *Batman*, "Holy rainbow!"

During the Stonewall Riots, Cesar Romero is shooting *The Computer Wore Tennis Shoes* for Walt Disney, starring as a town elder who turns out to be a crime boss. Slapstick mayhem ensues when Kurt Russell's brain accidentally merges with the computer containing Romero's criminal secrets, but said mayhem does not involve any marginalized members of the public fighting for their rights.

Cesar Romero has no conceptual frame of reference for LGBTQIA+ equality in the modern sense but is not a fan of public spectacles that seemingly confirm the "deviance" of his own orientation. Drawing attention to it makes it seem worse. A rather sad clue to his feelings about his sexual orientation comes from a thirdhand story from a secondhand source. During the shooting of a movie called *Simple Justice* in 1989, Doris Roberts is his costar. A few years before Doris Roberts dies in 2016, she tells the writer Frank DeCaro that one night during the *Simple Justice* shoot, she is alone with Cesar Romero. He starts crying and tells her, "I don't know why I am the way I am," in reference to his sexuality.

CESAR ROMERO

It is not necessarily accurate to jump to the conclusion that this moment is definitive in terms of Romero's sense of self and his sexual orientation. He may have gotten a little tipsy that night and indulged in a self-pitying crying jag. But it is dismaying that Cesar Romero could ever feel this way about himself, however fleeting the feeling may be, or however one may hope it is not a recurrent or, worse, permanent part of his sense of identity.

There are no existing, verifiable accounts of any relationships. Even the generally accepted notion of his love affair with Tyrone Power is speculative. "They were beautiful together," says Ruta Lee. "You could see the love and affection there between the two of them. Whether that love ever became physical, I don't know. I hope it did."

In a strange coincidence, in the early 2000s, Ruta Lee's next-door neighbor in Palm Springs for a time is Scotty Bowers, author of *Full Service: My Adventures in Hollywood and the Secret Sex Lives of the Stars*. In the vein of a Tom Wolfe quote about *Confidential* magazine (he called it "the most scandalous scandal magazine in the history of the world"), it is not inaccurate to state that *Full Service* is the most scandalous book of scandal in the history of the world. Bowers writes graphic details of his sexual encounters with Tyrone Power, Cary Grant, Randolph Scott, Vincent Price, Tony Perkins, Raymond Burr, Rock Hudson, and Charles Laughton, among many, many others. Ruta Lee is a rock-ribbed conservative (though, she is careful to stress, *not* a Trump supporter); she is not a let-it-all-hang-out lady when it comes to notions of behavior, and she has no particular taste for the salacious details of other people's personal lives. Yet she likes and believes Bowers.

And Cesar Romero's name does not appear once in the book.

As it happens, I have written extensively about *Confidential* magazine, a tabloid phenomenon of the era that at its height in 1957 is outselling *TV Guide* and *The Saturday Evening Post* on newsstands. *Confidential* rather merrily and often goofily outs stars like Van Johnson and Tab Hunter, among many others. But Cesar Romero does not appear in the magazine. The late Marjorie Roth, the New York–based magazine's eyes and ears on the West Coast in the 1950s and the niece of publisher Robert Harrison, does not remember a story about Romero ever being pitched to her.

"Cesar Romero never came up," she says when asked about various closeted gay celebrities. "But boy," she marvels, "he was so dreamy. Gay. What a waste."

While the lack of public gossip says nothing about Romero's sexual orientation, it says everything about his discretion and determination to keep his private life private. In the 1970s and 1980s, when he works with many others who try to keep their private lives private, does he exchange confidences or commiserate with Robert Reed, Dick Sargent, Raymond Burr, or Tab Hunter? It cannot be verified one way or the other, but it is doubtful. No one in print or in private interviews conducted for this book remembers him ever getting particularly personal with coworkers. Always extremely friendly, ready for a chat or a joke, he is easy and earthy, never looking for special treatment. Everyone loves him. No one remembers learning anything about his private life or his inner self.

There is an account from writer Boze Hadleigh in his book *Conversations with My Elders* about an informal interview said to have taken place before Romero's death but published posthumously. Hadleigh recounts a flirty off-the-record occasion when Romero confirms his orientation but stays completely tight-lipped about Tyrone Power. There are no personal revelations except a funny story about a raucous, drunken night with Desi Arnaz, who he says sort of lies back and lets things happen on a one-time-only basis. Hadleigh's story of meeting Romero is impossible to prove, but it sounds plausible enough. Hadleigh's detractors make much of a few timeline errors in other interviews in the book, but they don't seem egregious. What is significant is that if authentic, the story still reveals nothing about Romero's heart.

All we are left with is Tyrone Power. No telling correspondence between the men is known to exist. Many people who know them both attest to the depth of the connection. Part of it seems to be a kind of hero worship. Power is a much bigger star than Romero in these years—one of the biggest stars Fox has, along with Shirley Temple and Betty Grable. Sometimes it is as if Romero can't quite believe this movie god wants to be his friend.

If Romero is aware of the drag queens and other queer-identified pioneers "disturbing the peace," it does not alter his desire for privacy. He stays busy—private time is for family and donning one of his tuxes and dancing the night away at the never-ending charity balls that make up the bulk of his social life now. Mostly he works. In the first year following the demise of *Batman*, he appears on *The Joey Bishop Show* twice; guest stars on an episode of *Get Smart*; shoots five episodes of *The Hollywood Squares*; goes to Rome to shoot a Dustin Hoffman film, *Madigan's Millions*; plays a Rio de Janeiro customs inspector on the London shoot of the Peter Ustinov/

Maggie Smith comedy *Hot Millions*; has an important feature role back in California in the Otto Preminger all-star flower-power comedy debacle *Skidoo*; does a porn-tinged spaghetti Western called *A Talent for Loving* (that almost stars the Beatles); stars as a mob boss in London in *Sophie's Place* (aka *Crooks and Coronets*) opposite Telly Savalas, Dame Edith Evans, and Warren Oates; tangoes with Lucille Ball on an episode of *Here's Lucy*; and begins hosting his own syndicated travel show called *Cesar's World*—a relatively inexpensive production, largely utilizing licensed footage with Romero as a narrator. Forty episodes are produced by Ziv Television Productions on the cheap and syndicated for broadcast in 1968 and 1969. In interviews, Romero always has another project, another idea, another possibility on the horizon. In November 1968, the column "An Eye on Hollywood" in *Hollywood Studio Magazine* reports that Romero is hard at work on writing a novel on the life of Jose Martí and that he is delighted to reveal that several studios are interested in adapting the novel as a film. He may indeed have been thinking about such a project, but there is no evidence he ever puts pen to paper or that there is any studio interest. His television work immediately following *Batman* is composed of the kinds of guest appearances he is already known for. The film work is much more unusual, characterized by oddball projects—most of which fail to catch on with critics or the public.

Skidoo is one of those disasters-that-go-down-in-film-history projects that, with its big-budget all-star cast and impeccable production credits, seems like a home run to everyone except the audience, who gets one whiff and can't abide the smell. Mob henchman Cesar Romero forces ex-mobster Jackie Gleason into pulling one last job. Things take a colorful turn when the criminal establishment, affluent suburbia, and the counterculture collide—with Gleason and Carol Channing's daughter Alexandra Hay getting caught up with a group of hippies. Though producer and director Otto Preminger's interest in LSD and flower power is apparently genuine and well documented, this doesn't translate into anything fresh or funny. Romero refuses to merely go through the motions, and he hits his comedy beats with full commitment, but he performs in a vacuum. Even if the scenes are well-written and potentially funny (they're not), he, Gleason, and Channing are playing three different kinds of comedy in three different movies—none of which works. The film is a major disaster critically and at the box office, all but killing off the nascent film career of Broadway legend Channing, who just a year earlier is nominated for a Best Supporting Actress Oscar and wins a Golden Globe for *Thoroughly Modern Millie*.

Cast members Burgess Meredith, Frank Gorshin, and Cesar Romero and director Otto Preminger are all Special Guest Villain veterans from *Batman*. Everyone sinks. Romero may count other films as among his worst, but it is hard not to disagree and give *Skidoo* sole honors.

Vincent Canby sums up the critical response in the *New York Times*: "The movie's almost complete lack of humor, its retarded contemporaneousness (much is made of hippies, pot and LSD), its sometimes beautiful and expensive-looking San Francisco locations, and its indomitable denial that disaster is at hand (apparent from almost the opening sequence)—all give the film an undeniable Preminger stamp." *Variety* complains that the film "plods from scene to scene in one-two-three-kick, one-two-three-kick monotone. *Skidoo* patronizes young and old alike, which is pretty much like cutting off both legs before a track meet." The distance of time gives a slightly more nuanced take from Richard Brody in the *New Yorker* in 2016, calling it "Preminger's ultimate embrace of youth culture" and "one of the most wonderfully strange movies ever made in Hollywood."

Another oddity of Romero's early post-*Batman* projects is *A Talent for Loving*, adapted from the novel by Richard Condon. The plot has an elaborate backstory. A sixteenth-century Aztec priest cuts off his own hand and uses the bloody stump to lay a curse upon a blasphemous Spanish conqueror and all his direct descendants. Flash forward to 1871. The latest victim of the curse is the beautiful young virginal daughter of Cesar Romero, a fabulously wealthy Mexican rancher and gambler. Richard Widmark is a professional gambler who wins the deed to Romero's ranch and is then trapped into marrying his daughter. The curse is that she is a raving nymphomaniac. The marriage is supposed to free her from the curse of her own ravenous sexual desire. The weirdest thing about the film (which is saying a lot, since everything about the film is weird) is that from its early development in 1965 to just prior to commencing production in 1969, the Beatles are attached. It is supposed to be their follow-up to *Help!* How they would have figured into the story isn't clear (there is a press account at the time that references them singing to a horse, but it may be a joke). A treatment for the film signed by all of the Fab Four sells for just under £8,000 at auction in 2009. The end result is a lurid, ugly, unfunny movie about sex that somehow manages to have absolutely no sexual tension or erotic power. It's also one of the few times in Romero's career when he seems to lose interest, as if he takes a look at the shenanigans going on around him and just gives up.

He is back in fighting form, though, in *Sophie's Place*, aka *Crooks and Coronets*. Telly Savalas and Warren Oates are two American crooks with a plan to rob an eccentric old lady, Edith Evans, at her country estate. The plot is orchestrated by Romero, the CEO of Exploitation USA, a mob syndicate run like a corporation, with a vice president of its jewels and arts division who highly values some of the paintings Evans owns. The trouble is that instead of robbing her, Savalas becomes devoted to helping Evans raise the money to save her failing estate—much to Romero's violent displeasure. This droll crime comedy caper is released in the United States as *Sophie's Place* but as *Crooks and Coronets* in the UK. Romero makes the most of the dialogue he gets as a crime boss. When Savalas cites their time in reform school together as a reason Romero should cut him a break, Romero retorts, "Don't think I've forgiven you for that. I wouldn't have gone to reform school if the getaway car you stole hadn't run out of gas . . . right outside a police station!" (How they might have been in reform school together, when Savalas is fifteen years younger than Romero, is not addressed.) He later dismisses Savalas's excuse that his failure on a mission is just bad luck. "You're always having bad luck. Face facts, you're just not cut out to be a crook. You lack all of the qualities that make a good criminal—qualities that in all modesty have put me where I am today: ruthlessness, viciousness, meanness, deceit. Those are the qualities that have put me at the top of my profession." Edith Evans gets her own chance to shine. When Savalas apologizes for being a criminal, she reassures him that it's nothing to be ashamed of. She is essentially descended from a line of criminals herself. "They were some of the biggest scoundrels this country has ever seen. Why, if they were alive now, half of them would be in Dartmoor—murderers, rapists, thieves—you name any crime in the book, and they've done it. And they were the decent ones. The difference was, of course, they did it when it was legal." Taking a cue from his friend Joan Crawford's success with Pepsi product placement, Romero works a deal for Petrocelli Suits to be featured in the film, though one of his snappy suits is ruined when a bird is shot and falls out of the sky onto Romero's head.

He shoots a low-budget science fiction film in Tokyo called *Latitude Zero* that has a curious afterlife, popping up on *Mystery Science Theater 3000*. In it, he plays an evil warlord and mad scientist genius seeking to destroy an underwater Atlantis led by Joseph Cotton. And for some reason, drunk with power, he turns his submarine-captain mistress into a giant flying lion. In a rare instance of Romero coming off as bitter in an interview,

after the shoot he laments the state of the film industry to the *Los Angeles Daily News*, bitching that at this stage of his career, he can't believe he is reduced to schlepping to Japan for something like *Latitude Zero*. It is indeed a terrible movie.

Romero's turn in *Midas Run*, shot in Rome and London, is unusual. He plays a powerful, wealthy Italian in a sequence that starts out promisingly—a swinging 1960s party so exotic that gay men flirt with one another and a lesbian couple dances. Then it turns hideously ugly when Romero tries to strongarm the film's leading lady, Anne Heywood, into bed by threatening her husband's financial future. It's rare that Romero plays an absolute pig. He does it believably and without fuss, but it isn't any fun to watch.

He closes out the 1960s and heads into the 1970s with three Disney films, starting with the aforementioned *The Computer Wore Tennis Shoes* and going on to *Now You See Him, Now You Don't* in 1971 (for a 1972 release), and *The Strongest Man in the World* in 1974 (for a 1975 release). Kurt Russell plays Dexter Riley in all three. "Cesar Romero is a great actor," he says, looking back over fifty years later. "The set was fantastic. We supported each other, and that collaboration made the experience very memorable."

Other than the Disney films and a few television appearances, like bowling with Gary Owens against Sid Caesar and Ernest Borgnine on *Celebrity Bowling*, things come to a crashing halt in 1974 and won't really pick up again for another three years. The idea that his acting career might be dwindling away is a loss almost too terrible to contemplate. At the same time, a different kind of loss arrives, one that, while somewhat removed from his daily life at this point, is deeply entwined with his own history. Just after Christmas in 1973, former top box office star and internationally well-known interior designer Billy Haines dies of lung cancer a few days before what would have been his seventy-fourth birthday. Haines, an early mentor to Romero's close friend Joan Crawford, is openly gay, living with his partner, Jimmie Shields, for forty-seven years until his death. Crawford always calls them the "happiest married couple in Hollywood." Famously, in 1933, when Louis B. Mayer demands Haines break up with Shields, Haines declines, effectively walking away from his screen career rather than give up the love of his life. It is a choice Romero never contemplates. The end of Haines's career at MGM comes just before Romero's arrival at the studio to make *The Thin Man*, so they are not at the studio together, but Romero is friends with the couple for forty years. When he visits the grieving Shields, Romero is quite concerned, writing to Crawford afterward that Shields is

"heartbroken." Even the not particularly gay-friendly Ronald Reagan recognizes the loss, telling Shields, "It's very hard to go on, but Billy would want you to. He wouldn't want to see you like this." A few months later, Shields commits suicide, leaving behind a note: "Goodbye to all of you who have tried so hard to comfort me in my loss of William Haines, whom I have been with since 1926. I now find it impossible to go it alone, I am much too lonely."

Billy Haines and Jimmie Shields, a gay couple with the kind of life together Romero will never have with anyone, are now both gone. Joan Crawford is something of a recluse in New York. And Cesar Romero struggles to find acting work. He makes the difficult decision to sell his Saltair home and move with his sister into a large condo on San Vicente Boulevard. And at his doctor's insistence, he makes the possibly even more difficult decision to quit smoking. This is one of the longest periods in his professional life without acting work, almost as long as his service in World War II. He becomes involved in the restaurant industry, taking over Cappuccino's Ristorante on Celebrity Row, near the present site of a strip mall called Cienega Center, and renaming it Cesar Romero's Cappuccino Ristorante—"So Italian even your Godfather will love us!" It's next door to Alan Hale's Lobster Barrel. Romero's friends show up en masse for the opening, sparking an admiring piece in the *Los Angeles Times*: "From the looks of things, the friends invited their friends. One big jam! Someone cracked, 'I just hope this mob keeps up when the cocktails aren't free!' One quipster, backed up four-deep from the bar, answered, 'I'd pay for one if I could get one.' But no one really minded the crowding. Cesar is a very popular guy—ask Jane Wyman and daughter Maureen Reagan, the Robert Stacks, the Jules Steins, Glenn Ford . . . the Jack Oakies, Virginia Zanuck, the Ricardo Montalbans . . . and Cesar's sister, Maria."

He also opens two Cesar Romero menswear stores in Chula Vista and Buena Park, California. The tagline is "Don't settle for 'just clothes' . . . Get the Cesar Romero look." Romero remembers the stores as a financial disaster that cost him his entire investment. He works hard, getting as much press attention as possible and making personal appearances. "He was super nice!" recalls one man working at the time at a rival menswear store in the same Buena Park mall. "Always smiling, giving autographs. Just super nice."

Both business ventures fizzle, along with a chunk of the funds Romero makes from the sale of his house. In 1977, he appears in a high-profile episode of the hit NBC sitcom *Chico and the Man* as Freddie Prinze's long-lost

father, presumed dead. In a grim turn of real-life events, hours after taping the show, Prinze either intentionally, accidentally, or randomly in Russian Roulette fashion shoots himself in the head. Romero's episode as Prinze's long-lost father airs one week after his death. The tabloid press piles on, but it's not something Romero chooses to comment on beyond calling it "a tragedy" and leaving it at that.

He returns to the stage in *Mr. Barry's Etchings* in summer and dinner theaters as a kindly etcher who tries to save his town from corrupt politicians by printing counterfeit fifty-dollar bills. He also stars in a new stage comedy called *The Max Factor* as an aging Hollywood star whose sudden financial crisis prompts a new living arrangement, in turn causing romantic complications. *The Max Factor* is by two television writers, Marcy Vosburgh and Sandy Sprung, who are later producers on *Married with Children*. Romero and Vosburgh become fast friends, and she becomes his escort to the numerous galas and balls he still attends on the Beverly Hills charity circuit, including a charity dear to Ruta Lee's heart, the Thalians, devoted to funding mental health treatment.

"This one lovely lady," Lee remembers. "He was with her for such a long time, coming with her to events, always smiling together, so happy. For a while I thought, hmm, maybe this is an actual romance."

Robert Yacko, an actor who appears twice with Romero in productions of *The Max Factor* in 1982 and 1983, remembers him with a great deal of warmth. "He loved being surrounded by people," Yacko says, "and going out with us for meals. He was just this lovely, funny gentleman. He could have had his own dressing room or trailer or whatever, but he preferred to share with us for the feeling of camaraderie. I got the feeling that he didn't like being alone—not in some sort of anxious way—just that he preferred the stimulation of being with others. And for years afterward, I would run into him at an event or something and he would always stop and really take a moment to chat and ask about my life."

Romero gets back into the swing of things on television in a string of appearances on Aaron Spelling shows: *The Love Boat*, *Charlie's Angels*, *Hart to Hart*, and *Fantasy Island*. He has been friends with Ricardo Montalban from *Fantasy Island* for years. Romero does three episodes of *The Love Boat* in the 1980s, playing a different character each time. The first casts him in a gently comedic love triangle opposite Carol Channing and Betty White. In the second, he is a corporate big shot and workaholic who meets and falls for Jane Wyatt, not realizing she works for him. The third is in 1986 after

he joins the cast of *Falcon Crest*, and it is one of the show's lavish two-part episodes, shot on location in Spain, airing during the May ratings sweeps period. Romero plays a world-famous bullfighter, grandfather to *Falcon Crest* costar Lorenzo Lamas, whom Romero believes is destined to follow in his footsteps. But Lamas longs to be a composer and has fallen in love with a newswoman, Mary Crosby, who thinks bullfighting is immoral. Even forty years later, Crosby remembers the experience well: "Cesar Romero was just the epitome of elegance," she says. "What I remember is the incredible Spanish meals late at night with Cesar and Lorenzo Lamas, both of them telling fantastic stories about old Hollywood. Cesar was amazing." Romero is an old friend of Lorenzo's parents, stars Fernando Lamas and Arlene Dahl—both very much a part of the social set Romero frequents in the 1950s.

During that European shoot, the guest stars for another *Love Boat* episode set in Germany are also on hand, including Audrey Landers, Mel Ferrer, Alexis Smith, Susan Blakely, and Harry Morgan. One night, with the Spain and Germany casts seated together at dinner in the real Princess cruise line dining room, Morgan starts choking. Quick as a flash, Romero bolts over to start giving him the Heimlich maneuver. Memories differ as to whether Romero saves his life or if Audrey Landers's boyfriend at the time takes over from Romero and is ultimately responsible.

In 1982, Romero gets a promising shot at a series regular role—something he hasn't really had since the *Passport to Danger* days. (The Joker is a recurring character, not a series regular.) It's a pilot NBC is very high on, starring an It Girl of the time, Ann Jillian, as a singer on a show-within-a-show that Cesar Romero hosts. The gist is that Romero is charming on camera but a comically tough boss backstage. It doesn't come to anything. He tells his friend Marcy Vosburgh he feels like he is marking time, waiting for the next big thing—something to keep him occupied.

In 1984, he is presented with a Nosotros Golden Eagle award for his success as a Latino in the entertainment industry, and though graciously offering his thanks, he also remarks, "I never considered myself a Latin actor. I was born in New York City and my mother was born in Brooklyn." He also picks up career achievement honors at the Hollywood International Celebrity Awards for his fiftieth anniversary in show business. It's lovely to be honored for his past work. But what about his present work and, more importantly, his future? He refuses to think of this time as his waning golden years.

Then a very strange offer comes, seemingly from out of the blue. Tab Hunter is a former teen heartthrob from the 1950s, once a giant box office star, and, like Romero, a closeted gay man. Though from different generations and never part of the same circle, they are friendly acquaintances. Hunter and his partner and later husband, Allan Glaser, are shooting a Western parody, *Lust in the Dust*, with John Waters's drag queen superstar Divine, Hunter, and Lainie Kazan. The title is taken from the tongue-in-cheek nickname given to King Vidor's 1946 film *Duel in the Sun*. Hunter and Glaser have pushed *Lust in the Dust* up a very steep hill to raise the $4 million for the budget. In pitching it for financing, Glaser always refers to the project as "Divine's breakout film." His pitch is "We've got no competition—who else is producing a Western musical starring a three-hundred-pound transvestite?" Divine is over the moon about working with the legendary Cesar Romero. However, Glaser and Hunter's first choice to play opposite Divine, Shelley Winters, is not over the moon at the idea of playing opposite a man as her sister, which is how Lainie Kazan is hired.

The film begins with a sonorous voice-over: "The legend of Chili Verde tells of men and women who became slaves to their passions. They paid the price here under the blistering, burning, blazing, scorching, roasting toasting, baking, boiling, broiling, steaming, searing, sizzling, grilling, smoldering, very hot New Mexico sun. For there is a saying in these parts: those who lust in the dust shall die in the dust." The story involves a search for buried gold. Romero plays a seemingly peace-loving padre who turns out to hold the key to finding the treasure—which he very much wants for himself. A reporter from the *Asbury Park Press* does a full-page spread. The paper regards Romero as a native son: "He recently was feted on his fiftieth anniversary in show business with a party on the Santa Fe, New Mexico location of *Lust in the Dust*," the uncredited reporter writes. "It's his hundred and thirty-fourth movie, or is it a hundred and fifty-second, he's lost count. 'The New Mexico Film Commission presented me with a trophy for my fifty years in films,' Romero said. 'I said, "I'm happy to get it, considering the alternative."' He has played almost every kind of role. 'But *Lust in the Dust* is a first. I play a Catholic priest who used to be a rabbi in the Old West. No explanation is given. I think it's going to be a very funny picture. Not campy, but great.'"

Romero plays the whole thing straight. While Divine and Kazan tear up the scenery, he holds focus by staying still and letting his expressive eyes do all the work. The film is a hit and it garners more attention than anything

Romero has done for a decade. The critical response is very polarized. Roger Ebert gives his thumbs-up in the *Chicago Sun-Times*; *Variety*, Kenneth Turan in *California Magazine*, Stephen Schaefer in *US Magazine*, and Peter Travers in *People Magazine* also heartily approve. Travers is particularly funny addressing the fair number of critics who hate the film: "Well, what did they expect from a whacked-out Western parody starring has-been '50s hunk Tab Hunter and 300-pound female impersonator Divine—*High Noon*? The film delivers tacky, hit-and-miss hilarity with moments that offer more laughs than a barrel full of teenage sex comedies." Sheila Benson in the *Los Angeles Times*, Vincent Canby in the *New York Times*, and Rex Reed in the *New York Daily News* are among the detractors. "The film produces the kind of green reaction you get from eating a rancid burrito," writes Reed.

Romero hits the rounds of the talk shows to promote the film, and a raft of television appearances follows. He's a jewel thief teaching daughter Jenny Agutter tricks of the trade on *Magnum, P.I.*; there's his second *Love Boat* episode; a *Family Feud Hollywood Walk of Fame* special; *Murder, She Wrote*; *Riptide*; and a four-episode arc on a new show called *Berrenger's*. It's his first foray into a new genre for him: the glossy nighttime soap operas like *Dallas* and *Dynasty*. *Berrenger's* involves a fabulously wealthy family that owns a fabulously luxurious Manhattan department store who fabulously plot and scheme their way in and out of giant-shoulder-padded intrigues.

The show bombs, but its producers at Lorimar-Telepictures like Romero. They need a classic Hollywood star to play Jane Wyman's new husband on *Falcon Crest*. If this were 1940 and Louella Parsons got the scoop, she would get it into the first available edition: "FINALLY! Hollywood's Most Eligible Bachelor Takes the Leap! Cesar Romero to Wed Jane Wyman! 'I'm the happiest girl in the world!' cries joyful Jane, smiling like a cat who has caught the cutest Cuban canary that ever lived."

7

Sex, Lies, and Grandfathers

The *Batman* signature phrase "Same Bat time, same Bat channel" didn't stay confined to its television show origins. At some point, it entered the modern vernacular and became sort of a quippy way of saying you'll see someone again later. Some people still say it, and not just Boomers and Gen-Xers. Some members of younger generations have been known to use the 1960s phrase, perhaps not even knowing where it comes from.

Less ubiquitous though still present, at least at the margins of pop-cultural fandom, is the 1970s phrase "Good night, John-Boy." *The Waltons* is a Depression-era drama about a rural Virginia family with eight children (seven living) who navigate the trials of their hardscrabble life together, lovingly supporting one another against all odds. Richard Thomas is John-Boy, the eldest, who dreams of being a writer one day. At the end of each episode, over a static exterior shot of their ramshackle two-story house, the family has conversations from room to room, calling good night to one another, as lights go off in each window. Often the conversations are light and innocuous, sometimes relating to that week's plot. They change it up over the course of its nine seasons, but a recurring idea is that while the family sleeps, John-Boy writes, ostensibly about them, with the last line directed to him: "Good night, John-Boy."

The Waltons is one of those shows, like *Touched by an Angel*, that you turn on maybe thinking it will be a goof, something sickly sweet to make fun of, and you find yourself completely engrossed, holding back tears. "Good night, John-Boy" becomes something people toss off as a way of saying goodbye or good night to someone that has a hint of flippancy but is quite affectionate. Both the way it permeates the culture and the way it is used on the show are a testament to the good-heartedness at the core of *The Waltons*.

CESAR ROMERO

Creator Earl Hamner Jr. uses his own Blue Ridge Mountains childhood as the basis for the show, and that authenticity and humanity come through the characters and storylines. Yet when Hamner sets out to create *Falcon Crest*, he playfully makes a promise to CBS: "This will be the opposite of *The Waltons*."

Poverty is the danger always lurking around the corner on *The Waltons*. The families Hamner creates for *Falcon Crest* are poisoned by wealth. The danger comes from having too much rather than too little. He sets it around feuding factions of the interrelated Channing and Gioberti families—powerful forces in the California wine industry in fictitious Tuscany Valley, with the same proximity to San Francisco as Napa Valley. Hamner's stated intentions of exploring the poisonous dangers of wealth aside, CBS isn't that bothered about underlying themes and creative inspiration. They just want a companion piece to *Dallas*, and the idea of having a rich matriarch head up a show as opposed to another rich patriarch just seems like an interesting variation. It's different—but not *too* different.

Jane Wyman stars as Angela Channing, the tyrannical matriarch of the Falcon Crest Winery.

"It was created specifically with Jane Wyman in mind," Hamner and CBS insist.

"I heard they offered it to Stanwyck, and she turned them down," says Wyman.

Someone makes a list somewhere during development. Maybe Jane Wyman is number one. Maybe she is number three. Third choice Cesar Romero is an icon as the Joker. First and second choices Jose Ferrer and Gig Young, both bigger stars at the time, are largely forgotten. When the casting list is created for the *Falcon Crest* character Romero plays, a Greek shipping magnate billionaire named Peter Stavros, Wyman is said to take one look at the list and tell Lorimar, "You can cross off everybody else on that list right now. Cesar Romero is perfect." Is he the first name on the list? It doesn't matter. He gets the job.

Jane Wyman and Cesar Romero have been friends as long as they both have been in Hollywood. "Since before Methuselah," she says in a *TV Guide* interview. In the 1940s, fan magazines and columnists link them romantically but haphazardly, never making it seem all that serious. It's not like she's Joan Crawford or Betty Furness, always on the verge of saying yes or saying no or sitting on his lap. Wyman's ex-husband is Ronald Reagan, who is serving his first term as a historically well-liked US president. They are friends

with Romero when they are married, and each has stayed friends with him since the divorce—though Wyman is an actual friend while Reagan is more of a friendly acquaintance.

Some snicker that Wyman wouldn't even have the *Falcon Crest* job if Reagan weren't in the White House. It probably doesn't hurt. But the idea that a television network would risk tens of millions of dollars on the off chance that a marriage from thirty years ago will magically convince the American public to tune in to CBS and watch the president's ex-wife is absurd. Jane Wyman is an Oscar-winning actress with eighty-nine films under her belt. The biggest credit Larry Hagman has before *Dallas* is *I Dream of Jeannie*. For the last few years before *Dynasty*, all John Forsythe has going is a voice-over gig on *Charlie's Angels*. Wyman is an out-and-out star *already*. And apparently Barbara Stanwyck is busy.

Joining Wyman in the cast are Robert Foxworth as Chase Gioberti, her nephew; David Selby as Richard Channing, the illegitimate son of her ex-husband; Abby Dalton and Margaret Ladd as her daughters, Julia and Emma; Lorenzo Lamas as her grandson, Lance; Susan Sullivan as Foxworth's wife; William R. Moses as Sullivan and Foxworth's son, Cole; and Ana Alicia as a beautiful young rival heiress, Melissa Agretti. Other series regulars include Morgan Fairchild, Kim Novak, Leslie Caron, Lana Turner, Cliff Robertson, Mel Ferrer, Gina Lollobrigida, Ursula Andress, Rod Taylor, Robert Stack, Celeste Holm, Chao Li Chi, Laura Johnson, Simon MacCorkindale, Sarah Douglas, and John Saxon.

The show starts airing in 1981 and is immediately a top twenty success, so much so that CBS stars Carol Burnett in a six-hour parody miniseries as a matriarch based on Jane Wyman, with Dabney Coleman, Teri Garr, Gregory Harrison, and Charles Grodin. "They romp through the twisted vineyards in a tale of love, hate and sour grapes among the glamorous raisin growers of central California in *Fresno!*" Wyman immediately reaches out to Burnett, wishing her and the show success: "We're all waiting to see it," she tells Burnett. "I hear it's a hoot!"

Fresno gets press. That means *Falcon Crest* gets additional press. Wyman and the *Falcon Crest* team are adept at bringing attention to the show. One recurring strategy is boosting ratings with Hollywood royalty showing up for a season or two. Storylines before Romero joins the show have featured Lana Turner, Cliff Robertson, Mel Ferrer, Celeste Holm, and, as Wyman's secret half sister vying for control of Falcon Crest, Gina Lollobrigida, stepping in at the last minute when negotiations break down with Sophia Loren,

already announced for the part. (Three years earlier, Sophia Loren is Aaron Spelling's first choice for the role of Alexis Carrington on *Dynasty*. When Loren insists on too much, Joan Collins gets the role that defines her into Damehood. She is not number one on the list. It doesn't matter.)

But as the story goes, Cesar Romero *is* number one on the list this time, and it's a great job for him that illustrates just how strange and random a career in show business can be. The development and success of *Falcon Crest* before he joins the show have nothing to do with him. The American public is having a moment when nighttime soaps are one of their favorite things; CBS wants another one and decides to build it around a woman. One of Lorimar's other shows bombs in the ratings, but Romero's four-episode guest-starring arc impresses them; the *Falcon Crest* showrunner decides Wyman needs a silver fox love interest—someone powerful . . . Greek . . . a billionaire . . . everything he touches turns to gold. And Cesar Romero, feeling bored and underemployed, looking at his investments and knowing that while he is doing okay, he wishes he had more of a cushion, gets a call from his team at William Morris (or, more likely, one of the agent's assistants). And his life changes overnight. He has an impact on some of the steps that lead to it happening, certainly, and he is in no way passive about his life or his career. But a whole bunch of stars in the heavens need to align to create a relatively run-of-the-mill event for a network television show that is a life-altering event for an individual—Cesar Romero.

The importance of *Falcon Crest* to the later years of Romero's life cannot be overstated. He shoots fifty episodes, primarily from the beginning of the fall in 1985 through the spring of 1987, with all the money, activity, and press attention a high-profile gig like *Falcon Crest* entails. Being busy is great—he has always liked working—and it is fabulous to be invited to all of the big-ticket events again. You don't usually get asked to present a Golden Globe to Whoopi Goldberg on television if you're still just picking up random guest shots on *Riptide*. So absolutely, the work, and the money, and the prestige . . . it's all wonderful.

The miracle is the feeling of emotional connection it brings.

He hasn't really had it in over thirty-five years, since leaving Fox—the intimacy that comes from spending so much time with the same people over days, and weeks, and months, and years. It's not an intimacy that needs personal details to flourish—it just needs someone to remember you have a pet or how you take your coffee, someone asking if the knee that's been giving you trouble is feeling better. It's the connection of continuity and

belonging. He feels connected during the *Batman* years, but it isn't the same. He is a guest star doing other jobs in between. And schlepping to Japan and turning someone into a flying lion don't make you feel like you belong either. Reporting to the set at *Falcon Crest* does. Not because the writing or acting or directing is so special but because it runs like an old Hollywood studio set. It's congenial, constructive, and efficient. People are on time and prepared and treat each another with respect. That's certainly what Jane Wyman does, feeling it is her responsibility as the star of the show to set the tone. Her storylines require a lot of outraged glares, frowning, pursed lips, and taking offense at the smallest slight. On set, she is generous and kind—plus she plays a mean hand of poker with the crew at lunchtime. The younger stars, some of them veterans like David Selby, some without much experience, like Lorenzo Lamas and Ana Alicia, appreciate the value of working with a true professional like Wyman—and like Romero.

"I loved Cesar," says Selby. "He was just this wonderful gentleman, always telling jokes and these fascinating stories about old Hollywood. Never an unkind thing to say to anyone or about anyone. Nothing. He just wanted to make you smile."

"He was such a warm, gracious man," Lamas says. "Of course, he knew my parents, so it was great. You don't learn things from idiots, you learn things from people that are more mature, that have experience. And I learned that much at a very young age." Back in the day, Fernando Lamas and Arlene Dahl knew Tyrone Power, of course—everybody did. But maybe their son Lorenzo doesn't know about the time Cesar and Ty flew off on an adventure to South America. . . . Many cast members recall hearing happy stories of his famous trip to South America with Tyrone Power.

Romero's storylines on the show are emblematic of a nighttime soap opera, with its insane reversals of fortune, secrets buried and revealed, and fortunes won and lost and the constant possibility that one might be accused of a murder and the probability that one is absolutely capable of committing such a crime. *Falcon Crest* is such a huge part of the latter stage of Cesar Romero's work and his life that his character's trajectory bears recounting. It begins when billionaire Greek shipping tycoon Peter Stavros (Cesar Romero) arrives in San Francisco and invites Angela Channing (Jane Wyman) to his yacht. Many years have gone by since she broke his heart. She is happy for the reunion but has an ulterior motive. At the end of the fourth season, Angela lost two-thirds of the shares in her winery to the machinations of Anna and Cassandra (Celeste Holm and Anne Archer).

She asks for Peter's help in getting the shares back. He agrees to help Angela but will sign them over to her only as a wedding gift.... Then abruptly, Peter leaves a note calling off the wedding—when in truth he has been kidnapped by his daughter Sofia (Julie Carmen), determined to stop her father from leaving his fortune to Angela. When Angela discovers the will disinheriting his daughter and naming Angela the beneficiary, she fears for his safety and sends her grandson Lance (Lorenzo Lamas) to find Peter.

Meanwhile...!

Sophia and her evil husband, Philippe (Frank M. Benard), hold Peter and eventually Lance as well as prisoners at the Stavros château. At gunpoint, Philippe forces Peter to sign a power of attorney giving him control of everything. Meanwhile, finally aware of her husband's true evil, Sofia shoots and kills Philippe, setting her father and Lance free. She hopes her actions will allow Peter to forgive her for going along with Philippe's plot to kidnap him. He protects her by telling the police Philippe's death is the result of a hunting accident, but he then banishes Sofia from his house and his life. He cannot forgive her.

Peter returns to Falcon Crest, and the wedding plans move forward, but he is distracted and anxious about the kidnapping and regrets his estrangement from Sofia. Angela arranges a chance for them to work things out, bringing Sofia as well as Peter's son Eric (John Callahan) to meet with him. After a surprising heart-to-heart, Peter forgives his daughter. He also learns that Angela is about to be arrested for her supposed role in a wine truck hijacking aimed at sabotaging a competitor. They elope, leaving a note. But Peter returns without Angela, saying she is spending time resting in Italy, and presents the family with a signed power of attorney giving him complete control of Falcon Crest. Lance is suspicious—especially when he finds Angela's passport. She cannot be in Italy.

Peter rules Falcon Crest firmly, responding only with amusement at everyone's concerns about Angela's whereabouts. He wants to take out $30 million from the business accounts, but the firm's attorney refuses—so Peter fires him and gets the money. Lance successfully wrests temporary court-ordered control of the business away from Peter, who disappears along with the $30 million he took from the Falcon Crest accounts. Angela returns, telling her family that Peter abandoned her on his yacht with no explanation. And they never did get married. The elopement note was a lie. She is furious and baffled when she learns of Peter's actions while she was away, and she is shocked to learn that the hijacking arrest is still imminent.

Sex, Lies, and Grandfathers

She turns herself in and is put in a pretrial detention cell. Peter arrives to pay her bail and tries to explain he had his reasons for doing what he did, but Angela won't listen. At trial, there is only one unreliable witness testifying against Angela, and the case collapses. Peter reveals he was behind everything being done behind the scenes to destroy the case, and the seeming theft of her money was part of the plan. Her $30 million is safely returned, and they get married.

Meanwhile, Peter's son Eric becomes involved with Angela's much younger winery rival Melissa (Ana Alicia). Peter opposes them building a winery together but cannot convince Eric to walk away—personally or financially. In an unrelated storyline, an earthquake is predicted for the Tuscany Valley. Melissa and Eric hold a groundbreaking ceremony for their new winery, and Angela upsets Peter when she accuses Eric of plotting against her and his father by starting a competing winery. Numerous other romantic and business complications ebb and flow, and the season ends with an earthquake. Angela and Peter are at the Falcon Crest winery when it collapses. A frantic Peter searches for Angela in the rubble in that season's closing episode.

Next season: Coping with the loss of life and property after the earthquake takes its toll on everyone. Angela and Peter are unhurt, but there are other injuries and deaths to deal with. Meanwhile, Peter's long-lost stepdaughter Skylar surfaces in New York, and Angela invites her to Falcon Crest—but unbeknownst to Peter and Angela, it is not Skylar but Kit Marlowe (screen legend Kim Novak) posing as Skylar. Peter is thrilled to be reunited with Skylar and does not suspect anything is off—though Angela has serious doubts. Angela's stepson and rival, Richard, begins looking for embarrassing or incriminating information in the hopes of destroying Angela and Peter's marriage. Skylar (Kit) is a talented painter (and forger) with a strange past. Angela's suspicions about Skylar grow, and she hires a detective.

While Peter is away on business, Kit forges a check with Angela's signature. Richard promises to keep her secrets if she will help him destroy Peter and Angela's marriage. Kit is conflicted. She has grown fond of Peter, but she goes along with it, using her counterfeit checks as planted evidence in Eric's room to frame him for forging the checks; Angela's protégé Dan Fixx (Brett Cullen) becomes suspicious of Kit's mysterious activities. Peter and Angela argue over her stolen checks when Peter refuses to believe Angela's accusations that Eric stole them. For his part, Eric accuses Lance of planting

the forged checks, but Angela refuses to believe him. Peter becomes jealous of Angela's preoccupation with Dan Fixx. And when Fixx is revealed as an ex-convict, Peter is shocked that Angela continues backing Fixx.

Peter is bewildered by the hold Dan Fixx seems to have on Angela. Problems at Stavros Chemicals continue to bubble up. Richard learns from Kit that Peter has a toxic waste disposal problem. He gets hold of the waste and dumps it on the racetrack, making the land unusable to Angela for growing grapes—and possibly poisoning the water supply and endangering all of the Falcon Crest crops. The toxic effects of Peter's waste products begin to spread through the valley. Meanwhile, a hit man figures out that Skylar is Kit in disguise.

Richard forces Kit to forge papers indicating Angela is behind the dumping of Peter's toxic waste—just as she and Peter are bonding further while she paints his portrait. Tests prove rival vineyards are contaminated from the dumping at Tuscany Downs, with Richard's faked evidence pointing to Angela's conspiracy to ruin her competitors. Peter stands by Angela against the toxic dumping accusations, but privately he has his doubts, even as he must pay a $100,000 fine to the EPA. He is horrified when Angela suggests Eric might be behind the dumping. Richard is thrilled that his schemes against Angela seem to be bearing fruit.

Angela is unable to prove her innocence. Grudgingly satisfied that Peter's son Eric is not behind it, she begins to suspect her own grandson, Lance. Skylar/Kit becomes convinced her only hope to have a future is to fake her own suicide. Angela has a dinner party for Peter's birthday. Since she cannot prove her innocence, she cops a plea and agrees to one hundred hours of community service and to pay damages for the poisoned vines. Kit prepares for her "suicide" by designating some items she is leaving to Peter, including a painting he bought her.

Skylar/Kit's suicide hits Peter hard. He blames himself for not seeing how much she must have been struggling emotionally. Jane Wyman's real-life son with President Ronald Reagan, Michael Reagan, begins a recurring cameo as a concierge, appearing in five episodes during the season. Peter heads for his own private Greek island to mourn the suicide. Peter believes he will never be happy again at Falcon Crest because of its painful association with Skylar. He asks Angela to move with him to Monte Carlo, and she angrily refuses. He sends a letter: "Nothing would make me happier than to see you again, but I can't ask you to tear yourself away from your home and

your family. The time that we've shared has been the happiest of my life. I love you. I'll always love you, Peter." Angela is enraged. No one gets away with walking out on her. . . .

Peter returns after a change of heart, but Angela isn't ready to welcome him back, still smarting from his rejection. He agrees to stay at a hotel while they try to work things out. Learning of the apparent rift, Richard tries to recruit Peter in his vendetta against Angela. Peter refuses. Richard then offers Peter a partnership in his wine distribution business, holding out some bait: the truth about Skylar/Kit and the fact that he doesn't believe that the woman Peter cares for so much is actually dead. Richard becomes the new distributor for Angela's wines.

Hoping to reconcile with Angela, Peter flies to Europe in search of incriminating evidence to use against Richard. If he can bring his wife's archenemy down, it may convince her of his love. Angela conspires with Roland Saunders (Robert Stack), the "rudest billionaire in the Fortune 500," to help her bring Richard down. Peter returns with the incriminating evidence he sought about Richard, but during Angela's international wine show at the spa, she is fawning over Roland so much that Peter grows furious and returns to his hotel without telling her a thing about Richard.

Peter and Angela are at loggerheads. Eric encourages Peter to show Angela the incriminating documents, but Peter is too proud to take the first step and leaves for San Francisco on business. He is shocked to run into Skylar/Kit (in a wig), but she pretends to be someone else and to not know him. Peter fears he is losing his mind. Meanwhile, Richard confronts Kit and threatens to expose her in his newspaper, and after a melee over a gun, he gets her to confess all on videotape. He then heavily edits the tape to make everything Kit says about Angela sound like she has proof that Angela has always been using Peter for his money and never loved him at all. Richard shows the tape to Peter, and it convinces Peter to join Richard in his plans to destroy Angela.

Peter confronts Angela and Roland Saunders, believing they hired Kit to pretend to be his stepdaughter in order to swindle him out of his fortune. Angela is baffled since nothing of the kind ever happened, but she is unable to convince Peter of her innocence, and she is angry that she should be accused in the first place. Angela decides she will be the one to solve the mystery of Kit Marlowe. It turns out that Roland Saunders is a criminal with ties to the art forgery ring that killed Peter's real stepdaughter,

Skylar. At a party, both Richard and Peter confront Saunders, and Peter seeks vengeance for Skylar's death. Then Roland Saunders is found dead in the winery.

Peter is one of the suspects in Roland's murder. Lance's father, Tony (John Saxon), is Kit Marlowe's boyfriend, and he is also implicated in Roland's murder. Meanwhile, Angela seeks to annul her marriage to Peter but is shocked to learn that he has already filed for divorce. She is further enraged when she discovers that he has bought out Richard and now has sole control over distributing her wines. She vows to get her revenge. The district attorney eliminates Peter as a suspect and charges Tony using false evidence because of an unrelated vendetta. With his marriage all but dead, Peter turns his attention to his son Eric, who has started leading a dissolute life of the idle rich. He also visits Tony, now in jail for Roland's murder, and urges him not to reveal anything about his relationship with Kit since it would be incriminating.

Peter has the grave of "Kit Marlowe" exhumed in Florida, and tests on the corpse confirm that the body is actually that of his beloved stepdaughter Skylar, killed in an assassination attempt by men working for Roland. The district attorney reports to Angela that he has Tony "nailed to the wall" as Lance closes in on Kit, intent on proving her guilt and exonerating his father. At Tony's trial, the district attorney's plans for his swift conviction are derailed when Kit Marlowe shows up and confesses to the murder. Yet the evidence shows she cannot have done it because of her size and height. Shockingly, Peter then confesses to murdering Roland himself, describing the crime in great detail. Angela cannot believe her husband is the killer, and Eric cannot believe his father would do such a thing. But both Peter and Kit are arrested, with the DA believing they might have acted together somehow.

Angela pays Peter's bail, and they reconcile. She has evidence of how Richard faked Kit's tape to make it seem like Angela doesn't love him. She does. With all her heart. Peter returns the love, but he does not want to stay and face the murder charges. Angela helps him escape to his private Greek island, where he will be safe from prosecution. He takes Kit, whom he has come to think of as his daughter, whatever her true identity, and he disinherits Eric when his son refuses to come along. Nursing her sorrow over losing Peter, Angela discovers that her own child, whom she previously believed to have died in childbirth, is actually alive. Angela reads the farewell letter from Peter Stavros but has no time to wallow in sadness when the truth comes out that her archnemesis Richard is actually the biological child she thinks died in childbirth.

Sex, Lies, and Grandfathers

In the next season, Peter returns searching for Eric, who has gone missing. Peter is no longer wanted for murder and has somehow been able to buy off the right authorities to ensure his continued freedom. He asks Angela to come back to live with him in Europe and find some peace away from the drama and turmoil of Falcon Crest, and she agrees. But then Peter learns that his son has had a breakdown and is in a mental institute in Paris. He prepares to leave with Angela, but once again she breaks his heart, changing her mind and staying to fight to regain her wine empire—now under assault from her rivals.

Cesar Romero's main storyline ends in 1987, though he returns for a couple of episodes in 1988. Getting written off *Falcon Crest* isn't a particular surprise. Older Hollywood star roles on *Falcon Crest* usually last one or two seasons, and his stint on the show lasts way longer than he ever thought it would. He is not ready to retire—not by a long shot—and he would happily still dance all night, but his body isn't always willing to cooperate. In his last year on *Falcon Crest*, back trouble sometimes makes him unable to work. Arthritis affects his legs and hands, causing a great deal of pain, and the circulation in his legs isn't great. Sometimes he's a bit out of breath—a remnant of his lifetime of smoking. He can't stand the idea that the shooting schedule has to be rearranged because he can't just show up and do his job. It really upsets him, and he is full of apologies. Jane Wyman tells him to knock it off. It's to be expected at their age. She's been having some health problems as well, and the schedule gets rearranged for her sometimes. Neither of them talks about the specifics. Why complain? It's boring.

There are hardcore *Falcon Crest* fans out there who remember Cesar Romero not as the Joker but as Peter Stavros. Fan sites post memorabilia of his appearances along with studio photos from his Fox years and screenshots from his many television appearances. *Batman* isn't their cup of tea necessarily, and they tend to treat it as a kind of aberration in Romero's career as a romantic leading man. That is how they want to remember him.

But most people think of him as the Joker.

It isn't going out on much of a limb to imagine that if Cesar Romero were alive today, he would get enormous pleasure from the fact that the Joker is such a large part of his legacy and that he is still a vibrant part of the cultural landscape. He might be a little surprised by its endurance. He would definitely be surprised to learn that a successful power-pop/punk/garage band called Friends of Cesar Romero exists. He would also likely be somewhat mystified about what sort of music is included in a category

called power-pop/punk/garage band. One of Friends of Cesar Romero's more widely reviewed albums is *War Party Favors*, with a track list that includes "Restroom Riots," "Doomsday Hotties," and "The Girl with a Ween Tattoo." The band's founder, J. Waylon, even gets a song featured on *Grey's Anatomy*. "I thought the Joker was underappreciated," Waylon says. "I mean, I can appreciate how campy *Batman* was." He finds a deeper, albeit tongue-in-cheek, sociological struggle to the Joker's plight. "Here he is, just a blue-collar thug trying to make a living, hoping one day to make it up to crime boss. Underappreciated. Hopefully, the estate of Mr. Romero is cool with us . . . if they know about us." When asked if he has a favorite episode, Waylon is unequivocal. "When the Joker and Batman have a surf-off. That one's hard to beat."

There's a Walk of Western Stars in Newhall, California, which is in the Santa Clarita Valley; for nearly a century, film legends like John Ford, William S. Hart, and Gene Autry have used Santa Clarita as a stand-in for the Old West. Over the years, they have honored stars like Roy Rogers, Dale Evans, John Wayne, Sam Elliott, Richard Farnsworth, and Bruce Dern. In 2022, they add Cesar Romero, their first Latino honoree.

The campaign to include Romero is spearheaded by a woman named Miranda Cunha, best known to the public as a contestant on *America's Got Talent* who garners tons of publicity for calling judge Simon Cowell onstage to participate in her belly dance, writhing around him to wolf whistles and wild applause. It's actually a stunt created by the producers. Apparently, a lot of "unplanned" interactions are staged. But when she goes in for a kiss, it seems completely spontaneous, and Cowell appears genuinely shocked and not a little mortified.

Newspaper accounts of the Walk of Western Stars dedication ceremony identify Cunha as Romero's daughter with Carmen Miranda.

Cunha's backstory is complicated in a number of ways, but the part that concerns Romero is directly connected to Carmen Miranda, who dies when Cunha is a baby. Miranda Cunha is raised as the daughter of the Brazilian Bombshell's brother Amaro da Cunha and his wife. As an adult, she stumbles onto a different story: that she is a daughter Miranda had in secret from an extramarital affair while seeking solace away from her allegedly abusive marriage to producer David Sebastian. Miranda Cunha cites a long paper trail that she says proves that the affair was with Cesar Romero.

Surviving family members, Romero's nieces Victoria and Marti Romero, dismiss the claim as a delusion.

Sex, Lies, and Grandfathers

Cunha is aware of Romero's sexuality and doesn't dispute it—she just embraces the idea that a measure of sexual fluidity is not uncommon among actors and other creative artists. Her evidence is not available for review, nor is it possible to evaluate its authenticity. But step away from the notion of disproving or proving the claim—something perhaps best left to the Romero family and Cunha. Separate out the very real emotional impact of it on the people involved, and one is left with the observation that if a gay man is going to sleep with a woman, it's fabulous to imagine that the woman is Carmen Miranda.

Romero talks about her in a documentary, *Carmen Miranda: Bananas Is My Business*, which is released ten months after his death. He exhibits respect and affection for her, but there is no sense of a great intimacy beyond describing her as a lovely lady and a talented star eventually trapped by the image that makes her famous. He thinks her career is cut short by her staying the Lady in the Tutti-Frutti Hat too long. Her career is actually cut short by the heart attack she suffers after performing a number on *The Jimmy Durante Show* at age forty-six in 1955. That Romero doesn't reveal some sort of emotional, teary-eyed regard for her in the interview isn't evidence of anything one way or the other. It could mean he isn't her former lover. It could mean he is and stays especially reserved to keep the secret private.

The most bizarre Cesar Romero legacy is an ongoing stunt on *Gilbert Gottfried's Amazing Colossal Podcast*, a project launched in 2014 by the late Gottfried with his friend and cohost, comedy writer Frank Santopadre. In some ways, the show is a love letter to old Hollywood, with conversations that dive deep into the legacies of long-gone or forgotten entertainers. In what seems intended as a riff on the ridiculous obsession people have with speculating about the likely fictional sexual exploits of long-dead celebrities, Gottfried invents a lurid story about Cesar Romero having a fetish for being naked in the bathtub while young men throw orange slices at him. The young men become young boys over time as he retells the story.

It is clearly a gag.

But somehow it catches on. Devoted fans of the podcast start wearing orange slice pins—one even shows up on an Oscars telecast—and fan art fills the internet. A lot of it is ugly and disgusting. Gottfried's initial joke is funny if crass. What it becomes when his fans grab hold of it feels homophobic, horrifying even. But there's also an element of irony. As it happens, the idea of exploring the fictional sexual exploits of long-ago

celebrities provides Romero with one of his most memorable post–*Falcon Crest* television appearances—in 1988, when he gets the script of a very funny sketch show hosted by British comedian Tracey Ullman. He immediately accepts the offer. Ullman plays a long-forgotten Hollywood star working on her memoir with a ghostwriter. The writer worries that Ullman's nostalgic memories about how great it was working with legendary directors like Ernst Lubitsch and Erich von Stroheim in the 1920s will make for a boring book that doesn't sell. She encourages Ullman to spill some real dirt. Ullman starts making things up, including a torrid affair with one of her costars, a bullwhip-wielding Latin lover named Roland Diego. Among many, many other exploits comprising fourteen pages of her invented carnal encounters, she claims she and Diego indulge in a threesome with Erich von Stroheim.

Fast forward. The book, called *Lights, Camera, Scandal*, is a giant hit. She revels in her success, staying in a grand hotel suite while on her book tour. The Latin lover with a bullwhip unexpectedly arrives. It's Cesar Romero, who receives a sustained round of applause from the studio audience. Ullman braces for an attack, but he isn't angry. He's just been having memory problems. "And I'm embarrassed to be at an age when the better parts of my life elude this poor memory. Forgive me."

One thing leads to another, and they spend a passionate night together.

"Last night was wonderful," she tells him the next morning.

"I thought so," he says. "And I didn't miss von Stroheim one bit. Did you?"

"I have a confession to make," she says, her conscience tugging at her. "It's about my book."

"Say no more, say no more," Romero says with a wink. "I knew the things in your book were all lies. My memory is as sharp as my libido. It was just a charade to get into your bloomers."

She takes that in. "You bastard." Then she grins. "Thank you."

When Tim Burton's dark reboot of *Batman* appears in 1989, Romero is invited to the premiere in Westwood and almost upstages stars Michael Keaton and Jack Nicholson. He emerges from a limo in an elegant tuxedo, tall and regal, signing autographs and giving interviews with aplomb. He and castmates from the television show are contacted by the press for a number of interviews, and several reunions are arranged on various talk shows. At first Romero is very circumspect. "What we did was fun," he says. "It was a spoof—a comic strip. So you can't really compare it." But after a

while, he stops pulling his punches. "This picture is dreary," he tells reporters. "It's not the Batman concept at all. And Jack Nicholson, who is such a wonderful actor and who has done such good work, is just so violent."

In 1990, he does a memorable turn on *The Golden Girls* as Estelle Getty's new boyfriend. The episode opens with Estelle Getty seeking sex tips from Rue McClanahan to please him. McClanahan does a makeover, transforming "an eighty-four-year-old woman into a sixty-five-year-old drag queen," and Getty gets her guy. But when she says "I love you" after making love, Romero's response is "Thank you. I care for you very much," infuriating and embarrassing her to no end. Eventually, they get things back on track. He thinks saying "I love you" to anyone other than his late wife will be a betrayal of her memory. Getty understands, and they both pull out pictures of their late spouses, reminiscing about how much they love and miss them.

He shoots the *Golden Girls* episode after his role as Doris Roberts's husband in the film *Simple Justice*, for which he arrives on location in Pittsburgh on his own with no assistant or handler, carrying his own bags. No fuss. Director Deborah Del Prete meets him at the hotel, and they hit it off. He tells her all the old stories and reminisces about Tyrone Power with affection, leaving no doubt in Del Prete's mind that their friendship was deep and meaningful. It surprises her how quickly the afternoon flies by. They spend six hours talking like friends.

Romero and costar Doris Roberts have vastly different working styles. She is method—working out the motivations and behaviors behind every action and every line. Romero is not. Before one kitchen scene, she maps out her rationale for everything she's doing and turns to Romero, asking what he is going to do in the scene and what his motivations are.

"In the script it says I'm sitting at the table eating," he says. "So, I'm going to sit at the table and eat."

They kid each other throughout the shoot about their different approaches. The results on-screen are seamless. However they get there, they fit together beautifully, bringing the Italian couple to life with emotional immediacy.

He keeps working, but after his sister Maria's death in 1991, he starts having more serious trouble with arthritis and with the circulation in his legs. Walking becomes difficult. Ruta Lee's husband is good with building and engineering things, and he crafts a peddling device that Romero uses while lying in his recliner so he can keep his muscles active.

"I think it helped him a lot," Lee says. "After he died we got it back, because we didn't want it to get thrown away by someone who didn't really know what it was, and my mom had it at the end of her life. So, she was sitting on that chair peddling, and I always told her to think of it like she was dancing with Cesar. He loved my mom, and she loved him right back."

His friend Marcy Vosburgh visits often, as do family members and former castmates. He and Jane Wyman stay in touch. He shoots two episodic roles in 1992, the first on a show called *Jack's Place*, which stars Hal Linden as a former jazz musician who opens a restaurant where romance is usually on the menu. In Romero's storyline, being alone is the theme of a subplot involving widower Mickey Rooney, still grieving his late wife, and Romero as an erstwhile ladies' man. The shades of lost love, regret, and loneliness are poignant and moving. It is easy to imagine Romero's own lost love—whether it is Tyrone Power, someone unknown, or even Carmen Miranda—and wonder whether Romero is lonely. It stands to reason that he is. So many of his friends and family are gone. But it is only conjecture. Cesar Romero never publicly acknowledges feelings like loneliness, and no one alive who knew him and speaks on the record ever remembers him discussing his own vulnerability or mortality.

His last television acting job is on an episode of *Murder, She Wrote* called "Murder in Milan." Romero plays the star of a film adapted from one of Angela Lansbury's books. He dances as elegantly with Lansbury as he did so many years before with his lovely costars at Fox. The dazzling smile is still there, as is the physical grace, if not the litheness and strength. His very last acting gig is a couple of days of shooting on a low-budget indie film called *The Right Way* in 1993, as a gangster. The producer, writer, and director of the project, George Taglianetti, remembers Romero as incredibly vibrant and full of life on set.

Cesar Romero is eighty-six years old when he passes away on January 1, 1994, but it comes as a shock. He is in the hospital with a case of bronchitis and pneumonia but is expected to recover. His friends and nieces talk to him that morning, and he sounds fine. A sudden blood clot complicates the pneumonia, though, and he dies. He did not want a large public funeral, so there is a small, private family service, with a request that in lieu of flowers, donations be made to the Arthritis Foundation. He is cremated, and the remains are interred in the Romero family crypt at Inglewood Park Cemetery in Los Angeles, under a statue of a Terpsichorean lyre at the Mausoleum of the Golden West, in the Sanctuary of Dreams, the Alcove of Music.

Sex, Lies, and Grandfathers

In the months before his death, in addition to *The Right Way*, he gives interviews for *Sonja Henie: Queen of the Ice*, *Shirley Temple: America's Little Darling*, *Carmen Miranda: Bananas Is My Business*, and *The Century of Cinema* for Miramax, and he appears on *Dame Edna's Hollywood* on NBC and her Fox show *Edna Time*. He dashes from project to project to the very end. It is satisfying to imagine that perhaps there are still one or two possible job offers on the table the day he dies. Work: his lifeblood. It defines him, and it defines his legacy.

Plus, there's always his marvelous, joyfully diabolical laugh.

Afterword

I certainly respected Cesar Romero before starting this project. But I have come to love him—for everything he was and for everything he never had the chance to be, at least not publicly. I hope he experienced true romantic companionship. I cannot claim some special knowledge about his relationship with Tyrone Power, but I do believe there was a deep love between them. I hope with all my heart, however, that it was not his only love, that there were some other great and enduring love or loves in his life. It pains me to think perhaps there were not. In looking at his work, family life, and social life over the decades, it is hard to see much room for a long-term partner somewhere in that mix. It is clear that he found great joy and satisfaction in his work and his family. Maybe that was enough—more than enough—and perhaps he had no regrets. He didn't tend to dwell on such things.

Recall the statistics from this book's introduction: Romero's 110 movies; his 250 appearances on scripted television; 130-plus appearances as himself on talk shows and game shows and in documentaries; and his dozens of posthumous appearances in projects using archival footage. Over 500 professional credits. That body of work speaks for itself, but I hope the exploration of that work in this book encourages people to seek out his performances. The Joker is iconic. Peter Stavros is melodramatic perfection. But his many, many other characters deserve to live on as well.

By a weird coincidence, I am typing these words and finishing the first draft of this manuscript on January 1, 2024—the thirtieth anniversary of Cesar Romero's death.

Hail Cesar.

Special Thanks

The University of Southern California Cinematic Arts Library
The Margaret Herrick Library at the Academy of Motion Picture Arts and Sciences
The Billy Rose Theatre Division of the New York Public Library
American Film Institute
British Film Institute
The Paley Center for Media
The Texas Archive of the Moving Image
Marie Magaldino Anderson
Don Bachardy
Noah Berlatsky
Joe Berrocal
Poncho Carrillo
Sean T. Collins
Jim Colucci
Yvonne Craig
Mary Crosby
David Crow
Miranda Cunha
Frank DeCaro
Deborah Del Prete
Sandra M. Garcia-Myers
Tess Gledhill
James Grissom
Lorenzo Lamas
Ruta Lee
Flore Maquin
Genevieve Maxwell

Special Thanks

Michael Gregg Michaud
Jess Waylon Miller
Paul Nagle
José Pedras
Marti M. Romero
Victoria Romero
Jamie Rose
Kurt Russell
Frank Santopadre
David Selby
Matt Severson
Ronald Shore
Billy T. Smith
Lee Sobel
Susan Sullivan
Michael Uslan
Anthony Uzarowski
Greg Weisman

Chronology
The Film and Television Appearances

In most summaries, I use the names of the actors rather than their character names, though in Cesar Romero's three long-running series, *Passport to Danger*, *Batman*, and *Falcon Crest*, character names are used since there are many episodes with the same actors playing the same characters. The order of projects is determined by when the films are released and when the television shows air. When production dates are available, they are noted.

Cast and filmmakers are listed as they appear in opening or closing credits except in the few cases where credit sequences are missing from prints of older projects, such as *The Shadow Laughs* from 1933, and for a few of Romero's other early films and some later foreign and low-budget projects that are unavailable for viewing. Often, online film reference sources have incomplete or incorrect information, or they sometimes offer added credits that rely on rumors rather than verifiable facts. They also standardize filmmaker titles, regardless of how the person was originally credited—so those who write Screen Plays, Screenplays, screenplays, Scripts, and scripts (as credits may indicate on different projects) all become listed on imdb.com, for instance, as "Writer (screen play)." This makes sense in a number of ways, but for the record here, I think it is more interesting to go back to the original sources for the original nomenclature, complete with original capitalizations of various job titles.

That is also why credits in this filmography sometimes list "Twentieth Century-Fox" and sometimes switch to "Twentieth Century Fox." Even the filmmakers at Fox sometimes forget their company's own hyphen—a mark they later drop altogether, except when they forget they dropped it and add it back. These inconsistencies are part of the historical record.

There is also the whole messy matter of "the" versus "The." Throughout the text of this book, I default to modern usage, dropping the capitalization of the word in proper nouns when it is in the middle of sentences. So the

Chronology

character on the *Batman* television show, always written originally as "The Joker," even in the middle of a sentence, becomes "the Joker" unless it starts a sentence. And similarly, "The Cisco Kid" becomes "the Cisco Kid." In this filmography, however, I revert to the usage of the time. It seems a fair trade-off between creating a book with a consistent usage style and a filmography that defers to the eclectic usage standards of multiple studios and television networks.

1933

The Shadow Laughs (Trojan Pictures, role: Tony Rico). Hal Skelly is a wisecracking reporter who solves a murder and gets the girl. The primitive photography and sound recording call to mind the talkies from as early as 1929 and 1930, with long, static master shots, clumsy blocking, and interminable pauses between dialogue. Skelly is remarkably unfunny on film. Reviews of the time mainly think otherwise. Most studio bios of Romero list *The Thin Man* as his debut and drop *The Shadow Laughs* from his filmography. Writer and director Arthur Hoerl goes on to write the cult classic *Reefer Madness*. Cast: Hal Skelly, Rose Hobart, Walter Fenner, Harry T. Morey, Geoffrey Bryant, Robert Keith, Harry Short, John F. Morrissey, Bram Nossen, Cesar Romero (uncredited); Directed by Arthur Hoerl; Screenplay by Arthur Hoerl; Release date 03/27/33. *Film Daily*: "Murder mystery has ingenious plot with Hal Skelly delivering strong as investigating reporter." Keene Abbott, *Omaha World-Herald*: "When, where, or how the shadow laughs is more than I can tell." *Salt Lake Tribune*: "The suspense mounts throughout the picture, giving a breathtaking climax that won't be soon forgotten."

1934

The Thin Man (MGM, role: Chris Jorgenson). The first and perhaps best pairing of William Powell and Myrna Loy as Dashiell Hammett's chic, witty, and wealthy crime-solving duo, Nick and Nora Charles. Essential viewing. In a cast with plenty of heavyweights, Romero holds his own. *Metro-Goldwyn-Mayer presents* William Powell and Myrna Loy in *The Thin Man* with Maureen O'Sullivan, Nat Pendleton, Minna Gombell, and Porter Hall, Henry Wadsworth, William Henry, Harold Huber, Cesar Romero, Natalie Moorhead, Edward Brophy, Edward Ellis, and Cyril Thornton; Directed by W.S. Van Dyke; Produced by Hunt Stromberg; Screen Play by Albert

Hackett and Frances Goodrich from the Novel by Dashiell Hammett; Production dates 04/09/34 to 04/27/34; Release date 05/25/34. Pauline Kael, *5001 Nights at the Movies* (1982): "It turned several decades of movies upside down by showing a suave man of the world who made love to his own rich, funny, and good-humored wife."

British Agent (First National Pictures, role: Tito Del Val). When the Bolsheviks revolt, Leslie Howard's ho-hum job as British consul to Russia in 1917 suddenly gets interesting. He becomes an unofficial spy with orders to thwart Stalin's intention to sign a separate peace with Germany. Falling in love with Kay Francis, a Russian spy, makes it all the more fun. British director, actor, playwright, and screenwriter Roland Pertwee does uncredited work on the British dialogue. *First National Pictures, Inc. Present* Leslie Howard, Kay Francis in *British Agent*; Suggested by the Book *British Agent* by R.H. Bruce Lockhart; Directed by Michael Curtiz; Screen Play by Laird Doyle; Leslie Howard as Stephen Locke, Kay Francis as Elena, William Gargan as Medill, Phillip Reed as LeFarge, Irving Pichel as Pavlov, Ivan Simpson as Evans, Halliwell Hobbes as Sir Walter Carrister, J. Carroll Naish as Commissioner for War, Walter Byron as Stanley, Cesar Romero as Del Val; Production start date 03/26/34; Release date 09/15/34. *Variety* (1933): "A powerful yarn of espionage during the early days of the Russian revolution.... Historical accuracy is attempted by the portrayal of Trotsky, Lenin, David Lloyd George and others. Not a perfect job but well done generally." Hal C. F. Astell, *Apocalypse Later* (2011): "This was only Romero's third film after *The Shadow Laughs* and *The Thin Man*, but he was already well worth watching."

Cheating Cheaters (Universal, role: Tony Palmer). The third filmed version of the 1916 Broadway farce. Each of two apparently wealthy families living next door turns out to have criminal intentions toward the other. Cesar Romero is the eldest son of one of the families. His romance with Fay Wray (an undercover detective) complicates things immeasurably. *Carl Laemmle presents* Fay Wray in *Cheating Cheaters* with Cesar Romero, Minna Gombell, Henry Armetta, Hugh O'Connell, Francis L. Sullivan; Directed by Richard Thorpe from the Stage Hit by Max Marcin; Screenwriters Gladys Unger, Allen Rivkin, James Mulhauser; Production dates 09/10/34 to 09/24/34; Release date 11/05/34. *Los Angeles Times* (1934): "Crackles with wit and humor, thrills, surprises, and reveals admirable characterizations."

Strange Wives (Universal, role: Boris). "A Merry mad marital mix-up!" A stockbroker proposes to a Russian refugee and ends up supporting her entire family. He then endeavors to teach them self-reliance so they will get

out of his house. *Carl Laemmle presents* Edith Wharton's Exciting Romance of a Man Who Married a Whole Family! *Strange Wives* from the story *Bread Upon the Waters* starring Roger Pryor, June Clayworth, Esther Ralston, Hugh O'Connell, Ralph Forbes, Cesar Romero, Valerie Hobson, Francis L. Sullivan, and Leslie Fenton; Directed by Richard Thorpe; Screen Play Gladys Unger, James Mulhauser; a Stanley Bergerman Production; Production dates 10/13/34 to 10/29/34; Release date 12/10/34.

1935

Clive of India (20th Century-Fox, role: Mir Jaffar). A clerk at the East India Company in the mid-1700s transfers to the military side of the organization and rises to become the conqueror of Southern India. Cesar Romero is a rival to the king of Northern India who makes an alliance with Ronald Colman and becomes king himself, gifting Colman a whole lot of cash—which Colman's enemies use in a smear campaign against him. All the war and political hagiography aside, if you want to know what stars could bring to the table in old Hollywood, all you have to do is see Colman and Loretta Young breathtakingly and believably fall in love at first sight. They are magic together. *Joseph M. Schenck presents* a Darryl F. Zanuck Production, 20th Century-Fox, *Clive of India* by W. P. Lipscomb and R. J. Minney, starring Ronald Colman with Loretta Young, Colin Clive, Francis Lister, C. Aubrey Smith, Cesar Romero; Directed by Richard Boleslawski; Screen Play W. P. Lipscomb and R. J. Minney; Production dates 11/01/34 to 12/04/34; Release date 01/25/35.

The Good Fairy (Universal, role: Joe). Cesar Romero has a tiny, negligible role as a stage-door johnny in this terrific and funny fable that stars Margaret Sullavan as a comely orphan whose fibs cause charmingly romantic misadventures. There's a startlingly modern take on gender norms in an early scene that doesn't involve any of the principals. At the orphanage, a young girl answers the door. The expensively dressed Alan Hale asks, "Is the director in?" She answers, "Yes, sir." "Very good, then tell him I'd like to see him, please." "Yes, sir, but, uh, he's a lady, Dr. Schultz." "Dr. Schultz is a lady? Peculiar." "Yes, sir." "Well, tell him I want to see her. I mean . . ." And the little girl curtsies with a sly grin. "Yes, ma'am," she says to him, walking off, with the slightly bewildered Hale watching her go. *Carl Laemmle presents* Margaret Sullavan and Herbert Marshall, a William Wyler Production, in Ferenc Molnar's *The Good Fairy* with Frank Morgan; Produced

by Carl Laemmle, Jr.; Screenplay Preston Sturges; Original Molnar play translated and adapted by Jane Hinton; Directed by William Wyler; The Players: Margaret Sullavan, Herbert Marshall, Frank Morgan, Reginald Owen, Eric Blore, Beulah Bondi, Alan Hale, Cesar Romero, Luis Alberni; Production dates 09/13/34 to 12/17/34; Release date 02/18/35.

The Devil Is a Woman (Paramount, role: Antonio Galvan). Marlene Dietrich's beauty and otherworldliness is at its absolute pinnacle in this bonkers tale of a poor cigarette factory worker who morphs into a Spanish courtesan who destroys every man who falls in love with her, including the impossibly dashing Cesar Romero and his friend, the older, far less dashing but richer Lionel Atwill. The story is impenetrably nonsensical, but Dietrich's and Romero's cheekbones are absolutely mesmerizing. The critics mainly praised its sumptuous excesses, but the public stayed away in droves. *Adolph Zukor presents* Marlene Dietrich in a Josef von Sternberg Production, *The Devil Is a Woman*; Adapted by John Dos Passos from *The Woman and the Puppet* by Pierre Louys; The Players: Marlene Dietrich, Lionel Atwill, Edward Everett Horton, Alison Skipworth, Cesar Romero, Don Alvarado, Tempe Pigott, Paco Moreno; Directed and Photographed by Josef von Sternberg, A.S.C.; Production start date 10/15/34; Release date 03/15/35.

Cardinal Richelieu (20th Century-Fox, role: Count Andre de Pons). George Arliss is the cunning Cardinal Richelieu, who must save himself so he can protect King Louis XIII and make France a great power rather than a conglomeration of petty kingdoms ruled by feudal lords. Cesar Romero is a foolish young romantic who risks everything to protect Arliss and win the hand of Maureen O'Sullivan. *Joseph M. Schenck presents* a Darryl Zanuck Production, George Arliss in *Cardinal Richelieu* with Maureen O'Sullivan, Edward Arnold, Douglass Dumbrille, Francis Lister, Cesar Romero; Directed by Rowland V. Lee; Based on a play by Sir Edward George Bulwer-Lytton; Screen Play Maude T. Howell; Dialogue W. P. Lipscomb; Production dates 01/28/35 to 02/25/35; Release date 04/28/35. Andre Sennwald, *New York Times* (1935): "His Richelieu is not simply an ambuscade of churchly vestments and pointed mustaches, but a skillful mutation of Mr. Arliss in terms of the wily fox of historical romance. . . . In the customary romantic roles, Maureen O'Sullivan and Cesar Romero are pleasant."

Hold 'Em Yale (Paramount, role: Georgie, The Chaser). In a ticket-scalping scheme, Cesar Romero is sent by four criminal cohorts to buy up tickets to the Harvard-Yale football game. He switches gears and focuses

instead on scamming heiress Patricia Ellis. *Adolph Zukor presents Hold 'Em Yale*, Based on a Story by Damon Runyon; with Patricia Ellis, Cesar Romero, Buster Crabbe (credited as Larry "Buster" Crabbe), William Frawley, Andy Devine, George Barbier, Warren Hymer, George E. Stone, Hale Hamilton; Produced by Charles R. Rogers; Directed by Sidney Danfield; Screen Play by Paul Gerard Smith and Eddie Welch; Production start date 01/18/35; Release date 04/27/1935.

Diamond Jim (Universal, role: Jerry Richardson). Edward Arnold is the fabled orphan who rises from train station baggage master to bejeweled tycoon, gaining and losing two fortunes, surviving life-threatening injuries, and losing the love of his life to Cesar Romero. That Jean Arthur prefers Romero is not a surprise. This is one of Romero's few A pictures where he gets the girl. *Carl Laemmle presents* Edward Arnold in *Diamond Jim* with Jean Arthur, Binnie Barnes, Cesar Romero, Eric Blore, Hugh O'Connell; Screenplay by Preston Sturges; Adapted by Doris Malloy, Harry Clork; Based on the book *Diamond Jim* by Parker Morrell; an Edmund Grainger Production; Directed by A. Edward Sutherland; Production dates 04/03/35 to 04/20/35; Release date 09/02/35.

Rendezvous (MGM, role: Captain Nicholas Nieterstein). In 1917, soldier William Powell is happily headed for France, anxious to get in some real fighting, when Rosalind Russell, anxious to keep Powell near and dear, reveals his secret to her uncle, the assistant secretary of war: Powell is not just an ordinary soldier, but a noted expert on codes. Powell is reassigned to break enemy codes and uncover German spies, including femme fatale Binnie Barnes and double agent Cesar Romero. *Metro-Goldwyn-Mayer presents* William Powell in *Rendezvous* with Rosalind Russell and Binnie Barnes, Lionel Atwill, Cesar Romero, Samuel S. Hinds; a William K. Howard Production; Directed by William K. Howard; Produced by Lawrence Weingarten; Adaptation by Bella and Sam Spewack; Screen Play by P. J. Wolfson and George Oppenheimer from a book by Herbert O. Yardley; Production dates 06/24/35 to 07/29/35 and 09/06/35 to 09/26/35; Release date 10/25/35.

Metropolitan (20th Century-Fox, role: Nick Baroni). In a sort of operatic variation on a Mickey and Judy let's-put-on-a-show tale like *Babes in Arms*, tempestuous prima donna Alice Brady leaves the Metropolitan Opera and forms her own company, bankrolled by her wealthy husband. Lawrence Tibbett gets a lucky break as her leading baritone and a not so lucky break as

the offstage object of her affection. Dashing, debonair Cesar Romero (often in white tie and tails) is Tibbett's good-natured Italian friend and potential romantic rival. In the Fox archives, it is listed as a ten-reel film, but it was released in an eight-reel print, so extensive cutting must have occurred. *20th Century-Fox*; Lawrence Tibbett in *Metropolitan* with Virginia Bruce, Alice Brady, Cesar Romero, Thurston Hall, Luis Alberni, George F. Marion (the screenwriter's father, credited as George Marion Sr.), Adrian Rosley, Christian Rub, Franklyn Ardell, Etienne Girardot, Jessie Ralph, Jane Darwell (uncredited), Walter Brennan (uncredited); a Darryl F. Zanuck, Twentieth Century Production; Directed by Richard Boleslawski; Screen Play by Bess Meredyth and George Marion Jr.; Based on the Story by Bess Meredyth; Production dates 07/29/35 to 09/07/35; Release date 11/08/35.

Show Them No Mercy! (20th Century-Fox, role: Tobey). A young couple's car breaks down in the rain. They find shelter in an empty country house that turns out to be the hideout of a band of violent criminals with a kidnapped baby. Cesar Romero as the leader of the gang and the unhinged Bruce Cabot are genuinely frightening—Romero with rock-hard coldness and Cabot with unhinged heat. *20th Century-Fox*; *Show Them No Mercy!* by Kubec Glasmon; with Rochelle Hudson, Cesar Romero, Bruce Cabot; a Darryl F. Zanuck Twentieth Century Production presented by Joseph M. Schenck; Directed by George Marshall; Production dates 08/28/35 to late September; Release date 12/06/35.

1936

Love before Breakfast (Universal, role: Bill Wadsworth). A dizzy romantic comedy that now seems like a story of an extreme stalker taking possession of the object of his desire. Society beauty Carole Lombard is engaged to Cesar Romero, and Betty Lawford is a countess with her heart set on Preston Foster. When Foster fancies Lombard, he surreptitiously maneuvers a job in Japan for Romero and a voyage to Honolulu for Lawford. Foster's machinations have the full support of Lombard's mother. It's that kind of movie. *Carl Laemmle presents* Carole Lombard in *Love before Breakfast* with Preston Foster, Cesar Romero, Janet Beecher; Additional cast: Betty Lawford, Forrester Harvey, Richard Carle, Joyce Compton, Bert Roach, Diana Gibson; Screenplay by Herbert Fields from the novel *Spinster Dinner* by Faith Baldwin; an Edmund Grainger Production; Directed by Walter Lang; Production dates 12/16/35 to 01/27/36; Release date 02/29/36.

Chronology

Nobody's Fool (Universal, role: "Dizzy" Rantz). In a rare starring role, Edward Everett Horton is a small-town waiter who gets mixed up with con artists in New York City led by Glenda Farrell, naively fronting for a gang of thieves trying to extort racketeer Cesar Romero. In the end, Romero and Farrell go straight, becoming honest citizens, and the high-camp Horton ostensibly goes straight when Farrell falls in love with him. *Universal presents* Edward Everett Horton, *Nobody's Fool*; Directed by Arthur Greville Collins; with Glenda Farrell, Cesar Romero, Warren Hymer, Diana Gibson, Edward Gargan; Produced by Irving Starr; Original story by Frank Mitchell Dazey and Agnes Christine Johnston; Screen Play by Ralph Block and Ben Markson; Release date 05/31/36.

Public Enemy's Wife (Warner Bros., role: Gene Maroc). Husband and wife Cesar Romero and Margaret Lindsay are both in prison for robbery and kidnapping, though Lindsay now hates Romero for putting her behind bars with damning testimony even though she knew nothing of his criminal activities. He did it to keep any other man from having her. When she is released and divorces him, Romero threatens to kill any man who comes near her. Romero is the total bad guy here with no redeeming qualities save for his dashing good looks. Neither the direction nor the script offers any opportunity for charm or human feeling. *Warner Bros. Pictures, Inc. present Public Enemy's Wife* with Pat O'Brien and Margaret Lindsay, Robert Armstrong, Cesar Romero, Dick Foran, Joe King, Dick Purcell, Addison Richards; Directed by Nick Grinde; Screen Play by Abem Finkel and Harold Buckley; Story by P. J. Wolfson; Release date 07/25/36.

15 Maiden Lane (20th Century-Fox, role: Frank Peyton). Cesar Romero is a jewel thief who teams up with fellow criminal Claire Trevor, who turns out to be an amateur undercover detective. Kidnapping, murder, double crosses, and mind games complicate things immeasurably. *20th Century-Fox; 15 Maiden Lane* with Claire Trevor, Cesar Romero, and Douglas Fowley, Lloyd Nolan, Lester Matthews, Robert McWade; Executive Producer Sol M. Wurtzel; Directed by Allan Dwan; Screen Play by Lou Breslow, David Silverstein, John Patrick from a story by Paul Burger; Production dates 07/28/36 to late August; Release date 10/30/36. *Los Angeles Times* (1936): "Lavish display for milady's sake. Claire Trevor wears fur wraps and capes valued at $64,000 and real and replica jewels valued at $50,000 so womenfolk will see the latest for 1937 in *15 Maiden Lane*. Jewels and furs heavily insured."

Chronology

1937

She's Dangerous (Universal, role: Nick Sheldon / Al Shaw). No one is who or what they seem in this criminal tale with Cesar Romero as a violent swindler and Tala Birell as the good girl masquerading as a very bad girl indeed; she falls in love with Walter Pidgeon after a plane crash when Pidgeon nurses her and Romero back to health. Romero hates the movie and remembers it as one of the worst pictures of his career, along with *Armored Car*, the one that follows. *Universal presents She's Dangerous* with Tala Birell, Walter Pidgeon, Cesar Romero, Walter Brennan, Warren Hymer, Samuel S. Hinds; Screen Play Lionel Houser, Albert R. Perkins; Original Story by Murray Roth, Ben Ryan; Directed by Lewis R. Foster and Milton Carruth; Production dates 10/30/36 to 11/19/36; Release date 01/24/37.

Armored Car (Universal, role: Petack). Another bad-guy role for Cesar Romero. This time he terrorizes the hapless Robert Wilcox, a down-on-his-luck armored car driver who is unfairly fired after a young colleague is killed in the line of duty. Wilcox becomes part of an undercover sting operation, and Romero gets gunned down by an accomplice. It is his final film under contract to Universal. Fox borrows him for *Wee Willie Winkie* in January 1937 and never gives him back. *Universal presents Armored Car* with Robert Wilcox, Judith Barrett, Cesar Romero, Irving Pichel, David Oliver; Screen Play Lewis R. Foster, Robert N. Lee; Original Story by William A. Pierce; Associate Producer E. M. Asher; Directed by Lewis R. Foster; Production dates 04/12/37 to 04/28/37; Release date 06/20/37.

Wee Willie Winkie (20th Century-Fox, role: Khoda Khan). Shirley Temple's adorable sensibleness and intrinsic humanity spark an alliance between Indian rebels and the British at the end of the nineteenth century. It is a huge hit and benefits the careers of everyone involved—though Temple hardly needs a boost. She is already in her third year as the reigning number one box office star in the world. Years later, when she is Shirley Temple-Black and writes her bestselling autobiography, she ranks *Wee Willie Winkie* as the best film of her entire career, which is saying something. *20th Century-Fox presents* Rudyard Kipling's *Wee Willie Winkie* starring Shirley Temple, Victor McLaglen, and C. Aubrey Smith, June Lang, Michael Whalen, Cesar Romero, Constance Collier, Douglas Scott; Directed by John Ford; Screen Play by Ernest Pascal and Julien Josephson based upon the story by Rudyard Kipling; Darryl F. Zanuck in Charge of Production; Production dates late January to late March 1937; Release date 07/30/37.

Ali Baba Goes to Town (20th Century-Fox, role: Himself). Eddie Cantor is a bum who stumbles onto the film set of *The Arabian Nights*. All he wants is an autograph, but he ends up with an accidental head injury. Cesar Romero is featured in footage shot at the premiere of *Wee Willie Winkie* as part of the fictional film premiere in the final reel. *20th Century-Fox presents* Eddie Cantor in *Ali Baba Goes to Town* with Tony Martin, Roland Young, June Lang, Gypsy Rose Lee (credited as Louise Hovick); Darryl F. Zanuck in Charge of Production; Directed by David Butler; Screen Play by Harry Tugend and Jack Yellen based on a story by Gene Towne, C. Graham Baker, and Gene Fowler; Production dates late July through early September 1937; Release date 10/29/37.

Dangerously Yours (20th Century-Fox, role: Victor Morell). The fabled Omar diamond is crossing the Atlantic with glamorous thieves around every corner. Cesar Romero tops the cast in this elegant comedy-mystery, posing as the wealthy owner of an Argentine cattle ranch in a double bluff while also posing as a jewel thief. Jane Darwell as one of the thieves steals every scene that isn't nailed down. *20th Century-Fox presents Dangerously Yours* with Cesar Romero, Phyllis Brooks, Jane Darwell, Alan Dinehart; Executive Producer Sol M. Wurtzel; Directed by Malcolm St. Clair; Screen Play by Lou Breslow and John Patrick; Release date 11/12/37.

1938

Happy Landing (20th Century-Fox, role: Duke Sargent). Don Ameche and Cesar Romero crash-land near a Norwegian village and compete for the affections of Sonja Henie, a simple village girl whose hobby is skating in spectacular ice shows. Meanwhile, back in New York, Ethel Merman has her sights set on Romero. *20th Century-Fox presents* Sonja Henie and Don Ameche in *Happy Landing*; Darryl F. Zanuck in Charge of Production; with Ethel Merman, Cesar Romero, Jean Hersholt, Billy Gilbert, The Raymond Scott Quintet, Wally Vernon, Leah Ray; Directed by Roy Del Ruth; Original Screen Play by Milton Sperling and Boris Ingster; Production dates 10/18/37 to mid-December; Release date 01/23/38.

Always Goodbye (20th Century-Fox, role: Count Giovanni "Gino" Corini). A disconsolate and pregnant Barbara Stanwyck tries suicide after the death of her fiancé. Herbert Marshall is the drifter who stops her, gets his life as a surgeon back on track, and grows to love her. Cesar Romero is the playboy count who also pursues her. Ian Hunter is the adoptive father

of Stanwyck's son, now conveniently a widower, who also falls for Stanwyck. Meanwhile, she becomes a fabulously successful fashion buyer. Lots of self-sacrifice, not quite to the tear-drenched levels of *Stella Dallas* but close. *20th Century-Fox presents* Barbara Stanwyck, Herbert Marshall in *Always Goodbye* with Ian Hunter, Cesar Romero; Darryl F. Zanuck in Charge of Production; and Lynn Bari, Binnie Barnes, Johnny Russell; Directed by Sidney Lanfield; Screen Play by Kathryn Scola and Edith Skouras based on a Story by Gilbert Emery and Douglas Z. Doty; Production dates 04/18/38 to 05/24/38; Release date 07/01/38. Edwin Schallert, *Los Angeles Times* (1938): "An obvious pattern formula saved by the smooth direction, and by the work of Barbara Stanwyck, Herbert Marshall, Cesar Romero. . . . The best scenes are those with the youngster, and Mr. Romero and Miss Stanwyck." Harrison Carroll, *Los Angeles Evening Herald* (1938): "Most vital of all is Cesar Romero as a titled Parisian gigolo."

My Lucky Star (20th Century-Fox, role: George Cabot Jr.). For romantic, financially complicated, and entirely improbable reasons, Cesar Romero sends Sonja Henie to college as an undercover model for the clothing line being sold in his father's department store. Hijinks and hilarity ensue, and the school stages a gigantic ice show. The most enduring comic moment is Romero taking a pratfall and sailing across the ice on his derriere—a scene widely used in montages of musical comedies from Hollywood's golden age. *20th Century-Fox presents* Sonja Henie and Richard Greene in *My Lucky Star*; Darryl F. Zanuck in Charge of Production; with Joan Davis, Cesar Romero, Buddy Ebsen, Arthur Treacher, George Barbier, Gypsy Rose Lee (credited as Louise Hovick), Billy Gilbert, Patricia Wilder, Paul Hurst; Directed by Roy Del Ruth; Screen Play by Harry Tugend and Jack Yellen based on a Story by Karl Tunberg and Don Ettlinker; Production dates 04/25/38 to 07/01/38; Release date 09/02/38.

Five of a Kind (20th Century-Fox, role: Duke Lester). Capitalizing on the mania for the real-life Dionne Quintuplets, Cesar Romero and Claire Trevor are rival reporters trying to sign the kids for a radio broadcast. Jean Hersholt is the doctor and gatekeeper controlling access to the famous fivesome. Romero and Trevor treat one another abominably, resulting in arrests, firings, and lawsuits—but they fall in love anyway. The two actors are such pros that they almost make it seem plausible. *20th Century-Fox presents* The Dionne Quintuplets (Cecile, Yvonne, Marie, Annette, Emelie) in *Five of a Kind* with Jean Hersholt, Claire Trevor, Cesar Romero, and Slim

Summerville, Henry Wilcoxon, Inez Courtney, John Qualen, Jane Darwell, Pauline Moore; Executive Producer Sol M. Wurtzel; Directed by Herbert I. Leeds; Original Screen Play by Lou Breslow and John Patrick; Production dates 06/06/38 to 06/21/38 then late June to late July 1938; Release date 10/14/38.

1939

Wife, Husband and Friend (20th Century-Fox, role: Hugo). Big-time building contractor Warner Baxter tries to keep wife Loretta Young from pursuing her unrealistic dreams of becoming a professional opera singer and in the process becomes a singing star himself. Binnie Barnes is a concert diva with romantic designs on Baxter, and Cesar Romero is the pianist and voice teacher who enables Young's delusions. With everyone dubbed by professionals, it's hard to understand why one voice is deemed brilliant and another mediocre except that the plotting needs such distinctions to be made. Romero has very little to do. *20th Century-Fox presents* Loretta Young, Warner Baxter in *Wife, Husband and Friend*; Darryl F. Zanuck in Charge of Production; with Binnie Barnes, Cesar Romero, George Barbier, J. Edward Bromberg, Eugene Pallette, Helen Westley; Directed by Gregory Ratoff; Associate Producer and Screen Play by Nunnally Johnson based on the novel by James M. Cain; Production start date early November 1938; Release date 03/03/39.

The Little Princess (20th Century-Fox, role: Ram Dass). Quintessential Shirley Temple in her first color film, the most expensive of her projects to date. She is a rich girl at a boarding school when her father's disappearance and presumed death on the battlefield of the Second Boer War in 1899 leaves her a penniless orphan in service to a cruel headmistress and bullying students. Cesar Romero is her mysterious turbaned benefactor who creates a magical oasis in the dank attic to which Temple and fellow servant Sybil Jason are consigned. Temple holds on to the hope that her father is still alive, and her faith is miraculously rewarded. Even Queen Victoria shows up—just as charmed by Temple as the millions of moviegoers who make *The Little Princess* one of her biggest hits. During shooting, director Walter Lang took a medical furlough and was replaced by the uncredited William A. Seiter. *20th Century-Fox presents* Shirley Temple in *The Little Princess*; Darryl F. Zanuck in Charge of Production; with Richard Greene, Anita Louise, and Ian Hunter, Cesar Romero, Arthur Treacher, Mary Nash, Sybil Jason, Miles Mander, Marcia Mae Jones; Directed by Walter Lang; Screen

Chronology

Play by Ethel Hill and Walter Ferris based on the novel by Frances Hodgson Burnett; Production start date late September 1938; Release date 03/17/39. Benjamin R. Crisler, *New York Times* (1939): "With any other child on earth, it is amazing to reflect, *The Little Princess* would stand out as one of the most glaring exhibits of pure hokum in screen history; with Mistress Temple, it may very well be, as Mr. Zanuck unflinchingly proclaims, the greatest picture with which Mr. Zanuck has ever been associated."

The Return of The Cisco Kid (20th Century-Fox, role: Lopez). In his first Cisco Kid movie, Cesar Romero is not yet the title hero but his Mexican sidekick. As the film begins, Cisco barely escapes the deadly bullets of a firing squad and later meets a lovely señorita and falls in love, but she and her father have been cheated out of their life savings, and it's up to Cisco to set things right. Which he does. *20th Century-Fox presents* Warner Baxter in *The Return of The Cisco Kid*; Darryl F. Zanuck in Charge of Production; with Lynn Bari, Cesar Romero, Henry Hull, Kane Richmond, C. Henry Gordon, Robert Barrat; Directed by Herbert I. Leeds; Screen Play by Milton Sperling based on the famous character Cisco Kid created by O. Henry; Production dates 02/22/39 to 03/27/39; Release date 04/28/39.

Frontier Marshal (20th Century-Fox, role: Doc Halliday). In this retelling of the Wyatt Earp story, Cesar Romero is named Doc Halliday rather than Holliday. The production barrels along amiably and hits all the required notes. Some say Romero's success in the film (without the bushy beard and Mexican accent of his sidekick role in *The Return of The Cisco Kid*) helps Fox pull the trigger, as it were, on casting him as The Cisco Kid. *20th Century-Fox presents* Randolph Scott, Nancy Kelly in *Frontier Marshal* with Cesar Romero, Binnie Barnes, John Carradine; Executive Producer Sol M. Wurtzel; Screen Play by Sam Hellman based on the book by Stuart N. Lake; Directed by Allan Dwan; Production dates 06/10/39 to 07/11/39; Release date 07/28/39.

Charlie Chan at Treasure Island (20th Century-Fox, role: Rhadini). Charlie Chan investigates psychic phenomena to prove a suspected suicide is actually murder at the 1939 World Exposition on Treasure Island in San Francisco. He exposes mystic Cesar Romero as not just a charlatan but a killer as well. The plot barrels away quickly enough, but not fast enough to keep you from wondering for the umpteenth time why a White guy is playing Chan. At least his son is played by Asian actor Victor Sen Yung. *20th Century-Fox presents Charlie Chan at Treasure Island* with Sidney Toler and Cesar Romero, Pauline Moore, Victor Sen Yung (credited as Sen Yung),

Douglas Fowley, June Gale, Douglass Dumbrille, Sally Blane, Billie Seward, Wally Vernon, Donald MacBride; Directed by Norman Foster; Original Story and Screen Play by John Larkin; Based on the character Charlie Chan created by Earl Derr Biggers; Production dates 04/17/39 to 05/13/39; Release date 09/08/39.

The Cisco Kid and the Lady (20th Century-Fox, role: The Cisco Kid). Cesar Romero rescues an orphan whose father has been killed by bandits, preserving the child's inheritance and reuniting him with his real mother. Romero does a fantastic tango with Virginia Field and performs "La Cucaracha" and "Carmela" to great effect. *20th Century-Fox presents The Cisco Kid and the Lady* with Cesar Romero and Marjorie Weaver, Chris-Pin Martin, George Montgomery, Robert Barrat, Virginia Field, Harry Green; Screen Play by Frances Hyland; Original Story by Stanley Rauh; Suggested by the character The Cisco Kid created by William Sydney Porter (O. Henry); Directed by Herbert I. Leeds; Production start date 09/11/39; Release date 12/29/39.

1940

He Married His Wife (20th Century-Fox, role: Freddie). Joel McCrea and Nancy Kelly are amicably divorced, but she isn't above having him jailed when he falls behind on alimony payments. McCrea plots to marry her off to the amiable Roland Young so he can stop supporting her, but she instead seems to be falling for a gigolo, Cesar Romero. A reconciliation for McCrea and Kelly seems to be the only logical solution. *20th Century-Fox presents* Joel McCrea, Nancy Kelly in *He Married His Wife*; Darryl F. Zanuck in Charge of Production; with Roland Young, Mary Boland, Cesar Romero, Mary Healy, Lyle Talbot, Elisha Cook Jr., Barnett Parker; Screen Play by Sam Hellman, Darrell Ware, Lynn Starling, and John O'Hara; Original Story by Erna Lazarus and Scott Darling; Directed by Roy Del Ruth; Production dates 10/02/39 to 11/09/39; Release date 01/19/40.

Viva Cisco Kid (20th Century-Fox, role: The Cisco Kid). As soon as Cesar Romero tells longtime sidekick Chris-Pin Martin "From now on, Amigo, I am through with women," you know he's about to meet a lady who will change his mind. Jean Rogers is the comely lass, and her father is mixed up with outlaws, an aborted stagecoach robbery, and a replacement robbery—that Romero gets blamed for. Spoiler alert: he didn't do it. *20th Century-Fox presents Viva Cisco Kid* with Cesar Romero and Jean Rogers, Chris-Pin Martin, Minor Watson, Stanley Fields; Executive Producer Sol

M. Wurtzel; Screen Play by Samuel G. Engel and Hal Long; Suggested by the character The Cisco Kid created by William Sydney Porter (O. Henry); Directed by Norman Foster; Production dates late December 1939 to early February 1940; Release date 04/12/40.

Lucky Cisco Kid (20th Century-Fox, role: The Cisco Kid). Cesar Romero and Chris-Pin Martin learn there is an outlaw going around robbing stagecoaches who people are saying is The Cisco Kid. There is a large reward for his capture. Romero goes after the actual bad guys only to be wounded and accused of murder, all while falling in love with Mary Beth Hughes. *20th Century-Fox presents Lucky Cisco Kid* with Cesar Romero and Mary Beth Hughes, Dana Andrews, Evelyn Venable, Chris-Pin Martin; Screen Play by Robert Ellis and Helen Logan; Original Story by Julian Johnson; Based on the character The Cisco Kid created by William Sydney Porter (O. Henry); Directed by H. Bruce Humberstone; Production dates 02/26/40 to mid-March; Release date 06/28/40.

The Gay Caballero (20th Century-Fox, role: The Cisco Kid). Cesar Romero discovers his own grave and a weeping woman beside it. She reveals it is the grave of her fiancé, falsely accused of being The Cisco Kid, who was murdered by the foreman of the powerful lady rancher who employs her. Meanwhile, Romero rescues an Englishman and his daughter who are ambushed on their way to buy a parcel of land from the same lady rancher. *20th Century-Fox presents The Gay Caballero* with Cesar Romero as The Cisco Kid, and Sheila Ryan, Robert Sterling, Chris-Pin Martin, Janet Beecher, Edmund MacDonald, Jacqueline Dalya; Screen Play by Albert Duffy and John Francis Larkin; Original Story by Walter Bullock and Albert Duffy; Based on the character The Cisco Kid created by William Sydney Porter (O. Henry); Directed by Otto Brower; Production dates 05/21/40 to early June and 08/05/40 to 08/13/40; Release date 10/04/40. *Variety* (1940): "Cesar Romero is in the familiar role of Cisco, never losing his composure in the darkest situations."

1941

Romance of the Rio Grande (20th Century-Fox, role: The Cisco Kid/Carlos Hernandez). The plot is about a grandson returning from Spain to become the heir to a wealthy rancher. The rancher's son-in-law has other ideas and tries to have him killed before he gets to the ranch. But wouldn't you know, the grandson is the spitting image of Cesar Romero. For a quickly shot B programmer, Romero is surprisingly subtle in essentially playing three

characters: Cisco, the grandson, and Cisco pretending to be the grandson. *20th Century-Fox presents Romance of the Rio Grande* with Cesar Romero as The Cisco Kid, and Patricia Morison, Lynne Roberts, Ricardo Cortez, Chris-Pin Martin; Executive Producer Sol M. Wurtzel; Screen Play by Harold Buchman and Samuel G. Engel; Based on the novel *Conquistador* by Katherine Fullerton Gerould; Suggested by the character The Cisco Kid created by William Sydney Porter (O. Henry); Directed by Herbert I. Leeds; Production dates early September to 10/02/40; Release date 01/17/41.

Tall, Dark and Handsome (20th Century-Fox, role: J. J. "Shep" Morrison). On Christmas Eve, 1928, Chicago gang boss and nightclub owner Cesar Romero spots Virginia Gilmore in a department store and maneuvers her into working for him as a live-in nanny. The only fly in the ointment is that he is actually a childless bachelor. The limber-limbed Charlotte Greenwood is a moll pretending to be his starchy housekeeper, and Stanley Clements is the hard-boiled kid who Romero's flunky Milton Berle manages to find to impersonate Romero's son. Clements gives one of the funniest performances ever from a child actor, and Romero makes the most of the fable-like air of comedy that prevails. *20th Century-Fox presents* Cesar Romero, Virginia Gilmore, Charlotte Greenwood, Milton Berle in *Tall, Dark and Handsome* with Sheldon Leonard, Stanley Clements, Frank Jenks, Barnett Parker; Original Screenplay by Karl Tunberg and Darrell Ware; Directed by H. Bruce Humberstone; Production dates 11/12/40 to early December; Release date 01/24/41.

Ride On Vaquero (20th Century-Fox, role: The Cisco Kid). The US Cavalry is on hand for Cesar Romero's sixth and final Cisco Kid film, first arresting him, then letting him escape so he can unofficially work for them to capture an impostor who has been committing a series of kidnappings while pretending to be The Cisco Kid. The stakes are raised when Romero is given an unusually strong motive: avenging the death of a beloved patriarch who is like family to him. *20th Century-Fox presents Ride On Vaquero* with Cesar Romero as The Cisco Kid, and Mary Beth Hughes, Lynne Roberts, Chris-Pin Martin, Robert Lowry, Ben Carter; Executive Producer Sol M. Wurtzel; Original Screen Play by Samuel G. Engel; Suggested by the character The Cisco Kid created by William Sydney Porter (O. Henry); Directed by Herbert I. Leeds; Production dates mid-December 1940 to mid-January 1941; Release date 04/18/41.

The Great American Broadcast (20th Century-Fox, role: Bruce Chadwick). Set in 1919, the film is (very) loosely based on the industrialist and entrepreneur Atwater Kent, the first American inventor to mass produce

radio equipment. Alice Faye, Jack Oakie, and John Payne form a love triangle and business partnership, with Oakie in the role based on Kent. Cesar Romero is the rich dilettante who initially provides capital, then becomes a rival. Sadly he does not perform in any of the many musical numbers. A precredit montage shows Paul Whiteman, Eddie Cantor, Jack Benny, Kate Smith, Rudy Vallee, and Walter Winchell nostalgically paying tribute to the early days of radio. Romero counts this film as one of his best. *20th Century-Fox presents* Alice Faye, Jack Oakie, John Payne, Cesar Romero in *The Great American Broadcast* with The Ink Spots (credited as The Four Ink Spots), James Newill, Nicholas Brothers (Fayard Nicholas and Harold Nicholas), Wiere Brothers (Harry Wiere, Herbert Wiere, and Sylvester Wiere); Original Screen Play by Don Ettlinger and Edwin Blum, Robert Ellis and Helen Logan; Directed by Archie Mayo; Production dates late January to 03/17/41, with additional scenes shot on 03/27/41; Release date 05/09/41. *Variety* (1941): "Story details the adventures of Jack Oakie, John Payne, Alice Faye and Cesar Romero as early pioneers in radio broadcasting. Oakie tinkers with a crystal set in his room, idea-minded Payne gets enthusiastic over wireless entertainment possibilities, Faye is radio's first singing star, and Romero supplies the early coin."

Dance Hall (20th Century-Fox, role: Duke McKay). Carole Landis is the new singer at Danceland, a dance hall run by Cesar Romero, who cuts a dashing figure but is a boastful womanizer. They bicker and banter, and their love is sealed when she bails him out of jail after he fixes a raffle to pay off his gambling debts. *20th Century-Fox presents* Carole Landis, Cesar Romero in *Dance Hall* with William Henry, June Storey, J. Edward Bromberg; Executive Producer Sol M. Wurtzel; Screen Play by Stanley Rauh and Ethel Hill; Based on a novel by W. R. Burnett; Directed by Irving Pichel; Production dates 04/21/41 to mid-May; Release date 07/18/41.

Week-End in Havana (20th Century-Fox, role: Monte Blanca). Thrown together in Cuba's lush paradise, can Alice Faye and John Payne stop squabbling long enough to realize they are in love? Already living in Cuba's lush paradise, can Carmen Miranda and Cesar Romero also stop squabbling long enough to realize *they* are *also* in love? Odds are in everyone's favor. *20th Century-Fox presents* Alice Faye, Carmen Miranda, John Payne, Cesar Romero in *Week-End in Havana* with Cobina Wright, Jr., George Barbier, Sheldon Leonard, Leonid Kinskey, Chris-Pin Martin, Billy Gilbert; Original Screen Play by Karl Tunberg and Darrell Ware; Produced by William LeBaron; Directed by Walter Lang; Production dates mid-June to late July

1941; Release date 10/08/41. Pauline Kael, *5001 Nights at the Movies* (1982): "Probably the cheerfullest weekend in Havana's history, what with Carmen Miranda, Alice Faye, John Payne, Cesar Romero, Leonid Kinskey, George Barbier, and everybody else on the 20th Century-Fox lot beaming with fatuous goodwill. Carmen Miranda wears a headgear of grapefruit, grapes, apples, oranges, bananas, lemons, pineapples, and an occasional small plum."

1942

A Gentleman at Heart (20th Century-Fox, role: Tony Miller). Bookie Cesar Romero's flunky, Milton Berle, inherits a struggling art gallery where Carole Landis is trying to keep the business afloat. Romero cooks up a nifty art swindle that goes awry, putting him on the straight and narrow and in Landis's arms. *20th Century-Fox presents* Cesar Romero, Carole Landis, Milton Berle in *A Gentleman at Heart* with J. Carrol Naish, Richard Derr, Rose Hobart, Jerome Cowan, Elisha Cook Jr., Francis Pierlot; Screen Play by Lee Loeb and Harold Buchman; Based on the Story "Masterpiece" by Paul Hervey Fox; Produced by Walter Morosco; Directed by Ray McCarey; Release date 01/16/42.

Orchestra Wives (20th Century-Fox, role: Saint John "Sinjin" Smith). Ann Rutherford is beyond thrilled when Glenn Miller and His Orchestra appear in a nearby town, and she goes gaga for trumpeter George Montgomery. They marry, and she joins the band of tagalong wives who tour with the orchestra, but the catty drama behind the scenes almost ends her marriage. It's fairly turgid, but suddenly, near the end of the film, the Nicholas Brothers come out of nowhere and do a fantastic acrobatic tap number to *I've Got a Gal in Kalamazoo*. Heaven. For some reason, Glenn Miller's "Orchestra" is billed as his "Band." The Fox executive in charge of the production, William Goetz, will hire Romero twenty-five years later for a little project called *Batman*. *20th Century-Fox presents* George Montgomery, Ann Rutherford with Glenn Miller and His Band in *Orchestra Wives* with Lynn Bari, Carole Landis, Cesar Romero, Virginia Gilmore, Mary Beth Hughes, Fayard Nicholas and Harold Nicholas (credited as The Nicholas Brothers), Tamara Geva, Frank Orth; Screen Play by Karl Tunberg and Darrell Ware; Original Story by James Prindle; Produced by William LeBaron; Directed by Archie Mayo; Production dates 04/06/41 to 04/17/41 and 04/22/41 to early June; Release date 09/04/42.

Chronology

Tales of Manhattan (20th Century-Fox, role: Harry Wilson). A star-studded series of stories revolving around a custom-made formal tailcoat that brings each owner a change of fortune. Cesar Romero's story is a love triangle with Henry Fonda and Ginger Rogers. The most interesting story is one that gets cut: a very funny vignette with W. C. Fields as a teetotaling flimflam man, reportedly directed by Malcom St. Clair, that is restored for the VHS release then cut again for the DVD. The worst of the stories is the finale with Paul Robeson and Ethel Waters in a mawkish tale of poor African American sharecroppers who pray a lot when money rains down from the sky. Robeson is so disgusted by the degrading stereotypes he refuses to ever make another film. You can see why. *20th Century-Fox presents Tales of Manhattan*, a Julien Duvivier Film starring in the order of their appearance, Charles Boyer, Rita Hayworth, Ginger Rogers, Henry Fonda, Charles Laughton, Edward G. Robinson, Paul Robeson, Ethel Waters, Eddie "Rochester" Anderson, with Thomas Mitchell, Cesar Romero, Roland Young, Gail Patrick, Eugene Pallette, Victor Francen, George Sanders, James Gleason, and Marion Martin, Elsa Lanchester, Harry Davenport, James Rennie, J. Carrol Naish, and the Hall Johnson Choir; Original Stories and Screen Play by Ben Hecht, Ferenc Molnár, Donald Ogden Stewart, Samuel Hoffenstein, Alan Campbell, Ladislas Fodor, László Vadnay, László Görög, Lamar Trotti, Henry Blankfort; Produced by Boris Morros and Sam Spiegel (credited as S. P. Eagle); Directed by Julien Duvivier; Production dates 10/22/41 to 02/05/42 with retakes beginning in early March 1942; Release date 10/30/42. Pauline Kael, *5001 Nights at the Movies* (1982): "In competition for the most embarrassing section are the ones with Laughton as a symphony conductor and a heaven-sent miracle featuring Robeson and Waters."

Springtime in the Rockies (20th Century-Fox, role: Victor Prince). Betty Grable and John Payne are the top-billed couple—a dance team on the rebound with Grable hooking up with her old partner, Cesar Romero. Romantic misunderstandings and unusual pairings ensue when Payne shows up after a drunken bender to learn he has hired Carmen Miranda and Edward Everett Horton. *20th Century-Fox presents* Betty Grable, Carmen Miranda, John Payne, Cesar Romero, Charlotte Greenwood, Edward Everett Horton, and Harry James and His Music Makers in *Springtime in the Rockies*; Screen Play by Walter Bullock and Ken Englund; Adaptation by Jacques Thery; Based on a Story by Philip Wylie; Produced by William LeBaron; Directed by Irving Cummings; Production dates 06/15/42 to early August with retakes and added scenes from 08/08/42 to 08/10/42; Release date 11/06/42.

Chronology

1943

Coney Island (20th Century-Fox, role: Joe Rocco). Cesar Romero runs a Coney Island nightspot at the turn of the century where his star attraction is the brash and beautiful Betty Grable. George Montgomery is the interloper from Romero's past who insinuates himself into the club and into Grable's life, becoming a Svengali on her path to refinement and Broadway. *20th Century-Fox presents* Betty Grable, George Montgomery, Cesar Romero, in *Coney Island* with Charles Winninger, Phil Silvers, Matt Briggs, Paul Hurst, Frank Orth; Screen Play by George Seaton; Produced by William LeBaron; Directed by Irving Cummings; Production dates late September 1942 to 01/12/43; Release date 06/18/43.

Wintertime (20th Century-Fox, role: Brad Barton). Norwegians Sonja Henie and her uncle S. Z. Sakall spend the night at a broken-down hotel in Canada and end up buying the place. Cesar Romero is a wolfish hotel band singer. Swathed in fur, he sings "I Like It Here" with Carole Landis and dances with Sonja Henie to "Later Tonight." Henie and Sakall are stranded with their assets frozen when Hitler invades Norway (the film takes place in 1940 to make this plot detail work). They face financial ruin unless Henie can marry an American and go on a lucrative ice show tour. The film is quite watchable, benefiting from Sakall's and Romero's comedic charm. The ease of Romero's light, carefree performance belies the fact that it is his last project before starting his war service and heading out to the Pacific. *20th Century-Fox presents* Sonja Henie in *Wintertime* with Jack Oakie, Cesar Romero, Carole Landis, and S. Z. Sakall, Cornel Wilde, Woody Herman and His Orchestra; Screen Play by Eddie Moran and Jack Jevne and Lynn Starling; Story by Arthur Kober; Produced by William LeBaron; Directed by John Brahm; Production dates mid-March to mid-July 1943; Release date 09/17/43. *Variety* (1943): "Cesar Romero, as a frivolous Casanova, loses out, following a slapstick bit where he runs through the hotel in long underwear.... Henie's blade sequences, solo and with a partner, enhanced by gorgeous settings, are socko as always."

1947

Carnival in Costa Rica (20th Century-Fox, role: Pepe Castro). Cesar Romero and Vera-Ellen have never met but are promised by their Costa Rican parents to one another. Much of the action revolves around comic mayhem that develops from Romero's unwillingness to tell his father he

loves Celeste Holm. Romero is too worldly by this point for a paper-thin plot that hinges on his fear of making his papa angry. The only thing of lasting interest (especially to the Costa Rican people) is the location footage of San José, Heredia, Alajuela, and Cartago and other areas of Costa Rica, shot right before a civil war destroyed many of the buildings pictured in the film. *20th Century-Fox presents Carnival in Costa Rica* starring Dick Haymes, Vera-Ellen, Cesar Romero, Celeste Holm with Anne Revere, J. Carrol Naish and Pedro de Cordoba, Barbara Whiting, Nestor Paiva, Fritz Feld, Tommy Ivo, Mimi Aguglia, Ernesto Lecuona Cuban Boys; Original Screen Play by John Francis Larkin, Samuel Hoffenstein, and Elizabeth Reinhardt; Produced by William A. Bacher; Directed by Gregory Ratoff; Production dates of second unit Costa Rica shooting November 1945 to early January 1946; Studio filming 04/15/46 to 06/26/46 and additional scenes and retakes 07/10/46 to 07/13/46; Release date 03/21/47.

Captain from Castile (20th Century-Fox, role: Hernando Cortéz). Tyrone Power is unfairly accused of heresy and imprisoned but manages to escape and join Cesar Romero as Cortéz in his conquest of Mexico. A giant hit for Fox and a triumph for Romero, who gallops off with the picture. *20th Century-Fox, Darryl F. Zanuck presents Captain from Castile* starring Tyrone Power with Jean Peters, Cesar Romero, Lee J. Cobb, John Sutton, Antonio Moreno, Thomas Gomez, Alan Mowbray, Barbara Lawrence, George Zucco, Roy Roberts, Marc Lawrence; Screen Play by Lamar Trotti; From the Novel by Samuel Shellabarger; Produced by Lamar Trotti; Directed by Henry King; Production dates 11/25/46 to 04/04/47; Release date 12/25/47.

1948

Deep Waters (20th Century-Fox, role: Joe Sanger). Dana Andrews is an architect who prefers life as a Maine lobster fisherman, despite the objections of his fiancée, Jean Peters. His deeper connection seems to be with his lobster fishing partner and housemate, Cesar Romero, a Portuguese immigrant. In a complicated series of events, Andrews and Romero end up raising an adopted juvenile delinquent, the worldly and wise Dean Stockwell. *20th Century-Fox presents* Dana Andrews, Jean Peters in *Deep Waters* with Cesar Romero, Dean Stockwell, Anne Revere, Ed Begley; Screen Play by Richard Murray; based on the Novel *Spoonhandle* by Ruth Moore; Produced by Samuel G. Engel; Directed by Henry King; Production dates late September to late November 1947; Release date 07/22/48.

Julia Misbehaves (MGM, role: Fred Ghenoccio). Down-on-her-luck musical stage actress Greer Garson gets an unexpected invitation to the wedding of the daughter she hasn't seen since the child was a few months old—Elizabeth Taylor, at sixteen, on the verge of her elevation to full-fledged screen goddess. Garson hustles up some money, throws together an extravagant wardrobe she can't afford, and gets herself to the south of France for the nuptials, only to find that high society ex-husband Walter Pidgeon knows nothing about the invitation. More complications pile up. Cesar Romero is an acrobatic strongman who falls hard for Garson and wants her to join his troupe. *Metro-Goldwyn-Mayer presents* Greer Garson, Walter Pidgeon in *Julia Misbehaves*, Peter Lawford, Elizabeth Taylor, Cesar Romero, Lucile Watson, Nigel Bruce, Mary Boland, Reginald Owen, Henry Stephenson, Aubrey Mather; Screen Play by William Ludwig, Harry Ruskin, and Arthur Wimperis; Adaptation by Gina Kaus and Monckton Hoffe; Based upon the Novel *The Nutmeg Tree* by Margery Sharp; Produced by Everett Riskin; Directed by Jack Conway; Production dates 01/12/48 to 04/12/48; Release date 08/05/48.

That Lady in Ermine (20th Century-Fox, role: Count Mario). In this musical fantasy that aims for a fable-like quality, Betty Grable is the ruling countess of an Italian principality, newly married to the dashing but cowardly Cesar Romero. She is at a loss when her turf is invaded by the pesky Hungarian army, in the handsome countenance of Douglas Fairbanks Jr. Her look-alike ancestor, who saved the realm in a similar situation three hundred years before, comes to life from a portrait to help her descendant. It is a legendary bomb. *20th Century-Fox presents* Betty Grable, Douglas Fairbanks Jr. in *That Lady in Ermine* with Cesar Romero, Walter Abel, Reginald Gardiner, Harry Davenport, Virginia Campbell, Whit Bissell; Screen Play by Samson Raphaelson; Produced and Directed by Ernst Lubitsch; Production dates mid-October 1947 to early January 1948; Release date 08/25/48.

1949

The Actor's Society Benefit Gala (NBC, role: Himself). All-star benefit with a raft of celebrities on hand, including Romero. Airdate 04/18/49.

The Beautiful Blonde from Bashful Bend (20th Century-Fox, role: Blackie Jobero). Betty Grable is a saloon singer with a gun and an itchy trigger finger, and her charismatic boyfriend Cesar Romero is a two-timing wolf who doesn't deserve her. The film flops, and the Hollywood career of the great Preston Sturges is over. *20th Century-Fox presents* Betty Grable in

Chronology

The Beautiful Blonde from Bashful Bend with Cesar Romero, Rudy Vallee, Olga San Juan, and Sterling Holloway, Hugh Herbert, El Brendel, Porter Hall, Pati Behrs; a Screen Play Based on a Story by Earl Felton; Written, Directed and Produced by Preston Sturges; Production dates late September to late November 1948 with an additional sequence shot in early January 1949; Released 05/24/49.

1950

The Milton Berle Show (NBC, role: Himself). Originally called *The Texaco Star Theatre*, this is one of the most popular shows in the history of television, premiering in 1948 and reaching the top spot in the ratings for the 1950–1951 television season. Its vaudeville variety format highlights Berle's jokes, sight gags, and costumes, including his recurrent use of comedic drag; with Milton Berle, Margaret Whiting, Cesar Romero, Arnold Stang, Cole and Atkins, Lebrac and Bernice. Airdate 01/24/50.

The Ed Wynn Show (CBS, role: Himself). Variety with Cesar Romero, Irene Hervey, Allan Jones. Airdate 05/09/50.

The Saturday Night Revue with Jack Carter (NBC, role: Himself). In the early days of television, comedian Jack Carter hosts this three-hour weekly variety show; with Jack Carter, Cesar Romero, Billy Eckstine, Ada Lynn, The Albins. Airdate 05/20/50.

Love That Brute (20th Century-Fox, role: Pretty Willie Wetzchahofsky). Cesar Romero plays the rival gangster rather than the lead in this remake of his 1941 hit *Tall, Dark and Handsome*. Paul Douglas is a Chicago mobster who falls in love with Jean Peters, a principled young governess. Why Paul Douglas is considered a bigger star than Romero in 1950 is perplexing. Douglas is tired and bloated. Romero is in his prime, yet after fourteen years at the studio, this is the last film Romero makes under long-term contract to Fox. *20th Century-Fox presents* Paul Douglas, Jean Peters in *Love That Brute* with Cesar Romero, Keenan Wynn, Joan Davis and Arthur Treacher, Peter Price, Jay C. Flippen, Barry Kelley, Leon Belasco; Written by Karl Tunberg, Darrell Ware, John Lee Mahin; Produced by Samuel G. Engel; Directed by Henry King; Production dates mid–June to late July 1949; Release date 05/26/50.

Once a Thief . . . (United Artists, role: Mitch Moore). Ex–jewel thief June Havoc is trying to build a new life only to be dragged back into her criminal past by her new con-artist boyfriend, Cesar Romero. Betrayed by Romero and ready to face the long arm of the law, Havoc first robs a liquor

store to get the cash to bail Romero out of jail—so she can have the privilege of shooting him dead herself. *W. Lee Wilder presents* Cesar Romero, June Havoc in *Once a Thief* . . . costarring Marie McDonald, Lon Chaney Jr. and the City of Los Angeles in cooperation with Sheriff Eugene W. Biscailuz, Los Angeles County, and his staff; with Iris Adrian, Jack Daly, Marta Mitrovich, Michael Mark, Ann Tyrrell; Screenplay by Richard S. Conway; Based on a Story by Max Kolpé (credited as Max Colpet) and Hans Wilhelm; Music Michael Michelet; Produced and Directed by W. Lee Wilder; Production start date November 1949; Release date 07/07/50.

The Saturday Night Revue with Jack Carter (NBC, role: Himself). Variety with Jack Carter, Cesar Romero, Valerie Bettis, Patricia Morison, Donald Richards, Harry Sosnik. Airdate 09/23/50.

1951

The Bigelow Theatre (CBS/DuMont, role: The Manager). *Big Hello*: A wrestler and his manager fall in love with the same girl; with Cesar Romero, Jeanne Cagney, Raymond Burr, Kathryn Card. Airdate 04/23/51.

The Saturday Night Revue with Jack Carter (NBC, role: Himself). Variety with Jack Carter, Cesar Romero, Mary Hatcher. Airdate 05/19/51.

The Alan Young Show (CBS, role: Himself). Comedy vignettes and visually unusual musical numbers; with Alan Young, Cesar Romero, The Whippoorwills. Airdate 05/29/51.

Happy Go Lovely (RKO/Associated British Picture Corp., role: John Frost). Chorus girl Vera-Ellen gets a ride from millionaire David Niven's driver, and when she pulls up in the posh car, cash-strapped theater director Cesar Romero thinks she is Niven's girlfriend and makes her the star of the show, hoping to get backing from Niven to open at the Edinburgh festival. The film sinks at the American box office and does nothing for the career of anyone involved. *Associated British Picture Corporation Ltd. presents* David Niven, Vera-Ellen, Cesar Romero in *Happy Go Lovely*, Color by Technicolor, with Bobby Howes, Diane Hart, Gordon Jackson, Barbara Couper, Henry Hewitt, Gladys Henson, Hugh Dempster, Sandra Dorne, Joyce Carey, John Laurie, Wylie Watson; Screen Play by Val Guest; Based on a Film Story by Friedrich Dammann and Herbert Rosenfeld; Produced by Marcel Hellman; Directed by H. Bruce Humberstone; Release date 07/08/51.

Stars over Hollywood (NBC, role: Allen). Anthology. "A Letter from Home": Cesar Romero is a soldier who dies before receiving the letter he

has been hoping to get from his estranged wife. She wants to reconcile and save their marriage, but now it is too late; with Cesar Romero, Kristine Miller, William Andrews, Jeanne Bates, Paul Bryar, Robert Karnes, Jim Williams. Airdate 07/23/51.

Lost Continent (Lippert Pictures, role: Major Joe Nolan). Cesar Romero leads a rescue mission in the South Pacific to recover a downed atomic rocket. They crash-land on a mysterious island where they spend a lot of time climbing the same fake rocks over and over before adding "Native Girl" Acquanetta to their expedition and discovering a lost world of stop-motion dinosaurs—at which point the black-and-white movie suddenly becomes tinted green. *Robert L. Lippert presents Lost Continent* starring Cesar Romero with Hillary Brooke, Chick Chandler, John Hoyt, Acquanetta, Sid Melton, Whit Bissell, Hugh Beaumont, Murray Alper; Screenplay by Richard H. Landau; Story by Carroll Young; Produced by Sigmund Neufeld; Directed by Sam Newfield; Production dates 04/13/51 to late April; Release date 08/17/51.

The Colgate Comedy Hour (NBC, role: Himself). Dean Martin and Jerry Lewis are most often the hosts of this Colgate-sponsored comedy hour that has a successful five-year run; this episode is with host Eddie Cantor and Cesar Romero, Barbara Ashley, Robert Gari, Al Goodman, Billy Gray, Aura Levitas, Don Pardo, Stanley Prager, Jimmy Russell, Warner and McGuire, Helen Wood. Airdate 09/09/51.

The Colgate Comedy Hour (NBC, role: Himself). Variety with host Eddie Cantor and Cesar Romero, Sheilah Graham, Verna Felton, The Caprino Sisters, Al Goodman. Airdate 10/28/51.

F.B.I. Girl (Lippert Pictures, role: Glen Stedman). In a story that would now be a cybercrime on a television procedural, a powerful politician seeks to keep his criminal past hidden by removing his fingerprints from an FBI file. Cesar Romero and George Brent get top billing, but they are secondary characters as FBI agents who get the bad guys in the end. *Robert L. Lippert presents Cesar Romero, and George Brent, Audrey Totter in Rupert Hughes's F.B.I. Girl* with Tom Drake, Raymond Burr, Raymond Greenleaf, Margia Dean, Alexander Pope, Richard Monahan, Don Garner, Jan Kayne, Byron Foulger, Walter Coy, Joe Marston, Marie Blake and introducing Tommy Noonan and Peter Marshall; Screenplay by Richard H. Landau and Dwight Babcock; Based on a Story by Rupert Hughes; Produced and Directed by William Berke; Production dates mid-June to late June 1951; Release date 11/15/51.

The Colgate Comedy Hour (NBC, role: Himself). Variety with host Eddie Cantor and Cesar Romero, Eddie Fisher, Betty Graham. Airdate 11/25/51.

Gruen Guild Theater (ABC, role: Attorney). Anthology. "The Case of the Cavorting Statue": The wife of a lawyer schemes to make her husband a success but makes a crucial mistake; with Cesar Romero, Ann Rutherford, Byron Foulger, Kristine Miller, Ralph Sanford, John Sheehan. Airdate 11/29/51.

1952

The Jungle (Lippert Pictures, role: Rama Singh). With her father, the maharaja, on his deathbed, Princess Marie Windsor returns to India to serve as his regent. Upon arrival, she discovers local villages in turmoil because of rampaging elephants. Adviser and would-be suitor Cesar Romero had engaged great white elephant hunter Rod Cameron to handle the problem, but he goes out with ten hunters and returns the only one alive, telling an impossible tale of being attacked by a wild herd of woolly mammoths—creatures that have been extinct for millions of years. *A Robert L. Lippert presentation*: This picture was photographed entirely in India in the cities, the villages, and . . . *The Jungle*, starring Rod Cameron, Cesar Romero, Marie Windsor with Ruby Mayer (credited as Sulochana), M. N. Nambiar, David Abraham, Ramakrishna, Chitra Devi; Screen Play Carroll Young; Additional Dialogue Orville Hampton; Produced and Directed by William Berke; Production dates early February to late March 1951; Release date 01/08/52.

The Colgate Comedy Hour (NBC, role: Himself). Variety with host Eddie Cantor and Cesar Romero, Rusty Draper, Al Goodman, Francois Szony, Giselle Szony. Airdate 05/18/52.

Campbell Summer Soundstage (NBC, role: Attorney). Anthology. "The Cavorting Statue": The wife of a lawyer schemes to make her husband a success but makes a crucial mistake; with Cesar Romero, Ann Rutherford, Byron Foulger, Kristine Miller, Ralph Sanford, John Sheehan. A rerun after the episode airs on *Gruen Guild Theater* in 1951. Airdate 06/20/52.

What's My Line? (BBC, role: Himself). The British version of the American panel guessing game. Cesar Romero is in London shooting *Shadow Man* opposite Kay Kendell when he appears; with host Eamonn Andrews and Elizabeth Allan, Jerry Desmonde, Gilbert Harding, Marghanita Laski. Airdate 08/18/52.

Chronology

All Star Revue (NBC, role: Himself). Sid Caesar usually hosts the music and variety show that always trumpets its "host of beautiful girls," this week with guest host Martha Raye and Cesar Romero, Risë Stevens, Rocky Graziano. Airdate 09/27/52.

Scotland Yard Inspector (Lippert Pictures, role: Philip O'Dell). Cesar Romero is an American detective unable to get a flight out of London. He ends up helping Bernadette O'Farrell find out who killed her brother in a deliberate hit-and-run. Scotland Yard wants Romero to butt out even though he is seemingly the only one able to put the pieces together and catch the killer. Lois Maxwell is the cool, slinky nightclub owner with her foot on the gas pedal. *Robert L. Lippert presents* Cesar Romero, Lois Maxwell in *Scotland Yard Inspector* with Bernadette O'Farrell, Geoffrey Keen, Campbell Singer, Mary Mackenzie; Additional cast: Alastair Hunter, Lloyd Lamble, Frank Birch, Peter Swanwick, Lisa Lee, Lionel Harris, Betty Cooper, Clare James, Katie Johnson; Screenplay by Orville H. Hampton; Adapted from the Popular BBC Serial by Lester Powell; Produced by Anthony Hinds; Directed by Sam Newfield; Production dates early April to early May 1952; Release date 10/31/52.

The Colgate Comedy Hour (NBC, role: Himself). Variety with host Judy Canova and Cesar Romero, Zsa Zsa Gabor, Liberace, Hans Conried, Carl Ravazza, The Lancers, Charles Dent & His Orchestra. Airdate 11/02/52.

Schlitz Playhouse (CBS). Anthology. Originally presented live from New York City. "Tango": A nightclub affair winds up in intrigue and mystery; with Cesar Romero, Ann Savage, Irene Dunne. Airdate 11/07/52.

The Milton Berle Show (NBC, role: Himself). Comedy and variety with Milton Berle, Cesar Romero, Miriam Hopkins, Teresa Brewer, Don Cornell. Airdate 12/09/52.

What's My Line? (CBS, role: Himself). A celebrity panel asks yes-or-no questions trying to guess the occupation of a guest, culminating in a round where they wear masks and try to guess the occupation and identity of a well-known person. On this first appearance on the show, Cesar Romero is the celebrity guest, and he stumps the panel; with host John Daly and Dorothy Kilgallen, Bennett Cerf, Arlene Francis, Hal Block, Cesar Romero. Airdate 12/14/52.

The Name's the Same (ABC, role: Himself). Guests who have the same name as famous people, fictional characters, or things are quizzed by a celebrity panel trying to guess their names; with host Robert Q. Lewis, Cesar Romero, Joan Alexander, Cliff Norton, Lee Vines, Meredith Willson. Airdate 12/16/52.

Chronology

1953

The Ford Television Theatre (NBC). Anthology. "All's Fair in Love": A young matron's romantic ideas threaten her marriage; with Cesar Romero, Lynn Bari, Lee Aaker, John Eldredge, Sherry Jackson, Frank Jenks, Maudie Prickett, Frank Sully, Tina Thompson, June Vincent. Airdate 02/26/53.

All Star Revue (NBC, role: Himself). Variety with guest host Jimmy Durante, and Carmen Miranda, Cesar Romero, Eddie Jackson, Jack Roth, Wanda Smith's Cover Girls. Airdate 03/07/53.

The Milton Berle Show (NBC, role: Himself). Comedy and variety with Milton Berle, Laraine Day, Cesar Romero, Kathryn Murray, Jimmy Nelson. Airdate 04/07/53.

Your Chevrolet Showroom (ABC, role: Himself). The premiere of the music and variety show sponsored by Chevrolet; with host Cesar Romero and guests George Jessel, Herb Shriner, Toni Arden, Frank Waldecker. Airdate 09/25/53.

Your Chevrolet Showroom (ABC, role: Himself). Variety with host Cesar Romero and guests Sugar Ray Robinson, Betty Reilly, Mary Mayo, Frank Fontaine, Frank Waldecker. Airdate 10/02/53.

All Star Revue (NBC, role: Himself). Variety with guest host Martha Raye and Cesar Romero, Margaret Truman, Rocky Graziano, Jake La Motta, George Bassman & His Orchestra. Airdate 10/03/53.

I've Got a Secret (CBS, role: Himself). Four celebrity panelists take turns questioning someone with a secret; with host Garry Moore, Cesar Romero, Bill Cullen, Jayne Meadows, Henry Morgan, Dorothy Hart. Airdate 10/07/53.

Your Chevrolet Showroom (ABC, role: Himself). Variety with host Cesar Romero and guests Louis Armstrong and His Orchestra, Polly Bergen, Jimmy Wakely, Phil Foster, Joan Holloway, Robert Maxwell, Frank Waldecker. Airdate 10/09/53.

Shadow Man (Lippert Pictures, role: Luigi). "Every step he took led him to Murder and a woman!" Cesar Romero is a small-time arcade hustler in Soho who falls hard for the married Kay Kendall. Together they become embroiled in a murder case with Romero as the prime suspect. The real culprit proves too close for comfort. Romero and Kendall are fantastic looking together, both with cheekbones for days. Their chemistry elevates the often-nonsensical plot machinations, but beguiling Victor Maddern as Romero's clubfooted right-hand man literally walks off with the film. *Nat*

Chronology

Cohen and Stuart Levy present a Merton Park Studios Production *Shadow Man* starring Cesar Romero, Kay Kendall, Edward Underdown, Victor Maddern, Simone Silva; Screenplay by Richard Vernon; From Laurence Meynell's Novel *The Creaking Chair*; Produced by William H. Williams; Directed by Richard Vernon; Production start date mid-July 1952; Release date 10/16/53.

Your Chevrolet Showroom (ABC, role: Himself). Variety with host Cesar Romero and guests Frankie Carle's Orchestra, Rose Marie, Polly Bergen, Gloria Gilbert, Frank Waldecker. Airdate 10/16/53.

Your Chevrolet Showroom (ABC, role: Himself). Variety with host Cesar Romero and guests Jerry Gray Orchestra, Connee Boswell, Maurice Rocco, Henny Youngman, Mario and Florio, Frank Waldecker. Airdate 10/23/53.

Your Chevrolet Showroom (ABC, role: Himself). Variety with host Cesar Romero and guests Bobby Sherwood and His Orchestra, Kitty Kallen, Earl Wrightson, Morey Amsterdam, Kaye Ballard, Frank Waldecker. Airdate 10/30/53.

Prisoners of the Casbah (Columbia, role: Firouz). Cesar Romero is a double-dealing vizier in eighteenth-century Algiers who concocts a dastardly plan to have Princess Gloria Grahame kidnapped by Bedouins so he can take credit for saving her, thereby convincing her father to let them get married. The plot goes wrong in more ways than one, and Romero becomes the third wheel in a love triangle with Grahame and captain of the guard Turhan Bey. A very silly attempt at a sand-and-sandals epic on the cheap. Gloria Grahame as an Algerian princess is the least of its absurdities. Romero remembers it as one of his worst films. *Columbia Pictures Corporation presents Prisoners of the Casbah* starring Gloria Grahame, Cesar Romero, Turhan Bey with Nestor Paiva, Paul Newlan, Lucille Barkley, Philip Van Zandt, Frank Richards, John Parrish, Wade Crosby, Gloria Saunders, Eddie Fields; Screen Play by DeVallon Scott; Based on a story by William Raynor; Produced by Sam Katzman; Directed by Richard L. Bare; Production dates 01/20/53 to 02/02/53; Release date 11/03/53.

Your Chevrolet Showroom (ABC, role: Himself). Variety with host Cesar Romero and guests Louis Prima and His Band, Jim Backus, Ray Malone, The DeMarco Sisters, Frank Waldecker. Airdate 11/06/53.

Your Chevrolet Showroom (ABC, role: Himself). Variety with host Cesar Romero and guests Tex Beneke, The Four Aces, Bert Wheeler, Sonny Howard, Sunny Gale, Frank Waldecker. Airdate 11/13/53.

Chronology

The Colgate Comedy Hour (NBC, role: Himself). Variety with hosts Dean Martin and Martha Raye and Cesar Romero, Irene Dunn, Rocky Graziano. Airdate 11/15/53.

Your Chevrolet Showroom (ABC, role: Himself). Variety with host Cesar Romero and guests Hal Le Roy, Florian Zabach, Eileen Barton, Frank Waldecker. Airdate 11/20/53.

Your Chevrolet Showroom (ABC, role: Himself). Variety with host Cesar Romero and guests Tommy Tucker and His Orchestra, Joey Bishop, Monica Lewis, Bobby Breen, Clifford Guest, Hal Loman, Helene and Howard, Frank Waldecker. Airdate 11/27/53.

Your Chevrolet Showroom (ABC, role: Himself). Variety with host Cesar Romero, Frank Waldecker. Airdate 12/04/53.

On Your Way (ABC, role: Himself). A quiz show where contestants try to win a dream-destination domestic bus trip. Seriously. A bus trip. With host Bud Collyer and Cesar Romero, Don Morrow. Airdate 12/09/53.

Quick as a Flash (ABC, role: Himself). A quiz show with contestants following the clues of actors in detective story segments; with host Bud Collyer and Cesar Romero, Kitty Carlisle, Faye Emerson, Frank Gallop. Airdate 12/10/53.

Your Chevrolet Showroom (ABC, role: Himself). Variety with host Cesar Romero and guests Johnny Mack, Professor Backwards (James Edmondson Sr.), Jan August, Steve Lawrence, Kirkwood and Goodman, Jan August, Frank Waldecker. Airdate 12/11/53.

Your Chevrolet Showroom (ABC, role: Himself). Variety with host Cesar Romero and guests Judy Lynn, Jack Durant, Roses and West, Frank Waldecker. Airdate 12/18/53.

Your Chevrolet Showroom (ABC, role: Himself). Variety with host Cesar Romero and guests Rico Turchetti, Edith Fellows, Frank Waldecker. Airdate 12/25/53.

Sword of Granada, aka *El corazón y la espada* (Campeon Films, S.A., role: Don Pedro de Rivera). In Moorish-occupied Granada, Cesar Romero endeavors to win his castle back from the Moorish caliph who murdered his parents. He forms a merry band of compatriots (Katy Jurado, a swordswoman he first mistakes for a man; the ever-loyal Tito Junco; and a priest and alchemist, Miguel Ángel Ferriz). Romero wants to reclaim the castle. They *all* want a jewel that brings eternal youth. Newspaper accounts in Mexico report that the film is being shot simultaneously in both Spanish and English, but the only known English-language

version is just dubbed. The English translation of the Spanish title is *The Heart and the Sword*. Campeon Films, S.A. presenta la primera pelicula tridemensional hecha en Mexico, por Producciónes García Besné, S. de R. L. con Cesar Romero, Katy Jurado, Rebeca Iturbide, Tito Junco en *El corazón y la espada* y Miguel Ángel Ferriz, Fernando Casanova, Gloria Mestre, Víctor Alcocer, José Torvay, Norma Ancira, Manuel Casanueva; Argumento y adaptación (Screenwriters) Mildred y Edward Dein; Additional screenwriter: Rafael García Travesi; Jefe de producción (Producer) Manuel Rodríguez; Dirección de (Directors) Carlos Véjar hijo y Edward Dein; Production start date 06/08/53; Release date 12/31/53.

1954

Your Chevrolet Showroom (ABC, role: Himself). Variety with host Cesar Romero and guests Johnny Long and His Orchestra, Judy Lynn, Earl Wrightson, Johnny Morgan, Frank Waldecker. Airdate 01/01/54.

Your Chevrolet Showroom (ABC, role: Himself). Variety with host Cesar Romero and guests Eugenie Baird, The DeMarco Sisters, Frank Waldecker. Airdate 01/08/54.

Your Chevrolet Showroom (ABC, role: Himself). Variety with host Cesar Romero and guests Joan Holloway, Jack Smith, Billy Gilbert, Trudy Richards, Stan Fisher, Frank Waldecker. Airdate 01/15/54.

Your Chevrolet Showroom (ABC, role: Himself). Variety with host Cesar Romero and guests The Paulette Sisters, Will Mahoney, Will Jordan, Teddy King, Bobby Joyce and Ginger, Dana and Wood, Frank Waldecker. Airdate 01/22/54.

The Martha Raye Show (NBC, role: Himself). The premiere episode of the live comedy and variety show starring Martha Raye that begins as part of *All Star Revue* when Raye replaces host Sid Caesar for a month; with Martha Raye, Edward G. Robinson, Cesar Romero, Rocky Graziano, Jack Brown, Herbie Faye, Marion Strunk Garrigan, The Herbert Ross Dancers, Sid Raymond, Billy Sands, Johnny Trama, Walter Dare Wahl. Airdate 01/23/54.

What's My Line? (CBS, role: Himself). Game show; with host John Daly and Cesar Romero, Dorothy Kilgallen, Steve Allen, Arlene Francis; Mystery Guests Guy Madison, Dean Martin, Jerry Lewis. Airdate 01/24/54.

Your Chevrolet Showroom (ABC, role: Himself). Variety with host Cesar Romero and guests Connee Boswell, Morey Amsterdam, Ann Crowley, Cliff Edwards, The Cerneys, Frank Waldecker. Airdate 01/29/54.

Chronology

Your Chevrolet Showroom (ABC, role: Himself). Variety with host Cesar Romero and guests Richard Himber, Helen Ward, Sid Stone, Marcel LeBon, Carolyn Ayers and Her Escorts, Frank Waldecker. Airdate 02/05/54.

Your Chevrolet Showroom (ABC, role: Himself). Variety with host Cesar Romero and guests Jo Sullivan, Gabriel Dell, Sid Stone, Dick Lee and Karen Chandler, The Step Brothers, Frank Waldecker. Airdate 02/12/54.

The Pepsi-Cola Playhouse (ABC). Anthology. "When the Police Arrive": A couple tries to figure out just how to behave when the police arrive after elderly Aunt Mildred dies; with Cesar Romero, Hillary Brooke, Anita Colby. Airdate 06/25/54.

The Saturday Night Revue (NBC, role: Himself). This summer replacement series for *Your Show of Shows* features Hoagy Carmichael as the host, with established stars introducing new entertainers; with Hoagy Carmichael, Cesar Romero, George Gobel. Airdate 07/24/54.

A Star Is Born World Premiere (NBC, role: Himself). A live television broadcast of the lavish, star-studded world premiere of the Judy Garland and James Mason musical *A Star Is Born*; Romero attends with Joan Crawford, and they appear on camera along with over fifty other film and television actors. Airdate 09/29/54.

Climax! (CBS, role: Mendy Mendez). Anthology. "The Long Goodbye": Detective Philip Marlowe tries to help a friend who is accused of murdering his wife; with Dick Powell, Cesar Romero, Teresa Wright, Tristram Coffin, Tom Drake, William Lundigan, Horace McMahon. Airdate 10/07/54.

Hollywood Exclusive (Syndicated, role: Himself). A news and talk show about the entertainment industry; with host Army Archerd, and Katy Jurado, Tyrone Power, Cesar Romero. Airdate 10/13/54.

The Martha Raye Show (NBC, role: Himself). Live comedy and variety show; with Martha Raye, Cesar Romero, Rocky Graziano, Jane Dulo, The Herbert Ross Dancers, Paul Lynde. Airdate 11/23/54.

Vera Cruz (United Artists, role: Marquis Henri de Labordere). After the US Civil War, former soldier Gary Cooper meets gunslinger Burt Lancaster. They are hired by Emperor Maximillian and his trusted officer Cesar Romero to escort a countess, Denise Darcel, to the harbor of Vera Cruz. Once they learn that the countess's stagecoach is transporting $3 million in gold hidden below the seat, they plot to steal it. Plot twists include betrayals, romance, death, and destruction. Romero's role is not large, but he cuts a fine figure in his marquis plumage and uniform. Charles Bronson appears

in a small role as one of the mercenaries. *Metro-Goldwyn-Mayer, Harold Hecht presents* Gary Cooper, Burt Lancaster, *Vera Cruz*, with Denise Darcel, Cesar Romero, introducing Sara Montiel with George Macready, Jack Elam, Ernest Borgnine, James McCallion, Morris Ankrum, James Seay, Henry Brandon, Archie Savage, Charles Bronson (credited as Charles Buchinsky); Charles Horvath, Jack Lambert, Juan García; Screenplay by Roland Kibbee and James R. Webb; Story by Borden Chase; Produced by James Hill; Directed by Robert Aldrich; Production start date late February 1954; Release date 12/25/54.

Passport to Danger (Syndicated, role: Steve McQuinn). "Trieste": Steve must keep a coded book out of the hands of enemy spies; with Cesar Romero, Paula Corday, Jorja Curtright, Frank Puglia, Frank Richards, Konstantin Shayne, George E. Stone, Philip Tonge, Charles Wagenheim. Airdate 12/28/54.

Passport to Danger (Syndicated, role: Steve McQuinn). "Tangier": Steve tries to obtain an American visa for a schoolmaster hunted in Morocco by Bulgarian secret police; with Cesar Romero, Carol Thurston, Celia Lovsky, Jan Merlin, Sig Arno, Frank Wilcox, Gabriel Curtiz, William Yetter Sr.; Specific airdate in 1954 unknown.

1955

The Martha Raye Show (NBC, role: Himself). Live comedy and variety show; with Martha Raye, Cesar Romero, Will Jordan, Anne Russell. Airdate 01/18/55.

The Americano (RKO, role: Manuel Silvera / El Gato / Barbossa). Cattleman Glenn Ford borrows money from the bank so he can transport himself and his three prize Brahma bulls to Brazil, where a buyer has promised him $25,000. But the buyer fails to show. The jovial, helpful, mysterious Cesar Romero agrees to help, but he is a man with many secrets. *An R.K.O. Radio Picture, Robert Stillman Productions, Inc. presents* Glenn Ford, *The Americano*, Frank Lovejoy, Cesar Romero, Ursula Thiess, Abbe Lane with Rodolfo Hoyos Jr., Salvador Baguez, Tom Powers, Dan White, Frank Marlowe, George Navarro, Nyra Monsour; Screen Play by Guy Trosper; Original Story by Leslie T. White; Produced by Robert Stillman; Directed by William Castle; Production dates late July to late September 1953 in Brazil; resumed mid-June 1954 at RKO Radio Studios; Release date 01/19/55. Fred W. Fox, *Los Angeles Mirror-News* (1955), headline: "Cesar Saves 'American' from Ennui"; "The producers of *The Americano* were lucky when they hired

smoothie Cesar Romero to display his Latin nonchalance as the outlaw leader. In gesture, dialogue and general deportment he is the most engaging personality in the film."

The Racers (20th Century-Fox, role: Carlos Chavez). On the day of the qualifying runs for the Grand Prix at Monte Carlo, Kirk Douglas, a reckless race car driver with a chip on his shoulder, meets ballerina Bella Darvi when she gives him a hairpin to repair an engine part. It is love and lust at first sight. Cesar Romero is another driver, married to his *El corazón y la espada* costar Katy Jurado. Together they are the voice of sanity and common sense, with Romero intent on walking away from racing while he can still walk. *20th Century-Fox presents* a CinemaScope Production, Kirk Douglas, Bella Darvi, Gilbert Roland, *The Racers* also starring Cesar Romero, Lee J. Cobb, Katy Jurado with Charles Goldner, John Hudson, George Dolenz, Agnès Laury, John Wengraf; Screenplay by Charles Kaufman; From a Novel by Hans Ruesch; Produced by Julian Blaustein; Directed by Henry Hathaway; Production dates 08/02/54 to early October; Released 02/04/55.

Passport to Danger (Syndicated, role: Steve McQuinn). "Paris": Steve runs into an old friend who is involved in a scandal that attracts the interest of the Bulgarian police; with Cesar Romero, Ina Anders, Albert Carrier, William Ching, Mark Dana, Michael Emmet, John Hamilton, Alphonse Martell, Lita Milan, Phil Posner. Airdate 02/22/55.

Entertainment 1955 (NBC, role: Himself). The network's first color special of music, comedy, and dramatic vignettes, airing live simultaneously from the network's new $3.7 million Burbank studios and New York's Rockefeller Center. Airdate 03/27/55.

Passport to Danger (Syndicated, role: Steve McQuinn). "Madrid": Steve is attacked while dining with a Spanish duchess, and she is abducted; with Cesar Romero, Yvette Duguay, Vicente Padula, Nacho Galindo, Peter Adams, Martin Garralaga, Abel Franco, Felipe Turich, Salvador Baguez, Manuel Lopez, Natividad Vacío. Airdate 06/22/55.

Passport to Danger (Syndicated, role: Steve McQuinn). "Casablanca": Steve meets up with an old flame and stumbles onto a plot to overthrow the government; with Cesar Romero, Hillary Brooke, Rudolph Anders, Leonard George, William Forrest, Charles Horvath, Eugene Mazzola. Airdate 06/29/55.

Place the Face (CBS, role: Himself). Celebrity contestants try to identify people from their past whom they have encountered only briefly; with Bill Cullen, Bob Warren, Cliff Arquette, Cesar Romero. Airdate 07/12/55.

Chronology

Passport to Danger (Syndicated, role: Steve McQuinn). "Teheran": Steve arrives to find his old friend has been murdered; with Cesar Romero, Carl Esmond, Nestor Paiva, Shawn Smith, Hy Averback, Michael Granger, George Cisar, Edmund Hashim, Shirley Patterson, Cliff Harding. Airdate 07/20/55.

Passport to Danger (Syndicated, role: Steve McQuinn). Though aired out of order, this is the pilot episode. "Budapest": A Hungarian priest in prison passes vital information to Steve; with Cesar Romero, Steven Geray, Douglass Dumbrille, John Mylong, Ludwig Stössel, Albert Szabo, Nadia Posey, Teresa Tudor. Airdate 10/06/55.

Damon Runyon Theater (CBS, role: Spanish John). Anthology. "Situation Wanted": An unemployed bodyguard is hired to transport firearms to revolutionary forces south of the border; with Donald Woods, Cesar Romero, Anthony Caruso, Yvette Duguay, Paul Fierro, Allen Jenkins, Horace McMahon, Vicente Padula. Airdate 10/29/55.

Lux Video Theatre (CBS, role: Andre Casell). Anthology. "Appointment for Love": After an impulsive marriage, the honeymoon ends quickly when the progressive bride wants the two of them to have separate apartments; with Julie Adams, Cesar Romero, Otto Kruger, William Bakewell, Don Beddoe, Julie Bennett, Ken Carpenter, Russell Gaige, Sandra Gould, Arthur Gould-Porter, Nora O'Mahoney, Gus Schilling, Leigh Snowden, Jan Sterling. Airdate 11/03/55.

Passport to Danger (Syndicated, role: Steve McQuinn). "Rangoon": Steve tries to help an Indian holy man's village when bandits victimize the inhabitants; with Cesar Romero, Phillip Ahn, Soo Yong, Keye Luke, Maria Pinki Tsien. Airdate 12/08/55.

The Martha Raye Show (NBC, role: Himself). Variety with Martha Raye, Cesar Romero, David Burns, Will Jordan. Airdate 12/13/55.

Passport to Danger (Syndicated, role: Steve McQuinn). "Marseilles": Steve finds his travel companion dying on the docks from a stab wound. The man begs him to take care of his teenage daughter; with Cesar Romero, Iphigenie Castiglioni, Susan Seaforth Hayes, Booth Colman, Jacqueline Duval, Ross Elliott, Noel Cravat, Frederic Melchior, George N. Neise, Nick Dennis. Airdate 12/15/55.

Passport to Danger (Syndicated, role: Steve McQuinn). "Rio de Janeiro": Steve can't enjoy Carnival as he looks into a young woman's missing husband and must stop another girl from eloping; with Cesar Romero, Tol Avery, Yvette Duguay, Ernest Sarracino, Fay Wall, John Wengraf. Airdate 12/29/55.

1956

Private Secretary (CBS). Sitcom. Ann Sothern is a busybody secretary to handsome talent agent Don Porter, who keeps inadvertently messing up his private life. "In Darkest Manhattan": Sothern goes on safari in Central Park; with Ann Sothern, Don Porter, Cesar Romero, Woody Strode, Joan Banks. Airdate 01/08/56.

Celebrity Playhouse (Syndication, role: Ricardo Aguilar). Anthology. Airs repeats of *Schlitz Playhouse of Stars* dramas. "Bachelor Husband": A couple attempts to hide their marital status since the company where the woman works forbids its female employees to marry; with Cesar Romero, Richard Denning, Phyllis Kirk, Joi Lansing, Herbert Heyes, Arlen Stuart, Harry Brown, Mary Boyd, Joe Devlin. Airdate 01/31/56.

Passport to Danger (Syndicated, role: Steve McQuinn). "Lima": With the help of a young woman he meets on a plane, Steve tries to capture an American gangster operating in Peru; with Cesar Romero, Walter Sande, Elinor Donahue, Ted de Corsia. Airdate 02/05/56.

The Red Skelton Hour (CBS, role: Big Bill Racketeer). Comedy-themed variety show hosted by the popular comedian who also plays various characters in relatively long sketches with guest stars. The show runs uninterrupted from 1951 to 1971, starting on NBC until 1953, then moving to CBS until its final season back on NBC. "The Election Show": A sketch on an episode featuring Red Skelton, Cesar Romero, Jan Arvan, Art Gilmore, Ralph Sanford, Olan Soule, Ben Welden, David Rose and His Orchestra. Airdate 02/07/56.

Passport to Danger (Syndicated, role: Steve McQuinn). "Rome": While in Italy investigating a classified documents leak, Steve uncovers a German counterfeiting ring; with Cesar Romero, Donna Martell, Carl Milletaire, David Kasday, Donald Curtis, Ivan Triesault, Frank Nechero, Victor Romito. Airdate 02/13/56.

Passport to Danger (Syndicated, role: Steve McQuinn). "Havana": Steve learns that an otherwise honest pilot friend is smuggling people into Cuba; with Cesar Romero, Hy Anzell, Salvador Baguez, Harris Brown, Abel Franco, John Mylong, Manuel París, Stuart Randall, Lina Romay. Airdate 02/15/56.

Passport to Danger (Syndicated, role: Steve McQuinn). "Saigon": Steve's courier case is stolen by communists while he is traveling to Saigon by boat; with Cesar Romero, Angela Greene, Warren Lee, Richard Leo. Airdate 02/19/56.

Chronology

Passport to Danger (Syndicated, role: Steve McQuinn). "Sofia"; Steve travels to Sofia on the Orient Express to help a Bulgarian diplomat being deported to face false accusations of stealing jewels; with Cesar Romero, Murvyn Vye, Stephen Bekassy, Alana Monet, Nestor Paiva, Rolfe Sedan, Mary Young, Gilman Rankin, Peter Camlin. Airdate 03/07/56.

Passport to Danger (Syndicated, role: Steve McQuinn). "Mexico City": Steve helps a young man who is petrified before his first time in the ring as a matador; with Cesar Romero, Edgar Barrier, Manuel Rojas, Donna Martell, Robin Short, Julian Rivero, Orlando Rodriguez, Nacho Galindo, Rico Alaniz, Rosa Turich. Airdate 03/08/56.

Passport to Danger (Syndicated, role: Steve McQuinn). "Geneva": Steve uncovers an assassination scheme involving the Russians; with Cesar Romero, Karin Booth, Oscar Beregi Sr., Sasha Harden, Peter Coe, Gene Roth, Irvin Ashkenazy, Fritz Ford. Airdate 03/12/56.

The NBC Comedy Hour (NBC, role: Himself). Unusually fast-paced comedy and variety show; with Gale Storm, Hy Averback, Cesar Romero, Stan Freberg, Georgie Kaye, Emmett Kelly, Pat Sheehan, Bert Wheeler, Jonathan Winters. Airdate 04/01/56.

Passport to Danger (Syndicated, role: Steve McQuinn). "Athens": Steve woos a princess while investigating a narcotics ring in Greece; with Cesar Romero, Carolyn Jones, Mark Dana, Steven Geray, Raymond Greenleaf, Patrick Aherne, Peter Mamakos, Maria Kosti, Bert LeBaron, Jean Ransome, Josephine Parra. Airdate 04/19/56.

Passport to Danger (Syndicated, role: Steve McQuinn). "Baja, California": En route to deliver a radioactive cancer treatment to a brilliant scientist, Steve's plane crash-lands in Mexico during a hurricane, and the first person to reach the wreckage is a desperate criminal; with Cesar Romero, Dan Seymour, Jan Merlin, June Vincent, William Ching, Albert Carrier, Tony Roux, Eva Ralf, Coulter Irwin. Airdate 05/03/56.

Passport to Danger (Syndicated, role: Steve McQuinn). "Naples": Steve tries to revive an old friendship in Italy, but smugglers spoil the reunion; with Cesar Romero, Paul Picerni, Toni Gerry, Anthony Caruso, Lester Matthews, Harry Lauter, Henry Corden, Jack Perrin, Bernard Nedell. Airdate 05/07/56.

The Martha Raye Show (NBC, role: Himself). Live comedy and variety show; with Martha Raye, Cesar Romero, Robert Strauss, Fritz Feld. Airdate 05/29/56.

Chronology

Passport to Danger (Syndicated, role: Steve McQuinn). "Damascus": Steve must protect an Arabian sultan under threat of assassination en route to Syria; with Cesar Romero, Paula Vernay. Airdate 06/04/56.

Passport to Danger (Syndicated, role: Steve McQuinn). "Zamboanga": Steve investigates an American chorus girl who is about to marry the prince of Borneo; with Cesar Romero, James Burke, Alexander Campbell, Linda Goodridge, Charles Horvath, Michael Pate, Charles Regan, Gale Robbins, Rudy Robles, James Seay. Airdate 06/10/56.

The Leather Saint (Paramount, role: Tony Lorenzo). John Derek is an Episcopalian minister who boxes under an assumed name so he can win enough prize money to buy an iron lung and a swimming pool for his church community. He explains away the prize money as donations from a friend in the leather business—hence the film's title. Paul Douglas is a crusty-but-caring manager, Cesar Romero is a streetwise-but-generous fight promoter, and Jody Lawrance is an alcoholic-but-repentant nightclub singer who learns Derek's secret. *A Paramount Picture in VistaVision, The Leather Saint* starring Paul Douglas, John Derek, Jody Lawrance, Cesar Romero, Ernest Truex, Richard Shannon; Story and Screenplay by Norman Retchin and Alvin Ganzer; Produced by Norman Retchin; Directed by Alvin Ganzer; Production dates 01/09/56 to early February; Release date 06/15/56.

Passport to Danger (Syndicated, role: Steve McQuinn). "Calcutta": Steve tries vainly to recover a plague-ridden hawk stolen from him upon his arrival in Calcutta; with Cesar Romero, Dorothy Patrick, Robert Cabel, Naji, Harvey Stephens. Airdate 06/29/56.

Passport to Danger (Syndicated, role: Steve McQuinn). "Macao": Steve must escort a washed-up skipper to see his dying commodore father in San Francisco, but ruthless smugglers have other ideas; with Cesar Romero, Alan Hale Jr., Irene Tedrow, Charles Lung, Adeline De Walt Reynolds, Ernest Sarracino, Otto Reichow, Beulah Quo, William Tannen, Bruno VeSota. Airdate 07/02/56.

Passport to Danger (Syndicated, role: Steve McQuinn). "London": Steve uncovers a German woman working as a nurse and exposes a ring of spies; with Cesar Romero, Virginia Christine, Carl Esmond, Scott Forbes, Joy Lafleur. Airdate 07/09/56.

Passport to Danger (Syndicated, role: Steve McQuinn). "Helsinki": Steve is thrust into a political feud in Finland with a Romeo-and-Juliet twist; with Cesar Romero, Bette Arlen, Steven Geray, Gladys Holland, Kurt Kreuger,

Chronology

John Miljan, Otto Reichow, Henry Rowland, Olan Soule, Otto Waldis, William Yetter Sr. Airdate 07/14/56.

Passport to Danger (Syndicated, role: Steve McQuinn). "Ankara": Steve tries to protect two kidnapped children from a communist agent masquerading as their aunt; with Cesar Romero, Gladys Holland, John Wengraf, Christopher Cook, John Harmon, Nick Dennis, Mel Welles, Michael Mark, Peter Michael. Airdate 07/26/56.

Passport to Danger (Syndicated, role: Steve McQuinn). "Belgrade": Steve meets a dying man on a train to Belgrade who tells him about an assassination plot; with Cesar Romero, Maria Palmer, Dan Seymour. Airdate 07/28/56.

Passport to Danger (Syndicated, role: Steve McQuinn). "Dublin": Steve becomes involved with Irish patriots when a black bag is slipped into his luggage while arriving at the airport in Ireland; with Cesar Romero, Nancy Lee, Michael Emmet, James Fairfax, Michael Pate. Air-date 08/12/56.

Passport to Danger (Syndicated, role: Steve McQuinn). "Vienna": Steve finds intrigue when he looks up a senator's daughter attending ballet school in Austria; with Cesar Romero, John Warburton, Lisa Gaye, John Hamilton, Michael Emmet, Robert Carson, Michael Mark, Gregory Gaye, Lisa Golm. Airdate 08/19/56.

Around the World in Eighty Days (United Artists, role: Achmed Abdullah's Henchman). David Niven bets his fortune that he can circle the globe in eighty days—and does just that, accompanied by his new valet, Cantinflas, and dogged by Robert Newton, a Scotland Yard inspector who believes Niven has robbed the Bank of England. Cesar Romero plays a henchman to Gilbert Roland as the fabulously wealthy Achmed Abdullah in a very funny sequence that revolves around a bullfight and a borrowed yacht. *Around the World in Eighty Days*; Starring Cantinflas, Finlay Currie, Robert Morley, Ronald Squire, Basil Sydney, Noël Coward, Sir John Gielgud, Trevor Howard, Harcourt Williams, David Niven, Martine Carol, Fernandel, Charles Boyer, Evelyn Keyes, José Greco and Troupe, Gilbert Roland, Luis Miguel Domínguín, Cesar Romero, Alan Mowbray, Robert Newton, Sir Cedric Hardwicke, Melville Cooper, Reginald Denny, Ronald Colman, Robert Cabal, Shirley MacLaine, Charles Coburn, Peter Lorre, George Raft, Red Skelton, Marlene Dietrich, John Carradine, Frank Sinatra; Screenplay by James Poe, John Farrow, S. J. Perelman; Produced by Michael Todd; Directed by Michael Anderson; based upon a book by Jules Verne; Production dates mid-August to late November 1955 and reshoots early August 1956, over a total of 160 days; Release date 10/17/56.

Saturday Spectacular: Manhattan Tower (NBC, role: Mambo Teacher). A television movie based on the twelve-year-bestselling Gordon Jenkins record album of the same title. A boy-meets-girl plot in New York City joins the songs and dances together, with Peter Marshall and Helen O'Connell as the young couple and Cesar Romero in a sequence teaching them to mambo; with Ethel Waters, Phil Harris, Edward Everett Horton, Hans Conried, Tommy Farrell, Peter Marshall, Helen O'Connell, Cesar Romero, Bob Stevens, Ralph Brewster Chorus. Airdate 10/27/56.

Passport to Danger (Syndicated, role: Steve McQuinn). "Edinburgh": Steve gets involved in a murder and a search for buried treasure in Scotland; with Cesar Romero, Reginald Denny, Robert Boon, Lilian Fontaine, Sol Gorss, Jim Hayward, Arthur Space. Airdate 12/19/56.

Chevron Hall of Stars (Syndicated). Anthology. "Happy New Year": Cesar Romero is thrilled when a beautiful New Year's Eve guest knocks at his door—then she pulls a gun on him; with Cesar Romero, Virginia Field, Robert Bice. Airdate 12/27/56.

Passport to Danger (Syndicated, role: Steve McQuinn). "Antigua": Steve must stop a coffee speculator with a plot to keep the price of coffee artificially high; with Cesar Romero, Martin Garralaga, Rita Lynn, Margarita Martín, Lee Millar, Alberto Morin, Ann Morriss, Peter Reynolds, Charles Stevens, Robert Tafur. Airdate sometime in 1956.

1957

The Red Skelton Hour (CBS, role: Pierre). Variety. "Freddie the Count": An adaptation of O. Henry's classic story of a tramp who seeks shelter from the Christmas Day cold by trying to get thrown in jail, featuring Red Skelton as Freddie the Freeloader, Cesar Romero, Jan Arvan, Art Gilmore, The Skelton Dancers, Gilchrist Stuart, David Rose and His Orchestra. Airdate 01/08/57.

Climax! (CBS, role: Miguel). Anthology. "Strange Sanctuary": In the old southwest, a pair of bank robbers rides out after killing a man. One wants to get as far away as possible, but the other seeks a reunion with his daughter in a nearby convent; with Michael Rennie, Cesar Romero, Rita Moreno, Osa Massen, Noah Beery Jr., James Westerfield, Stacy Harris, Mack Williams, Fred Graham, Jim Hayward, Alan Roberts. Airdate 03/28/57.

The Tennessee Ernie Ford Show (NBC, role: Himself). Variety with Tennessee Ernie Ford, Cesar Romero, The Voices of Walter Schumann. Airdate 04/25/57.

Chronology

The Ford Television Theatre (NBC, role: Cousin Christopher). Anthology. "The Lie": A small lie has big consequences; with Cesar Romero, Betty Field, Gigi Perreau, Louis Lettieri, Pamela Baird. Airdate 06/05/57.

Schlitz Playhouse (CBS). Anthology. "An Old Spanish Custom": A temperamental movie star believes she can issue orders to everyone; with Dolores del Rio, Cesar Romero, Leon Askin, Salvador Baguez, Luis Gomez, Murray Hamilton, Celia Lovsky, Belle Mitchell. Airdate 06/07/57.

Passport to Danger (Syndicated, role: Steve McQuinn). "Prague": Steve helps a Russian ice-skating star defect to the West; with Cesar Romero, Ted de Corsia, Peter Brocco, Pamela Duncan, Gerry Gaylor, John Bleifer, Peter Coe. Airdate 07/04/57.

The Rosemary Clooney Show (NBC, role: Himself). Variety with Rosemary Clooney, Cesar Romero, Jane Wyman, Tennessee Ernie Ford, Frank De Vol, The Modernaires. Airdate 09/26/57.

What's My Line? (CBS, role: Himself). Game show; with guest host Bennett Cerf and Cesar Romero, Dorothy Kilgallen, Arlene Francis, Ernie Kovacs; Mystery Guests Henry J. Kaiser, Julie London. Airdate 09/29/57.

Matinee Theatre (NBC). Anthology. "Father Came Home": Cesar Romero is a suave father returning from Europe to meet his adult daughter for the first time; with Cesar Romero, host John Conte. Airdate 10/15/57.

The Red Skelton Hour (CBS, role: Fred Turner). Variety. "Cesar Romero Hires Deadeye for TV Series": A sketch on an episode featuring Red Skelton, Cesar Romero, David Rose and His Orchestra, Art Gilmore, The Skelton Dancers, Fred Turner. Airdate 10/22/57.

The Lucy-Desi Comedy Hour (CBS, role: Carlos Garcia). Sitcom. "Lucy Takes a Cruise to Havana": The origin story of Lucy and Ricky meeting in Cuba. Cesar Romero is partners with Desi Arnaz in a combination taxi-sightseeing service. They meet Lucille Ball and Ann Sothern fresh off a cruise ship. Everyone is far too old to be playing seventeen years younger. With Lucille Ball, Desi Arnaz, Cesar Romero, Ann Sothern, Rudy Vallee, Hedda Hopper, Vivian Vance, William Frawley, Richard Keith, Frank Nelson, Jorge Treviño, Nestor Paiva, Joaquin Del Rio, Vicente Padula, Louis Nicoletti. Airdate 11/06/57.

The Story of Mankind (Warner Bros., role: Spanish Envoy). Humans invent the super H-bomb sixty years ahead of schedule, sparking a High Tribunal of Outer Space where God and the Devil make their cases for why they should prevent the bomb from detonating or let it go off. In determining whether humanity is worth saving, evidence in the form of a sort of

greatest hits of humankind is presented and refuted by both sides. Vincent Price is the Devil, showing humankind's evil, with Ronald Colman as the Spirit of Man showing the good. With time ticking away, the judges must weigh the evidence and render their verdict. In a sequence about the power of art to inspire, Cesar Romero is an envoy from the king of Spain sent to threaten Agnes Moorehead as Queen Elizabeth I, and Reginald Gardiner as Shakespeare gives her courage. Colman cites the "peaceful" settlement of the New World as a positive outgrowth of England's victory over the Spanish Armada. Price acerbically retorts that the slaughtered Native Americans and enslaved people in the New World likely do not see it the same way. *Warner Bros. Pictures presents* Ronald Colman, Hedy Lamarr, Groucho Marx, Harpo Marx, Chico Marx, Virginia Mayo, Agnes Moorehead, Vincent Price, Peter Lorre, Charles Coburn, Cedric Hardwicke, Cesar Romero, John Carradine, Dennis Hopper, Marie Wilson, Helmut Dantine, Edward Everett Horton, Reginald Gardiner, Marie Windsor, George E. Stone, Cathy O'Donnell, Franklin Pangborn, Melville Cooper, Henry Daniell, Francis X. Bushman in *The Story of Mankind* with Jim Ameche, David Bond, Nick Cravat, Dani Crayne, Richard H. Cutting, Anthony Dexter, Toni Gerry, Austin Green, Eden Hartford, Alexander Lockwood, Melinda Marx, Bart Mattson, Don Megowan, Marvin Miller, Nancy Miller, Leonard Mudie, Burt Nelson, Tudor Owen, Ziva Rodann, Harry Ruby, William Schallert, Reginald Sheffield, Abraham Sofaer, Bobby Watson; Screenplay by Irwin Allen and Charles Bennett; Based on the classic by Hendrik Van Loon; Produced and Directed by Irwin Allen; Production dates 11/12/56 to late December; Release date 11/08/57.

The Gisele MacKenzie Show (NBC, role: Himself). Variety with Gisele MacKenzie, Cesar Romero, Axel Stordahl and His Orchestra, The Curfew Kids. Airdate 12/07/57.

Navy Log: The Beach Pounders (ABC, role: Himself). Reenactments of true naval events presented by celebrities; with host Cesar Romero; Cast: Larry Hilton, Ray Boyle, Lewis Martin, Richard Peel, Evelyn Scott. Airdate 12/19/57.

1958

Passport to Danger (Syndicated, role: Steve McQuinn). "New York": Steve discovers that a dance school is a front for a spy ring; with Cesar Romero, Mary Beth Hughes, Jean Willes, Jean Byron, Ann Doran, Frank Wilcox,

Chronology

Paul Dubov, Harlan Warde, Robert Brubaker, John Pickard, Gloria Marshall, Philip Van Zandt, Vernon Rich. Airdate 01/01/58.

Passport to Danger (Syndicated, role: Steve McQuinn). "Batavia": Steve must get an American woman out of Jakarta and back to the United States, but she is intent on locating her missing fiancé first; with Cesar Romero, Carolyn Jones, John Warburton, Irene Winston, Tol Avery, Walter Reed, Marya Marco, William Yetter Sr., Rudy Robles. Airdate 01/02/58.

The Tennessee Ernie Ford Show (NBC, role: Himself). Variety. Cesar Romero and Tennessee Ernie Ford perform "Chicken Road," Ford and the Top Twenty perform "Down Deep," and the Top Twenty perform "Sentimental Journey." Airdate 01/16/58.

Passport to Danger (Syndicated, role: Steve McQuinn). "Johannesburg": Steve protects a jewel prospector who has found a gigantic diamond; with Cesar Romero, James Gleason, Noreen Nash. Airdate 02/06/58.

The Patrice Munsel Show (ABC, role: Himself). Metropolitan Opera soprano Patrice Munsel sings and hosts this live variety show mixing show tunes, popular songs, and opera arias as well as comedy sketches; with Patrice Munsel, Cesar Romero, Carol Haney. Airdate 02/07/58.

What's My Line? (CBS, role: Himself). Game show; with host John Daly and Cesar Romero, Dorothy Kilgallen, Arlene Francis, Bennett Cerf; Mystery Guest Phil Silvers. Airdate 02/09/58.

Make Me Laugh (ABC, role: Himself). Game show where comics try to make contestants laugh; with Robert Q. Lewis, Cesar Romero, Joey Adams, Gene Baylos, Al Kelly, Don Tannen. Airdate 04/10/58.

What's My Line? (CBS, role: Himself). Game show; with host Clifton Fadiman and Cesar Romero, Arlene Francis, Dorothy Kilgallen, Bennett Cerf; Mystery Guest Bob Hope. Airdate 04/13/58.

Target (Syndicated). Anthology. Horror and suspense. "Bandit's Cave": Hunted bandit Cesar Romero risks his freedom and his life to keep a date with a beautiful woman in the 1860s; with host Adolphe Menjou and Cesar Romero, James Anderson, Lynn Cartwright, Edmund Cobb, Troy Melton, Zon Murray, Lee Roberts, Mickey Simpson, Dan White. Airdate 05/16/58.

Zane Grey Theatre (CBS, role: Carlos Gandara). Anthology. Based on the novels and stories of Zane Grey. Dick Powell is the host and often stars. "A Threat of Violence": The pilot for the series *Black Saddle*, which premieres a year later starring Peter Breck. Cesar Romero, a Mexican rancher

accused of killing the man he believes stole his land, is the client of a former gunfighter turned lawyer; with host Dick Powell and Cesar Romero, Lyle Bettger, Chris Alcaide, Jorja Curtright, Harry Lauter, Alex Gerry, Bruce Cowling, Jess Kirkpatrick, Jason Johnson. Airdate 05/23/58.

Passport to Danger (Syndicated, role: Steve McQuinn). "Brisbane": Steve's search for a mysterious girl leads to top-secret documents and murder; with Cesar Romero, Peter Adams, Shawn Smith, Lumsden Hare. Airdate 06/12/58.

The Tonight Show Starring Jack Paar (NBC, role: Himself). The second iteration of the late-night talk and variety show that is first hosted by Steve Allen; with Jack Paar, Hugh Downs, Cesar Romero, Freddy and Gladys, Genevieve, The Havana Symphony Orchestra, Betty Johnson, Jose Melis, Gina Romand, Miklós Rózsa. Airdate 07/28/58.

Studio One (CBS, role: Pat De Carlo). Considered the apex of dramatic television anthologies, *Studio One* received eighteen Emmy nominations and five wins during its nine-year run. Only five episodes aired after this one. "Birthday Present": Brian Keith is a young British businessman who attempts to smuggle a watch as a gift for his wife but is arrested by customs officials and sent to prison; with Brian Keith, Cesar Romero, Edgar Buchanan, Mary Beth Hughes, Betsy Jones-Moreland, Cecil Kellaway, J. M. Kerrigan, Betty Furness doing commercials. Airdate 08/18/58.

Passport to Danger (Syndicated, role: Steve McQuinn). "Tel Aviv": Steve helps the mother of a boy who arrives in Israel by plane and disappears; with Cesar Romero, Peter Votrian, Karen Verne, Peter Brocco, Sig Arno. Airdate 09/11/58.

Villa!! (20th Century Fox, role: Tomás Lopez). Pancho Villa is depicted as a devil-may-care playboy bandit interested only in women and gold before suddenly becoming aware of the suffering of the poor at the hands of the rich. He also wants to impress a gringa saloon singer, so he stops fooling around for a while and gains Mexico's independence. Cesar Romero is his trusted right-hand man; Brian Keith is an American criminal who joins the revolution; Margia Dean is the American saloon singer and object of Pancho's undying affection until she reconciles with Keith. *20th Century Fox presents Villa!!* Starring Brian Keith, Cesar Romero, Margia Dean and introducing Rodolfo Hoyos as Villa; Produced by Plato A. Skouras; Directed by James B. Clark; Written by Louis Vittes; CinemaScope; Color by De Luxe; Production dates late February to late March 1958; Release date 09/10/58.

Chronology

The Arthur Murray Party (NBC, role: Himself). Ballroom dancing, comedy, music, and dance contests—one of the few television shows to air over all four major commercial networks, starting on ABC in 1950, moving to CBS in the summer of 1952, Dumont in late 1952 to early 1953, back to CBS in mid- to late 1953, then to NBC in June 1954 through the rest of its run to September 1960; with Arthur Murray, Kathryn Murray, Joseph Cotton, Alfred Drake, Betty Johnson, Bert Lahr, Ann Miller, Patricia Morison, Ray Carter Orchestra, Basil Rathbone, Cesar Romero, June Taylor, William H. Vaux. Airdate 11/07/58.

Keep Talking (CBS, role: Himself). Game show where the regulars are divided into two teams of three players. The host gives each player a secret word, and the player has to tell a story using that word while the other team tries to guess the secret word; with Carl Reiner, Bern Bennet, Cesar Romero, Julie Wilson, Paul Winchell, Danny Dayton, Joey Bishop, Pat Carroll. Airdate 11/16/58.

Wagon Train (CBS, role: Honorable Don Charlie). Anthology. Stories of the journeys of a wagon train as it leaves post–Civil War Missouri on its way to California through the plains, deserts, and Rocky Mountains. "The Honorable Don Charlie Story": Cesar Romero is a gambler and womanizer who meets a woman who wants to marry him, but the mayor has promised her uncle to see her safely to San Francisco; with Ward Bond, Cesar Romero, Virginia Grey, Robert Horton, Diane Brewster, Lela Bliss, Hal Baylor, Ray Kellogg, Ken Christy, Jack Lomas, Terry Wilson, Frank McGrath. Airdate 11/22/58.

Passport to Danger (Syndicated, role: Steve McQuinn). "Monte Carlo": Steve must retrieve a roll of film with incriminating photographs of a corrupt politician; with Cesar Romero, Ann Robinson, Leonid Kinskey, Richard Hale, Mel Welles, Roland Varno, Henry Corden, Rolfe Sedan, Jean Del Val, Leo Mostovoy. Airdate 12/09/58.

1959

Where the Mountains Meet the Sea (Syndicated, role: Himself). A history and tour of Santa Monica, from the Wilshire corridor through Westwood, Brentwood, and on to Malibu, featuring famous residents Leo Carrillo, Cesar Romero, Raymond Burr, and Emmett Kelly as part of a series of short films called *Historic Travel U.S.* that could be aired or shown at conventions and events. Shot on location without sound—narration and effects are added in postproduction. Available 01/01/59 with various airdates.

Chronology

The George Gobel Show (NBC, role: Himself). Variety with George Gobel, Bea Arthur, Cesar Romero, Phyllis Avery, Eddie Fisher, The Johnny Mann Singers, The Kids Next Door, Myrna Loy, The Platters. Airdate 01/13/59.

Zorro (ABC, role: Uncle Esteban de la Cruz). Guy Williams as Don Diego de la Vega opposes the corrupt tyrants of Spanish California as the masked swordsman, Zorro. Cesar Romero has a four-episode arc as Diego's shyster uncle. "The Gay Caballero": Diego's uncle arrives and throws a lavish party to celebrate, but he arouses suspicion when he tries to sell jewels to several visitors. Diego suspects the jewels are fake; with Guy Williams, Cesar Romero, Henry Calvin, Gene Sheldon, Patricia Medina, George J. Lewis, Don Diamond, Nestor Paiva, Howard Wendell. Airdate 01/22/59.

The Arthur Murray Party (NBC, role: Himself). Variety with Arthur Murray, Kathryn Murray, Dick Clark, Cesar Romero, Shelley Winters, Gloria DeHaven, Kenny Gardner, Carmen Lombardo, Phyllis Newman, Ray Carter Orchestra, William H. Vaux. Airdate 01/26/59.

Zorro (ABC, role: Uncle Esteban de la Cruz). Drama adventure. "Tornado Is Missing": Esteban secretly plans to use Diego's horse to win money in a race and then to find and collect the reward for Zorro's capture; with Guy Williams, Cesar Romero, Henry Calvin, Gene Sheldon, Patricia Medina, Don Diamond, George J. Lewis. Airdate 01/29/59.

Zorro (ABC, role: Uncle Esteban de la Cruz). Drama adventure. "Zorro versus Cupid": Esteban announces his engagement to series regular Patricia Medina, but Diego, knowing his uncle is a gold digger, stops him as Zorro; with Guy Williams, Cesar Romero, Henry Calvin, Gene Sheldon, Patricia Medina, Don Diamond, George J. Lewis, Howard Wendell. Airdate 02/05/59.

Zorro (ABC, role: Uncle Esteban de la Cruz). Drama adventure. "The Legend of Zorro": After Zorro's multiple successful gambits to stop him from marrying Patricia Medina, Cesar Romero has one final plan, but Zorro thwarts him again, and with the letter Z on his forehead, Romero returns to Spain, still a bachelor; with Guy Williams, Cesar Romero, Henry Calvin, Gene Sheldon, Patricia Medina, Don Diamond, George J. Lewis, Howard Wendell. Airdate 02/12/59.

The Tennessee Ernie Ford Show (NBC, role: Himself). Variety with Tennessee Ernie Ford, Cesar Romero, Cathie Taylor, The Top Twenty. Airdate 02/19/59.

Chronology

The Red Skelton Hour (CBS, role: Clayton Harrison). Variety. "San Fernando Loses the Dixie Queen": A sketch on an episode featuring Red Skelton, Cesar Romero, Morris Ankrum, David Rose and His Orchestra, Art Gilmore, Terry Moore, Dick Ryan, The Skelton Dancers. Airdate 03/10/59.

The Dinah Shore Chevy Show (NBC, role: Himself). Variety with Dinah Shore, Cliff Arquette, Mahalia Jackson, Ginger Rogers, Cesar Romero. Airdate 03/22/59.

The Texan (CBS, role: Captain Joaquin Acosta). Rory Calhoun, a Civil War veteran with a reputation as the fastest gun in the West, roams across Texas getting himself into trouble. "Caballero": Rory Calhoun and Cesar Romero, a captain of the Mexican Rurales traveling to San Tomás to bid on a shipment of rifles and ammunition being sold at auction, become involved with a beautiful blonde and a notorious gunrunner who doesn't care if his guns fall into the hands of Apaches; with Rory Calhoun, Cesar Romero, Mari Blanchard, Whit Bissell, Fred Graham, Abel Fernandez, Jim Hayward. Airdate 04/13/59.

What's My Line? (CBS, role: Himself). Game show; with host John Daly and Cesar Romero, Arlene Francis, Dorothy Kilgallen, Bennett Cerf; Mystery Guests the McGuire Sisters. Airdate 06/07/59.

The Arthur Murray Party (NBC, role: Himself). Variety with Arthur Murray, Kathryn Murray, Cesar Romero, Denise Darcel, Ray Carter Orchestra, Bert Parks, William H. Vaux. Airdate 06/15/59.

The Arthur Murray Party (NBC, role: Himself). Variety with Arthur Murray, Kathryn Murray, Cesar Romero, Denise Darcel, Bert Parks, Ray Carter Orchestra, William H. Vaux. Airdate 09/14/59.

Death Valley Days (Syndicated, role: Don Augustin Olvera). Western stories based and filmed in and around Death Valley, California. One of the longest-running Western series, it originates on radio in the 1930s and runs on television from 1952 to 1970. The ongoing sponsor is 20 Mule Team Borax, a product formerly mined in Death Valley. "Olvera": Cesar Romero is a Mexican official who must balance his loyalty to his fellow caballeros and his obligations to the US government during the annexation of California; with Cesar Romero, Stanley Andrews, Michael Dante, Craig Duncan, Roy Engel, Rodolfo Hoyos, Victor Millan, Anna Navarro, Julian Rivero. Airdate 10/01/59.

Take a Good Look (ABC, role: Himself). Celebrities compete to identify people in the news, but if the newsmaker isn't available, Ernie Kovacs and other actors act out the event. With Ernie Kovacs, Edie Adams, Cesar Romero, Hans Conried, Janet Leigh, Scott Crossfield. Airdate 10/22/59.

Chronology

Take a Good Look (ABC, role: Himself). Game show; with Ernie Kovacs, Edie Adams, Cesar Romero, Hans Conried, Zsa Zsa Gabor, Fred Demara. Airdate 10/29/59.

Mis Secretarias Privadas (Columbia/Promexi, role: Rafael Travesi). A number of businessmen get into comedic and romantic entanglements with their private secretaries. The only Spanish-language film where Romero isn't dubbed—his Spanish is good enough to get by in social situations but not good enough for Spanish-speaking audiences. *Columbia Presenta, Promexi, Producciones Mexicanas Independentes, S.A. Presenta,* Cesar Romero, Lilia Prado, Rosa Carmina en *Mis Secretarias Privadas,* con Roberto Cañedo, Ema Arvizu, Eduardo Alcaraz, Armando Arriola, Luis Manuel Pelayo, Marianela Peña, Conchita Gentil Arcos, Bárbara Samperio, Aparición Especial de Luciane Auclaire (Miss Belgica); Dirección Roberto Rodríguez; Escritos Rafael García Travesi, Roberto Rodríguez; Película Producida por Fernando Orozco; Release date 10/29/59.

Take a Good Look (ABC, role: Himself). In this zany variant of *What's My Line?* celebrities compete to identify people in the news; with Ernie Kovacs, Edie Adams, Cesar Romero, Jim Backus, Hal Connolly, Olga Fikotová, Zsa Zsa Gabor. Airdate 11/05/59.

Take a Good Look (ABC, role: Himself). Game show; with Ernie Kovacs, Edie Adams, Cesar Romero, Jim Backus, Don Drysdale, Bob Lauher. Airdate 11/12/59.

Rawhide (CBS, role: Ben Teagle). Clint Eastwood becomes a star as a trail boss of a seemingly endless cattle drive. "Incident of the Stalking Death": A wounded puma kills the young son of a local rancher's widow. The men go on the hunt for the puma along with Cesar Romero, a friend of the widow; with Clint Eastwood, Eric Fleming, Sheb Wooley, Cesar Romero, Paul Brinegar, James Murdock, Steve Raines, Rocky Shahan, Mari Blanchard, Martin Garralaga, Regis Toomey, Scott Davey, Marilyn Winston, Doug Wilson. Airdate 11/13/59.

Take a Good Look (ABC, role: Himself). Game show; with Ernie Kovacs, Edie Adams, Cesar Romero, Peggy Connelly, Pat Harrington Jr., Mike Todd Jr., Marie Wilson. Airdate 11/19/59.

Take a Good Look (ABC, role: Himself). Game show; with Ernie Kovacs, Edie Adams, Cesar Romero, Hans Conried, Anne Jeffreys, Joe Meany Jr. Airdate 11/26/59.

Take a Good Look (ABC, role: Himself). Game show; with Ernie Kovacs, Edie Adams, Cesar Romero, Hans Conried. Airdate 12/10/59.

Chronology

Take a Good Look (ABC, role: Himself). Game show. Cesar Romero correctly identifies Miss America Mary Ann Mobley (they will appear together many times in the future on other television shows); with Ernie Kovacs, Edie Adams, Cesar Romero, Hans Conried, Max Conrad. Airdate 12/17/59.

Hotel de Paree (CBS, role: Charlie Pendleton). Earl Holliman is a reformed gunslinger just released from prison who inadvertently becomes a town's marshal and takes a shine to two French sisters who own the Hotel de Paree. "Sundance and the Violent Siege": Ex-convict Cesar Romero comes to town determined to make Holliman keep an old promise; with Earl Holliman, Jaclyn Hellman, Cesar Romero, Guy Wilkerson. Airdate 12/18/59.

Take a Good Look (ABC, role: Himself). Game show; with Ernie Kovacs, Edie Adams, Cesar Romero, Hans Conried, Joseph William Kittinger. Airdate 12/24/59.

Take a Good Look (ABC, role: Himself). Game show; with Ernie Kovacs, Edie Adams, Cesar Romero, Hans Conried, Jolene Brand, Bob Lauher, Elaine Shepard. Airdate 12/31/59.

1960

Zane Grey Theatre (CBS, role: Francisco). Anthology. "The Reckoning": Two cattle-ranching brothers want to drive a sheep herder out of the valley, but the younger brother becomes sympathetic to the herder's plight; with Cesar Romero, Stephen McNally, Robert Harland, Ed Nelson, Jeff Morris, James Rawley, Nick Borgani, host Dick Powell. Airdate 01/14/60.

The Betty Hutton Show (CBS). In this hybrid sitcom with music, Betty Hutton stars as a former showgirl, now a talkative manicurist, who inherits a legacy and the custody of three children from a rich Wall Street broker customer. "Goldie without Men": Hutton is depressed because Spring has sprung and everyone has been shot by Cupid's arrow except her—until she gets a look at guest star Cesar Romero; with Betty Hutton, Cesar Romero, Peter Miles, Gavin Muir, Dennis Olivieri, Gigi Perreau. Airdate 04/28/60.

Take a Good Look (ABC, role: Himself). Celebrities compete to identify people in the news; with Ernie Kovacs, Edie Adams, Cesar Romero, Hans Conried, Daniel Inouye, Mack Sennett. Airdate 04/28/60.

The Red Skelton Hour (CBS, role: Handsome Al). Variety. "San Fernando's Marriage Mill": Skelton, as San Fernando Red, decides to make easy money by acting as a matchmaker for husband-hunting women, on an episode featuring Red Skelton, Cesar Romero, David Rose and His Orchestra,

Juney Ellis, Art Gilmore, Gerald Harrison, Arte Johnson, Ray Kellogg, Barbara Morrison, The Skelton Dancers, Connie Van. Airdate 05/03/60.

Take a Good Look (ABC, role: Himself). Celebrities compete to identify people in the news; with Ernie Kovacs, Edie Adams, Cesar Romero, Hans Conried, Sally Rand. Airdate 05/19/60.

Take a Good Look (ABC, role: Himself). Celebrities compete to identify people in the news; with Ernie Kovacs, Edie Adams, Cesar Romero, Hans Conried, Peggy Connelly, Bob Lauher. Airdate 07/21/60.

Person to Person (CBS, role: Himself). The immensely popular interview show that originated in 1953 with host Edward R. Murrow live in the studio interviewing celebrity guests on location in their own homes. By 1960, Charles Collingwood has taken over from Murrow; with Cesar Romero. Airdate 07/22/60.

Ocean's Eleven (Warner Bros., role: Duke Santos). The archetypal all-star Vegas caper film. The Rat Pack star as ex-paratroopers who successfully stage a string of casino robberies. But their plan hits a snag when Cesar Romero (new groom to the divine Ilka Chase, who plays Peter Lawford's indulgent mother) figures out they did it and demands a hefty cut in exchange for his silence. That Romero completely holds his own against a cavalcade of stars comes as no surprise. He is sexy, vibrant, and droll. *Warner Bros. Pictures presents* Frank Sinatra, Dean Martin, Sammy Davis Jr., Peter Lawford, Angie Dickinson, Richard Conte in *Ocean's Eleven* also starring Cesar Romero, Patrice Wymore, Joey Bishop, Akim Tamiroff, Henry Silva; with Ilka Chase, Buddy Lester, Richard Benedict, Jean Willes, Norman Fell, Clem Harvey, Hank Henry, Lew Gallo, Robert Foulk; Guest Stars Red Skelton, George Raft; Screenplay by Harry Brown and Charles Lederer; Based on a Story by George Clayton Johnson and Jack Golden Russell; Produced and Directed by Lewis Milestone; Production dates mid-January to mid-March 1960; Release date 08/03/60.

The Chevy Mystery Show (NBC, role: Prince Florizel). Anthology. "The Suicide Club": Cesar Romero is a prince in a deep depression who discovers an organization that helps people commit suicide. When he changes his mind, they take deadly action; with host Vincent Price, Cesar Romero, Everett Sloane, Dan Tobin, Doris Dowling, Berry Kroeger, Chet Stratton, John Alderman. Airdate 09/18/60.

Pete and Gladys (CBS, role: Ricky Valenti). Insurance salesman Harry Morgan plays straight man to beautiful but scatterbrained wife Cara Williams and her zany antics. "Crime of Passion": Cesar Romero is a dance

Chronology

instructor who wants the couple to take dance lessons together; with Harry Morgan, Cara Williams, Cesar Romero, Gale Gordon, Ted Knight, Verna Felton, Peter Helm, Peggy Knudsen, Peter Leeds, George Colton, Shirley Mitchell, Delphine Seyrig, Barbara Stuart. Airdate 09/26/60.

Take a Good Look (ABC, role: Himself). Celebrities compete to identify people in the news; with Ernie Kovacs, Edie Adams, Cesar Romero, Hans Conried. Airdate 10/27/60.

Stagecoach West (ABC, role: Lalanda). Wayne Rogers and Robert Bray run a stagecoach line in the Old West and come across a cross section of damsels in distress, killers, and robbers, accompanied by Bray's young son. "A Time to Run": Cesar Romero is a wounded Mexican who tries to hijack the stagecoach and steal a horse, but he passes out from loss of blood before he can ride away; with Wayne Rogers, Richard Eyer, Cesar Romero, Steven Marlo, James Burke, Than Wyenn, Richard Coogan, William Schallert, Guy Wilkerson, Maxine Cooper, Lester Dorr, Barbara Nichols, Robert Bray. Airdate 11/15/60.

The Ann Sothern Show (CBS, role: Bernardo Diaz). Ann Sothern is the assistant manager of a New York hotel who gets into scrapes, often with her best friend and roommate, Ann Tyrrell. "Hasta Luego": Cesar Romero heads up a troupe of flamenco dancers who make sleeping impossible; with Ann Sothern, Don Porter, Cesar Romero, Ann Tyrrell, Genaro Gomez, Pepita Funez, Pepita Sevilla, Anthony Brand, Enrique Heredia, Rene Heredia, Stacy Keach Sr. Airdate 11/17/60.

Five Fingers (NBC, role: Ferri). David Hedison is a successful undercover agent based in Europe whose cover is as a talent agent for singer and object of his affection Luciana Paluzzi. Alan Napier, who will go on to play Alfred the Butler in *Batman*, has a featured role. "Counterfeit" is the final episode of the series; with David Hedison, Luciana Paluzzi, Paul Burke, Cesar Romero, Michael Granger, Yale Wexler, Peter Brocco, Montgomery Pittman, Eric Feldary, Joseph Ruskin, Richard Morris, Joseph Waring. Airdate 11/23/60.

Take a Good Look (ABC, role: Himself). Celebrities compete to identify people in the news; with Ernie Kovacs, Edie Adams, Cesar Romero, Hans Conried. Airdate 12/08/60.

Pepe (Columbia, role: Himself). Coming off the success of *Around the World in Eighty Days*, this is Mexican superstar Cantinflas's bid to establish an English-language career in the United States. He plays a simple man in Mexico who regards his racehorse as a son. He sells it to Dan Dailey, a Hollywood director whose career has seen better days. Disconsolate without his horse, Cantinflas travels to Hollywood with the hope

of getting his son back, and comic misadventures culminate in him and Dailey making a movie with Shirley Jones. A zillion celebrities, including Cesar Romero, appear as themselves in an attempt at meta coolness. The film bombs domestically, and Cantinflas never stars in another English-language A movie. *Columbia Pictures Corporation presents* George Sidney's production starring the international favorite Cantinflas as *Pepe*, costarring Dan Dailey, Shirley Jones with Carlos Montalbán, Vicki Trickett, Matt Mattox, Hank Henry, Suzanne Lloyd, Carlos Rivas; Screen Play by Dorothy Kingsley, Claude Binyon; Screen Story by Leonard Spigelgass and Sonya Levien; Based on a play by Leslie Bush-Fekete; Directed and Produced by George Sidney; Production dates 02/01/60 to 06/15/60; Release date 12/27/60.

1961

Take a Good Look (ABC, role: Himself). Celebrities compete to identify people in the news; with Ernie Kovacs, Edie Adams, Cesar Romero, Hans Conried, Leo Durocher. Airdate 02/23/61.

Take a Good Look (ABC, role: Himself). Celebrities compete to identify people in the news; with Ernie Kovacs, Edie Adams, Cesar Romero, Hans Conried, Carl Reiner. Airdate 03/02/61.

Here's Hollywood (NBC, role: Himself). Hollywood celebrities are interviewed, often at their homes; with Cesar Romero, Carol Heiss, Dean Miller, Helen O'Connell, Jack Linkletter, Art Linkletter. Airdate 03/21/61.

The Red Skelton Hour (CBS, role: General Santa Ana). Variety. "Deadeye and the Alamo": Skelton as Sheriff Deadeye and Romero as Santa Ana in a sketch about what *really* happened at the Alamo, in an episode featuring Red Skelton, Cesar Romero. Airdate 03/28/61.

Zane Grey Theatre (CBS, role: Tom Bowdry). Anthology. "Man from Everywhere": When local townspeople try to lynch suspected murderer Cesar Romero, the sheriff hires Burt Reynolds to escort him to the nearest court, with Ruta Lee in hot pursuit; with Cesar Romero, Peter Whitney, Burt Reynolds, Ruta Lee, Dabbs Greer, King Calder, Michael T. Mikler, Fred Graham, host Dick Powell. Airdate 04/13/61.

Stagecoach West (ABC, role: Francisco Martinez). Wayne Rogers and Robert Bray run a stagecoach line in the Old West and come across a cross section of damsels in distress, killers, and robbers, accompanied by Bray's young son. "The Big Gun": Cesar Romero is determined to steal a Gatling

gun from the stagecoach so he can get it into the hands of Juárez's forces fighting Emperor Maximilian; with Wayne Rogers, Richard Eyer, Robert Bray, Cesar Romero, DeForest Kelley, BarBara Luna, Jonathan Bolt, Gale Garnett, Bing Russell, Hal Baylor. Airdate 04/25/61.

The All New Truth or Consequences (NBC, role: Himself). Game show; with Bob Barker. Airdate 05/25/61.

The DuPont Show of the Week (NBC, role: Lukas). Anthology. "The Ballet of the Paper Bullet": Cesar Romero and six other prisoners of war are forced to carry out a Nazi plot to win the war by flooding the free world with counterfeit English and American money; with Russell Collins, Mark Lenard, Jerry Lester, Frank Lovejoy, Cesar Romero, Sandra Smith, Enzo Stuarti, Paul Tripp. Airdate 10/15/61.

7 Women From Hell, aka *Seven Women from Hell* (API/20th Century-Fox, role: Luis Hullman). Seven women escape from a Japanese internment camp in 1942. One is captured and tortured to death, two die by rifle fire, and the four who get away find a savior in Cesar Romero, a neutral German planter in New Guinea (who inexplicably speaks with an American accent). Among the four left alive, Sylvia Daneel is a German widow of an Allied soldier. She falls for Romero and agrees to stay with him ... until she figures out that his plan to get the other women to safety is actually just a means of turning them over to the Japanese. *20th Century-Fox presents* a CinemaScope Picture, *7 Women From Hell* starring Patricia Owens, Denise Darcel, Cesar Romero, Margia Dean, Yvonne Craig, Pilar Seurat, Sylvia Daneel; featuring Richard Loo, Evadne Baker, Bob Okazaki, Yuki Shimoda, Lloyd Kino, Kam Fong, and John Kerr as Bill Jackson; Written by Jesse Lasky Jr. and Pat Silver; Produced by Harry Spalding; Directed by Robert D. Webb; Release date 10/31/61.

The Runaway, aka *Saint Mike* (Summit Releasing Organization, role: Father Dugan). A young Mexican boy runs away from an orphanage in California to search for his father in Mexico. On the way, he takes a greyhound from a kennel in which he spent the night and meets up with Cesar Romero, a priest who decides to help the boy find his father. One of the nuns at his church is played by Anita Page, Joan Crawford's sexy pal in a series of Jazz Age melodramas. *The Runaway* with Cesar Romero, Roger Mobley, Anita Page, Lewis Martin, Chick Chandler, Nacho Galindo, Alex Montoya; Directed by Claudio Guzmán; Written by Samuel Roeca; Produced by Page Ostrow, Arthur Rupe; Release date 1961.

Chronology

1962

Target: The Corruptors! (ABC, role: Dimitris Hagias). A newspaper reporter and an undercover agent infiltrate the mob and report on a different crime every week. "My Native Land": In a fictional parallel to Lucky Luciano, gangland figure Cesar Romero is deported to Greece but tries to buy off a congressman to get back into the country; with Stephen McNally, Robert Harland, Cesar Romero, Ilka Windish, Ben Astar, Al Ruscio, Dan Grayam, John Megna, Athan Karras, John A. Neris, Stasa Damascus, Jerome Cowan, Will Kuluva. Airdate 03/16/62.

Follow the Sun (ABC, role: Dr. Berry Valentine). The drama and adventure of two freelance magazine writers based in Hawai'i. "A Ghost in Her Gazebo": When her children urge her to sell her large business, a widow consults a medium in order to seek business advice from her late husband; with Brett Halsey, Cesar Romero, Elsa Lanchester, Yvonne Craig, Dan Barton, Ann Del Guercio, Joan Marshall, Gregory Morton, Christopher Bowler, Jason Wingreen, Jerado Decordovier, William Windom. Airdate 03/18/62.

Rawhide (CBS, role: Big Tim Sloan). "The Child-Woman": Cesar Romero is a saloon owner who makes his wife's fifteen-year-old sister into a star attraction; with Eric Fleming, Cesar Romero, Paul Brinegar, Charles H. Gray, James Murdock, Steve Raines, Rocky Shahan, Robert Cabal, Jena Engstrom, Dorothy Morris, Julian Burton, John Hart, Coke Willis, George Barrows, Dick Winslow. Airdate 03/23/62.

The Beachcomber (Syndicated, role: Krasny). Wealthy business executive Cameron Mitchell chucks it all for the good life on a South Pacific beach, but life is still more complicated than he imagines it will be. "Flight to Freedom": A sailor from behind the Iron Curtain jumps ship and seeks refuge; with Cameron Mitchell, Cesar Romero, Grant Lockwood, Frances Fong, Don Megowan, Sebastian Cabot, Larry Chance. Airdate 09/04/62.

Keyhole (Syndicated, role: Himself). An American version of the long-running British show *Through the Keyhole*, in which celebrity guests are led through someone's home and try to guess who that individual is based on often misleading clues. "Hollywood Hopefuls" with Jack Douglas, Carol Channing, George Burns, Cesar Romero, June Lockhart. Airdate 09/20/62.

The Beachcomber (Syndicated, role: Joaquin Perez). Drama series. "The Spaniard": Cesar Romero seeks help finding his kidnapped daughter but may have ulterior motives; with Cameron Mitchell, Don Megowan, Sebastian Cabot, Cesar Romero, Anita Sands, Grant Woods. Airdate 09/25/62.

Chronology

If a Man Answers (Universal, role: Robert Swan/Adam Wright). At the instigation of her mother, Sandra Dee tries to train new husband Bobby Darin, inventing a fake mystery lover who hangs up when Darin answers—just like Mom used to do to Dee's father. In retaliation, Darin gets his father, Cesar Romero, to pretend to be the long-ago mystery lover come back to rekindle the flame with Dee's mother. Romero earns a Golden Globe nomination. In the clever opening credits sequence, animation of the characters and phones being dialed is accompanied by Bobby Darin jazzily singing, "If a man answers your phone, honey, I'm gone. . . ." *Universal International, Edward Muhl in Charge of Production, Ross Hunter Productions Inc. presents* Sandra Dee, Bobby Darin, Micheline Presle, John Lund in *If a Man Answers*, costarring Cesar Romero, Stefanie Powers with Christopher Knight, Ted Thorpe, Roger Bacon, John Bleifer, Pamela Searle, Warrene Ott, Dani Lynn, Charlene Holt, Gloria Camacho, Edmay Van Dyke, Rosalee Calvert; Screenplay by Richard Morris; From the Novel by Winifred Wolfe; Produced by Ross Hunter; Directed by Henry Levin; Production start date 02/27/62; Release date 10/10/62.

Stump the Stars (CBS, role: Himself). Cesar Romero versus Terry Moore, with Mike Stokey, Bill Baldwin, Sebastian Cabot, Jan Clayton, Diana Dors, Beverly Garland, Pat Harrington Jr., Mickey Manners, Ross Martin. Airdate 11/05/62.

The Red Skelton Hour (CBS, role: Plumber). Variety. "Dial P for Plumber": A woman orders her husband to plug a leak in the basement, but he makes such a mess of things that they are forced to call in a very expensive plumber, on an episode featuring Red Skelton, Cesar Romero, David Rose and His Orchestra, Art Gilmore, Jo Stafford. Airdate 11/13/62.

The Jerry Lewis Show: From This Moment On (Syndicated, role: Himself). Before it becomes an all-out Labor Day telethon for the Muscular Dystrophy Association of America, Jerry Lewis raises money in this shorter format; with many guest stars. Airdate 11/17/62.

1963

Delta Kappa Alpha Silver Anniversary Banquet (Syndicated, role: Himself). Honoring Mary Pickford and Harold Lloyd at the University of Southern California, School of Cinematic Arts, with many guest stars. Airdate 01/06/63.

Here's Edie (ABC, role: Himself). Comedy and variety show; with Edie Adams, Cesar Romero, Laurindo Almeida, Jerry Fielding, Stan Getz, Don Rickles. Airdate 01/20/63.

Chronology

The Red Skelton Hour (CBS, role: Witch Doctor). Variety. "Red Fails in the Sunset": Skelton is a con man who poses as a native fire god on a tropical island, much to the chagrin of the local witch doctor, in a sketch on an episode featuring Red Skelton, Cesar Romero, David Rose and His Orchestra, Art Gilmore, Alice Kessler, Ellen Kessler, Vici Raaf. Airdate 02/12/63.

We Shall Return, aka *Force of the Winds* (Carl-Phil Productions, role: Carlos Rodriguez). Poster copy: "A tense drama revolving around the lives of today's Cuban refugees!" and "The Dramatic Portrayal of History in the making . . . the planned downfall of Castro's Cuba!" With Fidel Castro in power, wealthy Cuban landowner Cesar Romero flees to Miami with his younger son and the young man's fiancée only to discover that his eldest son supports Castro and plans to reveal the location of the CIA's Bay of Pigs to pro-Castro forces. Romero makes the agonizing decision to shoot his son to stop him. *We Shall Return!* starring Cesar Romero with Linda Libera, Anthony Ray, Miguel O'Brien (credited as Michael O'Brien), Chico Cardenas; Produced by Robert M. Carson; Directed by Philip S. Goodman; Screenplay by Pat Frank; Production dates sometime in 1961; Release date 02/15/63.

The 20th Annual Golden Globe Awards (Syndicated, role: Himself). Cesar Romero appears as a nominee for Best Supporting Actor for *If a Man Answers*. He loses to Omar Sharif in *Lawrence of Arabia*. Airdate 03/05/63.

The Dick Powell Theatre (NBC, role: Lou Samson). Anthology. "Charlie's Duet": Nightclub owner Anthony Franciosa resists the attempts of bigtime gangster Cesar Romero to muscle in but fears for the life of the girl he loves, sultry Julie London; with guest host Milton Berle and Anthony Franciosa, Cesar Romero, Jim Backus, Zsa Zsa Gabor, Julie London, Jules Munshin, James Gregory, Richard LePore, Army Archerd, Alvy Moore, Henry Slate. Airdate 03/19/63.

You Don't Say (NBC, role: Himself). In this charades-like game show, two teams of players compete against each other to determine the name of a famous person; with host Tom Kennedy and Cesar Romero, Jayne Meadows, John Harlan. Airdate 04/08/63.

You Don't Say (NBC, role: Himself). Game show; with host Tom Kennedy and Cesar Romero, Jayne Meadows, John Harlan. Airdate 04/09/63.

You Don't Say (NBC, role: Himself). Game show; with host Tom Kennedy and Cesar Romero, Jayne Meadows, John Harlan. Airdate 04/10/63.

You Don't Say (NBC, role: Himself). Game show; with host Tom Kennedy and Cesar Romero, Jayne Meadows, John Harlan. Airdate 04/11/63.

Chronology

You Don't Say (NBC, role: Himself). Game show; with host Tom Kennedy and Cesar Romero, Jayne Meadows, John Harlan. Airdate 04/12/63.

Rawhide (CBS, role: Don Francisco Maldenado). "Incident at Rio Doloroso": While crossing private land, locals try to stampede the herd. When their leader is killed by the cattle, Clint Eastwood and Eric Fleming are sentenced to die at the behest of wealthy rancher Cesar Romero; with Clint Eastwood, Eric Fleming, Cesar Romero, Paul Brinegar, Charles H. Gray, James Murdock, Steve Raines, Rocky Shahan, Robert Cabal, Madlyn Rhue, Michael Ansara, Ernest Sarracino, William R. Thompkins, Martin Garralaga. Airdate 05/10/63.

Donovan's Reef (Paramount, role: Marquis Andre de Lage). John Wayne is perfectly happy as a single man living on a South Seas island paradise, where his main companions are Jack Warden and yearly visitor Lee Marvin, who arrives for an annual fistfight. When Warden's estranged high-society daughter, Elizabeth Allen, shows up, the island's governor, Cesar Romero, woos her for her money, but Wayne wins her heart by spanking her while encouraging her to accept her newly discovered mixed-race half siblings. *A Paramount Release*, John Wayne in the John Ford Production *Donovan's Reef*, costarring Lee Marvin, Elizabeth Allen, Jack Warden, Cesar Romero, Dick Foran and Dorothy Lamour, Marcel Dalio, Mike Mazurki, Jacqueline Malouf, Cherylene Lee, Jeffrey Byron (credited as Tim Stafford), Edgar Buchanan, Jon Fong; Screenplay by Frank S. Nugent and James Edward Grant; Story by Edmund Beloin; Produced and Directed by John Ford; Production dates 07/23/62 to sometime in September; Release date 06/12/63.

The Castilian, aka *El valle de las espadas* (Warner Bros., M.D. Producciónes, Cinematográficas, role: Jerónimo). In tenth-century Spain, the young leader of the Spanish kingdom of Castile emerges from a self-imposed exile after the death of his older brother to unite Spain and defeat the ruthless Navarrese troops and the Moors. *Warner Bros. Pictures presents* the Sidney W. Pink Production *The Castilian*, starring Cesar Romero as Jerónimo, Frankie Avalon as Jerifan; Guest Stars Broderick Crawford as Don Sancho, Alida Valli as Queen Teresa of Leon; Introducing Espartaco Santoni as Fernán Gonzáles (credited as Spartaco Santony), Tere Velázquez as Sancha; Executive Producer Richard C. Meyer; Produced by Sidney W. Pink; Written by Paulino Rodrigo, Luis de los Arcos, Javier Setó from a poem by Fernán González; English Script and Dialogue by Sidney W. Pink; Directed by Javier Setó; Production dates 05/14/62 through late October; Release date 09/06/63.

Chronology

You Don't Say (NBC, role: Himself). Game show; with host Tom Kennedy and Cesar Romero, Jaye P. Morgan, John Harlan. Airdate 10/07/63.

You Don't Say (NBC, role: Himself). Game show; with host Tom Kennedy and Cesar Romero, Jaye P. Morgan, John Harlan. Airdate 10/08/63.

You Don't Say (NBC, role: Himself). Game show; with host Tom Kennedy and Cesar Romero, Jaye P. Morgan, John Harlan. Airdate 10/09/63.

You Don't Say (NBC, role: Himself). Game show; with host Tom Kennedy and Cesar Romero, Jaye P. Morgan, John Harlan. Airdate 10/10/63.

77 Sunset Strip (ABC, role: Lorenzo Cestari). A pair of wisecracking, womanizing private detectives are the heroes of this drama series. "5: Part 4": In this star-studded episode, Efrem Zimbalist Jr. crisscrosses Europe trying to solve the mystery of art objects stolen by the Nazis; with Efrem Zimbalist Jr., Cesar Romero, Telly Savalas, Walter Slezak, Tony Bennett, Burgess Meredith, Lloyd Nolan, Jacques Bergerac, Richard Conte, Marisa Pavan, Rick Traeger, Robert Boon, Franco Corsaro, Walter Friedel, Charles H. Radilak, Mario Siletti, Al Lettieri. Airdate 10/11/63.

You Don't Say (NBC, role: Himself). Game show; with host Tom Kennedy and Cesar Romero, Jaye P. Morgan, John Harlan. Airdate 10/11/63.

Fractured Flickers (Syndicated, role: Himself). Host Hans Conried leads celebrities and voice artists in adding their own voices and sound effects to create comedy by transforming old film footage; with Cesar Romero. Airdate 10/31/63.

Burke's Law (ABC, role: Marcus DeGrute). Gene Barry is a millionaire captain of the LAPD homicide division, always driven to crime scenes in his chauffeured Rolls-Royce. Romero recurs as a police chief in five episodes over three seasons. "Who Killed Billy Jo?": A recording star is murdered, and there are three suspects: his agent, his sister, and his music arranger; with Gene Barry, David Niven, Cesar Romero, Ida Lupino, Gary Conway, Regis Toomey, Leon Lontoc, Nick Adams, Laraine Day, Howard Duff, Phil Harris, Tina Louise, Lynn Dexter, Elaine Stewart, Tom Tully, Kelly Gordon, Marlyn Mason, Ken Berry, Buddy Garion, Valora Noland, Anthony Larry Paul. Airdate 11/08/63.

The Red Skelton Hour (CBS, role: Russian Agent). Variety. "It's a Treat to Sell Your Wheat in the Vladivostok Mud": A Russian agent is sent to Clem Kadiddlehopper's farm to snare his secrets for fast-growing wheat, in an episode featuring Skelton as Clem Kadiddlehopper, Cesar Romero, The Womenfolk. Airdate 12/10/63.

Chronology

1964

Burke's Law (ABC, role: Louis Simone). Drama series. "Who Killed Snooky Martinelli?": With all the bodies piling up week after week, is it possible that Gene Barry has been murdered? Possible, but not likely; with Gene Barry, Hoagy Carmichael, Broderick Crawford, Cesar Romero, Arlene Dahl, Carl Reiner, Janice Rule, Gary Conway, Regis Toomey, Leon Lontoc, Eileen O'Neill, Sandra Giles, Don Gazzaniga, Joe Scott. Airdate 01/10/64.

The Object Is (ABC, role: Himself). Contestants try to identify famous people based on objects associated with them; with host Dick Clark and Cesar Romero, Nick Adams, Carolyn Jones, Mike Lawrence. Airdate 01/13/64.

The Object Is (ABC, role: Himself). Game show; with host Dick Clark and Cesar Romero, Nick Adams, Carolyn Jones, Mike Lawrence. Airdate 01/14/64.

The Object Is (ABC, role: Himself). Game show; with host Dick Clark and Cesar Romero, Nick Adams, Carolyn Jones, Mike Lawrence. Airdate 01/15/64.

The Object Is (ABC, role: Himself). Game show; with host Dick Clark and Cesar Romero, Nick Adams, Carolyn Jones, Mike Lawrence. Airdate 01/16/64.

The Object Is (ABC, role: Himself). Game show; with host Dick Clark and Cesar Romero, Nick Adams, Carolyn Jones, Mike Lawrence. Airdate 01/17/64.

Dr. Kildare (NBC, role: Dr. Paul Marino). Long-running radio series, film series, and now television series about the relationship between a young medical intern and his surgeon mentor. The show makes Richard Chamberlain into a romantic idol. "Onions, Garlic and Flowers That Bloom in the Spring": Cesar Romero is an acerbic veteran doctor recuperating from a heart attack who doesn't respond well to Chamberlain being temporarily assigned to take over his inner-city clinic; with Richard Chamberlain, Raymond Massey, Cesar Romero, Audrey Dalton, Joe De Santis, Penny Santon, Nick Alexander, James Noah, Marianna Hill, Jason Wingreen, Tina Menard, Beth Peters. Airdate 02/06/64.

The Red Skelton Hour (CBS, role: Concierge). Variety. "Keep the Tramp Fires Burning": Skelton is Freddie the Freeloader, confounding hotel concierge Cesar Romero on an episode featuring Red Skelton, Cesar Romero, David Rose and His Orchestra, Art Gilmore, Poncie Ponce. Airdate 04/21/64.

Chronology

Burke's Law (ABC, role: Antonio Cardoza). Drama series. "Who Killed Don Pablo?": A wax figure in a museum turns out to be a corpse; with Gene Barry, Agnes Moorehead, Cesar Romero, Forrest Tucker, Gary Conway, Regis Toomey, Leon Lontoc, John Cassavetes, Cecil Kellaway, Patricia Medina, Joan Staley, Irene Tedrow, Maurine Dawson, Ann Morell, Tita Marsell, Marissa Mathes, Jacqueline D'Avril, Elvera Corona. Airdate 05/01/64.

A House Is Not a Home (Embassy Pictures, role: Lucky Luciano). In this biopic of the notorious Roaring Twenties madam Polly Adler, Shelley Winters plays her as an angel trying to keep her girls safe, even as one of them hurls herself to her death because of the shame of selling her body, and another one overdoses. Cesar Romero does a snappy turn as the infamous Lucky Luciano, who gets ahead by bribing politicians but is framed for running a prostitution syndicate, leading to gang warfare. Raquel Welch makes her film debut as a call girl. *The True Story of America's Most Famous Madam, Polly Adler, A House Is Not a Home* starring Shelley Winters as Polly, Kaye Ballard, Ralph Taeger, Jesse White, Mickey Shaughnessy; with Meri Welles, Lisa Seagram, Hayden Rorke, Lewis Charles, Steve Peck, Michael Forest, Stanley Adams, Constance Dane, J. Pat O'Malley, Benny Rubin, Connie Gilchrist, Tom D'Andrea, Roger C. Carmel, Henry Beckman, Edmon Ryan, Alex Gerry, and Polly's Girls: Danica D'Hondt, Francine Pyne, Inga Neilsen, Raquel Welch, Gee Gee Galligan, Amadee Chabot, Astrid De Brea, Diane Libby, Patricia Thomas, Sandra Grant, Leona Gage, Patricia Manning, Edy Williams; Guest Star Broderick Crawford as Harrigan; Guest Star Cesar Romero as Lucky Luciano and costarring Robert Taylor as Frank; Screenplay by Russell Rouse and Clarence Green; Based on the book by Polly Adler; Produced by Clarence Greene; Directed by Russell Rouse; Production start date 03/10/64; Release date 08/12/64.

Hollywood Goes to a World Premiere (Disney, role: Himself). Short-form documentary about the premiere of *Mary Poppins* at Grauman's Chinese Theater; with many guest stars. Airdate 08/27/64.

Burke's Law (ABC, role: Gregorio Jonas). Drama series. "Who Killed Davidian Jonas?": A millionaire's corpse is found attached to the anchor of his yacht; with Gene Barry, Gary Conway, Regis Toomey, Leon Lontoc, Broderick Crawford, Dennis Day, Reginald Gardiner, Ruta Lee, Sheree North, Cesar Romero, Lisa Seagram, Peter Bourne, Walter Janovitz, Naji Gabbay, Raúl Martín, Pepita Funez, Tanya Lemani, Robert Hickman. Airdate 12/30/64.

Chronology

1965

Two on a Guillotine (Warner Bros., role: Duke Duquesne). Superstar magician Cesar Romero is testing out his grand guillotine trick with wife Connie Stevens. Mysterious events find Stevens gone AWOL and their young daughter sent to live in the Midwest. Twenty years later, the daughter returns, also played by Stevens, to attend the funeral of Romero, the father she never knew. At her late father's grand estate, things start going bump in the night, and handsome reporter Dean Jones is happy to play protector. When it turns out that Romero is not dead, that he accidentally killed Stevens #1 in a guillotine accident, drove himself balmy over the loss, and thinks Stevens #2 is actually Stevens #1, we're not a bit surprised. *Warner Bros. Pictures presents Two on a Guillotine starring Connie Stevens, Dean Jones, and Cesar Romero as "Duke" Duquesne; with Parley Baer, Virginia Gregg, Connie Gilchrist, John Hoyt; Screenplay by Henry Slesar and John Kneubuhl; Story by Henry Slesar; Produced and Directed by William Conrad;* Production start date 06/08/64; Release date 01/13/65.

The Tonight Show Starring Johnny Carson (NBC, role: Himself). Talk and variety show; with Johnny Carson, Ed McMahon, Cesar Romero, Xavier Cugat, Charo. Airdate 01/19/65.

Bonanza (NBC, role: Guido Borelli). Ben Cartwright and his sons manage to work their Nevada ranch, fending off all comers, while helping the surrounding community for an incredible fourteen-year run, from 1959 to 1973. "The Deadliest Game": While his troupe visits the Ponderosa, lonely, aging aerialist Cesar Romero gets involved in a plot that lands Michael Landon in jail for attempted murder; with Lorne Greene, Pernell Roberts, Dan Blocker, Michael Landon, Cesar Romero, Fabrizio Mioni, Ilze Taurins, Lili Valenty, Ray Teal, Grandon Rhodes. Airdate 02/21/65.

Burke's Law (ABC, role: Police Chief Alvaro). Drama series. "Who Killed the Rest?": A boat blows up, killing a notorious gossip columnist, and Burke is the chief suspect, accused by Police Chief Cesar Romero; with Gene Barry, Eartha Kitt (as a witch doctor!), Steve Cochran, Gary Conway, Cesar Romero, Regis Toomey, Leon Lontoc, Theodore Bikel, Janice Rule, Lisa Gaye, Pedro Gonzalez, Bern Hoffman, Inger Stratton, Pepe Callahan, Nestor Paiva, Rafael López, Linda Rivera. Airdate 03/17/65.

Branded (NBC, role: General Arriola). Unfairly tarred as a coward and thrown out of West Point, Chuck Connors now travels the country in the 1880s proving his bravery at every opportunity. "The Mission: Part 2": A

highly secret mission infiltrating a band of marauding Mexican bandits threatens to further brand Connors as a coward and also a traitor; with Chuck Connors, Peter Breck, John Carradine, Cesar Romero, Patrick Wayne, Wendell Corey, H. M. Wynant, Jon Lormer, William Bryant. Airdate 03/21/65.

The Man from U.N.C.L.E. (NBC, role: Victor Gervais). Two agents of the United Network Command for Law Enforcement (U.N.C.L.E.) fight an evil organization, coasting on charm, wit, and a never-ending assortment of gadgets. "The Never-Never Affair": An errand to get pipe tobacco inadvertently thrusts a young recruit into danger; with Robert Vaughn, David McCallum, Leo G. Carroll, Barbara Feldon, Cesar Romero, Robert Gibbons, Leigh Chapman, Kate Murtagh, Mel Gallagher, Clarke Gordon, Hank Grant, David Armstrong, David Banks, Herbert Bress, John Stephenson. Airdate 03/22/65.

Ben Casey (ABC, role: Frederic Delano). Gritty and realistic for its time, but a far cry from the BBC's *Casualty* or NBC's groundbreaking *ER*, this hospital drama pits young, intense Vince Edwards against the medical establishment under Sam Jaffe's watchful eyes. "Did Your Mother Come from Ireland, Ben Casey?": Cesar Romero, an alcoholic former doctor who hits rock bottom, is hospital roommates with appendicitis patient Edwards and gabby Irishman Tom Bosley; with Vince Edwards, Sam Jaffe, Cesar Romero, Tom Bosley, Bill Mumy, Stephen Coit, Raymond Joyer, William Long Jr., Michael Pataki. Airdate 05/03/65.

Sergeant Deadhead (American International Productions, role: Admiral Stoneham). Accident-prone sergeant Frankie Avalon inadvertently goes up into space with a chimpanzee, and when they return to Earth Avalon inexplicably develops the obnoxious personality traits of the chimp. Romero is one of the military bigwigs trying to cover up the blunder. This movie is announced in the end credits of *How to Stuff a Wild Bikini*. In its own end credits, *Sergeant Deadhead* proudly announces the upcoming *Dr. Goldfoot and the Bikini Machine*. *American International Pictures, James H. Nicholson and Samuel Z. Arkoff present* Frankie Avalon, Deborah Walley, Cesar Romero, Fred Clark, Gale Gordon, Harvey Lembeck, John Ashley, Buster Keaton, Reginald Gardiner; Special Cameo Star Pat Buttram as the President; also starring Eve Arden in *Sergeant Deadhead*, Written by Louis M. Heyward; Directed by Norman Taurog; Production dates May to June 1965; Release date 08/13/65.

Chronology

Marriage on the Rocks (Warner Bros., role: Miguel Santos). In this riff on *Divorce, Italian Style*, Frank Sinatra and Deborah Kerr are in a rut and get a hasty Mexican divorce. When they decide to remarry, Kerr mistakenly marries Sinatra's pal and her former boyfriend Dean Martin—then decides to teach Sinatra a lesson by staying married to Martin. Cesar Romero is the broadly comical Mexican lawyer and hotel manager who supplies the divorce and the wedding. In a role that could be a gross caricature, Romero shines. *Warner Bros. Pictures presents* Frank Sinatra, Deborah Kerr, Dean Martin in *Marriage on the Rocks*, Co-Starring Cesar Romero, Hermione Baddeley, Tony Bill, John McGiver, Nancy Sinatra, Davey Davison, Michael Petit, Guest Star Trini Lopez; with Joi Lansing, Darlene Lucht (as Tara Ashton), Kathleen Freeman, Flip Mark, DeForest Kelley, Sigrid Valdis; Written by Cy Howard; Producer and Director of Photography William H. Daniels, A.S.C.; Directed by Jack Donohue; Production start date 03/08/65; Release date 09/24/65.

Rawhide (CBS, role: Col. Emilio Vasquez). "The Vasquez Woman": Cesar Romero swindles the men out of two hundred cows. John Ireland tries to recover their money but ends up with Romero's wife, Carol Lawrence, instead; with John Ireland, Cesar Romero, Paul Brinegar, Steve Raines, Raymond St. Jacques, Carol Lawrence, Malachi Throne. Airdate 10/26/65.

Salute to Stan Laurel (CBS, role: Himself). Nine months after the comedian's death, CBS put together this collection of original comedy skits written as a tribute to Stan Laurel; with Dick Van Dyke, Lucille Ball, Mary Foran, Fred Gwynne, Oliver Hardy, Bern Hoffman, Danny Kaye, Buster Keaton, Leonid Kinskey, Harvey Korman, Tina Louise, Audrey Meadows, Bob Newhart, Louis Nye, Gregory Peck, Cesar Romero, Phil Silvers. Airdate 11/23/65.

The Hollywood Palace (ABC, role: Himself). Lavish variety show with a rotating series of celebrity hosts; with Cesar Romero, Milton Berle, Liberace, Joey Heatherton, The McGuire Sisters, Johnny Puleo & His Harmonica Gang, Milton Frome, The Peiro Brothers, The Berosinis. Airdate 12/04/65.

The Red Skelton Hour (CBS, role: Henry Cleancut). Variety. "Monotony on the Bounty": Trying to escape his throngs of female admirers, Cesar Romero turns to a crooked travel agency run by Skelton as San Fernando Red, a sketch in an episode featuring Red Skelton, Cesar Romero, The Alan Copeland Singers, Patrick Campbell, Minnie Coffin, Stephen Courtleigh, David Rose and His Orchestra, Mary Foran, Art Gilmore, Emmaline Henry, Helen Kleeb, Laura Mason, Ida Mae McKenzie, Barbara Morrison, Jerry Rannow, Silkie, Tom Hansen Dancers. Airdate 12/28/65.

Chronology

1966

Daniel Boone (NBC, role: Esteban de Vaca). Fess Parker as frontier hero Daniel Boone conducts surveys and expeditions in and around Boonesborough, running into both friendly and hostile Indians before, during, and even after the Revolutionary War with sidekick Ed Ames in brownface. This is the first of three different characters Cesar Romero plays on the show between 1966 and 1969. "Gabriel": Spanish officer Cesar Romero confuses Fess Parker with someone named Gabriel and, upon discovering his mistake, holds Ed Ames hostage until Parker tracks Gabriel down (an actor named Carlos Romero costars but is no relation); with Fess Parker, Ed Ames, Cesar Romero, Carlos Romero, Jacqueline Beer, Vincent Beck, Mike Mazurki. Airdate 01/06/66.

Batman (ABC, role: The Joker). "The Joker Is Wild": When the imprisoned Clown Prince of Crime finds out that the Gotham City Museum of Modern Art's Comedians Hall of Fame has neglected to include him, he escapes from the yard (while playing in a prison baseball game) and seeks revenge. Batman regular cast: Adam West as Batman and his alter ego Bruce Wayne, Burt Ward as Robin and his alter ego Dick Grayson, Alan Napier as Alfred the Butler, Neil Hamilton as Commissioner Gordon, Yvonne Craig as Batgirl and her alter ego Barbara Gordon (season 3), Stafford Repp as Chief O'Hara, Madge Blake as Aunt Harriet; Narrated by William Dozier; with guest cast Cesar Romero, Nancy Kovack, Jonathan Hole, Merritt Bohn, Dick Curtis, Al Wyatt Sr., Angelo DeMeo. Airdate 01/26/66.

Batman (ABC, role: The Joker). "Batman Is Riled": Among his continued antics, The Joker employs snakelike trick streamers, taunts Batman and Robin while appearing on a comical criminal game show called *What's My Crime*, plots to steal a steamship, and kidnaps Batman and Robin; with guest cast Cesar Romero, Jerry Dunphy, Nancy Kovack, Jonathan Hole, Merritt Bohn, Dick Curtis, Al Wyatt Sr., Angelo DeMeo. Airdate 01/27/66.

Batman (ABC, role: The Joker). "The Joker Goes to School": Batman and Robin must get to the bottom of why a vending machine at Woodrow Roosevelt High School is giving out silver dollars. They learn the machine is owned and operated by a company bought by The Joker after his release from prison; with guest cast Cesar Romero, Donna Loren, Kip King, Greg Benedict, Bryan O'Byrne, Tim O'Kelly, Cherie Foster, Linda Harrison, Sydney Smith, Glenn Allan, Donna Di Martino, Dick Bellis, Joan Parker, Breeland Rice, Jim Henaghan. Airdate 03/02/66.

Chronology

Batman (ABC, role: The Joker). "He Meets His Match, The Grisly Ghoul": A power failure prevents Batman and Robin from being electrocuted. Soon The Joker's plot is revealed: he is framing the basketball team's star players. With guest cast Cesar Romero, Donna Loren, Kip King, Greg Benedict, Bryan O'Byrne, Tim O'Kelly, Cherie Foster, Linda Harrison, Sydney Smith, Glenn Allan, Donna Di Martino, Dick Bellis, Joan Parker, Breeland Rice, Jim Henaghan. Airdate 03/03/66.

Batman (ABC, role: The Joker). "The Joker Trumps an Ace": The Joker commits two senseless crimes, stealing a hairpin from a rich woman at a fur salon and stealing the actual hole from a golf course, where his plan is to steal the solid gold golf clubs belonging to the visiting maharajah of Nimpah. And he does just that, using the hairpin as a trigger for a bomb in the stolen hole. With guest cast Cesar Romero, Jane Wald, Dan Seymour, Tol Avery, Angela Greene, Norman Alden, Byron Keith, Johnny Seven, Bebe Louie. Airdate 04/06/66.

Batman (ABC, role: The Joker). "Batman Sets the Pace": After an ingenious escape, Batman and Robin again pick up the trail of The Joker. They manage to capture some of The Joker's men, but he gets away—with the kidnapped maharajah, demanding a $500,000 ransom for the portly chieftain's safe return. With guest cast Cesar Romero, Jane Wald, Dan Seymour, Toi Avery, Angela Greene, Norman Alden, Byron Keith, Johnny Seven, Bebe Louie. Airdate 04/07/66.

The Hollywood Palace (ABC, role: Himself). Lavish variety show with a rotating series of celebrity hosts; with Cesar Romero, Cyd Charisse, Vikki Carr, Norm Crosby, Dick Martin, Tony Martin, Dan Rowan, The Suns Family, Bob Winters. Airdate 04/16/66.

Chain Letter (NBC, role: Himself). Two teams, each with a celebrity and a contestant, compete against each other, thinking of words that fit in various categories. The first player gives a word pertaining to the category. The next player gives the next word in the same category using the last letter of the previous word as the first letter of their new word. Comedian Jan Murray hosts; with Cesar Romero, Pat Carroll, Wendell Niles. Airdate 07/11/66.

Chain Letter (NBC, role: Himself). Game show hosted by comedian Jan Murray; with Cesar Romero, Pat Carroll, Wendell Niles. Airdate 07/12/66.

Chain Letter (NBC, role: Himself). Game show hosted by comedian Jan Murray; with Cesar Romero, Pat Carroll, Wendell Niles. Airdate 07/13/66.

Chain Letter (NBC, role: Himself). Game show hosted by comedian Jan Murray; with Cesar Romero, Pat Carroll, Wendell Niles. Airdate 07/14/66.

Chronology

Batman: The Movie (20th Century-Fox, role: The Joker). Batman and Robin's four dastardliest foes hold the world hostage with the help of a secret invention that instantly dehydrates people. The sight of Adam West and Cesar Romero surfing is not to be missed. *20th Century-Fox, Batman*, a William Dozier Production starring Adam West, Burt Ward, and the Rogues Gallery of Villains; The Catwoman Lee Meriwether, The Joker Cesar Romero, The Penguin Burgess Meredith, The Riddler Frank Gorshin; with Alan Napier, Neil Hamilton, Stafford Repp, Madge Blake and Reginald Denny as Commodore Schmidlapp, Milton Frome, Gil Perkins, Dick Crockett, George Sawaya; Written by Lorenzo Semple Jr.; Based on the characters created by Bob Kane appearing in Batman and Detective Comics Magazines published by National Periodical Publications, Inc.; Produced by William Dozier; Directed by Leslie H. Martinson; Production dates 04/25/66 to 06/02/66; Release date 07/30/66.

You Don't Say (NBC, role: Himself). In this charades-like game show, two teams of players compete against each other to determine the name of a famous person; with host Tom Kennedy and Cesar Romero, Anita Louise, John Harlan. Airdate 08/08/66.

The Mike Douglas Show (Syndicated, role: Himself). Talk and variety show; with Cesar Romero as cohost with Mike Douglas, Wynona Carr, Bob Crosby, Chris Crosby, Gunilla Knudson, Bob Melvin. Airdate 10/31/66.

The Mike Douglas Show (Syndicated, role: Himself). Talk and variety show; with Cesar Romero as cohost with Mike Douglas, Sebastian Cabot, Don Cherry, Prof. Irwin Corey, Margaret Whiting. Airdate 11/01/66.

The Mike Douglas Show (Syndicated, role: Himself). Talk and variety show; with Cesar Romero as cohost with Mike Douglas, Sammy Davis Jr., David Allyn, The DeJohn Sisters, Ralph Pope. Airdate 11/02/66.

The Mike Douglas Show (Syndicated, role: Himself). Talk and variety show; with Cesar Romero as cohost with Mike Douglas, Polly Bergen, The Pair Extraordinaire. Airdate 11/03/66.

Clown Alley (CBS, role: Clown). Red Skelton's Freddie the Freeloader populates a world of clowns in this extension of the character aired as a television special; with Red Skelton, Vincent Price, Martha Raye, Cesar Romero, Bobby Rydell, Audrey Meadows, The Alan Copeland Singers, Mark Anthony, Billy Barty, Amanda Blake, Jackie Coogan, David Rose and His Orchestra, Johnny Day, Tony Fossett, Art Gilmore, Harold Hall, Alean "Bambi" Hamilton, Bobby Kay, Robert Locke Lorraine, Jack McAfee,

Chronology

Robert Merrill, Bruce Morgan, Ben Moyer, Baby Sabu, Bill Shannon, Tom Hansen Dancers, Randy Whipple. Airdate 11/09/66.

ABC Stage 67 (ABC). A weekly anthology of one-hour plays, both original and literary adaptations. This episode is chock-full of stars and unusual personalities and is written by Earl Hamner, who goes on to create *The Waltons* and, more importantly to Romero, *Falcon Crest*. "The People Trap": Due to a population explosion, couples in the year 2067 must obtain a special permit in order to have a child, and privacy and green space are impossible to come by. With Stuart Whitman, Vera Miles, Cesar Romero, Pearl Bailey, Connie Stevens, Lee Grant, Mercedes McCambridge, Michael Rennie, Mort Sahl, Phil Harris, Estelle Winwood, Jackie Robinson, Lew Ayres, Betty Furness, Morgan Mason, Peter Howard, Biff Elliot, Russ McCubbin, Hagen Smith, Ivan Bonar, Milburn Shelton, Burke Rhind, William Estes, Sally Goldwater. Airdate 11/09/66.

Batman (ABC, role: The Joker). "The Impractical Joker": The Joker steals the Jeweled Key of Kaincardine by employing a mysterious box that seemingly renders Batman and Robin powerless, though they soon learn The Joker's real tool is hypnosis. With guest cast Cesar Romero, Kathy Kersh, Louis Quinn, Larry Anthony, Christopher Cary, Larry Burrell, Howard Duff (window cameo). Airdate 11/16/66.

Batman (ABC, role: The Joker). "The Joker's Provokers": The Joker creates another box, and now it seems he can control time itself. With guest cast Cesar Romero, Kathy Kersh, Louis Quinn, Larry Anthony, Valerie Szabo, Larry Burrell, Minta Durfee. Airdate 11/17/66.

The Mike Douglas Show (Syndicated, role: Himself). Talk and variety show; with Cesar Romero as cohost with Mike Douglas, Abe Burrows, Gilbert Bécaud, Hendra and Ullett, Gary and the Hornets, David Merrick, Elizabeth Montgomery. Airdate 11/18/66.

1967

T.H.E. Cat (NBC, role: Gordon Amley). Robert Loggia is a former circus aerialist and reformed cat burglar who offers his services as a professional bodyguard. "Queen of Diamonds, Knave of Hearts": A married countess hires Loggia to retrieve a necklace she gave to a blackmailing ex-lover, but the blackmailer is now using the necklace as collateral to cover heavy gambling debts; with Robert Loggia, Cesar Romero, Liliane Montevecchi, Robert Carricart, Barbara Stuart. Betty Harford. Airdate 01/06/67.

Batman (ABC, role: The Joker). "The Zodiac Crimes": The Joker, The Penguin, and Venus team up to go on a crime wave based on signs of the zodiac; with guest cast Cesar Romero, Burgess Meredith, Terry Moore, Hal Baylor, Joe Di Reda, Eddie Saenz, Dick Crockett, Charles Picerni, Charles Fredricks, Howard Wendell, Louis Cordova, Vincent Barbi. Airdate 01/11/67.

Batman (ABC, role: The Joker). "The Joker's Hard Times": Batman and Robin narrowly escape The Joker's death trap and quickly get back on the trail of their nemesis while he keeps the Gotham City Police busy with his continued string of zodiac crimes. The Joker chains the Dynamic Duo in a shallow pool with a giant clam that swallows Robin before turning its attention to Batman. With guest cast Cesar Romero, Terry Moore, Hal Baylor, Joe Di Reda, Eddie Saenz, Dick Crockett, Charles Picerni, Charles Fredricks, Howard Wendell, Louis Cordova, Guy Way, Jonathan Kidd, Milton Stark. Airdate 01/12/67.

Batman (ABC, role: The Joker). "The Penguin Declines": Before the clam can get its teeth into Robin, Batman pries open its mouth and frees his sidekick. Meanwhile, the Joker frees Penguin from prison and, for his second to last zodiac crime, Aquarius the water bearer sparks The Joker into turning all of Gotham City's water supply into strawberry jelly and demanding a $10 million ransom. With guest cast Cesar Romero, Burgess Meredith, Terry Moore, Hal Baylor, Joe Di Reda, Eddie Saenz, Dick Crockett, Charles Picerni, Guy Way, Rob Reiner (as a delivery boy). Airdate 01/18/67.

The Dream Girl of 1967 (ABC, role: Himself). Chuck Barris produces this daily all-year-long beauty pageant, featuring women aged eighteen to twenty-seven competing to win the title; with Cesar Romero appearing with "fashion hostess" Mary Ann Mobley, the former Miss America he was able to correctly identify on a 1959 episode of *Take a Good Look*. Dick Stewart hosts with Cesar Romero as a bachelor judge and Karen Valentine, Johnny Jacobs, Leo Durocher, Howard Morris, Mary Ann Mobley. Airdate 01/23/67.

The Dream Girl of 1967 (ABC, role: Himself). Beauty pageant; with Cesar Romero as a bachelor judge and Dick Stewart, Karen Valentine, Johnny Jacobs, Leo Durocher, Howard Morris, Mary Ann Mobley. Airdate 01/24/67.

The Dream Girl of 1967 (ABC, role: Himself). Beauty pageant; with Cesar Romero as a bachelor judge and Dick Stewart, Karen Valentine, Johnny Jacobs, Leo Durocher, Howard Morris, Mary Ann Mobley. Airdate 01/25/67.

Chronology

The Dream Girl of 1967 (ABC, role: Himself). Beauty pageant; with Cesar Romero as a bachelor judge and Dick Stewart, Karen Valentine, Johnny Jacobs, Leo Durocher, Howard Morris, Mary Ann Mobley. Airdate 01/26/67.

The Dream Girl of 1967 (ABC, role: Himself). Beauty pageant; with Cesar Romero as a bachelor judge and Dick Stewart, Karen Valentine, Johnny Jacobs, Leo Durocher, Howard Morris, Mary Ann Mobley. Airdate 01/27/67.

Batman (ABC, role: The Joker). "The Joker's Last Laugh": The Joker replaces a teller at Gotham National Bank with Mr. Glee, one of Joker's lifelike robots, which has been distributing counterfeit money; with guest cast Cesar Romero, Phyllis Douglas, Clint Ritchie, Ed Deemer, Lawrence Montaigne, Breena Howard, J. Edward McKinley. Airdate 02/15/67.

Batman (ABC, role: The Joker). "The Joker's Epitaph": Now vice chairman of the Gotham National Bank, The Joker installs his robots as tellers and threatens to blackmail Bruce Wayne with a secret tape recording of Wayne's phony demand for counterfeit cash; with guest cast Cesar Romero, Phyllis Douglas, Oscar Beregi Jr., Clint Ritchie, Lawrence Montaigne, Ed Deemer, J. Edward McKinley, Breena Howard. Airdate 02/16/67.

The Hollywood Squares (NBC, role: Himself). The ubiquitous tic-tac-toe question and answer celebrity game show where contestants turn to guest stars for answers to general knowledge questions; with a fair amount of mild sexual innuendo and, more often than not, one or two tipsy celebrities; with Peter Marshall, Cesar Romero, Zsa Zsa Gabor, Charley Weaver, Abby Dalton, Wally Cox, Della Reese, Chad Everett, Jan Murray. Airdate 03/06/67.

The Hollywood Squares (NBC, role: Himself). Celebrity game show; with Peter Marshall, Cesar Romero, Zsa Zsa Gabor, Charley Weaver, Abby Dalton, Wally Cox, Della Reese, Chad Everett, Jan Murray. Airdate 03/07/67.

The Hollywood Squares (NBC, role: Himself). Celebrity game show; with Peter Marshall, Cesar Romero, Zsa Zsa Gabor, Charley Weaver, Abby Dalton, Wally Cox, Della Reese, Chad Everett, Jan Murray. Airdate 03/08/67.

The Hollywood Squares (NBC, role: Himself). Celebrity game show; with Peter Marshall, Cesar Romero, Zsa Zsa Gabor, Charley Weaver, Abby Dalton, Wally Cox, Della Reese, Chad Everett, Jan Murray. Airdate 03/09/67.

The Hollywood Squares (NBC, role: Himself). Celebrity game show; with Peter Marshall, Cesar Romero, Zsa Zsa Gabor, Charley Weaver, Abby Dalton, Wally Cox, Della Reese, Chad Everett, Jan Murray. Airdate 03/10/67.

Chronology

The Red Skelton Hour (CBS, role: Mustapha Dame). Comedy-themed variety show hosted by the popular comedian. "The Schnook of Araby": Skelton's popular character Clem Kadiddlehopper appears at the Yugo-Crazian embassy as Arabian dictator Cesar Romero's bodyguard in a sketch on an episode featuring Red Skelton, Cesar Romero, Jan Arvan, Stephen Courtleigh, David Rose and His Orchestra, Everett Dirksen, Art Gilmore, Ray Kellogg, James Lanphier, Beverly Powers, The Serenaders, David Sharpe, Olan Soule, Glen Vernon. Airdate 03/14/67.

Batman (ABC, role: The Joker). "Pop Goes The Joker": The Joker appears at an art gallery spray-painting graffiti all over an exhibit and inexplicably is hailed as a modern art genius; with guest cast Cesar Romero, Reginald Gardiner, Diane Ivarson, Fritz Feld, Jan Aryan, Jerry Catron, Jody Gilbert, Gail Ommerle, Jack Perkins, Clark Ross, Jack Tornek, Duke Fishman as Pablo Pincus, Chester Hayes as Leonardo Da Vinski, Mike Morelli as Jackson Potluck, Woodrow Parfrey as Vincent Van Gauche. Airdate 03/22/67.

Batman (ABC, role: The Joker). "Flop Goes The Joker": The Joker steals a priceless Renaissance art collection and demands a $10 million ransom, or he will burn the whole lot; with guest cast Cesar Romero, Reginald Gardiner, Jody Gilbert, Diane Ivarson, Owen McGiveney, Gail Ommerle, Jerry Catron, Jack Perkins, Milton Stark. Airdate 03/23/67.

Daniel Boone (NBC, role: Colonel Carlos Navarro). Fess Parker as frontier hero Daniel Boone conducts surveys and expeditions in and around Boonesborough, running into both friendly and hostile Indians before, during, and even after the Revolutionary War. "Bitter Mission": Though badly wounded, Parker must stop a disgruntled retired general from causing a war between Kentucky and Virginia to gain Kentucky land from the Spanish, in the person of Cesar Romero; with Fess Parker, Simon Oakland, Cesar Romero, William Tannen, Morgan Jones, Mark Bailey, Richard Morrison, Abel Franco, Robert Fuca, Joe Ferrante, Berry Kroeger. Airdate 03/30/67.

The Hollywood Squares (NBC, role: Himself). Celebrity game show; with Peter Marshall, Cesar Romero, Soupy Sales, Barbara Bain, Cliff Arquette, Barbara Feldon, Wally Cox, Kaye Ballard, Pete Duel, Paul Lynde. Airdate 05/22/67.

The Hollywood Squares (NBC, role: Himself). Celebrity game show; with Peter Marshall, Cesar Romero, Soupy Sales, Barbara Bain, Cliff Arquette, Barbara Feldon, Wally Cox, Kaye Ballard, Pete Duel, Paul Lynde. Airdate 05/23/67.

Chronology

The Hollywood Squares (NBC, role: Himself). Celebrity game show; with Peter Marshall, Cesar Romero, Soupy Sales, Barbara Bain, Cliff Arquette, Barbara Feldon, Wally Cox, Kaye Ballard, Pete Duel, Paul Lynde. Airdate 05/24/67.

The Hollywood Squares (NBC, role: Himself). Celebrity game show; with Peter Marshall, Cesar Romero, Soupy Sales, Barbara Bain, Cliff Arquette, Barbara Feldon, Wally Cox, Kaye Ballard, Pete Duel, Paul Lynde. Airdate 05/25/67.

The Hollywood Squares (NBC, role: Himself). Celebrity game show; with Peter Marshall, Cesar Romero, Soupy Sales, Barbara Bain, Cliff Arquette, Barbara Feldon, Wally Cox, Kaye Ballard, Pete Duel, Paul Lynde. Airdate 05/26/67.

The Merv Griffin Show (Syndicated, role: Himself). Talk and variety show; with Merv Griffin, Cesar Romero, Tony Randall, Dr. Joyce Brothers, Merriman Smith. Airdate 08/10/67.

The Joey Bishop Show (ABC, role: Himself). This late-night talk show hosted by Rat Pack regular Joey Bishop is also known as the launching pad for his sidekick and announcer Regis Philbin, who famously walks off the show one night in 1968 and stays off the air for a week, believing he is being blamed for lower-than-expected ratings. Reportedly, ABC is deluged with fan mail asking for his return and welcomes Philbin back with better treatment. With Cesar Romero, The Association, Marlena Shaw. Airdate 09/13/67.

The Woody Woodbury Show (Syndicated, role: Himself). Comedy album legend Woody Woodbury (who, as of this writing, is still alive and turned 101 in February 2025) hosts this talk and variety show; with Cesar Romero, Woody Woodbury, The Blossoms, Grace Markay. Airdate 09/14/67.

The Dream Girl of 1967 (ABC, role: Himself). Beauty pageant; with Cesar Romero as a bachelor judge and Paul Petersen, Joyce Menges, Johnny Jacobs, Fernando Lamas, Ray Walston, Marguerite Piazza. Airdate 10/02/67.

The Dream Girl of 1967 (ABC, role: Himself). Beauty pageant; with Cesar Romero as a bachelor judge and Paul Petersen, Joyce Menges, Johnny Jacobs, Fernando Lamas, Ray Walston, Marguerite Piazza. Airdate 10/03/67.

The Dream Girl of 1967 (ABC, role: Himself). Beauty pageant; with Cesar Romero as a bachelor judge and Paul Petersen, Joyce Menges, Johnny Jacobs, Fernando Lamas, Ray Walston, Marguerite Piazza. Airdate 10/04/67.

The Dream Girl of 1967 (ABC, role: Himself). Beauty pageant; with Cesar Romero as a bachelor judge and Paul Petersen, Joyce Menges, Johnny Jacobs, Fernando Lamas, Ray Walston, Marguerite Piazza. Airdate 10/05/67.

The Dream Girl of 1967 (ABC, role: Himself). Beauty pageant; with Cesar Romero as a bachelor judge and Paul Petersen, Joyce Menges, Johnny Jacobs, Fernando Lamas, Ray Walston, Marguerite Piazza. Airdate 10/06/67.

Batman (ABC, role: The Joker). "How to Hatch a Dinosaur": The Joker appears in the episode's final bumper; with guest cast Vincent Price, Anne Baxter, Jon Lormer, Mary Benoit, William Corcoran, Violet Carlson, Pat Becker, Ron Burke, Pete Kellett, Ronnie Knox, Hans Moebus, Skip Ward, and in a bumper as the next episode's Special Guest Villain, Cesar Romero. Airdate 11/09/67.

Batman (ABC, role: The Joker). "Surf's Up! Joker's Under!": To win over Gotham City's gullible public, The Joker plans to become a cool dude and a surfing champion by using a clever machine to drain all of the surfing knowledge from current champion Skip Parker; with guest cast Cesar Romero, Skip Ward, Sivi Aberg, Ron Burke, Ronnie Knox, John Mitchum, Johnnie Green & His Green Men—Johnnie Green, Marilyn Campbell, Richard Person, Robert Van Holten, John Trombatore, and in a bumper as the next episode's Special Guest Villains, Glynis Johns, Rudy Vallee, Joyce Lederer. Airdate 11/16/67.

The Joey Bishop Show (ABC, role: Himself). Talk and variety show; with Joey Bishop, Regis Philbin, Cesar Romero, Anna Maria Alberghetti, The Righteous Brothers, Jackie Vernon. Airdate 12/06/67.

Batman (ABC, role: The Joker). "The Ogg Couple": The Joker appears in the episode's final bumper; with guest cast Vincent Price, Anne Baxter, Donald Elson, Ed Long, William Corcoran, Violet Carlson, Robert Buckingham, Pete Kellett, Jeff Lawrence, Gene LeBell, Hans Moebus, Mark Russell, and in a bumper as the next episode's Special Guest Villains, Cesar Romero, Eartha Kitt. Airdate 12/21/67.

Batman (ABC, role: The Joker). "The Funny Feline Felonies": The Joker, just released from prison, teams up with new Catwoman Eartha Kitt for a double helping of camp, conspiring to find a hidden cache of a million pounds of gunpowder; with guest cast Cesar Romero, Eartha Kitt, Dick Kallman, David Lewis, Sandy McPeak, Bobby Hall, Ronald Long, Howard Curtis, Joe E. Ross, Orangey the Cat. Airdate 12/28/67.

Chronology

1968

Batman (ABC, role: The Joker). "The Joke's on Catwoman": The Caped Crusaders manage to spoil The Joker and Catwoman's plot and haul the villains before a judge, but disorder in the court prevails when the jury finds the villains not guilty; with guest cast Cesar Romero, Eartha Kitt, Dick Kallman, Sandy McPeak, Bobby Hall, Rusty Lane, Christine Nelson, Louis Quinn, Russell Ash, Al Bain, Donald Chaffin, Howard Curtis, Bill Dyer, Sig Frohlich, Joseph Glick, Johnny Kern, Gil Perkins, Charlotte Portney, Joe E. Ross, Pierre Salinger, Sammy Shack, Orangey the Cat, and in a bumper as the next episode's Special Guest Villain, Milton Berle as Louie, The Lilac. Airdate 01/04/68.

The Hollywood Squares (NBC, role: Himself). Celebrity game show; with Peter Marshall, Cesar Romero, Felicia Farr, Cliff Arquette, Abby Dalton, Wally Cox, Zsa Zsa Gabor, Jackie Vernon, Bill Bixby, Jan Murray. Airdate 01/08/68.

The Hollywood Squares (NBC, role: Himself). Celebrity game show; with Peter Marshall, Cesar Romero, Felicia Farr, Cliff Arquette, Abby Dalton, Wally Cox, Zsa Zsa Gabor, Jackie Vernon, Bill Bixby, Jan Murray. Airdate 01/09/68.

The Hollywood Squares (NBC, role: Himself). Celebrity game show; with Peter Marshall, Cesar Romero, Felicia Farr, Cliff Arquette, Abby Dalton, Wally Cox, Zsa Zsa Gabor, Jackie Vernon, Bill Bixby, Jan Murray. Airdate 01/10/68.

The Hollywood Squares (NBC, role: Himself). Celebrity game show; with Peter Marshall, Cesar Romero, Felicia Farr, Cliff Arquette, Abby Dalton, Wally Cox, Zsa Zsa Gabor, Jackie Vernon, Bill Bixby, Jan Murray. Airdate 01/11/68.

The Hollywood Squares (NBC, role: Himself). Celebrity game show; with Peter Marshall, Cesar Romero, Felicia Farr, Cliff Arquette, Abby Dalton, Wally Cox, Zsa Zsa Gabor, Jackie Vernon, Bill Bixby, Jan Murray. Airdate 01/12/68.

Pat Boone in Hollywood (Syndicated, role: Himself). Music and variety show; with Cesar Romero, Pat Boone, Don Rickles, Frank Sinatra Jr., Judy Carne. Airdate 02/20/68.

Batman (ABC, role: The Joker). "I'll Be a Mummy's Uncle": The Joker appears in the episode's final bumper; with guest cast Victor Buono, Jock Mahoney, Victoria Vetri, Tony Epper, Joe E. Tata, Kathleen Freeman, Tony

Chronology

Gardner, Chuck Hicks, Shep Houghton, Henny Youngman, and in a bumper as the next episode's Special Guest Villains, Cesar Romero, Corinne Calvet, Richard Bakalyan, Jeff Burton. Airdate 02/22/68.

Batman (ABC, role: The Joker). "The Joker's Flying Saucer": With world domination on his mind, The Joker plants rumors of an impending invasion from outer space, warning of little green men from Mars: "Holy known unknown flying objects!" This is Cesar Romero's final performance as The Joker and the second to last episode of the entire series; with guest cast Cesar Romero, Corinne Calvet, Richard Bakalyan, Jeff Burton, Tony Gardner, Byron Keith, Fritz Feld, Ellen Corby, and in a bumper as the next episode's Special Guest Villains, Howard Duff, Ida Lupino. Airdate 02/29/68.

The Joey Bishop Show (ABC, role: Himself). Talk and variety show; with Joey Bishop, Regis Philbin, Cesar Romero, Pete Barbutti, Martha Raye, Adam Wade. Airdate 03/20/68.

Get Smart (CBS, role: Kinsey Krispen). Multiple Emmy-winning star Don Adams is Maxwell Smart, a brilliant but bumbling spy working for the CONTROL agency. He and the glamorous, always insouciantly slouching Barbara Feldon as Agent 99 battle the evil forces of rival spy agency KAOS. (Neither agency name is an acronym; they don't stand for anything.) "The Reluctant Redhead": In a typically convoluted plotline, CONTROL agents must get their hands on a list of KAOS informers that is in the possession of Cesar Romero (as the alliterative Kinsey Krispen), who won't give up the list unless CONTROL finds his missing wife, who looks exactly like a children's author—but does she really? With Don Adams, Barbara Feldon, Cesar Romero, Edward Platt, Julie Sommars, Alan Baxter, Noam Pitlik. Airdate 04/06/68.

The Joey Bishop Show (ABC, role: Himself). Talk and variety show; with Joey Bishop, Regis Philbin, Cesar Romero, The Chad Mitchell Trio, Norm Crosby. Airdate 04/30/68.

Madigan's Millions (Group W, role: Mike Madigan). Dustin Hoffman is an accident-prone US Treasury agent in Rome, searching for the $1 million owed to the government by the deported gangster Cesar Romero. Romero is only in the first six and a half minutes of the film, but he gets star billing and makes a big impact. The emotional resonance from his opening scenes carries us through the film, layering the caper with meaning. The *Millions* in the title variously appears on different prints and promotional material in both plural and singular form. The main title of the available print has

it as *Madigan's Million*. A Group W Films Presentation, *Madigan's Million* with Cesar Romero as Madigan and introducing Dustin Hoffman as Jason Fister; starring Elsa Martinelli; with Gustavo Rojo as Lt. Arco, Fernando Hilbeck as Burke, Franco Fabrizi as Condon, Riccardo Garrone as Cirini; Original Screenplay by James Henaghan; Executive Producers Mitchell Grayson, José López Moreno; Directed by Giorgio Gentili (credited as Stanley Prager); Release date 05/30/68.

The Hollywood Squares (NBC, role: Himself). Celebrity game show; with Peter Marshall, Cesar Romero, Ruta Lee, Cliff Arquette, Kaye Ballard, Wally Cox, Rose Marie, Jan Murray, Robert Conrad, Paul Lynde. Airdate 06/10/68.

The Hollywood Squares (NBC, role: Himself). Celebrity game show; with Peter Marshall, Cesar Romero, Ruta Lee, Cliff Arquette, Kaye Ballard, Wally Cox, Rose Marie, Jan Murray, Robert Conrad, Paul Lynde. Airdate 06/11/68.

The Hollywood Squares (NBC, role: Himself). Celebrity game show; with Peter Marshall, Cesar Romero, Ruta Lee, Cliff Arquette, Kaye Ballard, Wally Cox, Rose Marie, Jan Murray, Robert Conrad, Paul Lynde. Airdate 06/12/68.

The Hollywood Squares (NBC, role: Himself). Celebrity game show; with Peter Marshall, Cesar Romero, Ruta Lee, Cliff Arquette, Kaye Ballard, Wally Cox, Rose Marie, Jan Murray, Robert Conrad, Paul Lynde. Airdate 06/13/68.

The Hollywood Squares (NBC, role: Himself). Celebrity game show; with Peter Marshall, Cesar Romero, Ruta Lee, Cliff Arquette, Kaye Ballard, Wally Cox, Rose Marie, Jan Murray, Robert Conrad, Paul Lynde. Airdate 06/14/68.

The Woody Woodbury Show (Syndicated, role: Himself). Talk show; with Woody Woodbury, with Cesar Romero, The Irish Rovers, Leonard Nimoy. Airdate 06/18/68.

Hot Millions (MGM, role: Customs Inspector). Just out of prison, Cockney con artist Peter Ustinov wangles himself a job as an insurance company computer programmer so he can create an embezzlement scheme, collecting cash all over Europe. Meanwhile, he falls in love with inept secretary and frustrated flutist Maggie Smith, who has more than a few tricks up her sleeve as well. When Ustinov and Smith skip the country with over $1 million, there are several sequences at the airport in Rio de Janeiro with Cesar Romero as a droll Brazilian customs inspector who

has seen it all. The writing is quirky in all the right ways, and the script gets nominated for an Oscar and a Writers Guild Award. Ustinov and Smith are brilliant together. *Metro-Goldwyn-Mayer presents* a Mildred Freed Alberg Production, Peter Ustinov, Maggie Smith, Karl Malden, Bob Newhart in *Hot Millions*; Guest Stars Robert Morley, Cesar Romero; Screenplay by Ira Wallach and Peter Ustinov; Produced by Mildred Freed Alberg; Directed by Eric Till; Production start date 01/08/68; Release date 09/19/68.

Skidoo (Paramount, role: Hechy). Mob boss Cesar Romero forces Jackie Gleason into pulling one last caper, but things go awry because of Carol Channing, flower children, and psychedelic drugs. It is an unmitigated disaster. *Otto Preminger presents Skidoo* starring Jackie Gleason, Carol Channing, Frankie Avalon, Fred Clark, Michael Constantine, Frank Gorshin, John Phillip Law, Peter Lawford, Burgess Meredith, George Raft, Cesar Romero, Mickey Rooney, Groucho Marx; Written by Doran William Cannon; Produced and Directed by Otto Preminger; Production dates 03/18/68 to 05/17/68; Release date 12/19/68.

1969

A Talent for Loving (Paramount, role: Don Jose). Cesar Romero is a fabulously wealthy Mexican rancher with a nymphomaniacal daughter and a centuries-old curse. *Paramount, A Talent for Loving*, A Walter Shenson Production starring Richard Widmark, Topol, Geneviève Page, Cesar Romero; costarring Fran Jeffries, Derek Nimmo; From the novel *A Talent for Loving* by Richard Condon; Screenplay by Jack Rose; Produced by Walter Shenson; Directed by Richard Quine; Release date 01/01/69.

Here's Lucy (CBS, role: Tony Rivera). Lucille Ball is a widow with two teen children (played by her real-life kids) who takes a job as a secretary for her stuffy brother-in-law—who else? Gale Gordon. Working at his employment agency gives her ample opportunity to interact with a parade of celebrity guest stars. "A Date for Lucy": New love interest, debonair Cesar Romero, is actually a jewel thief, and comic chaos ensues at a fancy gala; with Lucille Ball, Gale Gordon, Lucie Arnaz, Desi Arnaz Jr., Cesar Romero, Mary Jane Croft, Barbara Morrison, Dick Winslow. Airdate 02/10/69.

The John Gary Show (Syndicated, role: Himself). Variety. Singer John Gary is the star and the host for a mix of music and comedy; with Cesar Romero, Joanie Sommers, Bobby Vee, The Nitty Gritty Dirt Band. Airdate 03/02/69.

Chronology

Sophie's Place, aka *Crooks and Coronets* (WB, role: Nick Marco). Telly Savalas and Warren Oates are two American crooks seeking to steal priceless artwork from Dame Edith Evans, at the direction of Cesar Romero, the CEO of Exploitation USA, a mob syndicate. *WB, a Kinney National Company presents* a Herman Cohen Production, *Crooks and Coronets* starring Telly Savalas, Edith Evans, Warren Oates; costarring Cesar Romero, Harry H. Corbett, Nicky Henson; featuring Hattie Jacques, Vickery Turner, Arthur Mullard, Frank Thornton, Thorley Walters, Jeremy Young, Leslie Dwyer, Will Leighton, Clive Dunn, David Bauer, Ivor Dean, David Lodge, Joan Crane; Produced by Herman Cohen; Written and Directed by Jim O'Connolly; Production start date 09/09/68; Release date 04/02/69.

The Hollywood Squares (NBC, role: Himself). Celebrity game show; with Peter Marshall, Cesar Romero, Gypsy Rose Lee, Cliff Arquette, Abby Dalton, Wally Cox, Sally Ann Howes, Allan Sherman, June Lockhart, Paul Lynde. Airdate 04/28/69.

The Hollywood Squares (NBC, role: Himself). Celebrity game show; with Peter Marshall, Cesar Romero, Gypsy Rose Lee, Cliff Arquette, Abby Dalton, Wally Cox, Sally Ann Howes, Allan Sherman, June Lockhart, Paul Lynde. Airdate 04/29/69.

The Hollywood Squares (NBC, role: Himself). Celebrity game show; with Peter Marshall, Cesar Romero, Gypsy Rose Lee, Cliff Arquette, Abby Dalton, Wally Cox, Sally Ann Howes, Allan Sherman, June Lockhart, Paul Lynde. Airdate 04/30/69.

The Hollywood Squares (NBC, role: Himself). Celebrity game show; with Peter Marshall, Cesar Romero, Gypsy Rose Lee, Cliff Arquette, Abby Dalton, Wally Cox, Sally Ann Howes, Allan Sherman, June Lockhart, Paul Lynde. Airdate 05/01/69.

The Hollywood Squares (NBC, role: Himself). Celebrity game show; with Peter Marshall, Cesar Romero, Gypsy Rose Lee, Cliff Arquette, Abby Dalton, Wally Cox, Sally Ann Howes, Allan Sherman, June Lockhart, Paul Lynde. Airdate 05/02/69.

Midas Run (ABC Pictures International, role: Carlo Dodero). Out of irritation over not getting a knighthood, Fred Astaire, a veteran British secret service officer, hijacks a government shipment of $15 million worth of gold ingots being flown from Zurich to Tanzania via Italy. Cesar Romero is a cruel, wealthy Italian with his own nefarious plans. The film suffers from negative comparisons to another far more successful gold ingot caper, *The*

Chronology

Italian Job. Selmer Pictures presents a Raymond Stross Production in association with Motion Pictures International, Inc.; starring Richard Crenna, Anne Heywood, Fred Astaire as Pedley; *Midas Run* costarring Ralph Richardson; Guest Stars Cesar Romero, Adolfo Celi; with Maurice Denham, John Le Mesurier, Jacques Sernas, Karl-Otto Alberty, George Hartmann, Carolyn De Fonseca, Aldo Bufi Landi, Fred Astaire Jr. (credited as Frederic Astaire); Stanley Baugh, Bruce Beeby, Robert Henderson and Roddy McDowall; Screenplay by James D. Buchanan & Ronald Austin and Berne Giler; Story by Berne Giler; Produced by Raymond Stross; Directed by Alf Kjellin; Production start date 05/07/68; Release date 05/07/69.

Target: Harry (ABC Pictures International, role: Lieutenant George Duvall). A starry cast double-crosses one another with gleeful abandon in Monaco, Turkey, and Greece as they try to take possession of stolen currency plates. Vic Morrow is the tough guy air/sea pilot unwillingly at the center of the action. He falls hard for a luminous Suzanne Pleshette, who elegantly plays both ends against the middle. Cesar Romero is a police lieutenant dogging Morrow with a nonchalant grace that harkens back to Claude Rains in *Casablanca*. Originally intended as a series pilot, it is deemed too violent for television, and although it is released theatrically in 1969 in selected markets (Dallas and Miami), it subsequently sits on the shelf for nine years before its domestic theatrical premiere on 05/18/79 and its international release starting in 1979 and running through 1980. Roger Corman directs but uses the pseudonym Henry Neill for unknown reasons. This is the second credited film job for legendary writer and production designer Polly Platt, working as the costume designer. *The Corman Company presents* Vic Morrow, Suzanne Pleshette, Victor Buono, Cesar Romero, Stanley Holloway in *Target: Harry*; costarring Charlotte Rampling, Michael Ansara, Christian Barbier, Milton Reid, Ahna Capri, Laurie Main, Victoria Hale, Jacques Léonard, Kemal Alinoren, Sait Nasifoglu; Introducing Kathy Fraisse, and Fikret Hakan as Inspector Devrim; Produced by Gene Corman; Written by Bob Barbash; Directed by Roger Corman (as Henry Neill); Production start date 09/25/67; Release date 05/23/69.

Della (Syndicated, role: Himself). The first national talk show hosted by an African American, the show enjoys high ratings but engenders a great deal of racist negative feedback about Ms. Reese's nonpink gums. Seriously. There are actual boardroom discussions about the color of African American gums being somehow distressing to Anglo viewers. With Della Reese, Cesar Romero, Gloria Loring, Skiles and Henderson. Airdate 07/04/69.

Chronology

The Hollywood Squares (NBC, role: Himself). Celebrity game show; with Peter Marshall, Cesar Romero, Gail Fisher, Cliff Arquette, Charley Weaver, Betty Grable, Wally Cox, Sally Ann Howes, Harvey Korman, Sandy Baron, Paul Lynde. Airdate 09/08/69.

The Hollywood Squares (NBC, role: Himself). Celebrity game show; with Peter Marshall, Cesar Romero, Gail Fisher, Cliff Arquette, Charley Weaver, Betty Grable, Wally Cox, Sally Ann Howes, Harvey Korman, Sandy Baron, Paul Lynde. Airdate 09/09/69.

The Hollywood Squares (NBC, role: Himself). Celebrity game show; with Peter Marshall, Cesar Romero, Gail Fisher, Cliff Arquette, Charley Weaver, Betty Grable, Wally Cox, Sally Ann Howes, Harvey Korman, Sandy Baron, Paul Lynde. Airdate 09/10/69.

The Hollywood Squares (NBC, role: Himself). Celebrity game show; with Peter Marshall, Cesar Romero, Gail Fisher, Cliff Arquette, Charley Weaver, Betty Grable, Wally Cox, Sally Ann Howes, Harvey Korman, Sandy Baron, Paul Lynde. Airdate 09/11/69.

The Hollywood Squares (NBC, role: Himself). Celebrity game show; with Peter Marshall, Cesar Romero, Gail Fisher, Cliff Arquette, Charley Weaver, Betty Grable, Wally Cox, Sally Ann Howes, Harvey Korman, Sandy Baron, Paul Lynde. Airdate 09/12/69.

The Merv Griffin Show (Syndicated, role: Himself). Talk and variety show; with Merv Griffin, Cesar Romero, Jack Benny, Zsa Zsa Gabor, Chill Wills, Lainie Kazan, Marty Allen. Airdate 11/05/69.

Daniel Boone (NBC, role: Admiral Alejandro Buenaventura). "The Grand Alliance": Two Spanish officers, including Cesar Romero, are on opposite sides over a plot to invade the United States, with Parker and Dean infiltrating their fort and putting a stop to it. With Fess Parker, Jimmy Dean, Cesar Romero, Patricia Blair, Darby Hinton, Roosevelt Grier, Armando Silvestre, Carlos Rivas, Joel Fluellen, Hugo Dargo, Abel Fernandez, Tom Hernández. Airdate 11/13/69.

The Computer Wore Tennis Shoes (Walt Disney, role: A. J. Arno). Kurt Russell and his classmates at Medfield College persuade big businessman and town university donor Cesar Romero to donate a computer to their school. When the computer breaks down and Russell tries to fix it, he gets an electric shock, and his brain turns into a computer. Now he remembers everything he reads—which makes Medfield a cinch to win the university quiz challenge and the badly needed prize money for the school. But he also remembers other information in the computer's memory: evidence of

Romero's illegal business activities. Comic mayhem ensues. *Walt Disney Productions presents The Computer Wore Tennis Shoes* starring Kurt Russell (Dexter), Cesar Romero (A. J. Arno), Joe Flynn (Dean Higgins); costarring William Schallert (Professor Quigley), Alan Hewitt (Dean Collingsgood), Richard Bakalyan (Chillie Walsh); with Debbie Paine (Annie), Frank Webb (Pete), Michael McGreevey (Schuyler), Jon Provost (Bradley), Frank Welker (Henry), Alexander Clarke (Myles); Featuring Bing Russell (Angelo), Pat Harrington Jr. (Moderator), Fabian Dean (Little Mac), Fritz Feld (Sigmund Van Dyke), Pete Renaday (as Pete Renoudet, Lt. Hannah), Hillyard Anderson (J. Reedy); Written by Joseph L. McEveety; Produced by Bill Anderson; Directed by Robert Butler; Release date 12/24/69.

1970

Life with Linkletter (ABC, role: Himself). Talk and variety show; with Art Linkletter, Jack Linkletter, Cesar Romero, Helen Colton, Dan Cortum. Airdate 02/09/70.

The Merv Griffin Show (Syndicated, role: Himself). Talk and variety show; with Merv Griffin, Cesar Romero, Fats Domino, Jackie Vernon, Teresa Graves, Jack E. Leonard, Leonard Barr. Airdate 02/27/70.

The Movie Game (Syndicated, role: Himself). Game show; with Cesar Romero, Sonny Fox, June Allyson, Pat Crowley, Bob Hope. Airdate 03/09/70.

It Takes a Thief (ABC, role: Mike). The adventures of suave former cat burglar Robert Wagner using his criminal skills on behalf of the American government. In this episode, Cesar Romero appears with *Latitude Zero* and future *The Timber Tramps* costar Joseph Cotten. "Beyond a Treasonable Doubt": With a shoot-to-kill order on his head after a false accusation of treason, Wagner must find out who is framing him and why; with Robert Wagner, Joseph Cotten, Cesar Romero, Ahna Capri, George Murdock, Whit Bissell, Walter Burke, Alan Baxter, James McCallion, Read Morgan, Jan Arvan. Airdate 03/16/70.

The Red Skelton Hour (CBS, role: Inmate). Variety. "Stone Walls Do Not a Prison Make, So They Added Iron Bars": Two inmates revolt against lousy prison food, and Ron Howard's little brother Clint Howard sells them spiked lemonade, in an episode featuring Red Skelton, Cesar Romero, Jan Arvan, Patrick Campbell, Henry Corden, David Rose and His Orchestra, Art Gilmore, Edward J. Heim, Clint Howard, The Jimmy Joyce Singers, Ray

Chronology

Kellogg, Brad Logan, Ida Mae McKenzie, Brenda Thomson, Tom Hansen Dancers. Airdate 04/07/70.

Julia (NBC, role: Bunny Henderson). Diahann Carroll is a young widow and single mother working as a nurse in this gentle sitcom that has a huge impact on the African American community, particularly little girls who can imagine emulating Carroll. At the end of the second season and beginning of the third, Cesar Romero has a four-episode romantic arc with one of Carroll's colleagues. "Bunny Hug": Romero is Lurene Tuttle's latest love interest; with Diahann Carroll, Lloyd Nolan, Cesar Romero, Lurene Tuttle, Marc Copage, Michael Link, Richard Steele, Kevin McCarley, Milton Stark. Airdate 04/28/70.

Latitude Zero (Toho Company, role: Dr. Malic/Lieutenant Hastings). Cesar Romero is a Ming the Merciless kind of mad scientist with a penchant for brain transplants and creating monsters. He is pitted against three-hundred-year-old Joseph Cotten in a gold jumpsuit, who lives in an underwater Shangri-la. *Toho Company, Ltd. presents* Joseph Cotten, Cesar Romero in *Latitude Zero*, a Tohi Production costarring Akira Takarada as Dr. Ken Tashiro, Masumi Okada as Dr. Jules Masson, Richard Jaeckel; also Patricia Medina with Mari Nakayama as Tsuruko, Akihiko Hirata, Tetsu Nakamura, Wataru Ômae (credited as Kin Ohmae), and introducing Linda Haynes as Dr. Anne Barton; Story and Screenplay by Ted Sherdeman based on his stories of Latitude Zero; Produced by Tomoyuki Tanaka; Director of Special Effects Eiji Tsuburaya; Directed by Ishirô Honda; Production dates early November 1968 to February 1969; Release date 05/06/70.

The Mike Douglas Show (Syndicated, role: Himself). Talk and variety show; with Mike Douglas, Cesar Romero, Vicki Anderson, James Brown, The J.B.s, Clay Tyson, Gwen Verdon. Airdate 05/07/70.

The Mike Douglas Show (Syndicated, role: Himself). Talk and variety show; with Mike Douglas, Cesar Romero, Louis and Lucille Armstrong, The First Edition, Kenny Rogers, Earl Wilson. Airdate 05/26/70.

The Merv Griffin Show (Syndicated, role: Himself). Talk and variety show; with Merv Griffin, Cesar Romero, Ursula Andress, Joan Blondell, Sonny King, Nancy Wilson. Airdate 06/26/70.

The Real Tom Kennedy Show (Syndicated, role: Himself). Talk and variety show hosted by Tom Kennedy, with Cesar Romero, Foster Brooks, Kelly Garrett, Meredith MacRae. Airdate 09/10/70.

Chronology

Julia (NBC, role: Bunny Henderson). "Half Past Sick": Diahann Carroll has a cold, and friends try to help; with Diahann Carroll, Lloyd Nolan, Cesar Romero, Lurene Tuttle, Betty Beaird, Marc Copage, Michael Link, Fred Williamson, Hank Brandt, Janear Hines, Stephanie James. Airdate 09/22/70.

Bewitched (ABC, role: Ernest Hitchcock). Elizabeth Montgomery is Samantha (Sam) Stephens, everybody's favorite witch, and Agnes Moorehead inspires drag queens for generations as her tempestuous drama queen mother Endora, who is aghast at having a mortal son-in-law. "Salem, Here We Come": When Jane Connell as high priestess of witches and warlocks casts a condemning eye on her mixed marriage to a mortal, Montgomery makes hubby Dick Sargent's ad agency client Cesar Romero fall madly in love with the high priestess so she can see mortals from an earthier perspective; with Elizabeth Montgomery, Dick Sargent, Agnes Moorehead, David White, Jane Connell, Cesar Romero, Erin Murphy, Ray Young. Airdate 10/01/70.

Julia (NBC, role: Bunny Henderson). "Altar Ego": Lurene Tuttle gets married in Vegas—is Cesar Romero the groom? With Diahann Carroll, Lloyd Nolan, Cesar Romero, Lurene Tuttle, Betty Beaird, Marc Copage, Michael Link, Mary Wickes, Henry Hunter. Airdate 10/06/70.

Julia (NBC, role: Bunny Henderson). "Bowled Over": Carroll takes up bowling to impress Fred Williamson; with Diahann Carroll, Lloyd Nolan, Cesar Romero, Lurene Tuttle, Betty Beaird, Marc Copage, Michael Link, Fred Williamson, Richard Steele, Bob Braun. Airdate 11/10/70.

The Merv Griffin Show (Syndicated, role: Himself). Talk and variety show; with Merv Griffin, Cesar Romero, Jack Valenti, Dennis Hopper, Jean Nidetch. Airdate 12/08/70.

The Red, White and Black, aka *Soul Soldier*, aka *Buffalo Soldier*, aka *The Black Cavalry* (Hirschman/Northern, role: Colonel Grierson). Cesar Romero is the White garrison commander of an all–African American troop of soldiers at Fort Davis, Texas, in 1871. Renegade Caucasian soldiers (the White) steal from the Indians (the Red), resulting in a death that provokes the Indians to attack, which leads to the African Americans (the Black) attacking the Indians. The futility of Black on Red violence at the behest of their White oppressors is the ironic point of it all. Sex and violence abound in the romantic subplot. Production and distribution details are murky. After this project, Isabel Sanford soon lands the role that will define her career, Louise Jefferson on *All in the Family* (1971–1975) and its

spin-off, *The Jeffersons* (1975–1985). *The Red, White and Black* with Robert DoQui, Janee Michelle, Lincoln Kilpatrick, Isaac Fields, Rafer Johnson, Cesar Romero, Barbara Hale, Isabel Sanford, Steve Drexel, Russ Nannarello Jr.; Directed by John Cardos; Produced by Stuart Z. Hirschman, James M. Northern; Screenplay by Marlene Weed; Production start date 02/23/70; reshoot start date 05/11/70; Release date 12/16/70.

1971

Alias Smith and Jones (ABC, role: Armendariz). Ben Murphy and Pete Duel are an amiable outlaw duo who are the most-wanted miscreants in the history of the West and so use aliases. Cesar Romero makes three guest appearances as a Mexican rancher feuding with Burl Ives, the owner of a ranch on the opposite side of the border, over a valuable bust of Julius Caesar. "The McCreedy Bust": Burl Ives hires the duo to procure a valuable bust of Caesar, but his nemesis Cesar Romero stands in his way; with Ben Murphy, Pete Duel, Burl Ives, Cesar Romero, Edward Andrews, Mills Watson, Duane Grey, Charles Wagenheim, Orville Sherman, Micil Murphy, Rudy Diaz. Airdate 01/21/71.

Nanny and the Professor (ABC, role: Schiavoni). Juliet Mills is an English nanny with gentle extrasensory skills she employs on behalf of the Everett family, a widowed professor and his three children (including future *Real Housewives of Beverly Hills* trainwreck of a star Kim Richards). "The Man Who Came to Pasta": Cesar Romero is a famous Italian director and former coworker of the professor who chooses dinner with the Everett family instead of attending a university presentation; with Juliet Mills, Richard Long, Cesar Romero, David Doremus, Trent Lehman, Kim Richards, Shepherd Sanders, Alfred Dennis, Robert Jayson Kramer, Kitty Carl, Patsy Garrett, Jeff Burton, Joe Zboran, Eileen Baral. Airdate 01/29/71.

The Merv Griffin Show (Syndicated, role: Himself). Talk and variety show; with Merv Griffin, Cesar Romero, Burt Reynolds, Peter Lawford, Hugh O'Brian. Airdate 02/11/71.

Love, American Style (ABC). Future superstar showrunner and director Garry Marshall is a frequent writer on this anthology comedy series featuring a lineup of different celebrity guest stars appearing in anywhere from one to four short stories or vignettes within an hour about versions of love and romance; with a catchy Emmy-winning theme song sung by the Cowsills, the inspiration for *The Partridge Family* ("Love, American Style, truer than the red, white, and blue... Love, American Style, it's me and you...").

"Love and the Duel": A weird weapon is the focus of a duel between a Latin lover and his press agent over glamorous *Gilligan Island* star Tina Louise; with Cesar Romero, Tina Louise, Bob Hastings, George Lindsey, Jay Novello. Airdate 03/05/71.

Celebrity Bowling (Syndicated, role: Himself). Competition sports show hosted by Jed Allan with Cesar Romero and Sid Caesar versus Hugh O'Brian and Gary Owens. Airdate 04/03/71.

Once Upon a Wheel (ABC, role: Himself). A one-off special on the history of auto racing; with Paul Newman, Mario Andretti, Stephen Boyd, Wilt Chamberlain, Chuck Connors, Kirk Douglas, Hugh Downs, Glenn Ford, James Garner, Pancho González, Art Johnson, Dean Paul Martin, Cesar Romero, Dick Smothers, Al Unser. Airdate 04/18/71.

Celebrity Bowling (Syndicated, role: Himself). Competition sports show hosted by Jed Allan with Cesar Romero and Elizabeth Allen versus Larry and Norma Storch. Airdate 04/24/71.

It's Your Bet (Syndicated, role: Himself). A game show featuring two celebrity couples (married, engaged, or dating) who face each other to answer questions asked by host Tom Kennedy. Though certainly not dating in real life, Cesar Romero and Ruta Lee are the couple competing against married couple Buddy Greco and Dani Crayne. Somehow, Cesare Danova also gets involved. Airdate 06/21/71.

The Virginia Graham Show (Syndicated, role: Himself). Daytime talk show; with Virginia Graham, Army Archerd, Maurice Jarre, Mervyn LeRoy, Cesar Romero, Jane Russell. Airdate 06/24/71.

Celebrity Bowling (Syndicated, role: Himself). Competition sports show hosted by Jed Allan with Cesar Romero and Gary Owens versus Sid Caesar and Ernest Borgnine. Airdate 07/24/71.

Don't Push, I'll Charge When I'm Ready (NBC, role: Teodoro Bruzizi). An Italian POW is accidentally drafted into the American army in World War II in this television movie; with Sue Lyon, Enzo Cerusico, Dwayne Hickman, Cesar Romero, Edward Andrews, Soupy Sales, Jerry Colonna, Gino Conforti, Mikel Angel, Parley Baer, Victoria Paige Meyerink, Kenneth Tobey, Avery Schreiber, Byron Morrow, Dick Simmons, Robert Ball, Lee Delano, Lev Mailer. Airdate 10/10/71.

The Jimmy Stewart Show (NBC, role: Harris Crofton). Jimmy Stewart makes his widely heralded television series debut in this sitcom about the frequently chaotic life of a small-town college professor. It is the first time the two stars work together. "A Hunch in Time": Stewart is excited by

Chronology

the prospect of getting involved with a land deal and tries to make a good impression on developer Cesar Romero; with James Stewart, Julie Adams, Cesar Romero, Jonathan Daly, Ellen Geer, Dennis Larson, Kirby Furlong, John McGiver, Michael Audley, Hal Williams, Jane Aull. Airdate 10/24/71.

The Grand Opening of Walt Disney World (NBC, role: Himself). Romero appears with a raft of other Disney stars, including Julie Andrews. Airdate 10/29/71.

Night Gallery (NBC, role: Count Dracula). In this variation on his iconic series *The Twilight Zone*, Rod Serling presents tales of horror and suspense illustrated in various paintings. "A Matter of Semantics": Cesar Romero as Count Dracula visits a blood bank and makes a very weird request; with Cesar Romero, E. J. Peaker, Monie Ellis, host Rod Serling. Airdate 11/10/71.

The Merv Griffin Show (Syndicated, role: Himself). Talk and variety show; with Merv Griffin, Cesar Romero, Arthur and Kathryn Murray. Airdate 11/16/71.

Mooch, aka *Mooch Goes to Hollywood* (Jim Backus/Richard Erdman, role: Himself). In between playing the dog on *Petticoat Junction* (with crossover appearances on *The Beverly Hillbillies* and *Green Acres*) and starring in *Benji* on the big screen, male canine star Higgins stars as a female pooch named Mooch who dreams of being an actress, complete with giant false eyelashes. Zsa Zsa Gabor narrates as she heads for Hollywood, where she meets a parade of celebrities and fantasizes about what her life could be like with temporary owners. Cesar Romero appears as himself at a star-studded party where he speaks to Mooch in Spanish. It first airs in 1971 in syndication, then is released on VHS in 1993 and DVD in 2004; incredibly, it gets its theatrical feature film premiere in 2019 at Beyond Fest, a genre film festival in the United States. *Mooch*, starring in order of appearance: Vincent Price, James Darren, Jill St. John, Jim Backus; Additional stars: Mickey Rooney, Phyllis Diller, Darrin McGavin, Edward G. Robinson, Cesar Romero, Marty Allen, Dick Martin, Sam Jaffe, Rose Marie; Written by Jerry Devine and Jim Backus; Directed by Richard Erdman; Television release date 1971; Theatrical release date 10/02/19. Gavin Crimson, imdb.com (2020): "A film that sends out a terrible message to young, impressionable dogs."

1972

Alias Smith and Jones (ABC, role: Armendariz). "The McCreedy Bust: Going, Going, Gone": Burl Ives hires the duo to steal the bust from Cesar Romero again, prompting a trip to San Francisco and a modest amount

of mayhem; with Pete Duel, Ben Murphy, Burl Ives, Cesar Romero, Lee Majors, Bradford Dillman, Ted Gehring, Bing Russell, Paul Micale, Robert P. Lieb. Airdate 01/13/72.

The Merv Griffin Show (Syndicated, role: Himself). Talk and variety show; with Merv Griffin, Cesar Romero, Zsa Zsa Gabor, Suzanne Pleshette, Jack Bradford. Airdate 02/01/72.

The Jimmy Stewart Show (NBC, role: Admiral Decker). Cesar Romero plays a character different from his appearance earlier in the season, this time as a sandwich shop franchise owner. "A Bone of Much Contention": Cesar Romero is set to open the newest franchise restaurant of his Admiral Decker sandwich shop chain, but James Stewart sparks a contentious delay; with James Stewart, Julie Adams, Cesar Romero, Jonathan Daly, Ellen Geer, Dennis Larson, Kirby Furlong, John McGiver, Michael Audley, Hank Brandt, Walter Barnes, Russ Grieve, Leonard Simon. Airdate 03/12/72.

The Proud and Damned (Interfilm Production, role: San Carlos's Mayor). After the Civil War, five Confederate mercenaries led by Chuck Connors are trapped in the middle of a rebellion and must choose between siding with Cesar Romero as the representative of a powerful military dictator and helping the local village fight for its independence. For unclear reasons, the film is not released until some three and a half years after shooting. Chuck Connors, *The Proud and Damned*, Aron Kincaid, Cesar Romero, José Greco, Smokey Roberds as Jeb, Henry Capps as Hank, Chuck Connors as Will Hansen, Aron Kincaid as Ike, Peter Ford as Billy, Andre Marquis as The General, Maria Grimm as Maria, Nana Lorca as Carmela, and Anita Quinn as Mila; Written, Produced, and Directed by Ferde Grofé Jr.; Production start date 10/23/68; Release date 05/31/72.

Now You See Him, Now You Don't (Walt Disney, role: A. J. Arno). College student Kurt Russell invents a spray that makes him invisible. Cesar Romero is fresh out of prison from his exploits in *The Computer Wore Tennis Shoes* and sees all his ships coming in at once if he can steal the formula from Russell. Poster copy: "He's going . . . going . . . gone! See the invisible kid do a fast fade and turn a campus caper into a SIGHT UN-SEEN." *Walt Disney Productions presents Now You See Him, Now You Don't* starring Kurt Russell (Dexter Riley), starring Cesar Romero (A. J. Arno), starring Joe Flynn (Dean Higgins), starring Jim Backus (Timothy Forsythe), starring William Windom (Lufkin); costarring Michael McGreevey (Richard Schuyler), Richard Bakalyan (Cookie), Joyce Menges (Debbie Dawson), Alan

Hewitt (Dean Collingsgood), Kelly Thordsen (Sgt. Cassidy), Bing Russell (Alfred), George O'Hanlon (Ted), John Myhers (Golfer), Pat Delaney (Secretary), Robert Rothwell (Driver), Frank Aletter (TV Announcer), Dave Willock (Mr. Burns) and Edward Andrews as Mr. Sampson, Jack Bender (Slither Roth), Frank Welker (Myles), Mike Evans (Henry Fathington), Ed Begley Jr. (Druffle), Paul Smith (Roadblock Officer) and Billy Casper (Professional Golfer), Dave Hill (Professional Golfer); Screenplay by Joseph L. McEveety; Based on a Story by Robert L. King; Produced by Ron Miller; Directed by Robert Butler; Production dates early May to mid-June 1971; Release date 07/07/72.

V.I.P.-Schaukel (ZDF, West Germany, role: Himself). Talk show; with Cesar Romero, Margret Dünser, Buzz Aldrin, Leslie Allen, Marilyn Cole, Nicholas Curtis, Tony Curtis, Sammy Davis Jr., Rhonda Fleming, Zsa Zsa Gabor, Hugh Hefner, Alfred Hitchcock, Carroll Righter, Claude Terrail. Airdate 08/25/72.

Mod Squad (ABC, role: Frank Barton). A trio of reformed juvenile delinquents work as undercover cops in this wildly influential pop culture milestone that inspires *21 Jump Street* and *Veronica Mars*, among others. This episode has a particularly high-octane cast. "The Connection": The trio goes undercover to take down an international drug ring; with Michael Cole, Clarence Williams III, Peggy Lipton, Cesar Romero, Tige Andrews, Edward Asner, Bradford Dillman, Cleavon Little, Barbara McNair, Claudia McNeil, Stefanie Powers, Richard Pryor, Robert Reed, Gene Washington, Ron Stokes, Bill Quinn, Eric Server, John Rayner, Ricky Powell, Barbara Rhoades, Vince Howard, Jason Wingreen, Jon Shank, Mia Bendixsen, Tuesday Knight. Airdate 09/14/72.

Alias Smith and Jones (ABC, role: Armendariz). "The McCreedy Feud": Tired of his feud with Cesar Romero, Burl Ives hires the duo to make a peace offering, but relations between the two nemeses are complicated by the arrival of Romero's dour religious freak of a sister, Romero's *Sword of Granada* and *The Racers* costar Katy Jurado; with Ben Murphy, Roger Davis, Katy Jurado, Burl Ives, Cesar Romero, Dennis Fimple, Rudy Diaz, Lou Peralta, Claudio Miranda. Airdate 09/30/72.

1973

The Timber Tramps (Alaska, role: Joe Richards). Claude Akins assembles a team of strapping lumberjacks to help out a struggling lumber company in Alaska. The proprietor turns out to be old flame Eve Brent, and her son is just about the right age to have been conceived when Brent and Akins were

together. Old *Latitude Zero* antagonists Joseph Cotten and Cesar Romero are in cahoots in a series of cartoonish vignettes as evil rich guys sabotaging the heavily mortgaged company so they can foreclose. Cotten's real-life wife, Patricia Medina, who was Romero's villainous girlfriend in *Latitude Zero*, makes her final film appearance and then retires from the screen when the film wraps. If this poorly shot, woodenly acted, melodramatic mess is the best material she can get, you see why. *Alaska Pictures presents The Timber Tramps* starring Leon Ames, Claude Akins, Tab Hunter, Joseph Cotten; Costarring Stanley Clements, Eve Brent, Patricia Medina; Introducing Mike Hagerty and Jennifer Richards; Featuring Hal Baylor, Shug Fisher, June Easten, Robert Easton, Noble "Kid" Chissell; Special Guest Stars Cesar Romero, Stubby Kaye, Roosevelt Grier; Written and Produced by Chuck D. Keen; Directed by Tay Garnett and Chuck D. Keen; Production start date 07/12/72; Release date 02/17/73.

It's Your Bet (Syndicated, role: Himself). Game show with Lyle Waggoner as the new host, replacing Tom Kennedy; with celebrity couples Cesar Romero and his great friend Elizabeth Allen versus Rick Jason and Nita Talbot. Airdate 04/23/73.

The Merv Griffin Show (Syndicated, role: Himself). Talk and variety show; with Merv Griffin, Cesar Romero, Xavier Cugat, Elena Verdugo, Jimmy Martinez. Airdate 11/22/73.

Chase (NBC, role: Parker). Adventures of an unconventional police unit led by *Dark Shadows* alum Mitchell Ryan as Capt. Chase Reddick. "A Bit of Class": with Mitchell Ryan, Brian Fong, Wayne Maunder, Reid Smith, Michael Richardson, Cesar Romero, Beth Brickell, John Elerick, Leigh French, Jack Manning. Airdate 12/11/73.

1974

Banacek (NBC, role: Marius Avantalu). Film star George Peppard plays freelance insurance investigator Thomas Banacek, who always manages to solve crimes before the responsible authorities can figure them out—a trope that goes all the way back to radio's *Johnny Dollar*, among many other titles on radio, film, and television. "The Vanishing Chalice": The search for a priceless stolen Greek chalice has unexpected consequences; with George Peppard, Christine Belford, Cesar Romero, Eric Braeden, Sue Ane Langdon, John Saxon, Murray Matheson, Ralph Manza, Robert Wolders, Don Collier, Lester Rawlins, George Murdock, Paul Picerni, Nedra Deen, Ruth Price, Carle Bensen, Little Egypt, Elisabeth Talbot-Martin, Dorrie Thomson. Airdate 01/15/74.

Chronology

The Haunted Mouth (American Dental Association, role: B. Plaque). In a short intended for distribution in schools and other organizations where cavity-prone children might be enticed to brush and floss regularly, Cesar Romero is the scary voice of B. Plaque in a deserted haunted house where furniture moves by itself and children learn of the evil consequences of dental negligence. As instructions appear at the end for what children should do to keep their teeth safe from him, he scarily intones, "But you won't do it, will you . . . Will you . . . Will you . . ." *The Haunted Mouth* with Cesar Romero as B. Plaque; Presented by the American Dental Association; Supported by a grant from Colgate Dental Cream, Division of Colgate-Palmolive Company and by Hoyt Laboratories, Division of Colgate-Palmolive Company. Release date 05/31/74.

The Spectre of Edgar Allan Poe (Cinerama Releasing Corporation, role: Dr. Richard Grimaldi). In this imagined episode in Poe's life, Robert Walker Jr. is devastated when his fiancée, Lenore, suddenly dies—but then during interment she miraculously awakens. The trauma of almost being buried alive drives her mad, so on the advice of his friend, Tom Drake, Walker commits her to an asylum run by Cesar Romero, never suspecting Romero is performing crude experimental brain surgeries, hoping to cure the madness of his own lady love. Walker Jr. has none of his father's talent, and the film is terrible. *Cintel Productions presents The Spectre of Edgar Allan Poe* starring Robert Walker Jr. as Poe (credited as Robert Walker), Cesar Romero as Dr. Grimaldi, Tom Drake, Carol Ohmart; costarring Mary Grover as Lenore and Mario Milano, Karen Kadler (credited as Karen Hartford), Frank Packard, Marcia Mae Jone, Dennis Fimple, Paul Bryar; Screenplay by Mohy Quandour Based on Original Story and Treatment by Kenneth Hartford, Denton Foxx; Produced and Directed by Mohy Quandour; Production dates late April or early May to mid-June 1972; Release date 05/31/74.

Bicentennial Minutes (CBS, role: Himself). One-minute segments counting down to America's bicentennial utilizing an "On this Day" format; with Cesar Romero coincidentally narrating the episode that airs the day Richard Nixon officially resigns as president of the United States. Romero's minute is unavailable for viewing, and the content is not known. Airdate 08/09/74.

Ironside (NBC, role: Tony Hudson). Wheelchair-bound detective Raymond Burr battles baddies on the slanted streets of San Francisco for 195 episodes from 1967 to 1975 after playing Perry Mason for 271 episodes

Chronology

from 1957 to 1966. Cesar Romero appears here with four former costars: Dana Andrews from *Deep Water*, Alan Napier from *Batman*, Virginia Gregg from *Two on a Guillotine*, and Eve Brent from *The Timber Tramps*. "The Last Cotillion": A wealthy socialite is the main suspect in the murder of two of her former beaux, but Ironside suspects she is actually innocent; with Raymond Burr, Don Galloway, Don Mitchell, Cesar Romero, Dana Andrews, Elizabeth Baur, Kim Hunter, Jess Walton, Frank Maxwell, Alan Napier, Virginia Gregg, Meg Wyllie, Charles Macaulay, Dennis McCarthy, Eve Brent, Henry Wills. Airdate 10/31/74.

Dinah! (Syndicated, role: Himself). Dinah Shore's talk and variety show; with Cesar Romero, Tex Beneke, Ralph Carter, Leo Durocher, Ken Murray, George T. Simon. Airdate 11/21/74.

1975

The Strongest Man in the World (Walt Disney, role: A. J. Arno). Kurt Russell and his friends accidentally discover a new chemical formula that, when mixed with cereal, causes superhuman strength. Rival cereal moguls Eve Arden and Phil Silvers want it—and so does Russell's old nemesis Cesar Romero. *Walt Disney Productions presents The Strongest Man in the World* starring Kurt Russell (Dexter), Joe Flynn (Dean Higgins), Eve Arden (Harriet), Cesar Romero as A. J. Arno, and Phil Silvers as Krinkle; costarring Dick Van Patten (Harry), Harold Gould (Dietz), Michael McGreevey (Schuyler), Richard Bakalyan (Cookie), William Schallert (Quigley), Benson Fong (Ah Fong), James Gregory (Chief Blair); our students Ann Marshall (Debbie), Don Carter (Gilbert), Christina Anderson (Cris), Paul Linke (Porky), Jack David Walker (Slither), Melissa Caffey (Melissa), John Debney (John), Derrel Maury (Hector), Matthew Conway Dunn (Matthew), Pat Fitzpatrick (Pat), David R. Ellis (David), Larry Franco (Larry); featuring Roy Roberts (Mr. Roberts), Fritz Feld (Mr. Frederick), Ronnie Schell (Referee), Raymond Bailey (Regent Burns), John Myhers (Mr. Roscoe), James Brodhead (Edward), Dick Patterson (Mr. Secretary), Irwin Charone (Irwin), Roger Price (Roger), Jack Bailey (Jack), Larry Gelman (Larry), Eric Brotherson (Eric), Jonathan Daly (TV Announcer), Kathleen Freeman as the Policewoman; with Iggie Wolfington (Mr. Becker), Ned Wertimer (Mr. Parsons), Milton Frome (Mr. Lufkin), Laurie Main (Mr. Reedy), Mary Treen (Mercedes), Eddie Quillan (Mr. Willoughby), Jeff DeBenning (Mr. Rogers), Henry Slate (Mr. Slate), Byron Webster (Mr. Webster), Burt Mustin (Regent

Appleby), Arthur Space (Regent Shaw), Bill Zuckert (Policeman), Larry J. Blake (Pete), William Bakewell (Professor), Art Metrano (TV Color Man), Peter Renaday (Reporter), Lennie Weinrib (State Coach), Danny Wells (Drummer), James Beach (TV Man); Written by Joseph L. McEveety & Herman Groves; Produced by Bill Anderson; Directed by Vincent McEveety; Production start date 05/28/74; Release date 02/12/75.

Medical Center (CBS, role: Packy). A forerunner to *House*, Chad Everett stars as an associate professor of surgery who solves approximately 171 medical mysteries over the course of 171 episodes from 1969 to 1976. "The High Cost of Winning": Pressured by his business associates, a young tennis pro seeks escape through surgery; with Chad Everett, James Daly, Erik Estrada, Lynne Marta, Cesar Romero, Barbara Baldavin, Gary Brient, Ed Fury, Jonathan Mumm, Tom Pace, Harv Selsby. Airdate 12/15/75.

1976

Ellery Queen (NBC, role: Armand Danello). Jim Hutton plays the son of a police detective who solves baffling crimes that stump his father, David Wayne. "The Adventure of the Wary Witness": Cesar Romero's son is dead, and the wrong man is on trial for his murder—until father and son detectives find the real killer; with Jim Hutton, David Wayne, Michael Constantine, Dwayne Hickman, Sal Mineo, Tricia O'Neil, Michael Parks, Cesar Romero, Dick Sargent, Ken Swofford, Frank Flannigan, Tom Reese, Katherine Woodville, Sam Gilman, Richard Young, Ollie O'Toole, Jackie Russell, Myron Natwick, Robert Stoneman. Airdate 01/25/76.

Carioca tigre, aka *A Fera Carioca* (Ipanema Filmes, role: Don Rosalindo y Guana). Smugglers, hitmen, and lottery money are on parade as three Italians in Brazil band together to retrieve a gun that was stolen from Mafia don Cesar Romero that can provide incriminating evidence of Romero's guilt in a murder. Never released in the United States, the film is not available for screening. In Italy, the film is released as *Carioca tigre*; in Brazil as *A Fera Carioca*. *Roberto Acácio e Salvatore Argento apresentam*, Aldo Maccione, António Cantafora (credited as Michael Coby) em *A Fera Carioca*, Cesar Romero, Augusto Enrique Alves, Milton Gonçalves com a participação de Grande Otelo; com Luciana Turina, Renato Pinciroli, Enzo Robutti, Jacques Herlin; Música de Chico Buarque (credited as Chico Buarque de Hollanda), Vinicius de Moraes, Toquinho; Uma Co-Produção Brasileira/Italiana Seda Spettacoli S.p.A. Roma; Cinemática

Produções Cinematográficas Ltda. Rio de Janeiro; Direaço de Giuliano Carnimeo. Release date 03/12/76.

Mission to Glory: A True Story, aka *The Father Kino Story* (Key International Pictures, role: Admiral Juan Atondo). A purportedly true account of the legendary "Padre on Horseback," Father Eusebio Francisco Kino, a Jesuit missionary who helped the lives of the Native Americans. He faced many challenges on his trips throughout California, Arizona, and Mexico, including obstruction from Cesar Romero. It is a poorly shot, dull mess. *The Father Kino Story* starring Richard Egan as Father Kino and Ricardo Montalban, John Ireland, Joseph Campanella, Cesar Romero; Producer Arthur E. Coates; Written and Directed by Ken Kennedy; Release date 12/08/76.

1977

Chico and the Man (NBC, role: Gilberto Rodriguez). Freddie Prinze shoots to stardom in this sitcom about a sexy mechanic working for a curmudgeon. "Chico's Padre": Freddie Prinze is shocked when his father, Cesar Romero, shows up out of the blue—and from beyond the grave, according to family lore; with Jack Albertson, Freddie Prinze, Scatman Crothers, Cesar Romero, Jerry Hausner, Wyatt Johnson. Airdate 02/04/77.

1978

ABC's Silver Anniversary Celebration (ABC, role: Himself). Former and modern-day ABC stars celebrate the network's twenty-fifth anniversary; with many guest stars. Airdate 02/05/78.

Vega$ (ABC, role: Christopher Vincente). Robert Urich plays perhaps the only television detective named for a restaurant. Producers Aaron Spelling and E. Duke Vincent are fans of legendary West Hollywood eatery Dan Tanna's (still in operation, since 1964) and figure they will get tables faster and easier if they create a character who works in Las Vegas in tribute. They're right. "Lost Women": Beautiful showgirls are the victims of Cesar Romero as a gold-chain-laden White slave trader; with Robert Urich, Bart Braverman, Phyllis Davis, Judy Landers, Naomi Stevens, Tony Curtis, Moses Gunn, Britt Lind, Charles Dierkop, Seamon Glass, Kim Hamilton, Cesar Romero, Greg Morris, Peter Mark Richman, Rhonda Hopkins, Wendy Hoffman. Airdate 11/22/78.

Chronology

1979

Over Easy (PBS, role: Himself). Hugh Downs hosts this talk show with news, interviews, and entertainment aimed at the older viewer; with Cesar Romero. Airdate 01/02/79.

Fantasy Island (ABC, role: Sheikh Hameel Habib). The mysterious Ricardo Montalban runs a unique resort island that can seemingly fulfill any fantasy. Factotum Hervé Villechaize famously shouts, "The plane! The plane!" at the top of each episode when the guest stars arrive. Romero plays an Arab sheikh. In other stories in the episode, Florence Henderson is a news reporter under a satanic curse and Lisa Hartman is a nun who meets an orangutan. "Casting Director": Cesar Romero is a lothario-sheikh-financier of a film in production that gives Don Knotts a chance at fulfilling his fantasy of playing casting director to a bevy of beautiful young actresses; with Ricardo Montalban, Hervé Villechaize, Don Knotts, Cesar Romero, Abe Vigoda, Phyllis Davis, Francine Gabel, Victoria Wells, Linda Kendall, Suzanne Copeland, Manis the Orangutan. Airdate 02/17/79.

The Bob Braun Show (Syndicated, role: Himself). A local Cincinnati, Ohio, talk show hosted by Bob Braun; with Cesar Romero, Nancy James, Colleen Murray, Rob Reider, Teddy Rafel Orchestra. Airdate 04/25/79.

Buck Rogers in the 25th Century (NBC, role: Amos Armat). In this reimagining of the old radio and film serial classic, a twentieth-century astronaut emerges from five hundred years of suspended animation and becomes Earth's greatest hero. Cesar Romero guest stars as the arms-dealing, human-trafficking, lawless father that future *Falcon Crest* costar Ana Alicia has never known. When she is kidnapped, he gives up his criminal empire in order to keep her safe. Romero in his jaunty fur hat and brooch and chain-covered cape is having the best time; with Gil Gerard, Erin Gray, Tim O'Connor, Christina Belford, Cesar Romero, Ana Alicia, Joseph Wiseman, Richard Lynch, Juanin Clay, Pamela Susan Shoop, James Luisi, Felix Silla, Alice Frost, Ted Chapman, the voice of Mel Blanc. Airdate 10/04/79.

1980

Charlie's Angels (ABC, role: Elton Mills). Aaron Spelling's classic "jiggle television" mystery series that helps propel ABC to a multiyear run as the most-watched network in the country. The never-seen detective Charlie (voiced

on the phone by the uncredited but instantly recognizable John Forsythe, who also works for Spelling as the lead on *Dynasty*) brings together a trio of beautiful women to be his investigative team, the Angels. This season is the third iteration of the three main characters, with Jaclyn Smith the only one of the original trio that remains. Shelley Hack will be replaced in the fifth season by Tanya Roberts. "Dancin' Angels": Cesar Romero is a bandleader at a nostalgic dance hall where he passionately promotes his old-time music and hosts dance contests. When a young female contestant goes missing, the Angels sashay in wearing vintage gowns. When the missing dancer's corpse turns up, things get dangerous—and in a shocking turn of events, a misty-eyed Romero steals Smith's gun and takes her hostage; with Jaclyn Smith, Cheryl Ladd, Shelley Hack, David Doyle, Cesar Romero, Norman Alden, John Lansing, Lee Delano, Dawn Jeffory, Brad Maule, Jason Kincaid, Lindsay Bloom, Pamela Peadon, John Forsythe on the phone as Charlie. Airdate 02/06/80.

The Mike Douglas Show (Syndicated, role: Himself). Talk and variety show; with Mike Douglas, Cesar Romero, Elaine Joyce, Donald O'Connor, Juliet Prowse. Airdate 05/02/80.

1981

Fantasy Island (ABC, role: Maestro Roger Alexander). "Loving Strangers": Jane Powell and Peter Marshall have been married for twenty-five years and want to see if they would still fall in love if they met again for the first time. Montalban magically makes them strangers, and Powell is entranced when she meets handsome Cesar Romero; with Ricardo Montalban, Hervé Villechaize, Peter Marshall, Jane Powell, Cesar Romero. Airdate 02/14/81.

1982

Rainbow Girl (NBC, role: Miles Starling). Pilot for a sitcom about a singer on a variety show and her family and friends. Ann Jillian is the singer and Cesar Romero is the host on the show-within-a-show, charming when he is in front of a camera but a tough boss backstage. Though it is difficult to confirm, it seems the show aired as a one-off special, but the show doesn't make it to series. Cast: Ann Jillian, Rae Allen, Candice Azzara, Cesar Romero, Michael Tucci, Robert Allan Browne, Dick Dean, Dallas Alinder; Writers Danny Jacobson, Barry Vigon; Producer Ernest Chambers; Associate

Producer Jack Watson; Theme Music by Ann Jillian; Directed by Herbert Kenwith; Series Pilot. Airdate 04/15/82.

Matt Houston (ABC, role: Miles Gantry). A wealthy Texan moves to California to oversee his family's offshore drilling business but spends most of his time solving crimes. (Don't the actual police ever solve anything?) Cesar Romero is miscredited as *Caesar*. "Who Would Kill Ramona?": Janet Leigh is a former star making a comeback, but when her young costar gulps down her drink (to prove she is drinking on the set), he dies of poisoning. Her suave producer Cesar Romero is one of several suspects; with Lee Horsley, Pamela Hensley, Janet Leigh, Cesar Romero, Kiel Martin, Carmen Zapata, John Aprea, Paul Brinegar, Dennis Fimple, Penny Santon, William Smith, Jill Whelan, George Wyner, Army Archerd, John Calvin, Matt Collins, Dabbs Greer, Paula Jones, Cindi Knight, Cis Rundle, Smidget. Airdate 10/31/82.

1983

Fantasy Island (ABC, role: Frederick Kragen). "The Tallowed Image": Cesar Romero is a nineteenth-century waxworks creator who makes his figures out of real people, and now he has his eye on model Audrey Landers; with Ricardo Montalban, Hervé Villechaize, Ray Buktenica, Audrey Landers, Cesar Romero. Airdate 01/29/83.

Hart to Hart (ABC, role: Dr. Villac). In this *Thin Man*–inspired series, Robert Wagner and Stefanie Powers are a glamorous millionaire couple who solve crimes because, as Lionel Stander, their loyal chauffeur and all-around helpmate, says in the show's iconic opening sequence, "When they met, it was murder!" "Chamber of Lost Harts": A Hart employee is murdered during an exploration in the jungle when he uncovers a plot to sell Inca treasures that are probably fake, and Robert Wagner and Stefanie Powers set off to solve the mystery in Peru, where they encounter double-dealing, gun-wielding archaeologist Cesar Romero. As a Peruvian. With Robert Wagner, Stefanie Powers, Lionel Stander, Cesar Romero, Beau Kayser, Gary Frank, Henry Darrow, Marcelo Tubert, Adam Ageli, Robert Balderson. Airdate 02/01/83.

Fantasy Island (ABC, role: Edmond Rome). In this, the show's final season, Christopher Hewitt is Montalban's new factotum after Hervé Villechaize demands pay parity and is fired. Romero's friend Ruta Lee appears in a parallel story to Cesar Romero's in the episode, but they don't

interact. "Roarke's Sacrifice": Cyd Charisse is a crippled former dancer (and former lover of Montalban's) who dreams of dancing again. When Montalban makes her dream come true, musical theater producer Cesar Romero wants to star her in a new show, and Montalban must make a painful choice about his own future so she can make the fantasy real and dance off to Broadway with Romero. Charisse is featured in several numbers, and almost forty years after her screen debut in *Ziegfeld Follies*, she still sizzles; with Ricardo Montalban, Christopher Hewett, Cyd Charisse, Cesar Romero. Airdate 11/12/83.

1984

The Love Boat (ABC, role: John Drake). "Authoress! Authoress!": Carol Channing and pal Betty White plot to persuade publisher Cesar Romero to publish White's memoir, but romance gets in the way; with Gavin MacLeod, Bernie Kopell, Fred Grandy, Ted Lange, Jill Whelan, Lauren Tewes, Carol Channing, Betty White, Cesar Romero. Airdate 01/07/84.

We Think the World Is Round (Hanna-Barbera/HBO, role: The Santa Maria). This animated special is shelved for a number of years after being produced in the 1970s. It tells the story of the arrival of Christopher Columbus from the points of view of the ships themselves. Sterling Holloway, who voices Winnie-the-Pooh for Disney, sounds an awful lot like Pooh as the narrator, Pegleg Pelican, bringing a new entry into the arguments about who "discovers" a country that is already inhabited—not Columbus, not the Vikings, but Winnie-the-Pooh. Cesar Romero voices the Santa Maria, and a likeness of his face is the entire prow of the ship; with Cesar Romero, Janis Paige, Sidney Miller, Sterling Holloway. Airdate 10/01/84.

All-Star Party for Lucille Ball (CBS, role: Himself). Celebrity special; with many guest stars. Airdate 12/09/84.

This Is Your Life: Alice Faye (ITV, role: Himself). Popular, long-running surprise reunion series; with Alice Faye, Eamonn Andrews, Don Ameche, Phil Harris, Bob Hope, Ruby Keeler, Mary Martin, George Murphy, Anthony Quinn, Ginger Rogers, Cesar Romero, Rudy Vallee, Jane Withers. Airdate 12/19/84.

1985

Magnum, P.I. (CBS, role: Doc Villoroch). Tom Selleck becomes a superstar as a dimpled, hirsute private investigator living in the guesthouse of a

mysterious, never-seen author's lavish estate; acerbic caretaker John Hillerman patrols the property with two Dobermans named Zeus and Apollo. The show runs for eight seasons. "Little Games": Over $170 million in jewelry is on display during a design competition held at the estate, and jewel thief Cesar Romero mentors his daughter (Jenny Agutter, worlds and decades away from playing the Reverend Mother on *Call the Midwife*) in the tricks of the trade; with Tom Selleck, John Hillerman, Jenny Agutter, Cesar Romero, Roger E. Mosley, Larry Manetti, Jeff MacKay, Jo Pruden, Lenor Vandercliff, Jimmy Borges, Steven Perry, Ed Kim Jr. Airdate 01/03/85.

Berrenger's (NBC, role: Rinaldi). "Overture": In the pilot episode, Sam Wanamaker announces merger plans over the objections of his son Ben Murphy (from *Alias Smith and Jones*) while Cesar Romero and Jack Scalia plot their takeover; with Sam Wanamaker, Anita Morris, Ben Murphy, Robin Strand, Jack Scalia, Andrea Marcovicci, Jeff Conaway, Cesar Romero, Yvette Mimieux, Donna Dixon, Eddie Velez, Robert Pastorelli, Alan Feinstein, Jonelle Allen, Leslie Hope, Neva Patterson, Art Hindle, Claudia Christian, Richard Sanders. Airdate 01/05/85.

The Love Boat (ABC, role: John Stockton). This is Cesar Romero's second time on the ship. "Love on the Line": Corporate big shot and workaholic Cesar Romero meets Jane Wyatt on board without realizing she is the switchboard operator in his office building—a year later he trades one Jane for another opposite Jane Wyman on *Falcon Crest*; with Gavin MacLeod, Bernie Kopell, Fred Grandy, Ted Lange, Jill Whelan, Ted McGinley, Pat Klous, Cesar Romero, Jane Wyatt. Airdate 01/26/85.

Family Feud Hollywood Walk of Fame Special (ABC, role: Himself). Game show hosted by Richard Dawson; with Cesar Romero, Rory Calhoun, Arlene Dahl, Gloria DeHaven, Mark Goodson, Dorothy Lamour, Rod McKuen, Audrey Meadows, Betty White, Keenan Wynn. Airdate 01/31/85.

Lust in the Dust (New World Pictures, role: Father Garcia). A group of unscrupulous characters seek buried treasure in the Old West with Divine and Lainie Kazan both pursuing (and catching) Tab Hunter as a Clint Eastwood type. Divine and Kazan figure out they are sisters, but it does nothing to lessen their lust for Hunter or for gold. Cesar Romero is a seemingly good-hearted priest (and former rabbi) who turns out to want the gold just as much as everyone else. *Lust in the Dust,* Tab Hunter, Divine, Lainie Kazan, Geoffrey Lewis, Henry Silva, Cesar Romero, Gina Gallego; costarring Nedra Volz, Courtney Gains; Written by Philip John Taylor; Produced

by Allan Glaser, Tab Hunter; Directed by Paul Bartel; Production dates 05/01/84 to early June; Release date 02/05/85.

Berrenger's (NBC, role: Rinaldi). "Power Play": Ben Murphy discovers Jack Scalia and Cesar Romero are behind the impending merger; with Sam Wanamaker, Anita Morris, Ben Murphy, Jack Scalia, Andrea Marcovicci, Yvette Mimieux, Donna Dixon, Robin Strand, Jeff Conaway, Cesar Romero, Eddie Velez, Robert Pastorelli, Alan Feinstein, Jonelle Allen, Leslie Hope, Neva Patterson, Art Hindle, Claudia Christian, Richard Sanders, Michael David Lally. Airdate 02/09/85.

Murder, She Wrote (CBS, role: Diego Santana). "Paint Me a Murder": Cesar Romero is a world-famous artist who invites a glamorous set of friends, including Angela Lansbury, to his sixtieth birthday celebration (Romero is seventy-eight at the time) on a Mediterranean island—but one of them kills him; with Angela Lansbury, Fernando Allende, Capucine, Judy Geeson, Robert Goulet, Stewart Granger, Steven Keats, Ron Moody, Cristina Raines, Cesar Romero, Pepe Hern, Alma Beltran. Airdate 02/17/85.

Berrenger's (NBC, role: Rinaldi). "Hidden Agenda": A model vanishes in the wake of a sex tape airing, and Sam Wanamaker realizes Jack Scalia and Cesar Romero do not wish him well; with Sam Wanamaker, Anita Morris, Ben Murphy, Jack Scalia, Andrea Marcovicci, Yvette Mimieux, Donna Dixon, Jeff Conaway, Robin Strand, Cesar Romero, Eddie Velez, Robert Pastorelli, Alan Feinstein, Jonelle Allen, Leslie Hope, Neva Patterson, Art Hindle, Claudia Christian, Richard Sanders. Airdate 03/02/85.

Half Nelson (NBC, role: Morgan). Joe Pesci is a former New York cop trying to make it as an actor in Hollywood whose day job at a private security agency provides innumerable crimes that need solving. "The Deadly Vase": Cesar Romero and Catwoman Julie Newmar are together again, except they never work together on *Batman*, so the reunion is something of a mirage; with Joe Pesci, Victoria Jackson, Dean Martin, Cesar Romero, Julie Newmar, Donald O'Connor, Robert Reed, Dick Butkus, Bubba Smith, Cesare Danova, Michael Frost, Gary Grubbs, Michelle Johnson, Thomas Rosales Jr., Susan Walden, Fred Williamson, Spuds MacKenzie the Dog. Airdate 03/29/85.

Riptide (NBC, role: Angelo Guirilini). Perry King and Joe Penny are two Vietnam War veterans who start a detective agency with their computer geek friend from high school. "Arrivederci, Baby": Italian gentleman Cesar Romero's son is badly wounded under mysterious circumstances during a diving expedition, and he turns to the guys for help;

Chronology

with Perry King, Joe Penny, Thom Bray, Cesar Romero, Dana Elcar, Ava Lazar, Russell Todd, Jack Ging, Glenn Morrissey, Steve Lattanzi, Bradford English, Nick Cavanaugh, James Andronica, Cece Bullard. Airdate 05/07/85.

Flesh and Bullets (Hollywood International Film Corporation of America, role: Judge in Santa Monica). Two strangers with unwanted wives meet in a Las Vegas bar . . . This low-rent, sex-obsessed *Strangers on a Train* knockoff is written and directed by porn director Carlos Tobalina under the name Efrain Tobalina. That two actors are billed as "Homo Wrestlers" as late as 1985 says it all. Most of the cast consists of painfully awkward amateurs. It's wonderful to see four stars from classic Hollywood in cameos, but Yvonne DeCarlo and Cesar Romero as judges and Aldo Ray and Cornel Wilde as cops don't really look like they are having much fun, and Romero seems tired and bored. Shortly after shooting, he lands *Falcon Crest*, and his vigor and good spirits are back in a flash. C. Tobalina Productions, Inc. Present *Flesh and Blood*, Special performances by Yvonne DeCarlo, Aldo Ray, Cesar Romero, and Cornel Wilde, Mr. Glenn McKay, Gail Sterling (credited as Miss Susan Silvers), Mr. Mick Morrow, Cydney Hill, Young Miss Gina Tobalina; Directed by Carlos Tobalina (credited as Efrain Tobalina); Executive Producer Efrain Tobalina; Written by Efrain Tobalina; Release date 05/08/85.

Falcon Crest (CBS, role: Peter Stavros). "Blood Brothers": Billionaire Greek shipping tycoon Peter Stavros arrives in San Francisco and invites Angela to his yacht; with Jane Wyman as Angela Channing, Susan Sullivan as Maggie Gioberti Channing, Robert Foxworth as Chase Gioberti, Ana Alicia as Melissa Agretti Cumson Gioberti and as Samantha Ross, Lorenzo Lamas as Lance Cumson, David Selby as Richard Channing, William R. Moses as Cole Gioberti, Morgan Fairchild as Jordan Roberts, Abby Dalton as Julia Cumson, Cesar Romero as Peter Stavros, Kim Novak as Kit Marlowe, Leslie Caron as Nicole Sauguet, Ursula Andress as Madame Malec, Robert Stack as Roland Saunders, Margaret Ladd as Emma Channing, Chao Li Chi as Chao-Li the Butler, Laura Johnson as Terry Hartford Ranson, Simon MacCorkindale as Greg Reardon, Sarah Douglas as Pamela Lynch, John Saxon as Tony Cumson. Airdate 10/18/85.

Falcon Crest (CBS, role: Peter Stavros). "Echoes": Peter agrees to help Angela, but he hints there may be strings attached—something he expects in return. He then offers to buy the shares from Cassandra, but she refuses. Airdate 10/25/85.

Chronology

Falcon Crest (CBS, role: Peter Stavros). "Ingress & Egress": Cassandra sells her shares in Falcon Crest to Peter Stavros thinking it will help destroy Angela but is bitter when she learns Peter actually loves Angela. Airdate 11/01/85.

Falcon Crest (CBS, role: Peter Stavros). "Sharps & Flats": Peter Stavros refuses to sign Greg Reardon's draft of the contract transferring ownership of his Falcon Crest stock to Angela. He will sign the shares over only as a wedding gift. Angela's hopes of saying yes, getting the shares, and jilting him are not going to work. So they can get to know one another again, she suggests he move in—to the guest room, not her bedroom. Airdate 11/08/85.

The Annual Friars Club Tribute Presents a Salute to Gene Kelly (NBC, role: Himself). Celebrity special; with numerous other guest stars. Airdate 11/09/85.

Falcon Crest (CBS, role: Peter Stavros). "Changing Partners": Peter takes Angela's somewhat simple-minded daughter Emma on a hot-air balloon ride, and realizing how much he wants a more relaxed life, he gives Angela an ultimatum: set a wedding date or he returns to Europe—*with* his Falcon Crest shares. Airdate 11/15/85.

Falcon Crest (CBS, role: Peter Stavros). "Storm Warnings": Peter surprises Angela by re-creating a picnic they once had in Spain, complete with "gypsy" music. He proposes again and she says yes, this time meaning it. Airdate 11/22/85.

The 2nd Annual American Cinema Awards (NBC, role: Himself). Awards show; with numerous other guest stars. Airdate 11/22/85.

Falcon Crest (CBS, role: Peter Stavros). "The Naked Truth": Angela announces her engagement to Peter. He agrees to a huge wedding celebration once Angela convinces him that her love is sincere. Emma falls for a handsome, good-hearted trucker, and though Angela opposes the match, Peter urges her to accept her daughter's hardworking boyfriend and to stop interfering in Emma's life. Airdate 11/29/85.

Falcon Crest (CBS, role: Peter Stavros). "Inconceivable Affairs": Peter signs over his shares to Angela, and they dance romantically to love songs in the mansion foyer. But trouble is brewing when his daughter Sofia learns in the newspapers about his wedding plans. Then abruptly, Peter leaves a note calling off the wedding—when in truth he has been kidnapped. In the subsequent eight episodes where Peter does not appear on-screen, Angela, humiliated by him seemingly jilting her and unaware that he has been kidnapped, lashes out at everyone but breaks down in tears when she is alone.

Then she finds Peter's will, disinheriting his daughter and naming Angela as his sole beneficiary. She begins fearing for his safety. Perhaps he did not jilt her after all. Airdate 12/06/85.

All-Star Party for "Dutch" Reagan (CBS, role: Himself). Celebrity special; with numerous other guest stars. Airdate 12/08/85.

Skip E. Lowe Looks at Hollywood (Cable Access, role: Himself). Talk show; with Cesar Romero, Marie Windsor, Skip E. Lowe. Airdate 12/31/85.

1986

Blacke's Magic (NBC, role: Eduardo Tozzi). From *Murder, She Wrote* producer Peter S. Fischer, Hal Linden is a magician who solves mysteries using a combination of sleight of hand and con games with his swindler father, Harry Morgan. "Ten Tons of Trouble": In the pilot episode, a priceless ten-ton statue disappears, and a ship steward is killed while the art is being transported under the watchful eye of the Italian deputy director of cultural affairs—but Romero knows far more than he lets on and is motivated by a deep need for revenge; with Hal Linden, Harry Morgan, Cesar Romero, Jane Badler, Ron Ely, Murray Hamilton. Airdate 01/08/86.

The 43rd Annual Golden Globe Awards (Syndicated, role: Himself). At the annual awards event, June Allyson and Cesar Romero present Best Actress in a Motion Picture Drama to Whoopi Goldberg for *The Color Purple*. Airdate 01/24/86.

Falcon Crest (CBS, role: Peter Stavros). "Gambit Exposed": Lance has wormed his way into Phillippe's trust and discovers Peter held captive at the Stavros château. They almost manage to escape but are thwarted. Peter is deeply shaken by his daughter's actions. He blames Phillippe, believing he married Sofia (who is now pregnant) only for money and power. Airdate 02/07/86.

Falcon Crest (CBS, role: Peter Stavros). "Finders and Losers": Peter and Lance remain prisoners at the Stavros château. Peter believes Phillippe will kill them. At gunpoint, Phillippe forces Peter to sign a power of attorney giving him control of everything. Meanwhile, finally aware of her husband's true evil, Sofia shoots and kills Phillippe, setting her father and Lance free. She hopes her actions will allow Peter to forgive her for going along with Phillippe's plot to kidnap him. He protects her by telling the police Phillippe's death is the result of a hunting accident, but he then banishes Sofia from his house and his life. He cannot forgive her. Airdate 02/14/86.

Chronology

Falcon Crest (CBS, role: Peter Stavros). "Flesh and Blood": Peter returns to Falcon Crest and the wedding plans move forward, but he is distracted and anxious about the kidnapping and regrets his estrangement from Sofia. Angela arranges a chance for them to work things out, bringing Sofia as well as Peter's son Eric to meet with him. After a surprising heart-to-heart, Peter forgives his daughter. Airdate 02/21/86.

Falcon Crest (CBS, role: Peter Stavros). "Law and Ardor": Peter learns that Angela is about to be arrested for her supposed role in the wine truck hijacking and leaves a note saying he has eloped with her. He returns without Angela, saying she is spending time resting in Italy, and presents the family with a signed power of attorney giving him complete control of Falcon Crest. Lance is suspicious when he finds Angela's passport. She cannot be in Italy. Airdate 02/28/86.

Falcon Crest (CBS, role: Peter Stavros). "Hidden Meanings": Peter rules Falcon Crest firmly, responding only with amusement to everyone's concerns about Angela's whereabouts. He tries to take out $30 million from the business accounts, but the firm's attorney refuses—so Peter fires him and gets the money. Airdate 03/07/86.

Riptide (NBC, role: Angelo Guirilini). Drama series. "The Pirate and the Princess": The guys partner up with Cesar Romero to find lost treasure; with Perry King, Joe Penny, Thom Bray, Cesar Romero, Ava Lazar, Christopher Cary, Paul Land, Warren Berlinger, Russell Todd, Christopher Neame, Stan Haze. Airdate 03/07/86.

Falcon Crest (CBS, role: Peter Stavros). "In Absentia": Peter wants Melissa to sell him her harvest, but she refuses. Lance successfully wrests temporary court-ordered control of the business away from Peter, who disappears—along with the $30 million he took from the Falcon Crest accounts. Angela returns, telling her family that Peter abandoned her on his yacht with no explanation. And they never did get married. The elopement note was a lie. Airdate 03/14/86.

Falcon Crest (CBS, role: Peter Stavros). "Unholy Alliances": Angela is furious and baffled when she learns of Peter's actions while she was away. And she is shocked to learn that the hijacking arrest is still imminent. She turns herself in and is put in a pretrial detention cell. Peter arrives to pay her bail and tries to explain he had his reasons for doing what he did, but Angela won't listen. At trial, there is only one unreliable witness testifying against Angela, and the case collapses. Peter reveals he was behind everything

being done behind the scenes to destroy the case, and the seeming theft of her money was part of the plan. Her $30 million is safely returned, they get married, and Angela learns Peter has made her Richard's partner in Tuscany Downs. Airdate 04/04/86.

Falcon Crest (CBS, role: Peter Stavros). "Dangerous Ground": Peter opposes his son Eric and Melissa building a winery together but cannot convince Eric to walk away—personally or financially. Chao-Li's long-lost daughter Li-Ying arrives, and Angela and Peter welcome her into their home, but she believes the Valley is due for an earthquake. Airdate 04/11/86.

Falcon Crest (CBS, role: Peter Stavros). "Cease and Desist": Chase learns that Peter Stavros purchased Richard's loans as a ruse to protect Angela. Erin advises Richard to form an alliance with Angela and Peter or leave the country. Melissa and Eric hold a groundbreaking ceremony for their new winery, and Angela upsets Peter when she accuses Eric of plotting against her and his father by starting a competing winery. Airdate 05/02/86.

The Love Boat (ABC, role: Carlos Belmonte). "Spain Cruise: The Matadors: Part 1 and Part 2": In his final *Love Boat* appearance, Cesar Romero is a world-famous matador whose grandson (*Falcon Crest* costar Lorenzo Lamas) is destined to follow in his footsteps but longs to be a composer and has fallen in love with a newswoman who thinks bullfighting is immoral; with Gavin MacLeod, Bernie Kopell, Fred Grandy, Ted Lange, Jill Whelan, Ted McGinley, Pat Klous, Cesar Romero, Lorenzo Lamas, Mary Crosby. Airdate 05/03/86.

Falcon Crest (CBS, role: Peter Stavros). "Consumed": Peter invites Eric and Melissa to dinner, but Angela puts a damper on the occasion with cutting remarks and rude behavior—with Lance's apparent approval. Richard presents Peter and Angela with false evidence that Chase paid off Miss Jones, the witness against Angela at trial, but they don't want to get involved. Airdate 05/09/86.

Falcon Crest (CBS, role: Peter Stavros). "Captive Hearts": Peter convinces Angela to change her mind about Emma and Dwayne's wedding. They arrive at the couple's simple ceremony in Reno, and Angela promises a huge celebration at Falcon Crest instead. After more earthquake warnings, Emma encourages Li-Ying to change her mind about staying in San Francisco, and Angela sends Lance to break up Melissa and Eric. Airdate 05/16/86.

Chronology

Falcon Crest (CBS, role: Peter Stavros). "The Cataclysm": When a stop order is issued on construction at the winery, Eric is convinced Angela is behind it, but Peter counters that he has no proof. The season ends with an earthquake, and Angela, Peter, and Julia are at the Falcon Crest winery when it collapses. A frantic Peter searches for Angela in the rubble. Airdate 05/22/86.

Falcon Crest (CBS, role: Peter Stavros). "Aftershocks": Coping with the loss of life and property after the earthquake takes its toll on everyone. Angela, Peter, Lance, and Eric are relatively unhurt, but Julia is rushed to the hospital, where she wakes from a coma to discover she is blind. Though the new winery suffers severe damage and his relationship with Melissa is in shambles, Eric stays on, cheered up by his father Peter's sentiments about the importance of family. Meanwhile, Peter's long-lost stepdaughter Skylar surfaces in New York, and Angela invites her to Falcon Crest. Peter doesn't realize she is not Skylar but a woman named Kit Marlowe (screen legend Kim Novak) posing as her. Airdate 10/03/86.

Falcon Crest (CBS, role: Peter Stavros). "Living Nightmare": Peter is thrilled to be reunited with Skylar and does not suspect anything is off—though Angela has serious doubts. Richard begins looking for embarrassing or incriminating information in the hopes of destroying Angela and Peter's marriage. Skylar (Kit) is a talented painter (and forger). Airdate 10/10/86.

Falcon Crest (CBS, role: Peter Stavros). "The Stranger Within": In a background check, Richard learns that Peter's stepdaughter Skylar has a strange past—a woman named Kit Marlowe who was involved with art forgery was murdered in front of her building. When confronted, Skylar says she knows nothing about Kit's criminal ties. Angela confronts Peter about neglecting his business responsibilities to spend time with Skylar. Airdate 10/17/86.

Falcon Crest (CBS, role: Peter Stavros). "Fatal Attraction": Richard finds proof that Skylar is actually Kit Marlowe and that the real Skylar is the one who died. Peter supports Eric's decision to sue Melissa but then changes his mind when he realizes Eric is just doing it so that he can stay in contact with her. Airdate 10/24/86.

Falcon Crest (CBS, role: Peter Stavros). "Perilous Charm": While Peter is away on business, Kit forges a check with Angela's signature. Richard promises to keep her secrets if she will help him destroy Peter and Angela's marriage. Kit is conflicted. She has grown fond of Peter, but she goes along

Chronology

with it, using her counterfeit checks as planted evidence in Eric's room to frame him for forging the checks. Airdate 10/31/86.

Falcon Crest (CBS, role: Peter Stavros). "Flash Point": Peter and Angela argue over her stolen checks when Peter refuses to believe Angela's accusations that Eric stole them. Airdate 11/07/86.

Falcon Crest (CBS, role: Peter Stavros). "Double Jeopardy": Peter learns of trouble at one of his companies, Stavros Chemicals. Eric accuses Lance of planting the forged checks, and Angela refuses to believe him. When her trusted employee Dan Fixx is revealed as an ex-convict, Angela surprises Peter by continuing to back him. Airdate 11/14/86.

Falcon Crest (CBS, role: Peter Stavros). "Nepotism": Peter is bewildered by the hold Dan Fixx seems to have on Angela. Problems at Stavros Chemicals continue to bubble up. Richard learns from Kit that Peter has a toxic waste disposal problem. He gets hold of the waste and dumps it on the racetrack, making the land unusable to Angela for growing grapes—and possibly poisoning the water supply and endangering all of the Falcon Crest crops. Airdate 11/21/86.

Falcon Crest (CBS, role: Peter Stavros). "Slow Seduction": The toxic effects of Peter's waste products begin to spread through the Valley. Chase and Tony discover that their vines are withering. A hit man figures out that Skylar is Kit in disguise. Airdate 11/28/86.

All-Star Party for Clint Eastwood (Syndicated, role: Himself). Celebrity special; with numerous other guest stars. Airdate 11/30/86.

Falcon Crest (CBS, role: Peter Stavros). "Maggie": Richard forces Kit to forge papers indicating Angela is behind the dumping of Peter's toxic waste—just as she and Peter are bonding further while she paints his portrait. Tests prove Chase and Tony's vineyards are contaminated from the dumping at Tuscany Downs, with Richard's faked evidence pointing to Angela's conspiracy to ruin her rivals. Airdate 12/05/86.

Falcon Crest (CBS, role: Peter Stavros). "Hot Spots": Peter stands by Angela against the toxic dumping accusations, but privately he has his doubts, even as he must pay a $100,000 fine to the EPA. He is horrified when Angela suggests Eric might be behind the dumping. Airdate 12/12/86.

Falcon Crest (CBS, role: Peter Stavros). "False Front": Angela is unable to prove her innocence. Grudgingly satisfied that Peter's son Eric is not behind it, she begins to suspect her own grandson, Lance. Skylar/Kit becomes convinced her only hope to have a future is to fake her own suicide. Airdate 12/19/86.

Chronology

1987

Falcon Crest (CBS, role: Peter Stavros). "Missed Connections": Angela has a dinner party for Peter's birthday. Since Angela cannot prove her innocence, she cops a plea and agrees to one hundred hours of community service and to pay damages for Chase and Tony's poisoned vines. Kit prepares for her "suicide" by designating some items she is leaving to Peter, including a painting he bought her. Airdate 01/02/87.

Falcon Crest (CBS, role: Peter Stavros). "Dark Passion": Kit/Skylar's suicide hits Peter hard. He blames himself for not seeing how much she must have been struggling emotionally. Though he cannot accept it, the tragedy has a healing effect on Emma, who is finally able to move on from Dwayne's death. Jane Wyman's real-life son with President Ronald Reagan, Michael Reagan, begins a recurring cameo as a concierge, appearing in five episodes during the season. Airdate 01/09/87.

Falcon Crest (CBS, role: Peter Stavros). "When the Bough Breaks": Peter heads for his own private Greek island to mourn the suicide. After selling his winery to Lance, Eric talks Angela into letting him manage the spa. Richard uses twisted logic to blame Angela for his son's kidnapping. Airdate 01/23/87.

Falcon Crest (CBS, role: Peter Stavros). "The Cradle Will Fall": Peter believes he will never be happy again at Falcon Crest because of its painful association with Skylar. He asks Angela to move with him to Monte Carlo, and she angrily refuses. He sends a letter: "Nothing would make me happier than to see you again, but I can't ask you to tear yourself away from your home and your family. The time that we've shared has been the happiest of my life. I love you. I'll always love you, Peter." Angela is enraged. No one gets away with walking out on her. Airdate 01/30/87.

Falcon Crest (CBS, role: Peter Stavros). "Topspin": Peter returns after a change of heart, but Angela isn't ready to welcome him back, still smarting from his rejection. He agrees to stay at a hotel while they try to work things out. Learning of the apparent rift, Richard tries to recruit Peter in his vendetta against Angela. Peter refuses. Richard then offers Peter a partnership in his wine distribution business, holding out some bait: the truth about Skylar/Kit and the fact that he doesn't believe the woman Peter cares for so much is actually dead. Airdate 02/06/87.

Falcon Crest (CBS, role: Peter Stavros). "A Piece of Work": Hoping to reconcile with Angela, Peter flies to Europe in search of incriminating

Chronology

evidence to use against Richard. If he can bring his wife's archenemy down, it may convince her of his love. Airdate 02/13/87.

Falcon Crest (CBS, role: Peter Stavros). "Dance of Deception": Angela conspires with Roland Saunders, the "rudest billionaire in the Fortune 500," to help her bring Richard down. Peter returns with the incriminating evidence he sought about Richard, but during Angela's international wine show at the spa, she is so fawning over Roland that Peter grows furious and returns to his hotel without telling her a thing about Richard. Airdate 02/20/87.

Falcon Crest (CBS, role: Peter Stavros). "Hat Trick": Peter and Angela are at loggerheads. Eric encourages Peter to show Angela the incriminating documents, but Peter is too proud to take the first step and leaves for San Francisco on business. He is shocked to run into Skylar/Kit (in a wig), but she pretends to be someone else and to not know him. Peter fears he is losing his mind. Meanwhile, Richard confronts Kit and threatens to expose her in his newspaper; after a melee over a gun, he gets her to confess all on videotape. He then heavily edits the tape to make everything Kit says about Angela sound like she has proof that Angela has always been using Peter for his money and never loved him at all. Richard shows the tape to Peter, and it convinces Peter to join Richard in his plans to destroy Angela. Airdate 02/27/87.

Falcon Crest (CBS, role: Peter Stavros). "Battle Lines": Peter confronts Angela and Roland Saunders, believing they hired Kit to pretend to be his stepdaughter in order to swindle him out of his fortune. Angela is baffled since nothing of the kind ever happened, but she is unable to convince Peter of her innocence, and she is angry that she should be accused in the first place. Angela decides she will be the one to solve the mystery of Kit Marlowe. Airdate 03/06/87.

Falcon Crest (CBS, role: Peter Stavros). "Nowhere to Run": It turns out that Roland Saunders is a criminal with ties to the art forgery ring that killed Peter's real stepdaughter Skylar. At a party, both Richard and Peter confront Saunders, and Peter seeks vengeance for Skylar's death. Roland Saunders is found dead in the winery. Airdate 03/13/87.

Falcon Crest (CBS, role: Peter Stavros). "Cold Hands": Peter is one of the suspects in Roland's murder. Melissa begins leading a double life as a singer named Veronique the Slumming Socialite at a bar on San Francisco's North Beach; Richard and Angela plot against one another with substituted wine shipments, and Lance's father, Tony, who is also Kit Marlowe's boyfriend, is implicated in Roland's murder. Airdate 03/27/87.

Chronology

Falcon Crest (CBS, role: Peter Stavros). "Body and Soul": Angela seeks to annul her marriage to Peter but is shocked to learn that he has already filed for divorce. She is further enraged when she discovers that he has bought out Richard and now has sole control over distributing Angela's wines. She vows to get her revenge. Airdate 04/03/87.

Falcon Crest (CBS, role: Peter Stavros). "Loose Cannons": With his marriage all but dead, Peter turns his attention to his son Eric, who has started leading a dissolute life of the idle rich. He also visits Tony, now in jail for Roland's murder, and urges him not to reveal anything about his relationship with Kit since it would be so incriminating. Airdate 04/10/87.

Falcon Crest (CBS, role: Peter Stavros). "The Great Karlotti": Peter Stavros has the grave of "Kit Marlowe" exhumed in Florida and tests on the corpse confirm that the body is actually that of his beloved stepdaughter Skylar, killed in an assassination attempt by men working for Roland. Airdate 05/01/87.

Falcon Crest (CBS, role: Peter Stavros). "Chain Reaction": At Tony's trial, Angela's plans for his swift conviction are derailed when Kit Marlowe shows up and confesses to the murder. Yet the evidence shows she cannot have done it because of her size and height. Shockingly, Peter then confesses to murdering Roland himself, describing the crime in great detail. Angela cannot believe her husband is the killer, and Eric cannot believe his father would do such a thing. But both Peter and Kit are arrested, with the DA believing they might have acted together somehow. Airdate 05/08/87.

Falcon Crest (CBS, role: Peter Stavros). "Desperation": Angela pays Peter's bail, and they reconcile. She has evidence of how Richard faked Kit's tape to make it seem like Angela didn't love him. She does. With all her heart. Peter returns the love, but he does not want to stay and face the murder charges. Angela helps him escape to his private Greek island, where he will be safe from prosecution. He takes Kit, whom he has come to think of as his daughter, whatever her true identity, and he disinherits Eric when his son refuses to come along. Airdate 05/15/87.

Happy 100th Birthday, Hollywood (ABC, role: Himself). Celebrity special; with numerous other guest stars. Airdate 05/18/87.

Falcon Crest (CBS, role: Peter Stavros). "Opening Moves": Angela reads the farewell letter from Peter Stavros but has no time to wallow in sadness when the truth comes out that her archnemesis Richard is actually the biological child who she thought had died during childbirth. And the drama continues without Peter. Airdate 10/02/87.

Chronology

The 32nd Annual Thalians Ball (NBC, role: Himself). Celebrity special; with numerous other guest stars. Airdate 10/17/87.

Win, Lose or Draw (Syndicated, role: Himself). Celebrity game show; with Cesar Romero, Vicki Lawrence, Delta Burke, Alice Ghostley, Lorenzo Lamas. Airdate 11/16/87.

Circus of the Stars (ABC, role: Himself). Celebrity special; with Cesar Romero as ringmaster and Delta Burke, Merv Griffin, Carol Channing, Candy Clark, Kirk Douglas, Tony Dow, Glenn Ford, Marla Gibbs, Pat Morita, Bronson Pinchot, Juliet Prowse, Richard Simmons, Andrew Stevens. Airdate 12/15/87.

1988

The 5th Annual American Cinema Awards (NBC, role: Himself). Celebrity special; with numerous other guest stars. Airdate 01/30/88.

The Late Show with Joan Rivers (Fox, role: Himself). Talk show hosted by Joan Rivers; with Cesar Romero, Frank Gorshin, Eartha Kitt, Julie Newmar. Airdate 04/28/88.

Mortuary Academy (Taurus Entertainment Company, role: Ship's Captain). Advertising copy: "It's sick. It's sexy, it's *Mortuary Academy* and it's not for the squeamish!" Christopher Atkins and Perry Lang inherit a mortuary school with the proviso that they attend classes and graduate. As a favor to his *Lust in the Dust* producer/director Bartel, Cesar Romero does a cameo as a ship's captain with a gag at the end of the film, accidentally pulling the skeletal hand off a corpse. *Landmark Films presents* Paul Bartel, Mary Woronov in *Mortuary Academy* starring Perry Lang, Tracey Walter as Dickson and Christopher Atkins as Max, Lynn Danielson-Rosenthal (credited as Lynn Danielson), Stoney Jackson, Anthony James; Special Appearance by Wolfman Jack and Cesar Romero as the Captain; Written by Bill Kelman; Produced by Dennis Winfrey, Chip Miller; Directed by Michael Schroeder; Production dates 06/08/87 to mid-July; Release date 05/20/88.

Judgment Day (Magnum Entertainment, role: Octavio). Two young American men get stuck in a small Mexican village named Santana where, unbeknownst to them, once a year Satan comes to Earth to claim souls. Their surreal adventure starts with a visit to the affable and charming Cesar Romero, a three-hundred-year-old cursed aristocrat. *A Rockport/Ferde Grofé Films Presentation, Judgment Day* starring Kenneth McLeod, David Anthony Smith, Monte Markham, Gloria Hayes; Special Guest Appearance by Peter Mark

Richman and Cesar Romero as Octavio; Produced by Ferde Grofé Jr. and Keith Lawrence; Written and Directed by Ferde Grofé Jr.; Release date 10/24/88.

Falcon Crest (CBS, role: Peter Stavros). "Changing Times": In the seventh season, Angela loses control of her winery to Melissa. At the start of the eighth, Peter Stavros returns searching for Eric, who has gone missing. Peter is no longer wanted for murder and has somehow been able to buy off the right authorities to ensure his continued freedom. He asks Angela to come back to live with him in Europe and find some peace away from the drama and turmoil of Falcon Crest, and she agrees. Airdate 10/28/88.

Falcon Crest (CBS, role: Peter Stavros). "Farewell My Lovelies": Peter learns that his son has had a breakdown and is in a mental institution in Paris. He prepares to leave with Angela, but once again she breaks his heart, changing her mind and staying to fight to regain her wine empire. Airdate 11/04/88.

The Tracey Ullman Show (Fox, role: Roland Diego). "Tell and Kiss": Tracey Ullman writes a tell-all with the torrid details of a long-ago affair with Cesar Romero. When they meet again, he wants to rekindle old flames; with Tracey Ullman, Cesar Romero, Dan Castellaneta, Anna Thomson. Airdate 11/13/88.

1989

CBS This Morning (CBS, role: Himself). Harry K. Smith hosts this segment on the news and talk show with a *Batman* reunion, coinciding with the release of Tim Burton's *Batman*; with Cesar Romero, Burgess Meredith, Julie Newmar, Burt Ward, Adam West. Airdate 06/14/89.

Bat Talk (Fox, role: Himself). A television special released a week after the premiere of Tim Burton's *Batman*; with Adam West, Burt Ward, Yvonne Craig, William Dozier, Frank Gorshin, Lee Meriwether, Vincent Price, Cesar Romero. Airdate 07/06/89.

The Joe Franklin Show (Syndicated, role: Himself). The oldest known television talk show, running uninterrupted from 1951 to 1993. In this episode, Cesar Romero gives short shrift to Corinne Calvet (his costar on multiple occasions) when she decries sexism and abuse in Hollywood; with host Joe Franklin, Cesar Romero, Edie Adams, Cornel Wilde, Corinne Calvet. Airdate 07/17/89.

Simple Justice (J2 Communications, role: Vincenzo DiLorenzo). Cesar Romero and Doris Roberts are Italian grandparents who become unlikely vigilantes when their pregnant granddaughter-in-law is brutally attacked during a bank robbery and lies in a coma after losing her unborn child.

Chronology

Street Law Associates presents Cesar Romero, Doris Roberts, John Spencer, Priscilla Lopez, Kevin Geer, Cady McClain and introducing Matthew Galle as Frankie in *Simple Justice*; Written by T. Jay O'Brien, Michael Sergio; Produced by Gigi Pritzker; Directed by Deborah Del Prete; Production dates mid-July to mid-September 1989; Release date 11/21/89.

This Is Your Life: Zsa Zsa Gabor (ITV, role: Himself). Surprise reunion series; with Michael Aspel, Chubby Checker, John Frederick, Magda Gabor, Zsa Zsa Gabor, Kathryn Grayson, Francesca Hilton, Bob Hope, Frankie Howerd, Barry Humphries, Ann Miller, Cesar Romero, Frédéric von Anhalt. Airdate 11/29/89.

1990

AFI Life Achievement Award: A Tribute to David Lean (ABC, role: Himself). Awards show; with Chevy Chase, Goldie Hawn, David Lean, Anthony Newley, Peter O'Toole, Gregory Peck, Cesar Romero, Omar Sharif, Steven Spielberg, Billy Wilder. Airdate 03/08/90.

American Masters, Preston Sturges: The Rise and Fall of an American Dreamer (PBS, role: Himself). Documentary; with Fritz Weaver, Peter Bogdanovich, Cesar Romero, Eddie Bracken, Joel McCrea, Andrew Sarris, Betty Hutton. Airdate 07/02/90.

Mulberry Street (CBS, role: Dominic Savoia). A failed series pilot about an independent businesswoman who winds up moving back home with her large, close-knit Italian family, including her grandfather, Cesar Romero; with Connie Sellecca, Eddie Mekka, Joely Fisher, Cesar Romero, Bradford Tatum, Mandy Ingber, Penny Santon, Shera Danese, Lila Kaye. Airdate 08/08/90.

Clive James' Postcard from Los Angeles (BBC, role: Himself). Talk show hosted by Clive James; with Kirstie Alley, Dudley Moore, José Eber, Kirk Douglas, Farrah Fawcett, Ryan O'Neal, George Peppard, Cesar Romero, Jaclyn Smith. Airdate 09/27/90.

Babes (Fox). Three plus-size sisters live their best lives in this sitcom lead-in to *The Simpsons*. "Dream Vacation": The sisters go to Club Med and meet Cesar Romero, a charming older gentleman à la Mr. Roarke from *Fantasy Island*; with Wendie Jo Sperber, Lesley Boone, Susan Peretz, Cesar Romero. Airdate 11/01/90.

The Golden Girls (NBC, role: Tony). "Girls Just Wanna Have Fun . . . Before They Die": Estelle Getty and Cesar Romero consummate their relationship, but when she tells him she loves him, his response is not what she

hopes; with Bea Arthur, Betty White, Rue McClanahan, Estelle Getty, Cesar Romero, Harold Gould. Airdate 11/24/90.

1991

Stars and Stripes: Hollywood and World War II (AMC, role: Himself). Documentary; with Cesar Romero, Douglas Fairbanks Jr., Bob Hope, Shirley Jones, Dorothy Lamour, Roddy McDowall, Tony Randall, Debbie Reynolds, Esther Williams. Airdate 11/11/91.

1992

The Howard Stern Show (MCA/All-American Television, role: Himself). Talk show; with Cesar Romero, Howard Stern, Robin Quivers, Martha Raye, Rose Marie. Airdate 04/04/92.

Jack's Place (ABC, role: Tony Yaniger). Hal Linden is a former jazz musician who opens a restaurant where romance is often on the menu. "Solo": Being alone is the theme of a subplot involving widower Mickey Rooney, still grieving his late wife, and erstwhile ladies' man Cesar Romero; with Hal Linden, Finola Hughes, Mickey Rooney, Cesar Romero, Starr Andreeff, George De La Pena, Michael DeBartolo, John Dye, Matt Nolan, Venus DeMilo Thomas, Shawn Weatherly. Airdate 06/16/92.

Murder, She Wrote (CBS, role: Marcello Abruzzi). Cesar Romero makes his final scripted television appearance and dances elegantly with Lansbury. "Murder in Milan": Cesar Romero is the star of a film adapted from one of Angela Lansbury's books. At the film's premiere in Milan, the producer is murdered; with Angela Lansbury, Susan Blakely, George Coe, Robert Desiderio, George DiCenzo, Paul Gleason, Robert Harper, Gary Kroeger, Leah Pinsent, Cesar Romero, Time Winters, Paul Ryan, Mary Wickliffe, Grace Kent. Airdate 09/20/92.

Hollywood Fantasy Christmas (Syndicated, role: Himself). Celebrity special hosted by Cesar Romero and Patrick Macnee; with David Carradine, Rita Coolidge, José Feliciano, Maureen McGovern, Lou Rawls, Helen Reddy. Airdate 12/19/92.

1993

Dame Edna's Hollywood (NBC, role: Himself). Comedy talk show hosted by Barry Humphries as Dame Edna; with Cesar Romero, Barry Manilow, Burt Reynolds, Sean Young. Airdate 01/02/93.

Chronology

Edna Time (Fox, role: Himself). Cesar Romero makes his final television appearance on this comedy talk show hosted by Barry Humphries as Dame Edna, inviting guests to her pretend Malibu home; with Luke Perry, Roseanne and Tom Arnold, Cesar Romero. Airdate 02/28/93.

Shirley Temple: America's Little Darling (Janson Media, role: Himself). Biographical documentary about child star Shirley Temple and her reign as a pint-size box office champion. Cesar Romero speaks well of her extraordinary charm, professionalism, fearlessness, and discipline. *America's Little Darling Shirley Temple* hosted by Tommy Tune; Written and Produced by Gene Feldman, Suzette Winter; Directed by Gene Feldman; Featuring: Sybil Brand, Frank Coghlan Jr., Alice Faye, Marilyn Granas, Darryl Hickman, Marcia Mae Jones, Dickie Moore, Cesar Romero, Richard R. Ross, Gloria Stuart, Delmar Watson, Jane Withers; Release date 08/31/93.

1994–1998 (Released Posthumously)

The Century of Cinema (Miramax, role: Himself). A documentary marking the one hundredth anniversary of the birth of film, interviewing many legendary twentieth-century filmmakers and stars; Directed by Caroline Thomas; Written by Bob Thomas; Producer Caroline Thomas; Release date 10/11/94.

Carmen Miranda: Bananas Is My Business (Channel 4 Films, role: Himself). Biographical documentary with fantasy and re-created sequences about the "Brazilian Bombshell" and "Lady in the Tutti-Frutti Hat," Hollywood and Broadway star Carmen Miranda. Romero speaks of her fondly. *International Cinema Presents Carmen Miranda: Bananas Is My Business* featuring Cesar Romero, Rita Moreno, Alice Faye, Aloysio de Oliveiro, Mario Cunha, Aurora Miranda, Synval Silva, Helena Solberg, Caribé da Rocha; A Film by Helena Solberg and David Meyer; Directed and Narrated by Helena Solberg; Produced by David Meyer and Helena Solberg; Release date 07/05/95.

Sonja Henie: Queen of the Ice (Janson Media, role: Himself). Biographical documentary about the Olympic skating champion and film star. Romero describes her as a "charming person" who lit up the screen. "No one expected her to be an actress." *A Presentation of Janson Media Sonja Henie: Queen of the Ice*; Written, Produced, and Directed by Edvard Hambro; Release date 08/31/95.

Chronology

The Right Way (GGT Entertainment, role: Don Genese). A prodigal son struggles to keep his father's business going, rekindle the relationship with his true love, and take on Cesar Romero, the local crime boss. *GGT Entertainment presents a George Taglianetti film*, Geoff Pierson, Bryan Kestner, Cheryl Lynn Michaels, Omar Kaczmarczyk, and Cesar Romero, *The Right Way* with Harold Pruett, Beth Chamberlin, Michael Prozzo, Joe Santos, Joseph Campanella, John Martino, Claire Kirk, David Jean Thomas; Original Story, Screenplay, Produced and Directed by George Taglianetti; Release date 12/28/98.

Selected Bibliography

Books and Articles

Basinger, Jeanine, and Sam Wasson. *Hollywood: The Oral History*. New York: Harper, 2022.

Bentley, Ben, and Scott Sebring. "'BATMAN' 1966–1968 Television Series—Shooting Dates." 66batman.com, 2023.

Berlatsky, Noah. "The Best Joker Is Still Cesar Romero in the '66 Batman TV Show, Hands Down." syfy.com, September 30, 2019.

Bowers, Scotty, and Lionel Friedberg. *Full Service: My Adventures in Hollywood and the Secret Sex Lives of the Stars*. New York: Grove, 2012.

Brooks, Tim, and Earle F. Marsh. *The Complete Directory to Prime Time Network and Cable TV Shows, 1946–Present*. New York: Ballantine, 2009.

Chandler, Charlotte. *Not the Girl Next Door*. New York: Simon and Schuster, 2008.

Collins, Sean T. "The Complete History of the Joker." rollingstone.com, December 16, 2019.

Crawford, Christina. *Mommie Dearest*. New York: William Morrow & Co., 1978.

Crawford, Joan. *My Way of Life*. New York: Simon and Schuster, 1971.

Crawford, Joan, and Jane Kesner Ardmore. *A Portrait of Joan*. New York: Doubleday, 1962.

Crow, David. "Joker: The Actors Who Have Played the Clown Prince of Crime in the Movies." denofgeek.com, July 6, 2023.

Davies, Marion. *Times We Had*. New York: Ballantine, 1985.

Ehrenstein, David. *Open Secret: Gay Hollywood, 1928–1998*. New York: William Morrow, 1998.

Eisner, Joel. *The Official Batman Batbook*. Bloomington, IN: Author House, 2008.

Eyman, Scott. *20th Century-Fox: Darryl F. Zanuck and the Creation of the Modern Film Studio*. New York: Running Press Adult, 2021.

Flurch, Y. Y., and Rian Hughes. *Batman: Facts and Stats from the Classic TV Show*. London: Titan, 2016.

Fragias, Leonidas. *Annual US Top Film Rentals 1912–1979*. Kindle Edition, 2017.

Fragias, Leonidas. *US Weekly Box Office Top 10 Charts of the 1930s*. Kindle Edition, 2017.

Selected Bibliography

Fragias, Leonidas. *US Weekly Box Office Top 10 Charts of the 1940s*. Kindle Edition, 2017.

Fragias, Leonidas. *US Weekly Box Office Top 10 Charts of the 1950s*. Kindle Edition, 2017.

Fragias, Leonidas. *US Weekly Box Office Top 10 Charts of the 1960s*. Kindle Edition, 2017.

Fragias, Leonidas. *US Weekly Box Office Top 10 Charts of the 1970s*. Kindle Edition, 2017.

Garza Bernstein, Samuel. *Mr. Confidential: The Man, His Magazine & the Movieland Massacre That Changed Hollywood Forever*. New York: Walford, 2006.

Garza Bernstein, Samuel. *Starring Joan Crawford: The Films, the Fantasy, and the Modern Relevance of a Silver Screen Icon*. Lanham, MD: Applause, 2024.

Griffith, Richard, and Arthur Mayer. *The Movies*. New York: Bonanza, 1957.

Hadleigh, Boze. *Hollywood Gays*. Bronx, NY: Magnus, 2013.

Hadleigh, Boze. *Scandals, Secrets, and Swan Songs: How Hollywood Stars Lived, Worked, and Died*. Guilford, CT: Lyons, 2021.

Halliwell, Leslie. *Halliwell's Film Guide*. New York: Macmillan, 1977.

Haskell, Molly. *From Reverence to Rape: The Treatment of Women in the Movies*. Chicago: University of Chicago Press, 1974.

Higham, Charles. *Bette: The Life of Bette Davis*. New York: Dell, 1981.

Hunter, Tab. *Tab Hunter Confidential*. New York: Algonquin, 2005.

Hyatt, Wesley. *Short-Lived Television Series, 1948 to 1978: Thirty Years of More Than 1,000 Flops*. Jefferson, NC: MacFarland, 2003.

Jaffe, S. *Higgins Family Report*. Brooklyn, NY: Brooklyn Historical Society, 2015.

Jeffers McDonald, Tamar. "Reviewing Reviewing the Fan Mags." *Film History* 28, no. 4 (2016): 29–57. https://www.jstor.org/stable/10.2979/filmhistory.28.4.02.

Kael, Pauline. *5001 Nights at the Movies*. New York: Picador, 1991.

Kashner, Sam, and Jennifer MacNair. *The Bad & the Beautiful: Hollywood in the Fifties*. New York: W. W. Norton, 2002.

Katz, Ephraim. *The Film Encyclopedia*. 7th ed. New York: HarperCollins, 2012.

Kearns, Burt. *Lawrence Tierney: Hollywood's Real-Life Tough Guy*. Lexington: University Press of Kentucky, 2022.

Lowe, Skip E. *The Boy with the Betty Grable Legs*. Los Angeles: Belle, 2001.

Mann, William J. *Behind the Screen: How Gays and Lesbians Shaped Hollywood*. New York: Penguin, 2001.

Mann, William J. *Wisecracker: The Life and Times of William Haines*. New York: Viking, 1998.

Mucciolo, Louis. *Eightysomething: Interviews with Octogenarians Who Stay Involved*. New York: Birch Lane, 1992.

Nelson, Richard. *Strictly Dishonorable and Other Lost American Plays*. New York: Theater Communications Group, 1986.

Quirk, Lawrence J., and William Schoell. *Joan Crawford: The Essential Biography*. Lexington: University Press of Kentucky, 2002.

Thomas, Bob. *Joan Crawford: A Biography*. New York: Simon and Schuster, 1978.

Selected Bibliography

Thomas, Bob. *Thalberg: Life and Legend*. Beverly Hills, CA: New Millennium, 2011.

Villeneuve, Hubert. *Teaching Anticommunism: Fred Schwarz and American Postwar Conservatism*. London: McGill-Queen's University Press, 2020.

Wallace, David. *Lost Hollywood*. Los Angeles: LA Weekly Books/St. Martin's, 2001.

Ward, Burt. *Boy Wonder: My Life in Tights*. Los Angeles: Logical Figments, 1995.

Webb, Clifton. *Sitting Pretty: The Life and Times of Clifton Webb*. Oxford: University Press of Mississippi, 2011.

West, Adam. *Back to the Bat Cave*. New York: Berkeley, 1994.

Whiting, Marvin Yeomans, and Robert G. Corley. *The Journal of the Birmingham Historical Society*. Birmingham, AL: Birmingham, 1980.

Williams, John L. *America's Mistress: The Life and Times of Eartha Kitt*. London: Quercus, 2014.

Zehme, Bill. *The Way You Wear Your Hat: Frank Sinatra and the Lost Art of Livin'*. New York: Harper, 1997.

Newspapers and Magazines

Asbury Park Evening Press
California Magazine
Chicago Sun-Times
Chicago Tribune
Film Daily
FilmInk
Hollywood Citizen-News
Hollywood Evening News
Hollywood Reporter
L.A. Weekly
Los Angeles City News
Los Angeles Daily News
Los Angeles Evening and Sunday Herald Examiner
Los Angeles Evening Herald and Express
Los Angeles Evening Herald Express
Los Angeles Evening News
Los Angeles Examiner
Los Angeles Herald Examiner
Los Angeles Herald Express
Los Angeles Magazine
Los Angeles Mirror
Los Angeles Times
Modern Screen
Motion Picture Herald Product Digest
New Republic
New York Daily News

Selected Bibliography

New Yorker
New York Evening Journal
New York Herald Tribune
New York Observer
New York Post
New York Times
New York World-Telegram
New York World-Telegram and the Sun
Omaha World-Herald
People Magazine
Photoplay
Pittsburgh Sun Telegraph
Rolling Stone
Sacramento Bee
Salt Lake Tribune
San Francisco Chronicle
Screenland
St. Louis Democrat
Tulane Drama Review
Variety

Websites

605magazine.com
66batman.com
allmovie.com
ancestors.familysearch.org
apocalypselaterfilm.com
archive.org
archives.com
avclub.com
bamfstyle.com
batman.fandom.com
beyondfest.com
catalog.afi.com
cinemaretro.com
cinematerial.com
colinedwards.medium.com
commons.wikimedia.org
ctva.biz
cubanstudiesinstitute.us
cultpix.com
denofgeek.com
ebay.com

Selected Bibliography

ebay.co.uk
epguides.com
falconcrest.fandom.com
falconcrest.org
filmaffinity.com
findagrave.com
friendsofcesarromero.bandcamp.com
hidingundercovrs.blogspot.com
historyofcuba.com
hollywoodsoapbox.com
imdb.com
jahsonic.com
kayfrancisfilms.com
mentalfloss.com
metv.com
moriareviews.com
moviesunlimited.com
mptvimages.com
mycg.uscg.mil
nightgallery.net
nndb.com
ok.ru
outofthepastblog.com
paleycenter.org
pastemagazine.com
rogerebert.com
rottentomatoes.com
spyguysandgals.com
syfy.com
tellytalk.net
thefamouspeople.com
thespinningimage.co.uk
tor.com
tvmaze.com
variety.com
videocollector.co.uk
vintagepaparazzi.com
walkoffame.com
web.archive.org
westernclippings.com
wikibooks.org
wikimedia.org
wikipedia.com
wikitree.com

Selected Bibliography

wouldyoubelieve.com
youtube.com

Film and Television Documentaries

Bat-Mania: From Comics to Screen, Burbank Video, 1989.
Carmen Miranda: Bananas Is My Business, Channel 4 Films, 1995.
Cesar Romero: In a Class by Himself, Biography, Actuality Productions, Fox Television Studios, A&E Networks, 2000.
Skip E. Lowe Looks at Hollywood, Syndicated, 1985.
Sonja Henie: Queen of the Ice, Janson Media, 1995.
Starring Adam West, Chromatic Films, Relativity Media, 2013.

Index

ABC's Silver Anniversary Celebration (1978), 232
ABC Stage 67 (1966), 207
accents, 35
Actor's Society Benefit Gala, The (1949), 162
advertisements, 112
AFI Life Achievement Award: A Tribute to David Lean (1990), 250
Alan Young Show, The (1951), 164
Alias Smith and Jones (1971–1972), 223, 225–26, 227
Ali Baba Goes to Town (1937), 150
All in the Family (1971–1975), 222
All New Truth or Consequences, The (1961), 193
All Points West, 23
All-Star Party for Clint Eastwood (1986), 245
All-Star Party for "Dutch" Reagan (1985), 240. See also Reagan, Ronald
All-Star Party for Lucille Ball (1984), 236. See also Ball, Lucille; Here's Lucy; Lucy-Desi Comedy Hour, The
All Star Revue (1952–1953), 77, 167, 168
Allyson, June, 9, 78, 220, 241
Always Goodbye (1938), 51, 150–51
American Masters, Preston Sturges: The Rise and Fall of an American Dreamer (1990), 251
Americano, The (1955), 73, 79, 173–74
Ann Sothern Show, The (1960), 191
Annual Friars Club Tribute Presents a Salute to Gene Kelly, The (1985), 240
archives, 9, 12–13

Armored Car (1937), 44, 79, 149
Arnaz, Desi, 84, 109, 181. See also Lucy-Desi Comedy Hour, The
Around the World in Eighty Days (1956), 83, 179
Arthur Murray Party, The (1958–1959), 85, 185, 186, 187
Astell, Hal C. F., 70–71, 143
Avalon, Frankie, 88, 90, 197, 202, 216

Babes (1990), 251
Ball, Lucille, 84, 110, 181, 203, 217, 236
Banacek (1974), 228
Batman (1989), 101, 102–4, 132–33
Batman (TV show), 107, 204–5, 207, 208, 209, 210, 212–14; cast, 96–97; premiere, 100–101; ratings, 6, 104–5, 106. See also Joker, the
Batman: fandom, 103, 119; The Joker Is Wild, 99–100; plot details, 102
Batman: The Movie (1966), 206
Bat Talk (1989), 250
Baxter, Anne, 72, 78, 103, 212
Baxter, Warner, 2, 51, 52, 53, 152–53
Beachcomber, The (1962), 194
Beatles, the, 111
Beautiful Blonde from Bashful Bend, The (1949), 26, 162–63
Ben Casey (1965), 202
Berrenger's (1985), 118, 237, 238
Betty Hutton Show, The (1960), 189
Bewitched (1970), 222
Bicentennial Minutes (1974), 229
Bigelow Theatre, The (1951), 164
Blacke's Magic (1985), 241

261

Index

Blake, Madge, 97, 204, 206
B list movies, 30, 42, 54, 56, 70, 71
Blood and Sand (1941), 56
Bob Braun Show, The (1979), 233
Branded (1965), 201–2
Brazil, 79
British Agent (1934), 34, 143
Buck Rogers in the 25th Century (1979), 233
Burke's Law (1963–1965), 198, 199, 200, 201

camp, 41, 96
Campbell Summer Soundstage (1952), 167
Cantor, Eddie, 35, 77, 80, 96, 150, 157, 165–67
Captain from Castile (1947), 67–68, 161
Cardinal Richelieu (1935), 38, 39, 43, 145
cards, playing games of, 35
Carioca tigre (aka *A Fera Carioca*, 1976), 231–32
Carmen Miranda: Bananas Is My Business (1995), 135, 253. *See also* Miranda, Carmen
Carnival in Costa Rica (1947), 65, 68, 160–61
Castilian, The (aka *El valle de las espadas*, 1963), 90, 197
CBS This Morning (1989), 250
Celebrity Bowling (1971), 113, 224
Celebrity Playhouse (1956), 176
Central Park (New York), 12, 86–87
Century of Cinema, The (1994), 253
Cesar's World, 110
Chain Letter (1966), 205
Channing, Carol, 110, 115, 194, 216, 236, 248
Charlie Chan at Treasure Island (1939), 153–54
Charlie's Angels (1980), 2, 115, 121, 233–34
Chase (1973), 228
Cheating Cheaters (1934), 35–36, 143
Chevron Hall of Stars (1956), 180
Chevy Mystery Show, The (1960), 190
Chico and the Man (1977), 114–15, 232
Circus of the Stars (1987), 248

Cisco Kid, 52, 53–55; *The Cisco Kid and the Lady*, 154; *The Gay Caballero*, 155; *Lucky Cisco Kid*, 155; *The Return of the Cisco Kid*, 52–53, 153; *Ride On Vaquero*, 156; *Romance of the Rio Grande*, 155; *Viva Cisco Kid*, 154–55
Cisco Kid and the Lady, The, 154. *See also* Cisco Kid
Climax! (1954, 1957), 172, 180
Clive James' Postcard from Los Angeles (1990), 251
Clive of India (1935), 38, 39–40, 44, 144
Clown Alley (1966), 206–7
Colgate Comedy Hour, The (1951–1953), 77, 80, 165, 166, 167, 170
color, films in, 52
Comics Code Authority, 7
communism, 86, 87, 92
Computer Wore Tennis Shoes, The (1969), 107, 113, 219–20, 226
Coney Island (1943), 3, 60, 160
Confidential (magazine), 108
Crawford, Joan, 6, 35, 50, 113, 120, 172
Cuba, 11–12, 13, 14, 58, 79, 86, 92, 157

Dame Edna's Hollywood (1993), 135, 252
Damon Runyon Theater (1955), 175
Dance Hall (1941), 55, 56, 60, 157
dancing: *Dance Hall*, 157; Romero and (overview), 14, 15, 16–17, 21, 35, 78, 80, 95; Romero and Higgins, 18, 19–21; Romero and Murphy, 40; Romero and Vernille, 21–22; the Twist, 85–86
Dangerously Yours (1937), 49, 50, 150
Daniel Boone (1966–1967, 1969), 204, 210, 219
Darin, Bobby, 88, 89, 195
Darvi, Bella, 82–83, 174
Davis, Joan, 51, 52, 151, 163
Death Valley Days (1959), 187
Dee, Sandra, 88, 89, 195
Deep Waters (1948), 8, 69, 161
Della (1969), 218
Delta Kappa Alpha Silver Anniversary Banquet (1963), 195
Depression era. *See* Great Depression

262

Index

Devil Is a Woman, The (1935), 13, 36–37, 38, 41–42, 84, 145
Diamond Jim (1935), 43, 146
Dick Powell Theatre, The (1963), 196
Dietrich, Marlene, 13, 36, 38–39, 41–42, 48, 84, 145, 180
Dinah! (1974), 229
Dinah Shore Chevy Show, The (1959), 187
Dinner at Eight (Kaufman, Ferber), 9, 28, 29
Divine, 117
Donovan's Reef (1963), 91–92, 197
Don't Change Your Husband, 93
Douglas, Paul, 72, 163, 179
Dozier, William, 7, 94–95, 96, 97, 99, 101, 102, 103, 105, 204, 206, 250
drag queens, 109, 133
Dream Girl of 1967, The (1967), 208–9, 211–12
Dr. Kildare (1964), 199
drugs, 110, 111
DuPont Show of the Week, The (1961), 193

Edgar Bergen Show, The, 73
Edna Time (1993), 135, 252
Ed Wynn Show, The (1950), 75, 163
effeminacy, 2
Ellery Queen (1976), 231
Entertainment 1955 (1955), 174
Europe, 14, 74

Falcon Crest (1985–1988), 239, 240, 241–48, 249; other cast members, 121–22; press for, 121; privilege and wealth in, 120; Romero's casting in, 118, 122; shooting in Spain, 116; storylines, 123–29; Wyman's casting in, 118, 120, 121
Family Feud Hollywood Walk of Fame (1985), 118, 237
Fantasy Island (1979, 1981, 1983), 115, 232–33, 234, 235
Faye, Alice, 3. See also *This Is Your Life: Alice Faye*
F.B.I. Girl (1951), 77, 165
Ferrer, Jose, 94, 95, 120
15 Maiden Lane (1936), 44, 148

5th Annual American Cinema Awards, The (1988), 248
Five Fingers (1960), 191
Five of a Kind (1938), 52, 151
Flesh and Bullets (1985), 238–39
Follow the Sun (1962), 105, 194
Fonda, Henry, 64, 158
Ford, John, 48, 91, 130, 149, 197
Ford Television Theatre, The (1953, 1957), 78, 168, 181
Forsythe, John, 121, 233, 234
Fox (20th Century): government and, 58, 67; merger to create, 33; Power and, 66; releases, 70, 71; Romero and, 47, 49, 50, 72, 73; units at, 54
Fractured Flickers (1963), 198
Friends of Cesar Romero (musical group), 129–30
Frontier Marshal (1939), 153
Furness, Betty, 6, 24, 38, 49, 50, 78, 120, 184, 207

Gable, Clark, 35, 64
games, 66
Garson, Greer, 69, 78, 162
Gay Caballero, The (1940), 155. See also Cisco Kid
gay men, 6, 33, 89, 113–14
gender, playing with, 80
Gentleman at Heart, A (1942), 3, 158
George Gobel Show, The (1959), 186
Get Smart (1968), 109, 214
Getty, Estelle, 133, 251
Gilbert Gottfried's Amazing Colossal Podcast, 131
Gisele MacKenzie Show, The (1957), 182
Glaser, Allan, 117, 237
Gleason, James, 110, 158, 183
Goldberg, Whoopi, 9, 122, 241
Golden Girls, The (1990), 133, 251
Golden Globe awards and nominations, 9, 89–90, 110, 122, 196, 241
Gombell, Minna, 29–30, 142, 143
Good Fairy, The (1935), 36, 38, 144–45
Good Neighbor policy, 4, 57–58
Gorshin, Frank, 97, 103, 111, 206, 216, 248, 250

Index

Grable, Betty, 3, 57–59, 60, 65, 70, 71, 109, 159–60, 162–63, 219
Grand Opening of Walt Disney World, The (1971), 225
Great American Broadcast, The (1941), 56, 156–57
Great Depression, 32, 33, 77
Great Diamond Robbery, The. See *Dangerously Yours*
Grinde, Nick, 44, 148
Gruen Guild Theater (1951), 166

Hadleigh, Boze, 109
Haines, Billy, 113, 114
Half Nelson (1985), 236, 238
Hamilton, Neil, 97, 204, 206
Happy Go Lovely (1951), 76, 164
Happy Landing (1938), 51, 150
Happy 100th Birthday, Hollywood (1987), 248
Hart to Hart (1983), 115, 235
Haunted Mouth, The (1974), 229
Havoc, June, 74–75, 163–64
He Married His Wife (1940), 154
Henie, Sonja, 3, 51, 60, 78, 135, 151, 160, 253. See also *Sonja Henie: Queen of the Ice*
Here's Edie (1963), 195
Here's Hollywood (1961), 192
Here's Lucy (1969), 110, 216. See also Ball, Lucille; *Lucy-Desi Comedy Hour, The*
Heywood, Anne, 113, 218
Higgins, Lisbeth, 18–20
history, living through, 33
Hold 'Em Yale (1935), 38, 39, 43, 145–46
Hollywood, social life in, 56
Hollywood Exclusive (1954), 172
Hollywood Fantasy Christmas (1992), 252
Hollywood Goes to a World Premiere (1964), 200
Hollywood Squares, The (1967–1969), 109, 209, 210–11, 213, 214–15, 217, 219
Hollywood Steps Out, 55
Hotel de Paree (1959), 189
Hot Millions (1968), 109–10, 215–16
House Is Not a Home, A (1964), 92–93, 200
Hovick, Louise, 51–52, 150. See also Lee, Gypsy Rose

Howard Stern Show, The (1992), 251
Hugo, Victor, 97
Hunter, Ross, 88–89, 195
Hunter, Tab, 6, 108–9, 117, 118, 228, 237

If a Man Answers (1962), 89, 90, 195
India, 47
Ironside (1974), 229
It's Your Bet (1971, 1973), 224, 227
It Takes a Thief (1970), 220
I've Got a Secret (1953), 80–81, 168

Jack's Place (1992), 134, 251–52
Jeffersons, The (1975–1985), 222
Jerry Lewis Show: From This Moment On, The (1962), 195
Jewishness, 33
Jimmy Durante Show, The, 131
Jimmy Stewart Show, The (1971–1972), 224–25, 226
Joe Franklin Show, The (1989), 250
Joey Bishop Show, The (1967–1968), 109, 211, 212, 214
John Gary Show, The (1969), 216
Joker, the: appearance, 97–98; casting, 94–95; laugh, 99; origins, 7, 33; queerness and, 2; reception in fandom, 7, 94; Romero as, 95, 97, 98, 104, 135, 204–5, 206, 207, 208, 209, 210, 212–14. See also Batman
Joker Is Wild, The, 99–100
Judgment Day (1988), 249
Julia (1970), 221, 222
Julia Misbehaves (1948), 69, 70, 162
Jungle, The (1952), 77, 166

Kane, Bob, 97, 206
Kazan, Lainie, 117, 237
Keep Talking (1958), 185
Kendall, Kay, 168–69
Keyhole (1962), 194
Kid Millions, 35
Kitt, Eartha, 103, 106, 201, 212–13, 248

Lamas, Fernando, 116, 123, 211–12
Lamas, Lorenzo, 116, 121, 123, 124, 239, 243, 248

Index

Late Show with Joan Rivers, The (1988), 249
Latitude Zero (1970), 112–13, 221
Leather Saint, The (1956), 178
Ledger, Heath, 7, 94, 97
Lee, Gypsy Rose, 51–52, 150, 151, 217, 240. *See also* Hovick, Louise
Lee, Ruta, 64–65, 84, 88, 108, 115, 134, 192, 200, 214–15, 224, 235
LGBTQIA+ people/culture, 55, 107; representations of, 1–2
Life with Linkletter (1970), 220
Lippert, Robert L., 77, 165, 166
Little Princess, The (1939), 2, 52, 152–53
Loren, Sophia, 121–22
Lost Continent (1951), 77, 165
Love, American Style (1971), 223–24
Love Before Breakfast (1936), 43, 147
Love Boat, The (1984–1986), 115, 236, 237, 243
Love That Brute (1950), 72, 163
Lubitsch, Ernst, 70, 132, 162
Lucky Cisco Kid (1940), 155. *See also* Cisco Kid
Lucy-Desi Comedy Hour, The (1957), 84, 181. *See also* Arnaz, Desi; Ball, Lucille
Lust in the Dust (1985), 117–18, 237
Lux Video Theatre (1955), 175

Mad Empress, The, 45
Madigan's Millions (1968), 109, 214
Magnum, P.I. (1985), 118, 236
Make Me Laugh (1958), 184
Man from U.N.C.L.E., The (1965), 202
Mantilla, Maria, 11–13, 15, 19, 58, 79, 91
Man Who Laughs, The, 97, 98
Marriage on the Rocks (1965), 93, 203
Martha Raye Show, The (1954–1956), 73, 81, 171, 172, 173, 175, 177
Martí, José, 12–13, 79, 86–87, 110
Matinee Theatre (1957), 181
Matt Houston (1982), 234–35
Max Factor, The, 115
McClanahan, Rue, 133, 251
Medical Center (1975), 231
mental health, 45, 115
Meredith, Burgess, 10, 97, 102, 103, 111, 198, 206, 208, 216, 250

Meriwether, Lee, 102, 103, 206, 250
Merman, Ethel, 35, 38, 51, 104, 150
Merv Griffin Show, The (1967, 1969–1973), 211, 219, 220, 221, 222, 223, 225, 226, 228
Metropolitan (1935), 43, 147
Mexico, 67–68, 79
MGM Studios, 34, 35, 69, 113
Midas Run (1969), 113, 217–18
Mike Douglas Show, The (1966, 1970, 1980), 206, 207, 221, 234
Milton Berle Show, The (1950), 75, 77, 163, 167, 168
Miracle of Morgan's Creek, The, 71
Miranda, Carmen, 3, 57–58, 59, 65, 130, 131, 134, 135, 157–58, 159, 168, 253. *See also Carmen Miranda: Bananas Is My Business*
Mis Secretarias Privadas (1959), 188
Mission to Glory: A True Story (aka *The Father Kino Story*, 1976), 231
Mod Squad (1972), 227
Montalban, Ricardo, 114, 115, 231, 232–33, 234, 235
Montgomery, George, 3, 60, 154, 159, 160
Mooch (aka *Mooch Goes to Hollywood*, 1971), 225
Mortuary Academy (1988), 249
Movie Game, The (1970), 220
Mulberry Street (1990), 251
Murder, She Wrote (1985, 1992), 118, 134, 238, 252
Murphy, George, 4–5, 23, 35, 40, 56, 87, 236
My Lucky Star (1938), 51–52, 151

Naked Sword, The, 73
Name's the Same, The (1952), 78, 167
Nanny and the Professor (1971), 223
Napier, Alan, 96–97, 191, 204, 206, 229
Navy Log: The Beach Pounders (1957), 182
Nazism, 87, 160
NBC Comedy Hour, The (1956), 177
Newmar, Julie, 97, 102, 238, 248, 250
Nicholson, Jack, 7, 132, 133
Night Gallery (1971), 225

Index

Niven, David, 66, 76, 164, 179, 180, 198
Nobody's Fool (1936), 44, 148
Now You See Him, Now You Don't (1972), 113, 226–27

Oakie, Jack, 3, 56, 60, 157, 160
Object Is, The (1964), 199
Ocean's Eleven (1960), 87–88, 190
O'Hara, John, 23–25
Once a Thief . . . (1950), 74–75, 163–64
Once Upon a Wheel (1971), 224
On Your Way (1953), 170
Orchestra Wives (1942), 158
Oscar nominations and awards, 69, 83, 110
otherness, 28, 33
Over Easy (1979), 232

Paramount Decree, 69–70, 74
Passport to Danger (1954–1958), 173, 174–75, 176–79, 180, 181, 183, 184, 185; finances for, 82; Romero and, 73; storyline, 78–79
Pat Boone in Hollywood (1968), 213
Patrice Munsel Show, The (1958), 183
Payne, John, 3, 58–59, 64, 157–58, 159
Pepe (1960), 191–92
Pepsi-Cola Playhouse, The (1954), 172
Perón, Eva, 4, 67
Perón, Juan, 4, 67
Person to Person (1960), 190
Pete and Gladys (1960), 190–91
Phoenix, Joaquin, 7, 94, 97
Place the Face (1955), 174
Playhouse, The, 82
poverty, 120
Power, Annabella (Tyrone Power's wife), 56, 66, 67
Power, Tyrone: in *Captain from Castile*, 67–68; career, 64, 90; life and death, 76, 84–85, 90, 108, 109, 123; memories of, 105, 133; Romero and, 4, 66–67, 109
Preminger, Otto, 70, 104, 110, 111, 216
Presle, Micheline, 89, 195
Prisoners of the Casbah (1953), 73, 79, 169
Private Secretary (1956), 84

Production Code, 33
Proud and Damned, The (1972), 106, 226
Public Enemy's Wife (1936), 44, 148

queerness, 1–2
Quick as a Flash (1953), 170

Racers, The (1955), 82–83, 174
racial identity, 15, 16–17, 40, 44, 47, 49
radio, 56
Rainbow Girl (1982), 234
Rat Pack, 87, 89
Rawhide (1959, 1962–1963, 1965), 188, 194, 197, 203
Reagan, Ronald, 87, 89, 114, 120–21, 126, 245. See also *All-Star Party for "Dutch" Reagan*
Real Tom Kennedy Show, The (1970), 221
Red, White and Black, The (1970), 222–23
Red Skelton Hour, The (1956–1957, 1959–1965, 1967, 1970), 176, 180, 181, 187, 189, 192, 195, 196, 198, 199, 203, 210, 220–21
Rendezvous (1935), 43, 69, 146–47
Repp, Stafford, 97, 204, 206
Return of the Cisco Kid, The (1939), 52–53, 153. See also Cisco Kid
Ride On Vaquero (1941), 156. See also Cisco Kid
Right Way, The (1998), 134, 135, 253
Riptide (1985–1986), 118, 122, 238, 242
Roberts, Doris, 8, 107, 133, 250
Robinson, Jerry, 97
Roland, Gilbert, 33, 82, 83, 174, 179–80
Romance of the Rio Grande (1940), 155–56. See also Cisco Kid
Romero, Cesar: adult life, 33–34, 35; animals and, 52; awards and recognition, 88, 89, 116, 122, 129–30; birth and death, 7, 11, 134; businesses (outside acting), 114; camp and, 94; comedy skills, 51, 52, 77–78, 123; early years, 13–14, 15–16, 17–18; fandom around, 37, 39–40; filmography, 7–8; friendships, 6, 18–19, 35, 64, 65, 84, 87, 115, 120–21, 134; hard times, 73–74, 114; health,

266

Index

22, 133; housing arrangements, 22, 23, 32, 45, 55, 114; intersectionality and, 3-4; jobs, 15, 17, 19, 22, 23, 61; as the Joker, 1, 95, 97, 98, 104, 135, 204-5, 206, 207, 208, 209, 210, 212-14; military service, 60-65, 74, 114; mustache, 44-45, 98; nicknames, 4-5, 37; nightlife, 4, 6, 35; as other, 28; physical appearance, 52-53, 55; private life, 33-34, 109; privilege and wealth, 73-74, 91, 114; race, 3-4, 15, 16-17, 40, 44, 47; recordings, 83-84; relationships and romance, 4, 5-6, 55-56, 57, 77, 95, 108, 130, 131-32, 134; sexuality, 55, 81, 91, 107-9, 114, 131; social life, 56, 65, 66, 116; stunts, 54; travels, 66-67, 77, 79; writing, 110. *See also* Mantilla, Maria; Martí, José; Romero, Cesar, Sr.

Romero, Cesar, Sr., 13, 15-16, 17, 19, 21, 45, 77

Romero, Eduardo, 45, 64

Romero, Graciela/Grace, 45, 65

Romero, Maria, 32, 45, 64-65, 133

Rosemary Clooney Show, The (1957), 181

Runaway, The (aka *Saint Mike*, 1961), 193

Russell, Kurt, 107, 113, 219-20, 226, 230

Russia, 34

Rutherford, Ann, 38, 95, 159, 166, 167

salt and pepper shakers, 58

Salute to Stan Laurel (1965), 203

Saturday Night Revue, The (1954), 172

Saturday Night Revue with Jack Carter, The (1950-1951), 75, 163, 164

Saturday Spectacular: Manhattan Tower (1956), 180

Savalas, Telly, 90, 110, 112, 198, 216

scandals, 108

Scarlet Empress, The, 39

Schlitz Playhouse (1952, 1957), 78, 167, 181

Scotland Yard Inspector (1952), 167

2nd Annual American Cinema Awards, The (1985), 240

Selby, David, 121, 123, 239

Semple, Lorenzo, Jr., 94, 96, 206

Sergeant Deadhead (1965), 202

Seven Deadly Arts, The, 105

77 Sunset Strip (1963), 198

7 Women from Hell (1961), 87, 105, 193

Shadow Laughs, The (1933), 28-29, 30, 141, 142

Shadow Man (1953), 73, 168-69

Shellabarger, Samuel, 67, 72

She's Dangerous (1937), 44, 79, 149

Shirley Temple: America's Little Darling (1993), 135, 252. *See also* Temple, Shirley

Show Them No Mercy! (1935), 5, 43, 53, 147

Simple Justice (1989), 107, 133, 250

Sinatra, Frank, 87, 88, 89, 93, 95, 180, 190, 203

skating, 50, 51, 52

Skidoo (1968), 110-11, 216

Skip E. Lowe Looks at Hollywood (1985), 240

Smith, C. Aubrey, 47, 48, 144, 149

Social Register, The (Loos, Emerson), 23

Songs by a Latin Lover (1958), 83

Sonja Henie: Queen of the Ice (1995), 135, 253. *See also* Henie, Sonja

Sontag, Susan, 41, 96

Sophie's Place (aka *Crooks and Coronets*, 1969), 110, 112, 217

Spectre of Edgar Allan Poe, The (1974), 229

Spelling, Aaron, 115, 122, 232, 233

Springtime in the Rockies (1942), 3, 58-59, 159

Stagecoach West (1960-1961), 191, 192-93

Star Is Born World Premiere, A (1954), 172

Stars and Stripes: Hollywood and World War II (1991), 251

Stars over Hollywood (1951), 78, 164-65

Stewart, Jimmy, 64, 224-25, 226

stock market crash, 32

Stonewall protest, 107

Story of Mankind, The (1957), 181-82

Strange Wives (1934), 38, 143-44

Street Singer, The, 21

Strictly Dishonorable, 9, 25-27, 76, 83

Index

Strongest Man in the World, The (1975), 113, 230–31
Studio One (1958), 184
Stump the Stars (1962), 195
sugar, 14
Sullavan, Margaret, 27, 35, 36, 50, 144–45
Sword of Granada, The (*El corazón y la espada*, 1953), 79, 170–71

tabloids, 108
Take a Good Look (1959–1961), 187–90, 191, 192
Talent for Loving, A (1969), 110, 111, 216
Tales of Manhattan (1942), 158–59
Tall, Dark and Handsome (1941), 3, 55, 56, 72, 156, 163
Target (1958), 184
Target: Harry (1969), 218
Target: The Corruptors! (1962), 194
Temple, Shirley, 2, 46, 47–49, 52, 109, 135, 149, 152, 252. See also *Shirley Temple: America's Little Darling*
Tennessee Ernie Ford Show, The (1957–1959), 180, 183, 186
Texan, The (1959), 187
That Lady in Ermine (1949), 70, 162
T.H.E. Cat (1967), 207
Thin Man, The (1934), 29, 30–31, 34, 113, 142–43
32nd Annual Thalians Ball, The (1987), 249
This Is Your Life: Alice Faye (1984), 20, 236. See also Faye, Alice
This Is Your Life: Zsa Zsa Gabor (1989), 250
Thousand and One Knights and Ladies, The, 20
Timber Tramps, The (1973), 227
Tonight Show Starring Jack Paar, The (1958), 184
Tonight Show Starring Johnny Carson, The (1965), 201
Tracey Ullman Show, The (1988), 249. See also Ullman, Tracey

20th Century Fox: government and, 58, 67; merger to create, 33; Power and, 66; releases, 70, 71; Romero and, 47, 49, 50, 72, 73; units at, 54
Two on a Guillotine (1965), 201

Ullman, Tracey, 132, 249. See also *Tracey Ullman Show, The*
Universal Studios, 35–36, 43, 45–46, 49
Uslan, Michael, 97

variety shows, 77–78, 81
Vega$ (1978), 232
Veidt, Conrad, 97, 106
Vera Cruz (1954), 73, 81, 82, 172–73
Vera-Ellen, 65, 76, 78, 160, 161, 164
Villa!! (1958), 184–85
Virginia Graham Show, The (1971), 224
Viva Cisco Kid (1940), 154–55. See also Cisco Kid
von Sternberg, Josef, 36, 38–39, 41–42, 145
Vosburgh, Marcy, 115, 116, 134

Wagon Train (1958), 85, 185
Walk of Western Stars (California), 130
Waltons, The, 119–20
Ward, Burt, 96–97, 103, 204, 206, 250
Wayne, John, 88, 91, 130, 197
Week-End in Havana (1941), 3, 55, 57, 58, 157–58
Wee Willie Winkie (1937), 2, 47–49, 149, 150
Weisman, Greg, 94
We Shall Return (aka *Force of the Winds*, 1963), 92, 196
West, Adam, 96–97, 98, 99, 102, 103, 204, 206, 250
We Think the World Is Round (1984), 236
What's My Line? (1952, 1954, 1957–1959), 73, 78, 167, 171, 181, 183, 184, 187
Where the Mountains Meet the Sea (1959), 185
White, Betty, 115

Index

Wife, Husband and Friend (1939), 51, 52, 53, 152–53
Win, Lose or Draw (1987), 248
Wintertime (1943), 3, 60, 160
Witness for the Prosecution, 84
women, misogynistic treatment of, 60
Woody Woodbury Show, The (1967–1968), 211, 215
World War II, 59–65, 160
Wyman, Jane, 38, 89, 114, 118, 120–23, 126, 129, 134, 181, 237, 239, 245

Yacko, Robert, 115
You Don't Say (1963, 1966), 196–97, 198, 206
Young, Gig, 94, 95, 120
Your Chevrolet Showroom (1953–1954), 81–82, 168–70, 171, 172

Zane Grey Theatre (1958, 1961), 88, 184, 189, 192
Zanuck, Darryl F., 35, 46, 60, 65, 67, 82. *See also names of specific films*
Zorro (1959), 85, 186

About the Author

Photo by Joshua Michael Shelton

Stonewall Book Award–winning writer Samuel Garza Bernstein is a best-selling author, screenwriter, and playwright whose work often reflects the wild intersections of modern life. He was born to an undocumented Mexican mother who grew up with a White American identity and a Jewish father who threw in his lot with the Palestinians when the family lived in Cairo in the early 1970s, while Israel and Egypt were still at war. In his own telling, Garza Bernstein was a gay Jewish kid surrounded by Egyptians, living in his head and spinning stories. His family was nomadic, and he grew up all over the world. He has worked in just about every aspect of show business, in a career that began at the age of seventeen when he graduated a year early from high school in Austin, Texas, and moved alone to New York City. He, husband Ronald Shore, and their pack of incorrigible dachshunds split their time between Porto, Portugal, and Los Angeles, California.

Screen Classics

Screen Classics is a series of critical biographies, film histories, and analytical studies focusing on neglected filmmakers and important screen artists and subjects, from the era of silent cinema through the golden age of Hollywood to the international generation of today. Books in the Screen Classics series are intended for scholars and general readers alike. The contributing authors are established figures in their respective fields. This series also serves the purpose of advancing scholarship on film personalities and themes with ties to Kentucky.

Series Editor Patrick McGilligan

Books in the Series
Olivia de Havilland: Lady Triumphant
 Victoria Amador
Mae Murray: The Girl with the Bee-Stung Lips
 Michael G. Ankerich
Harry Dean Stanton: Hollywood's Zen Rebel
 Joseph B. Atkins
Hedy Lamarr: The Most Beautiful Woman in Film
 Ruth Barton
Rex Ingram: Visionary Director of the Silent Screen
 Ruth Barton
Conversations with Classic Film Stars: Interviews from Hollywood's Golden Era
 James Bawden and Ron Miller
Conversations with Legendary Television Stars: Interviews from the First Fifty Years
 James Bawden and Ron Miller
They Made the Movies: Conversations with Great Filmmakers
 James Bawden and Ron Miller
You Ain't Heard Nothin' Yet: Interviews with Stars from Hollywood's Golden Era
 James Bawden and Ron Miller
Charles Boyer: The French Lover
 John Baxter
Von Sternberg
 John Baxter
Hitchcock's Partner in Suspense: The Life of Screenwriter Charles Bennett
 Charles Bennett, edited by John Charles Bennett
Hitchcock and the Censors
 John Billheimer
The Magic Hours: The Films and Hidden Life of Terrence Malick
 John Bleasdale
A Uniquely American Epic: Intimacy and Action, Tenderness and Violence in Sam Peckinpah's The Wild Bunch
 Edited by Michael Bliss
My Life in Focus: A Photographer's Journey with Elizabeth Taylor and the Hollywood Jet Set
 Gianni Bozzacchi with Joey Tayler
Hollywood Divided: The 1950 Screen Directors Guild Meeting and the Impact of the Blacklist
 Kevin Brianton
He's Got Rhythm: The Life and Career of Gene Kelly
 Cynthia Brideson and Sara Brideson

Ziegfeld and His Follies: A Biography of Broadway's Greatest Producer
 Cynthia Brideson and Sara Brideson
Eleanor Powell: Born to Dance
 Paula Broussard and Lisa Royère
The Marxist and the Movies: A Biography of Paul Jarrico
 Larry Ceplair
Dalton Trumbo: Blacklisted Hollywood Radical
 Larry Ceplair and Christopher Trumbo
Warren Oates: A Wild Life
 Susan Compo
Helen Morgan: The Original Torch Singer and Ziegfeld's Last Star
 Christopher S. Connelly
Improvising Out Loud: My Life Teaching Hollywood How to Act
 Jeff Corey with Emily Corey
Crane: Sex, Celebrity, and My Father's Unsolved Murder
 Robert Crane and Christopher Fryer
Jack Nicholson: The Early Years
 Robert Crane and Christopher Fryer
Anne Bancroft: A Life
 Douglass K. Daniel
Being Hal Ashby: Life of a Hollywood Rebel
 Nick Dawson
Bruce Dern: A Memoir
 Bruce Dern with Christopher Fryer and Robert Crane
Intrepid Laughter: Preston Sturges and the Movies
 Andrew Dickos
The Woman Who Dared: The Life and Times of Pearl White, Queen of the Serials
 William M. Drew
Miriam Hopkins: Life and Films of a Hollywood Rebel
 Allan R. Ellenberger
Vitagraph: America's First Great Motion Picture Studio
 Andrew A. Erish
Cesar Romero: The Joker Is Wild
 Samuel Garza Bernstein
Jayne Mansfield: The Girl Couldn't Help It
 Eve Golden
John Gilbert: The Last of the Silent Film Stars
 Eve Golden
Strictly Dynamite: The Sensational Life of Lupe Velez
 Eve Golden
Stuntwomen: The Untold Hollywood Story
 Mollie Gregory
Jean Gabin: The Actor Who Was France
 Joseph Harriss
Yves Montand: The Passionate Voice
 Joseph Harriss
The Herridge Style: The Life and Work of a Television Revolutionary
 Robert Herridge, edited and with an introduction by John Sorensen
Otto Preminger: The Man Who Would Be King, updated edition
 Foster Hirsch
Saul Bass: Anatomy of Film Design
 Jan-Christopher Horak

Lawrence Tierney: Hollywood's Real-Life Tough Guy
 Burt Kearns
Hitchcock Lost and Found: The Forgotten Films
 Alain Kerzoncuf and Charles Barr
Pola Negri: Hollywood's First Femme Fatale
 Mariusz Kotowski
Ernest Lehman: The Sweet Smell of Success
 Jon Krampner
Sidney J. Furie: Life and Films
 Daniel Kremer
Albert Capellani: Pioneer of the Silent Screen
 Christine Leteux
A Front Row Seat: An Intimate Look at Broadway, Hollywood, and the Age of Glamour
 Nancy Olson Livingston
Ridley Scott: A Biography
 Vincent LoBrutto
Mamoulian: Life on Stage and Screen
 David Luhrssen
Maureen O'Hara: The Biography
 Aubrey Malone
My Life as a Mankiewicz: An Insider's Journey through Hollywood
 Tom Mankiewicz and Robert Crane
Hawks on Hawks
 Joseph McBride
John Ford
 Joseph McBride and Michael Wilmington
Showman of the Screen: Joseph E. Levine and His Revolutions in Film Promotion
 A. T. McKenna
William Wyler: The Life and Films of Hollywood's Most Celebrated Director
 Gabriel Miller
Raoul Walsh: The True Adventures of Hollywood's Legendary Director
 Marilyn Ann Moss
Veit Harlan: The Life and Work of a Nazi Filmmaker
 Frank Noack
Harry Langdon: King of Silent Comedy
 Gabriella Oldham and Mabel Langdon
Mavericks: Interviews with the World's Iconoclast Filmmakers
 Gerald Peary
Charles Walters: The Director Who Made Hollywood Dance
 Brent Phillips
Some Like It Wilder: The Life and Controversial Films of Billy Wilder
 Gene D. Phillips
Ann Dvorak: Hollywood's Forgotten Rebel
 Christina Rice
Mean . . . Moody . . . Magnificent! Jane Russell and the Marketing of a Hollywood Legend
 Christina Rice
Fay Wray and Robert Riskin: A Hollywood Memoir
 Victoria Riskin
Lewis Milestone: Life and Films
 Harlow Robinson
Michael Curtiz: A Life in Film
 Alan K. Rode

Ryan's Daughter: The Making of an Irish Epic
 Paul Benedict Rowan
Arthur Penn: American Director
 Nat Segaloff
Film's First Family: The Untold Story of the Costellos
 Terry Chester Shulman
Claude Rains: An Actor's Voice
 David J. Skal with Jessica Rains
June Mathis: The Rise and Fall of a Silent Film Visionary
 Thomas J. Slater
Horses of Hollywood
 Roberta Smoodin
Barbara La Marr: The Girl Who Was Too Beautiful for Hollywood
 Sherri Snyder
Ethel Barrymore: Shy Empress of the Footlights
 Kathleen Spaltro
Lionel Barrymore: Character and Endurance in Hollywood's Golden Age
 Kathleen Spaltro
Buzz: The Life and Art of Busby Berkeley
 Jeffrey Spivak
Victor Fleming: An American Movie Master
 Michael Sragow
Aline MacMahon: Hollywood, the Blacklist, and the Birth of Method Acting
 John Stangeland
My Place in the Sun: Life in the Golden Age of Hollywood and Washington
 George Stevens, Jr.
There's No Going Back: The Life and Work of Jonathan Demme
 David M. Stewart
Hollywood Presents Jules Verne: The Father of Science Fiction on Screen
 Brian Taves
Thomas Ince: Hollywood's Independent Pioneer
 Brian Taves
Picturing Peter Bogdanovich: My Conversations with the New Hollywood Director
 Peter Tonguette
Jessica Lange: An Adventurer's Heart
 Anthony Uzarowski
Carl Theodor Dreyer and Ordet: My Summer with the Danish Filmmaker
 Jan Wahl
Wild Bill Wellman: Hollywood Rebel
 William Wellman Jr.
Harvard, Hollywood, Hitmen, and Holy Men: A Memoir
 Paul W. Williams
The Warner Brothers
 Chris Yogerst
Clarence Brown: Hollywood's Forgotten Master
 Gwenda Young
The Queen of Technicolor: Maria Montez in Hollywood
 Tom Zimmerman